WORD AND IMAGE

WORD AND IMAGE

The Hermeneutics *of* The Saint John's Bible

MICHAEL PATELLA, OSB

CHAPTER 3 CONTRIBUTED BY
BENJAMIN C. TILGHMAN

THE SAINT JOHN'S BIBLE

Collegeville, Minnesota

A Saint John's Bible Book published by Liturgical Press
Donald Jackson – Artistic Director
www.saintjohnsbible.org

1 2 3 4 5 6 7 8 9

Library of Congress Cataloging-in-Publication Data

Patella, Michael, 1954–
 Word and image : the hermeneutics of the Saint John's Bible / Michael Patella, OSB.
 pages cm.
 ISBN 978-0-8146-9196-0 — ISBN 978-0-8146-9197-7 (e-book)
 1. Saint John's Bible. 2. Illumination of books and manuscripts.
 3. Bible. English. New Revised Standard—Commentaries. I. Title.

BS191.P38 2013
220.5'20434—dc23 2012051401

Abbot Timothy Kelly, 1934–2010

Brother Dietrich Reinhart, 1949–2008

Those who are wise shall shine like the brightness of the sky, and those who lead many to righteousness, like the stars forever and ever. (Dan 12:3)

CONTENTS

ACKNOWLEDGMENTS

To Donald and Mabel Jackson and the whole Scriptorium Team for their warm hospitality, wonderful dinners, and engaging conversations on both sides of the Atlantic, I remain always grateful.

To the Committee on Illumination and Texts. Although it went through various configurations over the years, it always remained the most enjoyable, creative, and lively committee I ever worked with: the late Johanna Becker, OSB; David Cotter, OSB; Nathanael Hauser, OSB; Ellen Joyce; the late Rosanne Keller; David-Paul Lange, OSB; Irene Nowell, OSB; Simon-Hoà Phan, OSB; Alan Reed, OSB; Columba Stewart, OSB; Jerome Tuba, OSB; and Susan Wood, SCL; and to the late Carol Marrin as project director, my everlasting gratitude.

To the professors and administration at Yale Divinity School, which granted me a research fellowship during the 2011–2012 academic year; to Harold and Jan Attridge for their warm hospitality and many kindnesses; to Stephen J. Davis and Hindy Najman for welcoming me into their seminar, "Reading Practices in Antiquity"; to the administration and residents of the Overseas Ministry Study Center in New Haven for their living accommodations and community support; to the Saint Thomas More Catholic Center and Chapel at Yale University for being a liturgical and spiritual home; my deepest appreciation.

To Richard J. Bautch and Jean-François Racine of the Catholic Biblical Association and the members of the Task Force on Biblical Hermeneutics and Cultural Studies; to Cheryl Exum and Martin O'Kane of the Society of Biblical Literature's unit on Bible and the Visual Arts, my indebtedness.

To those who aided my access to research materials: E. C. Schroeder, director of the Beineke Rare Book & Manuscript Library and his exceedingly friendly and helpful staff; Colin Harris, superintendent, Special Collections Reading Rooms, Bodleian Libraries, Oxford; J. Felix Stephens, OSB, and the staff at St Benet's Hall, Oxford; Kenneth Dunn, senior curator, Manuscripts and Archive Collections, National Library of Scotland; Susie and Julian Leiper

for hosting me in Edinburgh; Angelika Pabel, director of Handschriften und Alte Drucke at the Würzburg Universitätsbibliothek; I am much obliged.

To everyone at Liturgical Press, especially Peter Dwyer, Hans Christoffersen, Barry Hudock, Ann Blattner, Lauren L. Murphy, Colleen Stiller, Nikki Werner, Julie Surma; I am most thankful.

To my monastic community of Saint John's Abbey for all their fraternal encouragement; to my colleagues at Saint John's University and the College of Saint Benedict for the sabbatical to complete the book; to former and current project directors, Michael Bush and Tim Tiernes; to Linda Orzechowski at HMML for accessing the archives and providing all sorts of logistical support, my heartfelt thanks.

To Angela G. Del Greco for her many suggestions and advice on the manuscript, I am most appreciative.

To Ursula Klie whose great interest in art over the past twenty-two years has led me in many directions of exploration, *vielen Dank*.

ABBREVIATIONS

ASV American Standard Version; a revision of the KJV, completed in 1901

CIT Committee on Illumination and Text; the group in charge of selecting images and providing theological oversight for *The Saint John's Bible*

HMML Hill Museum & Manuscript Library; contains the world's largest collection of microfilmed and digitized early and medieval Christian manuscripts and curates, houses, and exhibits *The Saint John's Bible* on the campus of Saint John's University, Collegeville, MN

KJV King James Version of the Bible; completed in 1611

LXX Abbreviation for *Septuagint*; the Old Testament written in Greek and the version used by the Evangelists and other New Testament writers

NRSV New Revised Standard Version; a revision of the RSV completed in 1989

NT New Testament

OT Old Testament

RSB Rule of Saint Benedict

RSV Revised Standard Version; an American revision of the KJV, completed in 1952

INTRODUCTION

Back in 1996 when the millennium was fast approaching, the monastic community at Saint John's Abbey in Collegeville, Minnesota, pondered how to mark this great turning point in Christian history. The desire was to find something that could draw on the fifteen-hundred-year-old Benedictine tradition while simultaneously vivifying the Christian imagination in its service to the future. Sponsoring a handwritten and illuminated Bible seemed to fit both criteria. Just as the biblical account of divine revelation was the source of artistic inspiration for previous centuries, there was hope among the monks that it could once again proclaim the glory of God by reigniting the fires of artistic imagination. Doing so was no easy task. One of the biggest obstacles was trying to make clear for themselves, as well as for others, why, in an age when even the commercial printing press faces an uncertain tomorrow, anyone would want to embark on a project using vellum, ink, and goose quills to produce something that could be obtained by the click of a button.

The university president, Brother Dietrich Reinhart, convened a task force to develop a project plan for *The Saint John's Bible* once both the regents of the university and the monks of the abbey had approved the undertaking. The plan included what has since become known as the "Vision and Values" statement listing six points grounding the reason for the work:

- to glorify God's Word
- to give voice to the unprivileged
- to ignite the imagination
- to revive tradition
- to discover history
- to foster the arts

All told, these six points can be summed up by the word "evangelization," for they each stand as component parts of proclaiming Christ's salvation to the ends of the earth. Christianity is an incarnational faith, and that faith takes root in the things of this world, including all noble human endeavor.

The commentary that follows functions as a guide to and a study of *The Saint John's Bible*. Divided into four parts, it discusses the many areas that have influenced the composition, art, reading, and interpretation of the first handwritten and illuminated Bible commissioned by a Benedictine abbey since before Gutenberg invented the printing press.

PART 1: WORD AND IMAGE: A HERMENEUTICAL MATRIX

The hermeneutical key for understanding *The Saint John's Bible* lies with reading, viewing, and reflecting upon it as an experience and encounter with the Word in a sacramental form. It is a treasury of the church's rich tradition of prayer, faith, and thought as well as a repository of beauty and a promoter of social justice. Anything that assists us in understanding the Bible and growing in the love of God is good—inconsistencies, ambiguities, contradictions, and puzzlements notwithstanding. Proceeding with this intent, we should keep an important point in mind: Ancient theologians and exegetes had one ultimate goal in reading Sacred Scripture and that was the divinization of the human person into life with the risen Christ. And they employed the greatest tools of faith and reason to achieve it. Resting on two thousand years of ongoing scholarly, biblical tradition, we should now use the best at our disposal for that same goal. Part 1 draws, therefore, from the tradition of biblical interpretation as well as develops a way to keep the Word of God dynamic, challenging, and life-changing.

PART 2: WHY THIS ENGLISH TEXT

The Bible has played a tremendous role in the formation of civilization in both the East and West, and that influence, though changed, was not diminished when it was translated from Latin to the vernacular, in this case, English; its role in the development of the thought and culture of the English-speaking world is a case in point. Because *The Saint John's Bible* uses the interplay of image and text in its interpretation, this discussion on the New Revised Standard Version (NRSV) and its antecedents displays some of the scholarship that establishes the textual fidelity to the Word. This English edition of the Bible is a noble work in its own right; no other English translation could have sufficed for this project.

PART 3: THE SAINT JOHN'S BIBLE: PART OF AN ARTISTIC AND MONASTIC LINEAGE

Benjamin C. Tilghman, currently assistant professor of art history at Lawrence University and former curatorial fellow at the Walters Art Museum in

Baltimore, Maryland, examines several distinct moments in which monasteries and others reflecting on the ecclesiological goals of reformers sponsored the handwriting of Bibles. He demonstrates what we can learn from history about a monastery's use of artists and scribes of the highest caliber to write the Bible and related works. *The Saint John's Bible,* by employing an ancient method for a contemporary age, reinforces the continuity of the faith tradition.

PART 4: HERMENEUTICAL GUIDE

As the largest section of the book, these chapters feature material from the deliberations of the Committee on Illumination and Text (CIT), the artists at the Scriptorium in Wales, and discussion on the images themselves.

Approach

A dynamic tension exists in biblical interpretation between what the faith community sees as the meaning of a certain passage and the great many thoughts given birth by that meaning. For example, the four gospel accounts of Christ's baptism have filled Christianity with hymns and artistic works referencing water, the Jordan River, the Red Sea, dew, cleansing, grace, doves, seashells, clouds, and heavenly voices—things that go beyond what is mentioned in the gospel passages. Do they enhance the biblical interpretation, hinder it, bring forth greater understanding of baptism, or lead people to confusion? The resolution may very well lie in the constant dialogue between the accepted understanding of the faith community and the resulting meditations of its members.

The pages that follow guide readers through such a dialogue inhering within *The Saint John's Bible.* In doing so, readers must keep in mind some assumptions upon which the hermeneutics of *The Saint John's Bible* rest:

A primary consideration is that the CIT, in its own discussion and in its communication with Donald Jackson, the artistic director of *The Saint John's Bible,* perceived early on in the project that the different books from both Testaments, in their numerous stories, episodes, and personages covering a period of approximately twelve hundred years of composition are connected to each other through themes, plots, and vocabulary. The Christian Bible, therefore, relates only one message: God has brought salvation to the world through his only begotten Son and continues to do so in the Holy Spirit, and the community of the baptized must respond accordingly. While this understanding may seem like an oversimplification of a tome yielding a variety of genres and countless passages, it is actually an acknowledgment of the great diversity comprising not only the human race but also the whole creation. Yet, all creation's complexity and intricacy springs from that one moment of

creation's birth at the Big Bang and leads to that one moment when the fullness of Christ's salvation will come in its completeness.

Second, throughout *The Saint John's Bible*, we should never consider art and theology separate entities. Indeed, the word written in calligraphy and the accompanying images expressing a salient point are both art. In this sense, the art is not only a vehicle to express the theology but also an embodiment of theological thinking, wonderment, and exploration. Moreover, in its best moments and pieces, the art functions as a window into the divine.

Third, by working with both word and image, *The Saint John's Bible* utilizes two human senses—hearing and sight. The Bible is meant to be read aloud, preferably within a community at prayer and worship together. Images, on the other hand, are meant to be seen, and the fullness of their interpretation comes from the Christian context which inspired them, even as that context is broadly construed. Word and image have a symbiotic relationship with each informing the other, and together they give rise to Sacred Scripture's polyvalence. Readers should not be surprised if they find that their engagement with *The Saint John's Bible* opens their imaginations, hearts, souls, and intellect to new ways of conceiving God. In addition, they may also find themselves entering a deeper relationship with God.

Finally, we should always keep in mind what the project represents for the church as the Body of Christ in this space and time. At the dawn of the third millennium, the Holy Spirit has moved an abbey and university to write and illuminate by hand and on vellum the Word of God, the same Word of God that has become flesh in a particular time and place two thousand years ago. *The Saint John's Bible* is a great sacramental enterprise from within the Body of Christ, making the Word of God present to the same Body of Christ.

A Guide

This book is meant to guide the reader through *The Saint John's Bible*. Although it includes small images of some of the major and minor illuminations, these thumbnail representations are not meant to substitute for the work itself. The point is to concentrate on *The Saint John's Bible*, whether the original, the Heritage volumes, or the reproduction books. My hope is that by reading, pondering, and meditating on the Bible, and by using this book to assist the effort, the reader will come to greater experience and understanding of the Word of God and its transformational power. By no means is this study exhaustive. If readers find fonts of inspiration or connections that I may not have mentioned, so much the better, for they show the Holy Spirit at work.

Part 1

WORD AND IMAGE: A HERMENEUTICAL MATRIX

Chapter 1

IMAGE AND TEXT

B iblical study has its own rich methodologies for deciphering and under-
standing a text. There are age-old ways of interpreting Scripture: for
Christianity, the traditional, patristic,[1] fourfold way of interpretation
(literal, allegorical, moral, anagogical), and for Judaism, the rabbinical and
midrashic. In the modernist period there arose the historical-critical method
along with narrative and reader-response criticisms. And now in the face of
postmodernity we see many employing the hermeneutics of suspicion and
intertextuality among others.

It is not difficult to find corresponding political and social associations
tied to each method used for interpreting Scripture. We could categorize
them as liberal and conservative, fundamentalist and holistic,[2] modern and
postmodern, and I am sure many others. Much of the tension and debate,
however, centers on claims of modernity and the disciplines or, at least, the
biblical disciplines that have derived from the thought of the Enlightenment,
with historical criticism chiefly among them.

The church's tradition of faith and reason includes establishing a coherent
reading of the text amid any of its ambiguities or inconsistencies, studying
how the culture over time has influenced the interpretation of the text (as
well as how the text has influenced the culture, thereby allowing the text to

1. The term "patristic" refers to the period from the first generation of theologians
after the death of the last apostle (ca. 150) to the death of Augustine AD 430. Patristic
writings set the foundation for the development of Christology, trinitarian thought, salva-
tion, and justification.

2. Used here to mean an interpretation cannot be reduced to isolated, fractured parts.
It is the opposite of fundamentalist. A holistic reading sees the necessity of interpreting
all Scripture within the context of history and the 2,500-year-old faith tradition.

affect our action in the world), and finally forming a personal and communal relationship with the Word of God.

I present below, therefore, an exceedingly brief history of biblical interpretation as well as a way to draw from that tradition an interpretive process that will keep the Word of God dynamic, challenging, and life-changing.

THE PAST

Of all the great battles Christian apologists have had to face, the one over the interpretation of Sacred Scripture has loomed among the largest. Many of the theologians of the patristic era were forced to answer for inconsistencies, contradictions, and redundancies found in the biblical text. This situation led some, notably Origen, to rely on a "mystical interpretation" of Scripture.[3] Augustine to a certain degree departed from Origen on this issue and preferred a more literal reading, with the idea that passages whose content tested the credulity of human reason must be interpreted within the "rule of faith." For Augustine, this rule is set in place by the believing and praying community instructed by homilies gathered around a bishop and the sacraments. Whether or not one sees this optic as just, valid, or desirable, it at least provides a counterweight to today's kind of biblical literalism, as well as to our era's skeptical nihilism.

When Christianity arrived on the scene, it inherited a culture in which the line between the material and spiritual was not easy to distinguish. The Greeks and the Romans may not have been a part of the Jewish monotheistic tradition, but they certainly believed in something beyond this time, space, and dimension. The Roman *lares* and *penates* (household gods) were real and omnipresent, and functional in a way that the major gods of the state, such as Mars and Minerva, were not. On an anthropological and sociological level, one of Christianity's strengths was that it had the ability to take this human need for contact with divinities and reconstitute it by employing Christian theological interpretations of the world it had inherited and converted. So, for instance, the personal, household gods that people treasured would become the cult of the saints. The protection and blessing of Jupiter and Juno came under the aegis of the personal, omnipresent, beneficent, and triune Godhead. In addition, because of high mortality rates (which did not really begin to fall until the last century), death was never far away, and so the early

3. See David Laird Dungan, *The History of the Synoptic Problem* (New York: Doubleday, 1999), for a historical treatment of biblical hermeneutics.

Christian community found fertile soil in stressing the salvation of one's soul as the primary purpose of life.

This mentality engendered a vision that looked for signs of God's presence in the everyday experience. Rain and sun in their proper seasons were expressions of God's love. Misfortune befell a person who had lapsed in his or her prayer life. And if God's merciful minions of angels were always around, so were the diabolical forces ready to engage them in a tug-of-war over the soul of the recently deceased. The important point of this mentality is that none or very little of this worldview is described in the Bible, yet it was this very same worldview that people wanted the biblical stories to address; simultaneously, this worldview helped people interpret these stories. In its greatest moments, this fusion of the Bible and the premodern *Zeitgeist* produced a mysticism in which every human endeavor was measured by its ability to maximize the presence of God's grace in the world and in one's life so that people could rest secure in the promise of eternal salvation. The incarnation made such a fusion possible, and it became the foundation for a grace-filled universe, from which the church's sacramental life springs.

The doctrine of the incarnation asserts that the Second Person of the Trinity took on human flesh and became a mortal being at a certain point in history. As Saint Athanasius would say, "God became human so that the human could become divine."[4] If created matter in the form of human flesh were to be so elevated, the rest of creation, too, has its role to play in reflecting and participating in the presence of the divine. One can point not only to the outdoor shrines and forest chapels dotting the landscape in Christian countries, but also to the cultural output of the first sixteen hundred years of Christianity in art, music, architecture, literature, and manuscript illumination as evidence of Christian expressions of divine presence in the world. Art expresses reality through metaphor, and if looking for a way to describe the premodern worldview, one would have to say that it is a symbolic, metaphorical one.

Although the Christian West often relied on allegory as the matrix of interpretation in its biblical and sacramental life, it did not do so exclusively; it has always maintained a strong footing in the metaphorical world as well. The Christian East, on the other hand, never loosened its firm hold on the metaphorical world, as its icon tradition attests. The ability to appreciate metaphor opens the way to greater mysticism. So, for example, as artistic and well-executed as a Greek icon is, it is never to be considered a mere decoration.

4. *De Incarnatione* 54.3 in J.-P. Migne, ed., *Patrologia Graeca cursus completus accurante*; *Series Graeca* in *Patrologia Graeca* 25:192B (Paris: Frères Garnier, 1912).

Rather, it is a window into the realm of God, and when we gaze upon the icon, we enter the divine realm while it simultaneously permeates us. Furthermore, because the icon makes the "invisible reality . . . more perceptible" it can be "as effective as printed or spoken words—perhaps for some people, even superior to words," as a vehicle of the holy.[5]

In the Greek East, the icon is on par with Sacred Scripture.[6] It can transmit historical fact, such as the birth of Christ, and point to a truth beyond the fact. This "truth beyond the fact" rides on the metaphor. An icon, like Scripture, "indicates the revelation that is outside time, contained in a given historical reality."[7] Through icons, then, we not only read factual details[8] but also encounter and know God, and, in this sense, the icon is like Sacred Scripture.[9]

An important point—indeed the most important point within these ancient forms of exegesis—is that reading Sacred Scripture and venerating an icon are interpreted as encounters with the divine, in all the deep mystery and incomprehensible love that probing the divine can muster.

THE FRACTURED SYMBOL

The Enlightenment ushered in many advances in the biblical sciences, with the historical-critical method being primary. The period's emphasis on empirical data, however, not only shunned the symbolic world but also castigated it. Faith and belief were seen as obstacles to interpreting Scripture and therefore had to be jettisoned in favor of a reading that stressed the text uninhibited by a bias toward faith. For those scholars interested in demonstrating the folly of religion, the difficult passages with their incredulous miracles or glaring inconsistencies served as proof that religion was for, well, the "unenlightened." These scholars themselves pursued their intellectual interests, content that

5. Robin M. Jensen, *The Substance of Things Seen: Art, Faith, and the Christian Community* (Grand Rapids, MI: Wm. B. Eerdmans, 2004), 72–73.

6. Leonid Ouspensky and Vladimir Lossky, *The Meaning of Icons*, trans. G. E. H. Palmer and E. Kadloubovsky (Crestwood, NY: St. Vladimir's Seminary Press, 1982), 36.

7. Ibid.

8. While the Bible contains details that can be factual, not every detail is factual. For example, we know through archaeology that the walls of Jericho crashed several times in the city's history, yet scholars dispute whether the archaeological and historical evidence date from the time when, according to the text, Joshua was in the area.

9. Ouspensky and Lossky, *Meaning*, 36.

they were advancing Western civilization by unmasking such bogus elements as religious belief and spiritual practice.[10]

To be sure, this new thought and the social advances it encouraged gave rise to modern medicine, science, and parliamentary and representative democracy. It successfully challenged religious structures that maintained their power by using dogma and belief as tyrannical weapons. Moreover, in biblical studies, it promoted historical-critical research that utilized archaeology, anthropology, and other disciplines as a way of furthering the interpretation of the text.[11]

The Enlightenment's greatest drawback, however, is that it destroyed that symbolic system that acted as the counterweight to an overly literalistic reading of the Bible. This legacy is the soil that has given rise to biblical fundamentalism. Whereas the agnostics and the atheists could manage in this universe without recourse to the world of either religious texts or metonyms,[12] the believers could not. Christians, without the sensitivity to and awareness of the symbolic system (especially if they belonged to sects that had eradicated all symbols during the Reformation), had nothing left but the biblical text; as such, every word could only be taken as literal—*not* metaphorical—truth.

Historical-Critical Method

Historical criticism is a necessary component of biblical exegesis. It situates the text most closely with the writer's time and place and, thus, his or her intent, insofar as we are ever able to know fully that particular intent. Problems arise with historical criticism when exegetes present it as the all-encompassing final word of any passage, capable of completely asking and answering all the relevant questions a text may raise. For example, historical criticism cannot answer a question on why or how a certain biblical passage

10. A case in point is Baruch Spinoza's *Theological-Political Treatise*, which questioned biblical claims of a divinely inspired text. In a similar vein, Thomas Jefferson reworked the New Testament by removing the beginning and end of each of the four gospels. In Luke, he deleted every reference of divine intervention at the birth of Christ: the annunciation, virginal conception, and hosts of angels. The result was his *The Philosophy of Jesus of Nazareth*, in which Jesus is portrayed as a teacher of common sense.

11. It should be noted, however, that early forms of some of these other disciplines existed before the rise of modernity and are seen particularly in Origen's tools of textual analysis—tools that are afforded to the material culture of Rome during the period stretching from the early church through the Renaissance. Moreover, the great emphasis placed on pilgrimage to the Holy Land brought the context of the Bible closer to the reader.

12. A "metonym" is a part that represents the whole, as in the phrase, "The White House," for the whole executive branch of government. More to our point, for Christians, a statue of the Blessed Mother could represent the whole cult of saints.

is used in a liturgical antiphon, and because it cannot, many employing this analytical lens may feel that the respective passage has no place in the liturgy at all and, unfortunately, may say as much.

A more organic approach (and a more honest one) would be to admit the limits of historical criticism by introducing, for example, the polyvalent nature of Scripture, the context of its use within the history of the living faith, and the reason why certain writers and artists have interpreted it in a particular way. Doing so breathes life, creativity, and excitement into the subject matter while showing a great deal of sensitivity and humility before the Word of God. People coming from a variety of positions, from liberal to conservative and churched to unchurched, can understand and become enthusiastic by such an open approach.

Why Images?

In the words of John Julius Norwich, "Ever since the dawn of history, when man first became a religious animal and almost simultaneously—give or take a millennium or two—made his first clumsy attempts at adorning the walls of his cave, he has had to face one fundamental question; is art the ally of religion, or its most insidious enemy?"[13] While Norwich's question lacks nuance, it is exactly what plays itself out in the iconoclast controversy, for as the outcome of this debate shows, the truth is that art cannot be separated from theology.

The iconoclast controversy broke out in the Eastern church in the early eighth century. The argument was that the Bible explicitly stated graven images of any kind were prohibited (Exod 20:4; Lev 19:4; Deut 5:8 and 7:5), and yet the church, from almost the very beginning, made use of representational art. Furthermore, this art had found its way into the hearts, minds, and devotion of most Christians. When others began to challenge the practice of using representational art, those who held on to the veneration of mosaics, paintings, and statues were threatened, especially when both secular rulers and church leaders backed the iconoclasts (those destroying the religious icons).

The western half of the church, that is, the area from Constantinople to Spain, was much less affected by the iconoclasts. Much of the reason can be credited to the pagan, Greco-Roman civilization. Unlike the eastern regions (Anatolia to the Persian border), pagan Greece and Rome reveled in their statues, mosaics, and frescoes, all depicting their gods of various temperaments. Lands under Persian cultural influence, on the other hand, were more prone to the predominant religion of Zoroastrianism, which had a very strong aniconic

13. John Julius Norwich, *Byzantium: The Early Centuries* (New York: Alfred A. Knopf, 1989), 354.

tradition that frowned on the use of images. Once the Roman world became Christian, these two cultural backgrounds determined how each population would more or less respond to images as representations of its faith.

A deeper look. The theology of icons was first articulated by Saint John of Damascus or Damascene (dates uncertain, ca. 676–787), who around 706 became a monk at Mar Saba monastery in Palestine. John Damascene wrote three treatises explaining his point; the first sets out the argument and the remaining two recapitulate it after a fashion. No doubt John Damascene's life under the Muslim Caliph al-Walid in the Syrian city of his birth had a great effect on his thinking. As a Christian in the Caliph's court, John Damascene had to learn the subtleties of theology as a matter of religious survival. While the Muslims condemned icons as idolatrous, the iconoclasts were doing the exact same thing in the Christian Empire. With great scholarly intensity, John Damascene's argument outlines that to capitulate on the question of icons would place Christian doctrine itself in jeopardy. More was at stake than art, or, rather, art became united with theology.

John Damascene's methodology in his treatises is a paradigm of scholarly presentation. He defines two key terms, "icon" and "veneration." *Icon* is Greek for "image." Damascene says that the Son is the image of the Father and that God the Father relates to the created order through images of his divine intention.[14] Visual images tell us something about invisible realities. For instance, a painting or statue of a historical figure reminds us of events, people, and circumstances of the past, or in the case of Damascene, the Old Testament prefigures the New. To destroy icons is to destroy past and present realities as well as to call God into question (1.9–13).[15]

"Veneration" is another term Damascene defines. A translation of the Greek *proskynesis*, literally "bowing down," Damascene distinguishes "veneration" from "worship" (Greek, *latria*). "Veneration" is done on account of God, to God's friends and servants, and even to places that God has touched. Here, Damascene gives examples from Scripture: "Let us go to his dwelling place; let us worship [Greek, *proskyneo*] at his footstool" (LXX Psalm 131:17). He also discusses how ancient Israel venerated the temple tabernacle (1.14–15).[16]

John Damascene then moves into the heart of the matter with some of the most uplifting passages in theology. Iconoclasts based their conclusions

14. Andrew Louth, trans., *Saint John of Damascus: Three Treatises on the Divine Images* (Crestwood, NY: St. Vladimir's Seminary Press, 2003), 10.

15. Ibid., 25–27.

16. Ibid., 28–29.

on the assumption that created matter could not possibly represent the uncreated God. Damascene counters, however, that the incorporeal God became corporeal in the incarnation of God's son, Jesus Christ. If God's son became created matter, how can created matter be sinful or lead into sin (1.16)?[17] The cross of Christ is physical matter. Golgotha is physical matter; so is the tomb, the place of resurrection (1.16).[18] He continues, "Is not the ink and the all-holy book of the Gospels matter? Is not the life-bearing table, which offers to us the bread of life, matter? [Are] not the gold and silver matter, out of which crosses and tables and bowls are fashioned? And, before all these things, is not the body and blood of my Lord matter? Either do away with reverence and veneration for all these or submit to the tradition of the Church and allow the veneration of images of God and friends of God, sanctified by name and therefore overshadowed by the grace of the divine Spirit" (1.16).[19]

Damascene's genius lies in connecting the veneration of images to the incarnation and resurrection, and from there to the whole sacramental life of the church. He continues by arguing with those who would countenance making an image of Mary, Mother of God and Jesus, but who would protest images of any saints. This move, says Damascene, denies the effects of the redemption, for Christ has called all to salvation and glory. If one cannot venerate the saints, one is saying that it is impossible to attain the glory God destined for us, and one becomes an enemy of God (1.19).[20]

Finally, John Damascene does not rely on his wisdom alone to make his point. He concludes by quoting such patristic sources as Saints Basil the Great, Gregory of Nyssa, Gregory Nazianzen, John Chrysostom, and others (1.28–65).[21] This tack of using a plurality of sources, too, is an important one in theology. Writing that employs the works of past theologians and scholars is called *florilegia*, a Latin term meaning "a selection of flowers." *Florilegia* remains a standard feature of theological writing up through the Middle Ages and beyond. Indeed, one can see in this style of writing the forerunner to footnotes, endnotes, and other forms of documentation. For our purpose here, we see the great theologian and hymn writer, John of Damascus (whose compositions we still sing today), relying on the intellectual tradition of the church to make a point.

17. Ibid., 29.
18. Ibid.
19. Ibid., 29–30.
20. Ibid., 32.
21. Ibid., 40–56.

The conclusion to draw from the iconoclast controversy is that art and theology in the Christian tradition are of an organic whole. Entering theology through art or art through theology is not something that starts with *The Saint John's Bible*. It is an ancient practice almost lost first during the iconoclast controversy, second through the excesses of the Reformation, and third through the empiricism of the Enlightenment. It could very well be that biblical exegesis will never be complete without recovering the ancient forms of exegesis that included icons and, in today's case, artistic components to Christianity that have developed since then.

THE TRANSCENDENT METANARRATIVE

The great rub in any biblical interpretation is acknowledging what we expect Scripture to be and do. From the outset, let us all be clear that the Bible is not intended to be an empirical handbook proving God's existence. The Bible does not prove anything. The proof of the faith comes in living within the divine relationship explicated by Scripture and charged by the Holy Spirit. Like all good relationships, there is a great deal of mystery that one must enter into but never solve or complete. No conclusion is possible in mystery; possibilities are constantly unfolding, and these possibilities keep the relationship alive.

For the community of believing Christians and similarly, though not identically, for Jews, the Bible is a transcendent text in physical form—specifically, a sacrament. The written Word of the Bible is the presence of God in our midst. While differing in kind but not degree, the same can be said of beauty. When the biblical Word and its artistic expression influence each other, therefore, we can have a very strong sacramental encounter. Such a sacramental experience of God is bound to have moral and ethical implications, provided that the beauty leads us to see beyond the object. Concentrating only on the object itself is literally and figuratively a dead end, for anything of creation is, by nature, subject to decay.[22]

By relinquishing the tight empirical hold on the Bible, it is much easier to focus on the fact that Sacred Scripture deals with divine revelation. As pastors, teachers, parents, and students, we can and should do justice to the rigor and insight of biblical scholarship as a theological exercise—which is, by Saint Anselm's famous dictum, *faith seeking understanding*—enabling one to make the leap of viewing the sacred text as the Word of God in human language. We have faith in the transcendent metanarrative seeking understanding through

22. Jensen, *Substance*, 9. Jensen reflecting on Augustine's *Confessions* 10, chap. 33, para, 49–50.

study of its physical form; it is a sacramental engagement between divine reality and its physical manifestation in the written text.

Some people respond with words while others utilize images. Yet the word is most important in creating the image, as Robin Jensen notes: "The greatest works of literature and poetry . . . rely on words to shape and express the images that appear to our imaginations."[23] Making art is hard work. It demands as much attention, concentration, and focus as we would expect from a researcher. It also demands skill. It is not "the result of a moment of unconscious or mystically channeled genius."[24] Artists are in dialogue with the society in which they live, and their work contributes to the communal experience.

Lectio Divina

As a Benedictine venture, the CIT relied on the Benedictine spiritual practice of *lectio divina* as the model and means for discussion. *Lectio divina*, or sacred reading, is an ancient monastic discipline in which one reads a biblical passage as a prayer. One meditates on it, reflects on it, and ruminates on it. In fact, an often used analogy is that one "chews and digests" the sacred text. In this exercise, one avails oneself of thoughts and insights that would otherwise not be possible. In the Christian tradition, such insight is considered to occur under the direction of the Holy Spirit.[25]

Lectio divina describes a culture as well as a method. While it certainly refers to the slow, meditative reading of Sacred Scripture, at one point in history it also affected the environment that fostered and sustained such a study. Within this system, everything read in Scripture must be interpreted within what Hugh of St. Victor calls "the grand *historia*"; that is, to be understood properly, everything one peruses must find a place between the books of Genesis and Revelation.[26] The grand *historia* is the narrative in which the

23. Jensen, *Substance*, 14.

24. Ibid.

25. *Lectio divina* is not a private undertaking in which a reader is left alone to interpret Scripture on his or her own, without recourse to commentaries or reference to the scientific world. It is not, in other words, a synonym for a fundamentalist reading of the Bible, as some would have it. From antiquity until today, *lectio divina* demands that one use all the interpretive tools at one's disposal in order to understand the biblical text.

26. Ivan Illich, *In the Vineyard of the Text: A Commentary to Hugh's* Didascalicon (Chicago: University of Chicago Press, 1993), 33. See also Erich Auerbach, *Mimesis: The Representation of Reality in Western Literature* (Princeton, NJ: Princeton University Press, 1953); S. Boynton and D. J. Reilly, eds., *The Practice of the Bible in the Middle Ages: Production, Reception and Performance in Western Christianity* (New York: Columbia University Press, 2011); Justin

personal experience, Christian devotion, and spiritual growth are a unified entity. The individual reads in order to learn and grow in Christ, and in this sense the reader has wisdom as its motivator and goal.[27] Moreover, wisdom contributes to and is gleaned from the artistic.

In the monastic culture, the Word becomes flesh in the *book*, and as such, it becomes an allegory for Christ's incarnation in Mary's womb, and the allegory is but one reason why the Bible is venerated.[28] This assimilation of one reality into another recalls Augustine's dictum, "God has written two books, the book of creation and the book of redemption."[29] Art and text fuse into a whole, resonant, unified sound of God's indwelling on earth.[30]

For the great theologians of the early church, then, *lectio divina* furthers the end of reading and studying Scripture as a mystical encounter with the divine. Because such study is sacred, one who would read Scripture must use all the tools of scholarship and study at his or her disposal to delve into the mystery the Bible holds. Anything less does not take the Word of God seriously.

To be sure, the culture of the early church cannot be reproduced today; now, the world is too pluriform and diverse to support such an enclosed system even if it were desirable. This ancient monastic approach, however, can provide us with a new vision of how to read and interpret the Bible in ways that postmodernism makes possible. The internet, iPads, and other sources that provide and proliferate music, art, literature, and performance build a culture of experience and information—the foundation for an ambient Wisdom tradition. The key is to situate them somehow within the grand *historia*.[31] Reading the Bible is an encounter with the divine Word of God, and we should approach it as such. To do so, we must use research tools as a means to an end and not an end in themselves.

Intratextuality. Brevard Childs, in his book *The New Testament as Canon: An Introduction*, breaks away from the ironclad rules of historical criticism and sees that, in the New Testament anyway, "the canon was fashioned through a particular intertextuality to render its special message."[32] Childs holds that "at times the canonical text receives a meaning which is derivative of its function within the

Taylor, "The Treatment of Reality in the Gospels: Five Studies," in *Cahiers de la Revue Biblique* (Pendé, France: J. Gabalda et Cie, 2011), 78.

27. Illich, *Vineyard*, 64.

28. Ibid., 122.

29. Ibid., 123, citing Augustine, *De Genesi ad Litteram*.

30. Illich, *Vineyard*, 124.

31. Ibid., 33.

32. Brevard Childs, *The New Testament as Canon: An Introduction* (Valley Forge, PA: Trinity Press International, 1994; first printing 1984), 48.

larger corpus, but which cannot be directly linked to the intention of an original author."[33] To clarify, Childs emphasizes that books of the Bible were written independently of the whole work, yet they are all interconnected with each other. Childs confines intertexuality to works within the biblical canon (hence, I refer to his practice as *intratexuality*) and the response of those works to each other.

Canon within the Canon. In this discussion on the relationship of one book to another within the canonical text of the Bible, I must draw attention to the fact that in planning *The Saint John's Bible*, the CIT engaged in developing a canon within the biblical one. The themes of the project plan, along with those passages highlighting Christian salvation history, made some parts of the Bible determinative for the overall understanding of the text while relegating other sections of the Bible to a lesser status. For example, the book of Numbers has three special calligraphic treatments[34] and 1 Chronicles has none. On the other hand, the Wisdom books are awash in visuals and the book of Revelation has an image at nearly every turn of the page.

Although many of these choices for selection have parallels in earlier Bibles, some do not. An overview of illuminated Bibles throughout history shows that different works within different cultural settings stressed different passages. It is easy to conceive, therefore, that years hence, should anyone wish to produce something similar to *The Saint John's Bible*, there would be another set of images stressed that may or may not match the ones the CIT has chosen here. From the perspective of the role of Sacred Scripture in the life of the church, these historical nuances simply give evidence of the Holy Spirit's working in the faith lives of people; the Spirit nourishes us with the food we need at a particular time.

The interrelatedness of individual biblical books with each other is a definitive hermeneutical stance. Generally, our manner in interpreting a particular book in the Bible is that each text must be studied independently of any other book. A scholar, for example, cannot look to references in Psalms as a means of interpretation for the book of Job. A scholar can note the parallels that a section of Job has with a particular psalm, but that psalm in question cannot influence the meaning we ascribe to Job. *The Saint John's Bible* takes another tack—in fact, the opposite approach.

While there are many books composing the Bible and each may have its own message and theme, the Bible itself, from Genesis to Revelation, has only one central message for the Christian: the story of salvation, beginning now.

33. Ibid., 49.
34. Num 6:24-27; 20:12; 21:8-9.

Such an understanding allows for questions raised in Genesis, Deuteronomy, or 2 Kings to find their answers in Romans, Hebrews, or the Gospel of Luke. The ability to see and make these connections is in a very large part developed and enhanced by the practice of *lectio divina*.

This act of seeing Old Testament stories fulfilled in New Testament gospels is called "recapitulation," which dates back to the evangelists themselves. Recapitulation as a theological term defines the system of biblical exegesis in which events and passages in the Old Testament are seen as foreshadowing Christ's salvific act in the New Testament. For example, Matthew's gospel comments on the events leading up to Christ's birth by paraphrasing Isaiah 7:14, "All this took place to fulfill what had been spoken by the Lord through the prophet: / 'Look, the virgin shall conceive and bear a son, / and they shall name him Emmanuel,' / which means, 'God is with us'" (Matt 1:22-23). In their approach to the Bible, the gospels in particular, the earliest artists followed the lead of the evangelists in presenting their biblical depictions in a series of Old Testament foreshadowing and New Testament fulfillment.[35]

Intertexuality

In the practice of *lectio divina*, human experience both meets and is interpreted through the biblical text. It is not so much a process that filters out thoughts and experiences that seemingly have no biblical context, inasmuch as these same thoughts and experiences are converted into a scriptural idiom with biblical references. For example, personal struggles are tied to biblical figures and events, daily ambiguities are cast into the ambit of the mystery of God, and human love is seen within the realm of divine love. There is no end to what can be interpreted through the scriptural tradition. No thought is considered unworthy or profane, for even tangents of thought are under the Holy Spirit. While many might see this process as a postmodern exercise, from the perspective of *lectio divina*, it is at least as old as monasticism itself. In this sense, *lectio divina* is very similar to what Mikhail Bakhtin and Julia Kristeva

35. Recapitulation becomes erroneous and even dangerous when misused or misunderstood. Old Testament prophets, for example, speak to the situation, period, and personages in which they are living without any regard for events five hundred to one thousand years after they are living—namely, the birth, life, death, and resurrection of Christ. Recapitulation results when Christian writers, looking backward, interpret the Old Testament events in the light of Christ. A helpful parallel is to consider the American Declaration of Independence and Constitution. When the founders wrote these documents, they did not have anyone in mind other than free white males of property over the age of twenty-one. As time went on, and as discrepancies manifested themselves, others saw that the founding principles implied full citizenship to all adults, regardless of income, race, or gender.

mean when they employ such nomenclature as "intertexuality" and "dialogue between texts."[36] These terms are very useful for describing the mind-set for interpreting *The Saint John's Bible*.

Anyone reading and looking at *The Saint John's Bible* will be encountering the bits of experiences and of thoughts others have had and interpreted through Sacred Scripture. The pages can contain only the partial reflections and memories. The limits of space and time have precluded the full breadth of comments from the CIT. More important, any reader of *The Saint John's Bible* will never bring the full gamut of human consciousness to its pages. The images and the texts are meant to inspire others to do what monks, nuns, the CIT, and many others have done with the Bible throughout the ages, which is to use the images to connect personal and communal experiences to the Bible and to let the Bible interpret the experiences. In fact, engaging *The Saint John's Bible* has caused some to pun on the term *lectio divina* by calling their experience *visio divina* or "sacred viewing."

The emphasis on *lectio divina* as a means of biblical interpretation might be mistaken as an attempt to bar any scholarly research into a text; however, it would be a terrible misreading of the tradition to think so. The ancients, by practicing *lectio divina*, used all the tools at their disposal to interpret the Bible they were reading. In their libraries they had books to define the meaning of any flora or fauna mentioned in Scripture with symbolic value attached to each. These *lapidaries* and *bestiaries*[37] are the source of nearly every manner of poetic language of the period. The monks and nuns of an earlier period respected the great Christian scholars that came before them and even some pagan ones as well (Virgil and his *Eclogues* come to mind). In our day and age, we also use the best that science and the humanities say about the world. In other words, *lectio divina* is not a private enterprise or an anti-intellectual endeavor. We glorify God when we use the human mind and talents he has given to individual persons as well as to the whole human race. It is not a system closed to the world; it is open to everything that the human endeavor has to offer. Art, literature, and music contribute to and lead from our understanding of Scripture. Science, chemistry, and biology have their own laws that reflect

36. Magdolna Orosz, "Literary Reading(s) of the Bible: Aspects of Semiotic Conception of Intertextuality and Intertextual Analysis of Texts," in *Reading the Bible Intertextually*, ed. Richard B. Hays, Stefan Alkier, and Leroy A. Huizenga (Waco, TX: Baylor University Press, 2009), 191.

37. The *bestiary* and *lapidary* worked with the notion that God reveals God's self in the created world. Animals, therefore, reflected God's glory and had a moral purpose that humans could follow. As a book, *bestiaries* describe and allegorize the symbolic value of each animal. Similarly, *lapidaries* are books that relate the same for stones and minerals.

the greater glory of God. Neglecting or downplaying any of these areas of knowledge or discipline is a nearly blasphemous negation of the incarnation and the Holy Spirit's presence in the universe.

In studying the work of Childs, Bakhtin, and Kristeva, it becomes evident that their theories—to the extent that they respect the complexity of human experience and knowledge—very much approach the worldview of the Bible as it was before the Reformation, or at least before the Enlightenment.

In this vein, *The Saint John's Bible* represents a fuller, more organic, richer, and catholic understanding of Sacred Scripture than what many of us have come to expect from the world of biblical interpretation; it is a visual commentary on the written text. Moreover, *The Saint John's Bible* reworks the fourfold system of interpretation that we see in Origen and Augustine up until the Enlightenment. The literal now employs the tools of historical criticism; the allegorical includes recapitulation as well as intra- and intertexuality; the anagogical leads to a life in Christ, which is the sole aim of the whole endeavor of Scripture study. The moral is the result of love of and life in Christ.[38]

As such, its use of a premodern answer to a postmodern question brings us back to sacramentality.

Catholicism is nothing if it is not sacramental.[39] Painting, sculpture, architecture, music, dance, and all the smells and bells that go with liturgy are a part and a parcel of faith. Just as the windows, carvings, and layout of medieval cathedrals taught people of the Middle Ages everything about the Bible and salvation, good art today can do the same thing for those who encounter it. People are drawn to beauty, and beauty is a reflection of the glory of God. What better way to bring people to the Catholic tradition than by using the treasury of resources that the tradition has given birth to? *The Saint John's Bible* draws on and contributes to the great patrimony of Christian art, and in doing so, leads us into a relationship with God.

Contemporary Biblical Criticism

The fact of the matter, however, is that we are not living in the High Middle Ages when Christianity provided the sole optic for interpreting reality. Nine

38. Unlike the classic definition of the fourfold interpretation, these various ways of gleaning meaning from the text are not seen as a progression. Rather, they are integrated into a life of ongoing maturity. Consequently, the *moral* derives from the anagogical even as it leads to it.

39. The term *catholic* is not used in a sectarian sense. Here it means all forms of Christianity that see God's self-revelation in the whole of Creation, manifested in liturgies, sacraments, sacramentals, processions, plays, songs, etc.

centuries ago in the lands of Christendom, the symbol structure forming the metaphors as well as the reasons for every human endeavor arose from the faith life of the people. No doubt there were certain degrees of faith and its intensity, but even if one were able to live in a way not particularly religious, he or she would still understand the significance of the Christian metonymy; it was nearly universal and absolutely pervasive. Such a society no longer exists, and building a Christian culture in our globalized environment is exceedingly difficult but not impossible.

Robin Jensen observes that since the time of Plato, there has been a conflict between those who champion art as free and pure aesthetic and those who hold art as subject to the formation of a moral society.[40] In a Christian context, art goes beyond the formation of a moral society; it becomes anagogical, that is, it leads to life in Christ. In the Christian optic, art competes against thought systems, some of which could be flagrantly anti-Christian.[41]

How art and text function. Is the art in *The Saint John's Bible* supposed to enhance, replace, or explain the biblical text? The answer is that if it were to do any one of these things, it would fail in its endeavor. Rather, the art and the text form a single, rich, overlapping work that can draw in, as much as possible, a full sensory reading of the Bible. Indeed, the text itself is in calligraphy, that is, "beautiful writing." On the pages without any artwork, the rhythm, shadows, and form of the script alone are beautiful and communicate with the viewer. As a test, we should take time to step back far enough from the written text so that we cannot read the material but still see the writing. The balance, shape, and design of the letters upon the page create an experience of communication. While it may be difficult to denote what the meaning might be, connotations of grace and beauty arising from the written forms of the letters and sentences can be strong and enduring.

When the experience of gazing at calligraphy imparts a nonverbal meaning to us, we are touching the nonrational part of our being. Nonrationality is another plane of reality. It refers to perceptions that can touch us deeply and profoundly but which defy logical explanation. For example, few Westerners can read and write Standard Chinese but nonetheless will find beauty and meaning in Chinese calligraphy. The experience of beauty and the transforma-

40. Jensen, *Substance*, 89.

41. The question of what constitutes Christian or religious art is a delicate one. The incarnation can make seemingly vulgar or even offensive works a vehicle of God's grace. This situation is part of the Christian paradox. Nonetheless, one would be hard-pressed to find the moral or anagogical content in racist music or demonic symbolism.

tion that takes place because of it rests on the nonrational plane. There may be logic and rational thought involved in many of the parts that lead to the experience, but the total experience itself will still be nonrational. Another example is good liturgy in worship. The component parts of the Mass or other celebration—processions, bells, music, incense, readings, homily, and actions—have historical, theological, and practical reasons in their execution, but the overall experience for any one of us can be indescribable.

The image and text of *The Saint John's Bible* work best when they work nonrationally, and certain pages work better in this regard than others. Moreover, some people will be greatly moved by one configuration that might very well leave another cold. Part of the reason for such different responses can be attributed to what each of us brings to the page when we encounter it, and these variables can be as numerous as the personalities involved.

An obvious influence upon our encounter with the page is our experience of the passage. Something read at Christmastime will bring with it warm memories of food, family, and friends, and the corresponding image will work with these memories. A particular metaphor used in the image, say, a recognizable flower such as a crocus, can elicit memories of springtime, rebirth, and Easter. Likewise, the color palette might even remind us of our grandparents' home, or the overall theme of the work could touch us regarding our own vocations and life choices. Such variables and many more will also work in combination with one another. Employing nonrepresentational art is the key in allowing for the multiplication of possibilities.

For example, illustrated Bibles have long been a part of catechetical programs in nearly every Christian denomination. They have served as good teaching tools for generations and are a result of strides in mass publication and lithographic printing. While certainly many illustrated Bibles were produced with sophisticated audiences in mind, they nonetheless featured a great deal of representational art. On the one hand, representational art can be of high technical quality, and may even be necessary for those who do not understand the story, but, on the other, it can also inhibit the participation of the viewer in the interpretation of the piece; it is a visual form of literalism.

Interpreting the text and image. Interpretation is also based on factors independent of each individual's experience or personality. The Bible has been foundational in civilization and culture for over two thousand years. What its inspired writers intended as well as what saints, scholars, and believers—i.e., the community of faith—have said throughout the ages has an impact on the understanding of the passage. The art, therefore, must take into consideration both the personal and the communal backgrounds. It is not so much that

certain genres of art do a better job than others at breathing new life into
an age-old tradition inasmuch as some art is better at evoking God through
beauty. For instance, in comparing the richness of Suger's Saint-Denis in
Paris with the nearly contemporaneous austerity of Cistercian monasteries,
Jensen observes that despite the two different styles, "both can be described
as beautiful and inspiring."[42]

Likewise, art is not merely decorative to give pleasure to the viewer; beauty
must also give "glorification and praise of the divine."[43] Art that is didactic must
do more than relay information as a literalistic rendering of the story; it must
also impart "a point of view, dimension, and amplification of the narrative."[44]
Art that is prophetic cannot become propaganda; its goal must be to "call forth
personal transformation, not to sell a particular product or idea."[45]

How biblical texts are envisioned in the mind's eye and how that view is
shared with others is a difficult line to walk. At no point should an image in *The
Saint John's Bible* be the totality of the experience with the text. The artwork is
intended to lead the viewer into the image, the Word, and the mystery. Here
we enter the world of metaphor.

Metaphor as communication. Metaphor makes communication possible
at the deepest level. Such communication is beyond words, or if words are
written or spoken, they are employed analogously. We are more accustomed
to this type of communication than we might initially think. For example,
if someone wishes to evoke our response to a beautiful sunset, all she or he
need do is say, "Look at the sunset!" If at that moment the person continues to
explain the intricacies of the purple, orange, and red colors upon the remaining
clouds with their reflection off the water, the impact of that beautiful sunset is
debilitated, if not entirely destroyed. The best way to evoke the response is by
silence; even the best-intended speech becomes idle, distracting chatter. Later,
when the moment of the sunset has sufficiently passed, we might respond to
the experience with a series of descriptors: "majestic," "peaceful," and "ethe-
real." Then, maybe without any connecting phrases, we might launch into
a discourse on loved ones, childhood, or important events in our lives. Still
later, because we are so engaged with the experience, we may want to find
out all the science of sunsets, light theory, and such. In the end, the scientific
knowledge will enhance that particular sunset and all future ones.

42. Jensen, *Substance*, 84.
43. Ibid., 81.
44. Ibid., 86.
45. Ibid., 100.

This example of the sunset, and other similar occurrences in our lives, are communicating metaphorically and analogously. Specific words describing the particular event itself stumble and fall; they cannot carry the weight of what has transpired. On the other hand, someone listening to us talk, say, about the death of a loved one would know exactly how and why that sunset has become so important to us.

For purposes of outlining the interplay of image and text within *The Saint John's Bible*, we must rely on the experience of metaphor, not only with the images, but also with the text. This process does not mean that there cannot be any analysis of individual components constituting the work; it means that this analysis cannot dominate the interpretation or, worse yet, replace it. As with the sunset, our experience might very well be enhanced by knowing Einstein's particle theory of light, but the light theory will not explain the significance or depth of our experience. In this case, poetry is better than scientific treatise, and we are standing once again within the realm of nonrational thought. Indeed, scientists see their work as highly poetic and explain it as such.

Word and image as metaphor. In order to enter the world of metaphor, we must be prepared to visualize texts.[46] The depictions in *The Saint John's Bible* are the result of many people not only imagining the narrative line of the passage in question but also conceptualizing two, three, or four-dimensional interpretations of that same passage in form and color. Furthermore, the images are meant to inspire within the viewer ways of imagining the text in light of the experiences he or she has brought to the biblical encounter. People should not view *The Saint John's Bible* thinking that what they see on the page has only a single meaning based on a one-to-one correspondence with the written text. In other words, the illuminations, like the Word of God, have a life guided by the Holy Spirit. The correct interpretation is one that respects the divine revelation as understood by the Christian theological tradition plus our own experiences with the tradition. Moreover, just as we all grow, mature, and change our opinions on any number of issues over time, so too may our interpretations and imaginative depictions of Scripture change. The artwork within the pages is meant to prompt images of one's own making over time.

46. See Martin O'Kane, *Painting the Text: The Artist as Biblical Interpreter* (Sheffield, UK: Phoenix Press, 2007); and Italo Calvino, *Six Memos for the Next Millennium* (London: Random House, 1996). Both O'Kane and Calvino expand upon the importance of using our imaginations to visualize the text we are reading. In the words of Calvino, we should be able to "paint frescoes crowded with figures on the walls of [our] mind" (86).

The artwork is also an invitation. As we gaze and meditate on any one of the illuminations, we are invited to step into the image itself. Our interpretation depends on expanding the text through the imagination, a point that Martin O'Kane further develops. Relying on Paolo Berdini,[47] O'Kane states, "The relationship between text and image is conceived of, not in terms of a correspondence between a narrative and its visual equivalent, but rather in terms of the visualization of an expanded notion of it. . . . What the visual exegesis describes is the new encounter with the text made possible by the image."[48] This new encounter occurs when the beholder brings to the image his or her reading of the text in light of his or her life experience.[49] It is for this reason that some people are drawn to one particular piece of art and others gravitate toward another.

It may seem that such an approach to the art would lead to a relativistic and highly subjective exegesis of biblical texts, particularly if that exegesis employs art. We must emphasize, therefore, that exegesis is not the work of the beholder alone. Hans-Georg Gadamer refers to *Horizontverschmelzung*[50] or "fusion of horizons" to describe joining our experience with that of the author or, in this case, the artist.[51] I would add that with *The Saint John's Bible*, the three horizons must come together: those of the biblical writer, the artist, and the viewer along with their respective experiences of God and the faith community.

Postmodernism.[52] Over the past fifty years, the rise of postmodernism, especially where it emphasizes deconstructionism, has contested modernity to the point that any absolute claim to truth is immediately suspect. Nearly

47. Paolo Berdini, *The Religious Art of Jacopo Bassano: Painting as Visual Exegesis* (Cambridge: Cambridge University Press, 1997).

48. O'Kane, *Painting*, 41.

49. Ibid., 43.

50. Hans-Georg Gadamer, *Truth and Method* (New York: Crossroad, 1975), 358–59.

51. O'Kane, *Painting*, 37.

52. A full study of postmodernism is well beyond the scope of this book, and I have had to take many liberties to discuss it both accurately and succinctly. At the same time, postmodernism defies any ready or concise definition. It is better known for its characteristics than for its precision. Postmodernism, then, is predominantly recognizable by its rejection of any ultimate truth claim as well as anything that smacks of it and, consequently, any metanarrative such as the Bible. Modernity, on the other hand, seeks empirical, universal truth, and because that truth is absolute, it is not always open to nonrational claims of truth. Readers who wish to explore postmodernism in greater depth can find helpful resources listed in the bibliography for this chapter.

every department in every university has been affected, including theology and biblical studies. Among those who disagree with the postmodern argument, the response has gone in at least two directions. The first is to insist ever more loudly that the truth is found in the biblical text and that text does not vary—in a word: fundamentalism. The other is to engage and critique the postmodern assumption. This critique can agree with postmodernism that truth cannot be nailed down by any one particular text or school of thought or culture, but such an agreement does not mean there is no universal truth. This latter position maintains that it is possible to approach truth and arrive ever closer to it, but the text alone, or even scholarship of the text alone, is not going to accomplish it. This stance is the one taken by *The Saint John's Bible*.

From the perspective of hermeneutics, *The Saint John's Bible* tries to recover the metaphorical and symbolic counterweight to the biblical text lost during the Enlightenment, and it does so by emphasizing the sacramental quality of the transcendent text (metanarrative) in physical form (written text). For the Christian, the search for truth always involves an encounter with the sacramental, for all truth has entered the world through the incarnation.

Synesthesia

The study of Sacred Scripture does not aim toward accruing knowledge; it is directed toward encountering Wisdom. Wisdom, in the Christian tradition is personified in the Second Person of the Trinity: the Son of God, Jesus Christ. Just as in life our encounters with people can be through letters, artifacts, meals, clothing, and even scents, so too can be the case with Scripture.

We categorize our perception of reality according to our senses of sight, hearing, taste, smell, and touch, and despite attempts to avoid any overlapping of those categories in our descriptions, we usually do. For instance, when we go to a concert, are we listening to it or are we watching it? To listen to it, a radio would do. We can even think of watching that concert on television or through a live-stream download, but neither would satisfy the desire to be in the actual concert hall. There is something about the live performance that cannot be reproduced or substituted in any other way except by being physically present for the event. While this description of the experience of attending a concert, an experience that involves both watching and listening, only approximates the idea behind a synesthetic experience, the analogy, nonetheless, is not exact.

Clinically, *synesthesia* is a psychological term used to describe stimulation in one sensory pathway that prompts stimulation in another. In a synesthetic experience, a person might see certain colors when particular numbers are read or spoken. Another might taste a flavor or smell a certain scent upon hearing a musical note, or vice versa. While synesthesia has been a technical

field of study from the late nineteenth century, I refer to it here as a broader and less technical experience, in which there is a blending of senses by which one informs the other.[53] For purposes of the interpretation arising from the interplay of image and text, synesthesia serves a most useful purpose. Our interpretation of Scripture is bathed in the senses. Smells, tastes, music, and poetry intermix in providing an experience of the sacramental metanarrative, and these sensory experiences also tie into the monastic practice of *lectio divina*.

In the ancient mystical tradition, the reading of Scripture and the participation in the sacramental life were the primary ways of humans endeavoring toward a union with Christ. These means are still open to us today, and we should avail ourselves of them.

Ever Old, Ever New

We have become accustomed to relying on a particular system to impart meaning. Up until the birth of modern biblical criticism, the fourfold interpretation held sway. Historical criticism has its own set of rules, and in the case of textual criticism, these rules go back to the time of Origen. We might be tempted, as some are, to reject all organized systems of biblical interpretation, because no single system can deliver on producing the final word on what a text means. I am not at all convinced, however, that dropping a school of interpretation, such as historical criticism, is the way forward in biblical studies.

Biblical research and interpretation are not an exact science. Even in chemistry, with all variables constant, a repeated experiment does not always yield the same results as every other. Just because something cannot produce the final word, however, does not mean that such a system is wrong, false, wanting, or bad. Biblical criticism, unlike chemistry, has a myriad of changing variables at any given time. While this statement may seem to suggest that all is chaos in biblical studies, it is truer to the mark to maintain that biblical studies is enormously rich with an abundance of ways to arrive at an understanding as well as an abundance of understandings. As we read Sacred Scripture, we are encountering nearly twenty-five hundred years of accumulated meaning even as we add another level of interpretation upon it. What forms the normative text, and what shapes the normative meaning of the text? For our discussion on interpretation of image and text, let us use the tradition to shape current and future understanding of Sacred Scripture. Specifically, let us turn to the fourfold sense.

53. For more information and further study, see the bibliography for this chapter.

The *literal* sense is the normative text. Historical criticism and related studies furnish us with the accurate version of the text. In addition, archaeology, history, linguistics—indeed, every science and skill that can provide us with a reading as close to the original as possible—contribute to forming the literal sense and, thus, the normative text.

From the literal arises the *allegorical* sense. Much wider and more varied than classical definitions of allegory, the allegorical sense encompasses the world of metaphor and a great range of other disciplines and experiences—that is, the realm of intra- and intertexuality. From this sense grows the experience of synesthesia. Because the allegorical sense is solidly based on the normative, literal sense, the meaning and interpretation that surface here are normative meanings of the text. The literal reading forming the normative text maintains the bond with the Christian tradition, and from it sprouts a variety of normative meanings, which in turn shape and increase that very same tradition.

The *moral* sense is evident in the application of the allegorical sense and its attendant normative meanings. At this point in time, the moral sense would include attention to life issues, social justice, environmental and ecological concerns, as well as what the church has often referred to as the corporal and spiritual works of mercy. Our experience with Sacred Scripture should prod us to transform this world into the kingdom of God.

Finally, there is the *telos* or end point, the *anagogical* sense. The purpose and goal of all Christian endeavors—endeavors fueled and catalyzed by the sacramental life of which Sacred Scripture is an integral part—is union with Christ. Study of the normative text, the normative meanings that arise from it, the moral life that blossoms from a sacralized imagination, all lead to a relationship with Christ. As standing before the apse of an ancient church, we live, move, and have our being under the constant and loving gaze of the cosmic *Christos Pantokrator*, Christ the Almighty.

Reading *The Saint John's Bible* as the door to a great treasure trove places us in a good frame of mind to see the nuances of both the history of interpretation and our current experience with the images and text. Over time, we should expect our understanding to shift and change, if only slightly, with each reading of this Bible, as we notice certain phrases, verses, and words in combination with new forms, details, and colors on the pages. Troubling passages may become clarified, and favorite stories may become more challenging. We are dealing with God's living Word, after all. Using all the tools and senses in our reading and interpretation of Sacred Scripture maintains that ancient ideal of reading and viewing Sacred Scripture as union with Christ. Hence, science, study, art, and knowledge lead to the mystical experience of Holy Wisdom.

SUMMARY

How to interpret Sacred Scripture is a question that reaches back to the very formation and canonization of the Bible itself. For Christians, people like Origen, Tatian, and Augustine loom large. In the Christian West, Augustine's *rule of faith* determined interpretation from the fifth century through the Reformation. The fourfold system of literal, allegorical, moral, and anagogical was rooted in a strong sense of Christ's incarnation as well as a sacramental view of the universe. This reliance on metaphorical reality is best seen in the iconography of the Christian East in which invisible reality is made more perceptible.

The empirical worldview that entered the West at the Enlightenment sidelined nearly all other forms of knowledge and thought and, with it, the highly symbolic way of interpreting religious reality, particularly among Protestants for whom the printed Bible became the paramount, if not the singular, source of divine revelation. For Catholics, Christian art, icons, symbols, and metonymies remained, but their interpretation became highly circumscribed and constrained.[54] In the biblical disciplines, the historical-critical method takes root at this point.

Because *The Saint John's Bible* employs premodern methods and genre at this point in the twenty-first century, it must call forth earlier ways of interpreting text through image while simultaneously recognizing and respecting the postmodern world in which we now find ourselves. *Lectio divina* has become a viable means in which new and seemingly unrelated thoughts are folded into the biblical narrative. *Lectio divina* views Sacred Scripture as a sacrament, that is, the Christian transcendent metanarrative in concrete form. The flow of ideas and inspiration, both intra- and intertextually, therefore, also becomes sacramental.

The fullness of such biblical interpretation can lead to a synesthetic experience whereby all the senses—taste, touch, sight, smell, and hearing—can both inspire and resolve an exegetical question. This experience, either partially or fully, acts as a counterweight to the overly literal and fundamentalist interpretation of the Bible. With such a mind-set, reading and viewing *The Saint John's Bible* connects with the mysticism of the Christian tradition: reading and studying the Bible is union with Christ.

54. As seen in baroque architecture, which despite all its flights of fancy controlled and guided the human imagination toward a definite and sanctioned end.

Part 2

WHY THIS ENGLISH TEXT

Chapter 2

THE ROLE OF THE NEW REVISED STANDARD VERSION

In the Bible we have inherited a text of such antiquity that major parts of it go back nearly thirty centuries.[1] It all began, both Old and New Testaments, as oral tradition among a community of believers. Eventually, that oral tradition was copied down, edited, recopied, reedited, recopied, reedited, translated—and so on. Yet, the Bible is much more than a collection of copied, edited, and translated documents; it is the inspired Word of God, and the Holy Spirit has been with the copiers, editors, and translators nearly every step of the way. The text for *The Saint John's Bible* reflects this great biblical tradition. The New Revised Standard Version (NRSV) is an English translation of the Bible that has remained faithful and true to the original languages of Hebrew, Greek, and Aramaic while at the same time being accessible to the greatest number of English speakers.

The factors entering into the choice of using the NRSV in *The Saint John's Bible* were very convincing from the start. The NRSV is gender inclusive with strong and enduring English vocabulary and idioms, and it is a lineal descendant of the Revised Standard Version (RSV). It had a wide and respected ecumenical editorial board, including the late Jesuit scholar Carlo Martini from the Pontifical Biblical Institute in Rome. As a translation to celebrate

1. Sections of this chapter were originally presented under "The KJV and Its Role in Ecumenism" at the *Nida/SBL Symposium: KJV at 400*, 20 November 2011, San Francisco, California.

the beginning of the twenty-first century of Christianity, nothing in English could surpass the NRSV.

Criticism of the choice of the NRSV for *The Saint John's Bible*, however, emerged from various quarters. Such reproof of revisions and translations of the Bible is nothing new, and in the light of history, for someone to refer to the NRSV as "last year's edition of the politically correct handbook" is not all that bad.[2] The interesting point, however, is that one could very easily call the King James Version a politically correct handbook, especially when compared to the Geneva Bible and all its notes.

This history of the KJV and ultimately the NRSV brings to light many of the issues that separated Protestants and Catholics at the Reformation. Part of the mission of *The Saint John's Bible* is to heal that rift, with the NRSV text assisting in the effort.

THE PEDIGREE OF THE NRSV

King James wanted a Bible capable of the widest circulation possible and accepted by the greatest number of the people—which is exactly what his committee handed him. Its descendants, the ASV, RSV, and the NRSV, all came into being when pastors and scholars realized that some people were unable to understand the Word of God. As a result, the KJV translation had to be made to a wider segment of the population.

The desire to translate the Bible into the vernacular has a long history predating the Reformation. Although the Byzantine or Eastern Roman Empire was using the Greek New Testament definitely by the mid-fourth century, the Roman West, for which Greek was practically an unknown language, made do with a Bible translation known today as "Old Latin." In order to rectify this problem, Pope Damasus I in 382 commissioned Saint Jerome to translate the Old and New Testaments into Latin. The resulting work, called the Vulgate, became the standard Bible for Western Christendom until the Reformation,

2. Richard John Neuhaus wrote, "St. John's University in Collegeville, Minnesota, sometimes described as a training camp for liturgical terrorists, is spending several million dollars to have a scribe illuminate on vellum the entire Bible. You may have noticed the news stories on that. It's a lovely idea, except that the text to be used is the NRSV. So here we will have a beautifully illuminated vellum manuscript that will last a thousand years, with a trendy text"; in "Bible Babel," in *First Things* (May 2001), http://www.bible-researcher.com/neuhaus1.html.

and it continued as the standard Bible for the Roman Catholic Church through the middle of the twentieth century.

While Pope Damasus saw a need to have a Bible in the Latin vernacular, others at various times and places saw a need to have a Bible in the native tongue of the people. Venerable Bede of England attempted to translate at least the gospels into Old English but never finished the project.[3] As an aid, many of the Latin manuscripts would also have glosses in the vernacular written above the Latin to help the reader along.[4] There was a West Saxon version of the Psalms, called the "Paris Psalter," in prose, dating from the time of King Alfred, as well as Aelfric of Winchester's translation of the Pentateuch.[5] Despite these attempts and various others like them both in Britain and on the continent, the language of the Bible in the West remained very much in Latin up until the Reformation.

It is not difficult to see why. In addition to the fact that the educated classes spoke and wrote in Latin, and despite the fact there were many kingdoms both large and small, there were no nation-states, thereby making the legacy of Rome the single unifying entity for the West, concretized in the life, liturgy, and devotion of the church. The centers that kept this Latin culture alive were the monasteries, and in Britain this meant the monasteries founded first by the Celtic monks and then, in the late sixth century, those established by Augustine of Canterbury who eventually adopted the Benedictine Rule.

The great monasteries and abbeys used individual books of the Bible, especially the Psalter, in their daily round of prayer. It was imperative, therefore, that the monks know it. Learning Scripture was the foundation for the monastic schools. In addition to the periods of the day set apart for the monks to gather in choir for their communal prayer, called the Liturgy of the Hours, the RSB takes great care in establishing set times for private reading. Since there was a scarcity of books, and in order for monastic men and women to pray the Hours in common, they were required to memorize first the Psalter and then other major sections of the Bible.

With few exceptions, most monasteries between the seventh and thirteenth centuries did not have a complete Bible as we know it today. Rather, Sacred Scripture was accessible by its individual books (Genesis, Joshua, Job, etc.) but

3. Henry Wansbrough, *The Story of the Bible* (London: Darton, Longman and Todd, 2006), 63.

4. Ibid., 64.

5. Ibid.

most often through the liturgical books: lectionaries, missals, and Psalters.[6] Writings not used regularly at the liturgies would have been read in the refectory or dining room. It was the practice then and still today for Benedictines, Cistercians, and other monastic orders to have table reading during meals mostly—though not entirely—from the Bible. The major text for the daily prayer was the Psalms. But there was more.

Monks and nuns also had to perform their daily *lectio divina* or sacred reading. The material was nearly always scriptural, and when not, patristic works were the literature of choice. Memorization played a role here too. The goal behind *lectio divina* was to fill the mind and soul with the Word of God; it is analogous to taking in food for nourishment, which the monk or nun was supposed to savor for the whole day. To do so, these passages too had to be committed to memory.

The monastic scriptorium, or writing room, became one of the central workshops of any monastery. In order to keep the monastic life going, texts had to be written and rewritten; the results are evident in the great illuminated manuscripts and tomes. The artwork serves a dual purpose. With the lectionaries and Psalters, the painted images engage the senses by reflecting the burning oil lamps or candles in the churches back to the people, as if the book itself were the source of light. Consequently, the images underscored the sacramentality of the sacred text: The Light of Christ physically jumps out from the Word of God. Second, the decorated capitals and strange creatures running through the margins provided the reader with mnemonic devices so that he or she could recall the memorized pages and text in the mind's eye.

All that changed in 1440. The invention of the printing press in that year forever altered how books were made and, as a result, how people learned. Not surprisingly, with more books available for people to read, more people began to learn to read. Memorization of the Psalter was no longer necessary if every monk or nun could hold a Psalter in his or her hand. In fact, in 1459 the new printing press landed one of its first large commissions, when all the Benedictine monasteries of the Bursfeld Congregation ordered copies of the Psalter for liturgical use in their respective houses. The printer for the Psalter was Johann Fust, the man who first invested in Gutenberg's press and then claimed it after the inventor went bankrupt. This *Psalterium Benedictinum* was so overused that only small portions of it are known to exist today; there

6. Lectionaries contained the daily Scripture readings for the liturgies; missals, the prayers and readings for Mass; Psalters, the psalms chanted by the nuns and monks in choir.

is no fully complete copy.[7] Thus did matters lie at the cusp of the Reformation, which is where the story of the NRSV begins.

The history of the NRSV can be divided into two parts: first, the switch from Saint Jerome's Latin Vulgate to an established Greek New Testament text[8] as the basis for translations into the vernacular language of respective nations, and second, the development of the Bible in the English language.

ESTABLISHING THE GREEK TEXT

With the Renaissance came new interest in antiquity, bolstered by the influx of artisans and scholars from Constantinople after it fell to the Turks in 1453. This interest brought to light many Greek texts. At about the same time, the invention of the printing press definitively removed the production of books from the monastic cloister to the major cities of Europe: Basel, Zurich, Cologne, Paris, Venice, Mainz, Rome, and, eventually, London.[9]

One prominent person to take full advantage of the situation was Desiderius Erasmus. Erasmus stood out as one of the greatest minds of the age. He was also one of the age's greatest opportunists. Erasmus became obsessed with publishing the first Greek edition of the New Testament, and this obsession led him to be the first to print and disseminate it. He was not, however, the first to consider the idea.

In 1499, Francisco Cardinal Ximenes de Cisneros established a university in the Spanish town of Alcalá or, in Latin, *Complutum*. Gathering many scholars there, including Greeks who had fled the Turkish conquest of Constantinople,[10] Ximenes de Cisneros decided in 1502 to begin work on a volume of the NT that would include the major variant texts in their original languages. The

7. The International Standard Text Code shows that of the thirteen nearly complete copies of the 136 leaf Psalters in the world, most of them are lacking a couple of leaves. In addition, according to the ISTC, there are ten fragments of single leaves, one of which survives in the *Arca Artium Collection* of the Hill Museum & Manuscript Library in Collegeville, Minnesota.

8. At this time as the source for the OT, scholars turned away from the Greek Septuagint to the Hebrew Masoretic text, which became available to them through Jewish scholars living in the major cities of Europe; it is a transition that went much more smoothly than the settling on a reliable Greek New Testament.

9. The shift away from the monastic cloister began in the thirteenth century with the rise of cities, the universities within them, and the mendicant orders serving them.

10. Bruce M. Metzger and Bart D. Ehrman, *The Text of the New Testament*, 4th ed. (New York: Oxford University Press, 2005), 139.

Complutensian Polyglot, as it came to be called, contained six volumes: the OT in Hebrew, Greek,[11] Aramaic, and Latin (1–4), the NT in Greek and Latin (5), and Hebrew grammar and lexicon (6).[12] The NT was completed in 1514, but Ximenes de Cisneros wanted all six volumes to be distributed as a set, and by the time the remaining five volumes were ready and the issues of the papal sanction resolved, it was not until 1522 that the *Complutensian Polyglot* was published and distributed.[13]

During this interstice, Erasmus and the printer Johann Froben of Basel, hearing of Ximenes de Cisneros's project, saw an available market for a Greek New Testament.[14] Erasmus was able to obtain twelfth-century Byzantine manuscripts containing the NT in Greek. These Greek manuscripts, however, were so inferior to the texts used at Alcalá that Erasmus had to correct them, and to do so he used the Latin Vulgate.[15] In addition, Erasmus's work suffered from incredibly poor proofreading with hundreds upon hundreds of typographical errors.[16] It was completed on March 1, 1516. By 1519, Erasmus's Greek New Testament was in its second printing, just in time for Martin Luther to use for his magnificent translation of the Bible into German.[17]

Despite its obvious inferiority to the *Complutensian Polyglot*, the Erasmus text of the NT became the primary document utilized for subsequent translations into Western vernacular languages. It was not only finished sooner than the grand work of Ximenes de Cisneros and his scholars but also cheaper and more widely published.[18] On this basis, it achieved the ill-deserved status as the *textus receptus*, the "received text,"[19] and it has taken four hundred years to undo the damage.

The development of the Greek New Testament overlaps with the beginning of the Reformation. The question of people's accessibility to Sacred Scripture loomed very large in the great debates leading up to and continu-

11. The LXX.

12. Metzger and Ehrman, *Text*, 139.

13. Ibid.

14. Ibid., 142. It is unclear whether Erasmus first approached Froben or Froben sought out Erasmus.

15. Ibid., 145. The most egregious of these corrections was his completing the last six verses lost from the book of Revelation by back translating the Latin Vulgate into Greek.

16. Ibid., 143.

17. As the King James Version did for English, the Luther Bible played a large role in regularizing and elevating the German language.

18. Metzger and Ehrman, *Text*, 149.

19. "Received text," that is, received from the earliest manuscripts known to exist. An obviously false and fraudulent claim.

ing through the Reformation. All hopes for understanding and compromise among the various parties were hampered, however, by the fact that, with all the learning of biblical languages and the discovery of ancient texts, there was no common Greek text that any scholar, Catholic or Protestant, could use as the basis for a new translation of the Bible into the vernacular, even as the call for one became more sustained.

Had Erasmus applied his talents to working with the other scholars at Alcalá, or if he had exercised more expertise and less cupidity in developing his own Greek text, the Reformation most likely would have gone differently. The Reformation would have occurred in any case—and it should have, for the church was in dire need of one—but it certainly would have been much easier to reconcile differences among the religious groups. Having a common, bona fide Greek New Testament would have lessened the possibility that arguments between divided churches would have turned so vitriolic and bloody.

Erasmus's Greek New Testament was used as a basis for the long-awaited English translations—Tyndale and the KJV among them. On the Roman Catholic side, the glaring errors in the *textus receptus* combined with the rapidity in which Protestant churches eagerly adopted it only served to confirm Rome's worst fears regarding unregulated access to the Bible. Ironically, the Vatican Library has one of the oldest and most complete Greek manuscripts—the Codex Vaticanus—which was one of the texts used in the *Complutensian Polyglot*.

In the late eighteenth century Protestant scholars soon realized that the gross deficiencies of the *textus receptus*, which had been evident to many from the beginning, needed to be corrected. While scholars undertook the search for more dependable texts that could serve as the basis for a Greek New Testament, the vernacular translations based on the *textus receptus* elevated that Greek version to an exalted status, and it was very difficult to tamper with it, for if the Greek were different, the respective vernacular translation would have to change, and these translations, particularly the English KJV Bible and the German Luther Bible were endeared to churchgoing, pious, and dedicated people. In addition, war and other human failings hampered the effort to develop a reliable Greek version of the NT; the work was painstakingly slow, and it took nearly four centuries to complete.

Greek New Testament, A Shaky Foundation

We have no record in which Erasmus refers to his Greek New Testament as the *textus receptus*; it acquired that name around 1633.[20] Despite its short-

20. David Daniell, *The Bible in English: Its History and Influence* (New Haven, CT: Yale University Press, 2003), 509.

comings, the Erasmus *textus receptus* remained the Greek version of the NT. The Germans were particularly hard at work in trying to determine the earliest extant manuscript of the NT, for the rationale was the earlier the text, the purer the text.[21] This mind-set forms a useful point of departure for any search of this type.

While knowing the history of the development of a text is very important and most beneficial in determining the interpretation of the written word, problems enter when one forgets that later copies often reflect greater insight into what the written word is saying than earlier versions do; that is, a finished copy of a book is more helpful, readable, and less confusing than its first draft. In the arena of Sacred Scripture, we should keep in mind that just because something is later does not mean it is uninspired. There were a series of scholars who exercised sensitivity in this area; among them are Johann Jakob Griesbach (1745–1812),[22] Karl Lachmann (1793–1851),[23] Constantin von Tischendorf (1815–74).[24]

Such scholarship was assisted by the work of American and European explorers, who, very often attached to universities, were also allied with missionaries. In North Africa and the Middle East, this exploration meant the search for arti-

21. This understanding reflects the mentality that drove so much of the Protestant cause during the Reformation. The contention of Luther and other early reformers was that the early church was free of all the corruption of the contemporary church that he had experienced during his lifetime. One had to be keen and vigilant in reading Scripture, so the logic went, to purge later corrupting additions to a text. We can see a good example of this mentality in the way Luther dealt with the Letter of James. Since reading it could lead to works of righteousness, Luther wanted to exclude it from the Bible on the presupposition that such a writing could not be inspired.

22. The first since Origen to see that there was not a single, pure manuscript containing the NT.

23. He compared the earliest of biblical and patristic manuscripts, and from this study of the documents, he published a version of the Greek New Testament with a list of passages where this version differs from the *textus receptus*.

24. Dedicated his life to gathering early Greek texts of the NT, and from this effort, he published two volumes of a critical apparatus, a system where footnotes are organized using specified abbreviations and symbols by which one can determine which manuscript supplies the reading in the body of the text. The critical apparatus indicates what words or phrases one scribe has deleted, or what words or phrases another has added. From this apparatus, and using the skills and techniques of textual criticism, scholars can determine what passage among many has the highest probability of being the correct one. Unfortunately, Tischendorf is also associated with the skullduggery involving the theft of the Codex Sinaiticus from Saint Catherine's Monastery in the Sinai. See D. C. Parker, *Codex Sinaiticus: The Story of the World's Oldest Bible* (London: British Library, 2010).

facts and texts of the biblical period. When some of these finds, say, the Codex Sinaiticus, were compared to the Erasmus *textus receptus*, it became clearer to all that there is no single *textus receptus*. Rather, the Greek New Testament appeared to be composed of many *texti recepti*, received texts. The deft and knowledgeable expertise of two Greek scholars from Cambridge, Brooke Foss Westcott (1825–1901) and Fenton John Anthony Hort (1828–92), finally untangled how to recognize the various texts as well as how to interpret them.[25] The end of Erasmus's Greek New Testament soon came and with it the implication that the *textus receptus* was useless for a revision of the King James Bible.

Scholars may have been excited by Westcott and Hort's research, but the pastors, people, and poets outside that circle were not, especially in Germany, with its beloved Luther Bible, and England, with its esteemed King James. Another problem was the question of which of the many Greek texts, along with their critical editions, was best. Constantin von Tischendorf's or Westcott and Hort's? It was a problem not only for scholars but also for pastors and their congregants, if not the poets.

Bible Societies and Their Influence.

If the rise of Western imperialism drove capitalists to seek new supplies and new markets, it inspired citizens of great religious fervor to missionary work in the newly colonized lands. While this unhappy connection between Bible and business was in so many ways detrimental to Christ's call to make disciples, it did have its bright spots.

The British and Foreign Bible Society, founded in 1804, had as its mission to provide Bibles in the languages of the people, first in the British Isles (most immediately, Wales), and also to the whole of the British Empire, and then to the entire world.[26] Certainly an ambitious project, but like many projects built on big visions, it started to reap results from the beginning.

The British Society was interdenominational with fifteen Anglicans joined by fifteen members of the Free Churches plus six representatives from churches

25. Westcott and Hort published a two-volume work, *The New Testament in the Original Greek*, which aptly demonstrated that both the Byzantine text, which formed the basis of the Erasmus *textus receptus*, and the Alexandrian text, which did the same for Jerome's Vulgate, were inferior to the Codex Vaticanus and the Codex Sinaiticus. Moreover, the so-called Western Text, as exemplified by Codex Bezae, provided great assistance to Vaticanus and Sinaiticus in establishing what Westcott and Hort called the "neutral text." Westcott and Hort called for the end of any further use of the *textus receptus*. Metzger and Ehrman, *Text*, 181; and David Laird Dungan, *A History of the Synoptic Problem: The Canon, the Text, the Composition, and the Interpretation of the Gospels* (New York: Doubleday, 1999), 295.

26. Wansbrough, *Story*, 97.

on the Continent.[27] Interestingly—and perhaps reflecting the Geneva Bible that so annoyed King James and furthered his wish for an authorized version for all the churches—the Society pledged to distribute Bibles "without note or comment."[28]

The British and Foreign Bible Society met tremendous success and became the parent society of many others. By the end of the Napoleonic Wars in 1815, there were Bible societies in Germany, Russia, Greece, and the United States translating the Bible into the languages of all the lands into which Christianity was spreading.[29] This missionary effort continued unabated, but as the work of Tischendorf, Westcott, Hort, and even Hermann von Soden became known, the missionaries needed and wanted a reliable translation of the NT.

The solution came in 1898 with Eberhard Nestle (1851–1913), whom the German Bible Society or the *Württembergische Bibelanstalt* commissioned to produce a text that would combine the work of the growing number of critical editions. Rather than champion any one manuscript exclusively, Nestle aligned the agreements between Tischendorf, Westcott and Hort, and another scholar, Bernard Weiss.[30] Nestle's critical edition was most timely, for it paralleled the work and goals of the missionary societies in Great Britain, Germany, and the United States.

Catholic Movement

The interdenominational makeup of the British and Foreign Bible Society had no Catholics, and it is not that the Catholics were uninterested in evangelization; Catholic missionaries were spreading across the globe as well. They were still relying on Jerome's Vulgate, however.

Catholics may have been absent from the work of the Bible societies, but despite all appearances to the contrary, they were doing their homework, albeit, quietly. In the late nineteenth and early twentieth centuries, scholars at the Dominican École biblique et archéologique française in Jerusalem were heavily involved in textual, historical, and archaeological research surrounding biblical studies and were writing about their findings. Simultaneously, in Rome, the Jesuits and others at the newly established Pontifical Biblical Institute were heavily engaged in the study of ancient languages. At both institutions, the level of scholarship and publication was second to none, despite the limited audience.

27. Ibid., 98.

28. Ibid.

29. That is, without any explanations or annotations. Ibid.

30. Metzger and Ehrman, *Text*, 190.

The rift between Protestants and Catholics slowly started to heal after World War II, and textual research on the NT was one area in which the mend became evident. Eberhard Nestle's son, Erwin, had continued his father's work by refining and improving it between the wars, and the scholars Kurt and Barbara Aland joined him after 1945. Eventually, the project moved to the University of Münster, where it was housed under the *Institute for New Testament Textual Research.*[31]

In 1955 Eugene Nida, the translations secretary for the American Bible Society, proposed to Kurt Aland the establishment of an international and ecumenical committee to produce a Greek New Testament specifically for the world's Bible translation committees.[32] The result was the *United Bible Societies*, and their joint committee composed of Matthew Black of St. Andrews, Bruce Metzger of Princeton, Allen Wikgren of Chicago, Kurt Aland of Münster, and Carlo Cardinal Martini of the Pontifical Biblical Institute.[33]

Against every committee member's advice, Eugene Nida insisted on a system that would indicate the degree of confidence the committee had when deciding for a particular, disputed Greek reading: "A" signifies a high level of confidence, "B" a moderate level, etc., down to "D," which indicates that the committee has a high level of doubt that the words in the text are correct.[34]

Rather than being unduly complex or unnecessary, as some might think, this notation system allowed translators and anyone else interested in the matter to have confidence in the text. Nida's system shows that agreement on the really important verses was exceptionally strong, with the majority of disagreements occurring over relatively insignificant repetitions, misspellings, and omissions.[35] The result is that the Nestle-Aland editions used by the United Bible Societies represent nearly 95 percent of the original Greek.[36] Kurt Aland himself stated, "The new [standard text] is a reality and as the text distributed by the United Bible Societies and by the corresponding offices of the Roman Catholic Church (an inconceivable situation until quite recently), it has rapidly become the commonly accepted text for research and study in universities

31. Dungan, *History*, 298.

32. Kurt Aland and Barbara Aland, *The Text of the New Testament: An Introduction to the Critical Editions and to the Theory and Practice of Modern Textual Criticism* (Grand Rapids, MI: Eerdmans, 1989), 31.

33. Dungan, *History*, 298.

34. Ibid., 299.

35. Ibid., 300.

36. Ibid.

and churches."[37] By the mid-twentieth century, the Nestle-Aland provided the standard NT Greek text for every major vernacular translation.

While scholars were working on the Greek text of the NT, there was a simultaneous call from kings, clergy, and pastors for a usable Bible in the respective vernacular languages. For English speakers, the development of a Greek New Testament and an updated English Bible merged.

DEVELOPMENT OF THE BIBLE IN ENGLISH

Background to the NRSV

When the KJV was printed in 1611, the Reformation had been going on for nearly one hundred years. The simple break with Rome that Henry VIII wanted, a break in which Scripture, liturgy, and worship would remain the same under the authority of the Crown, had splintered into dozens of pieces. The human toll from the internecine battles mounted heavily among both Protestants and Catholics. The KJV was written in this context. The Greek text for the New Testament was, as we have seen, the slipshod work of one prominent man, not a committee of diverse scholars. The KJV itself had a reputable committee, but circumstances were such that no Roman Catholic was on it. For the next four hundred years, English-speaking Protestants and Catholics would use two different English Bibles from two different sources, Saint Jerome's Vulgate for the Catholics and Erasmus's *textus receptus* for the Anglicans and the Protestants.

There were English Bibles before the KJV. John Wyclif (1320–84), an Oxford professor, was the first to produce the whole Bible in English. Although many at the time believed that Wyclif himself had translated the Bible from Latin into English, it seems that it was actually the work of two of his followers, Nicholas of Hereford and John Treviso.[38] Unfortunately, he promoted the primacy of Scriptures as the source of true doctrine as he fulminated against the corruption of the papacy.[39] Whether fairly or not, this stance caused Wyclif to become associated with the Lollards and their revolt in 1382, and, consequently, he was banished from Oxford. He escaped further persecution by taking refuge with the powerful John of Gaunt, Duke of Lancaster. Because

37. Aland and Aland, *Text*, 35.
38. Wansbrough, *Story*, 68.
39. Ibid., 67.

of his real or imagined connection with the Lollard uprising, however, all further attempts to translate the Bible into English were banned.[40]

William Tyndale translated the whole Bible into English in two stages. The first, based on Erasmus's Greek version, was the NT in 1525, and the second, based on a Hebrew text for the OT, came out in installments through the 1530s.[41] Tyndale's work is foundational to English translations of the Bible. Not only did his work break the ban imposed on translating the Bible into English that had been in place since the time of Wyclif but it also lent itself to its successors, who borrowed liberally from Tyndale—the committees for the KJV included. In 1536, while in Vilvoorden, Flanders, Tyndale was kidnapped, imprisoned for a year and a half under miserable conditions, tried for heresy and treason, and strangled to death before being burned at the stake.[42]

The injustice and irony of killing William Tyndale was glaring, for Henry VIII had already broken with Rome in 1534. Because there was no other prototype for an English Bible, Tyndale's execution was counterproductive to the English king's ends. In addition, the religio-political situation in England had changed. Many were no longer content with breaking away from Rome; rather, they wanted the total purification of everything that smacked of Rome.

There were several attempts to find a suitable Bible that everyone could use, three of which appeared during Henry VIII's reign:

- Miles Coverdale (1488–1569) produced a translation in 1535, but not knowing Hebrew or Greek, he based it primarily on the Vulgate supported by four other works: Luther's Bible, Zwingli's Bible, Tyndale's Bible, and a Latin version produced by the Dominican friar Sanctes Pagninus.[43]

- Matthew's Bible, allegedly credited to Thomas Matthew but actually the work of John Rogers, was published in 1537 at the request of Thomas Cranmer. It used Erasmus's Greek New Testament but borrowed heavily from Tyndale's English version to make the translation into English. It also used Luther's and Tyndale's annotations, a fact that Henry VIII found displeasing because of the Protestant tendencies of the two men responsible for them.[44]

40. Ibid., 69.
41. Ibid., 78.
42. Ibid., 79.
43. Daniell, *Bible*, 176.
44. Wansbrough, *Story*, 87.

- To rectify the problems with Matthew's Bible, Cranmer commissioned Coverdale to oversee a new translation that would be placed in every parish church. Called the "Great Bible" to show its importance, it was designed to fit on a parish lectern at 38 x 23 centimeters or 15 x 9 inches. It was to include notes, but they never made it into print, either because the task was too delicate or the publication too rushed. Despite these drawbacks, the Great Bible was very popular with the people.[45]

Henry VIII's major concern was to have an English Bible that everyone in every denomination could use without any group renouncing it on dogmatic grounds; not only did Protestants and Catholics distrust each other, but various Protestant and Reformed denominations held each other in suspicion. Although the king's goal was an increasingly impossible one to meet when all of Europe was roiling in the arguments and battles of the Reformation, a translation could possibly be acceptable to all if there were no notes or other annotations within the biblical text. Henry VIII died in 1547. Thirteen years later an English Bible went to press that would do everything Henry tried to avoid in his reign.

The Geneva Bible of 1560 was the work of English exiles living in John Calvin's city of the same name. Full of notes, commentary, and maps, it had the Calvinist theology running from cover to cover. It was a scholarly revision of the Great Bible, and although the Great Bible was the official text used in the churches of Elizabethan England, the Geneva Bible was in the households.[46] There was a vain attempt to supplant the Geneva Bible with another version, the "Bishops' Bible" (1569), so-called because a committee of bishops removed the notes, but it received a lackluster reception once it was published. Between 1560 and 1603, fifty-one editions of the Geneva Bible were printed as opposed to seven of the Bishops' Bible.[47]

By the time King James I (reign 1603–1625) commissioned an authorized version of the Bible for use in the realm, the English Catholic exiles who had escaped to France set up a college at Rheims, France, for the education of Catholic clergy who, it was hoped, would eventually return to England and restore the kingdom to the Catholic faith. Oxford scholar Gregory Martin along with Richard Bristow translated the NT from Jerome's Vulgate in 1582. The college then moved to Douai where the OT was completed in 1609. As an English Bible translated from Jerome's Vulgate, the Douai-Rheims was

45. Ibid.
46. Ibid., 88.
47. Ibid., 89.

the official Bible for English-speaking Catholics well into the middle of the twentieth century.[48]

King James Bible

Pragmatic, practical, and paragon of compromise, the King James Bible—or, more accurately, the Authorized Version—which James I commissioned, had requirements that guided its formation. It was not to have any notes or annotations. The model was to be the Bishops' Bible, and it was to employ the best of other English translations, such as Tyndale, Matthew's, Coverdale, and even the Geneva and Douai-Rheims Bibles, including the use of the second-person singular pronouns "thou" and "thee," forms that were already fast disappearing from the spoken language.[49] English translation of Greek words and terms were not to be standardized for all uses but could vary according to the context. Arguably, in the greatest compromise of all, it was to include the Apocrypha, books that both the king and Puritan reformers earlier had dismissed as having no divine authority.[50] It was a success, whose popularity within twenty years soon exceeded all English translations; only Roman Catholics did not use it.[51]

The Bible in United States of America. The Puritans and other nonconformists who settled in New England in the early to mid-seventeenth century were among those who still preferred the Geneva Bible over the KJV, however.[52] It is not too difficult to see why. Their aim in leaving England for the American colonies was to be as far from the established church as possible. An authorized Bible commissioned by the Crown did not supply them with the necessary enthusiasm to exchange the Geneva Bible for the new one, despite the fact that the new Authorized Bible was intended to have as broad a reach as possible. Outside New England, however, the attachment to the Geneva Bible would have been considerably less. New York, for example, had a high percentage of Anglicans, and Maryland was initially settled by Roman Catholics; the former used the KJV, and the latter, the Douai-Rheims.

Nonetheless, by the time of the American Revolution, the KJV seems to have been well established, for on January 21, 1781, Robert Aiken of Philadelphia

48. Wansbrough, *Story*, 89–90.

49. Ibid., 92.

50. Ibid., 92–93.

51. Ibid., 93.

52. Metzger in Bruce M. Metzger, Robert C. Dentan, Walter Harrelson, *The Making of the New Revised Standard Version of the Bible* (Grand Rapids, MI: Eerdmans, 1991), 50.

petitioned the United States Congress for permission to print the Bible, because "in every well regulated Government in Christendom The Sacred Books of the Old and New Testament, commonly called the Holy Bible, are printed and published under the Authority of the Sovereign Powers."[53] Although there was no congressional act granting the permission, two congressional chaplains pronounced it an "expensive work," which was good enough for Aiken to go ahead with the venture.[54] The first copy presented to those same two chaplains for inspection replaced the royal preface of the KJV with a page and a half of commendations from the American Congress, complete with the arms of the Commonwealth of Pennsylvania. The chaplains deemed the Bible without error, and on 10 September 1782, Congress recommended Aiken's edition of the Bible "to the inhabitants of the United States."[55]

Robert Aiken's dealings with Congress show an earnest desire to ensure that the population have access to the Bible, revolutionary break notwithstanding; he did not make money for his efforts and, in all likelihood, took a loss since the overhead for printing materials in the newly independent states was so high. That the Bible was an edition of the KJV and not a separate translation helped to maintain religious ties, no matter how tenuous, with Europe; a connection to the faith of the old country meant more to Episcopalians (the postrevolutionary name for adherents to Anglican doctrine) than to the New England Congregationalists.

In the mid-nineteenth century, a good deal of language in the KJV had become archaic, and in both Great Britain and the United States, there were calls for a revision. In the 1870s, scholars from both sides of the Atlantic began work on what is known as the Revised Version. The joint venture floundered in 1901, however, when scholarly and cultural tensions between the two groups became insurmountable, and Americans set out to revise the text for themselves.[56] Called the American Standard Version (ASV), it became a successful attempt to rid the English translation of words in the KJV that by then had either lost all their meaning or whose meaning had considerably changed. By concentrating the changes on obscure and archaic vocabulary, the ASV was able to retain the beloved cadences and syntax of the KJV, which was the staple of nearly all the Protestant churches in the country and had taken

53. Daniell, *Bible*, 587.

54. Ibid. Aiken also asked for financial backing, but none was forthcoming.

55. Ibid., 588–89.

56. Daniell cites as an example the verb "amerced" (2 Chr 36:3), used in the English Revised edition, which the American Standard changed to "fined" (*Bible*, 737).

root in American idiom. Naturally, it did not matter much to Catholics, who continued with the Douai-Rheims for their vernacular version.

Revised Standard Version

Despite some of the translation advances included in ASV, its inadequacy for the twentieth century became evident shortly after its publication in 1901. Primarily, it did not reflect the latest scholarship on the composition of the Greek New Testament; it also showed a slavish attachment to much of the vocabulary of the KJV.[57] By 1929 the American body of the International Council of Religious Education appointed fifteen scholars to explore the need for a revision. Arguments about what that revision should entail coupled with the financial difficulties brought on by the Great Depression delayed any action until 1937.[58] The new work, called the Revised Standard Version (RSV), saw the NT come out in sections beginning in 1946 and completed in 1952. The Apocrypha (also called the "Deuterocanon") was added in 1966.

For its scholarship, for its language, and for its interdenominational inclusivity, the RSV was a great success in America as well as in Great Britain.[59] It may not have had a Roman Catholic on its advisory board of fifty members, but a Catholic edition was published in 1966 that included notes sensitive to interpretations within the Catholic tradition.[60] Its greatest weakness, and for this day and age a considerable weakness, is that it was not gender inclusive. A push for a revision of the RSV mounted.

57. Daniell, *Bible*, 738.

58. Ibid.

59. Ibid., 738–42. Yet, even this translation raised all sorts of suspicions. During the McCarthy hearings in the United States Congress, certain members of the RSV committee were accused of being Communists or Communist sympathizers and were listed as such in the United States Air Force Training Manual. Their names were eventually cleared (Metzger, Dentan, and Harrelson, *Making*, 51).

60. Daniell, *Bible*, 742. The Catholic Bible consists of OT: Genesis, Exodus, Leviticus, Numbers, Deuteronomy, Joshua, Judges, Ruth, 1–2 Samuel, 1–2 Kings, 1–2 Chronicles, Ezra, Nehemiah, Tobit, Judith, Esther, 1–2 Maccabees, Job, Psalms, Proverbs, Ecclesiastes, Song of Solomon, Wisdom, Sirach, Isaiah, Jeremiah, Lamentations, Baruch, Ezekiel, Daniel, Hosea, Joel, Amos, Obadiah, Jonah, Micah, Nahum, Habakkuk, Zephaniah, Haggai, Zachariah, and Malachi. NT consists of: Matthew, Mark, Luke, John, Acts of the Apostles, Romans, 1–2 Corinthians, Galatians, Ephesians, Philippians, Colossians, 1–2 Thessalonians, 1–2 Timothy, Titus, Philemon, Hebrews, James, 1–2 Peter, 1–3 John, Jude, and Revelation.

New Revised Standard Version

In 1990 the New Revised Standard Version was published. The Standard Bible Committee followed the mandate given it in 1974 by the Division of Education and Ministry of the National Council of Churches of Christ in the USA to make changes (1) in paragraph structure and punctuation; (2) in the elimination of archaisms while retaining the flavor of Tyndale-King James tradition; (3) in striving for greater accuracy, clarity, and euphony; and (4) in eliminating masculine-oriented language relating to people, so far as this could be done without distorting passages that reflect the historical situation of ancient patriarchal culture and society.[61]

The issue of inclusive language is among the most obvious changes from the RSV. Rather than go through the English text and rewrite "man," "men," and all male pronouns into gender-neutral language indiscriminately, the editors exercised scholarly and pastoral responsibility by basing all changes on the Hebrew and Greek; it was evident that the original texts do not support the frequent occurrences of exclusively masculine nouns and pronouns. In addition, the editors removed the second-person singular pronouns ("thou" and "thee") in direct address to God along with archaic verb endings (i.e., "doest"), which the RSV had retained.

Its reception did not match the enthusiasm that met the RSV, most likely because so many other translations had also come forth by that time.[62] Interestingly, just as the KJV had attained such exalted and venerated status over the centuries, there were those who had elevated the RSV to nearly the same degree in the forty years since its publication; for many, the thought of any revision of it was off-putting if not outrageous. Yet, we should not let this lack of enthusiasm blind us to the NRSV's strengths, for it has greatly tightened the common bond among Protestants and Catholics.

The committees responsible for the translation and oversight of the NRSV were ecumenical by not only including Protestant, Greek Orthodox, and Roman Catholic scholars of the Catholic Biblical Association but also including a Jewish biblicist for the books of the OT/Hebrew Scriptures. One woman was on the initial committee with female participation increasing as time went on.[63] Because the NRSV was intended to be a revision of the RSV and not a new translation, the editors made a consistent and concentrated

61. Metzger, Dentan, and Harrelson, *Making*, 57.

62. Daniell, *Bible*, 743. The New American Bible, for example was the first major Catholic, English translation after Vatican II, as was the Jerusalem Bible for French. Eventually, the Jerusalem Bible was translated from French into English.

63. Metzger, Dentan, and Harrelson, *Making*, 11.

effort to render into modern English the "mood, tone, style, and uniform dignity of the KJV, which was the *original* Standard Bible."[64]

The *Biblia Hebraica Stuttgartensia* (1977)[65] was the text the NRSV committee used for the OT. For the NT, the committee relied on the Greek New Testament version meticulously prepared by the other ecumenical group of scholars associated with the United Bible Societies.[66] Consequently, the NRSV made use of the ancient texts discovered in Egypt, the Judean desert, Qumran, and Masada. Its presentation of OT narratives has been called "scintillating" and its solutions to various translation problems, "brilliant."[67] So successful has it been that both the United States Conference of Catholic Bishops and the Canadian Conference of Catholic Bishops gave the NRSV their imprimatur,[68] and it is used for the biblical quotations within the English edition of the Roman Catholic Catechism.

Conclusion

One of the goals of *The Saint John's Bible* is to further appreciation of the Word of God among Christians and people of goodwill everywhere. The committee that prepared the NRSV was composed of Protestants, Catholics, and Jews from the start. The Greek New Testament, which provided the text for the NT English, has been compiled by an international group of scholars, both Protestant and Catholic, one of whom was the former rector of the Pontifical Biblical Institute.[69] Both the pedigree of the NRSV and the story of its formation have won the respect of scholars' and bishops' conferences throughout the English-speaking world. No other Bible could suffice as the text to write an illuminated Bible for the third millennium.

64. Ibid., 14; emphasis original.

65. The *Biblia Hebraica Stuttgartensia*, based on the Masoretic text as found in the Codex Leningradensis, has been the standard Hebrew version used for translation since the middle of the twentieth century. Because the Hebrew manuscript tradition is not as vast and is more regularized than the Greek New Testament's, its publication and subsequent translations in Christian Bibles have been much less controversial throughout history.

66. Metzger, Dentan, Harrelson, *Making*, 58.

67. Wansbrough, *Story*, 102.

68. On September 12, 1991, and October 15, 1991, respectively.

69. Carlo Cardinal Martini, Archbishop of Milan, 1980–2012.

Part 3

THE SAINT JOHN'S BIBLE: PART OF AN ARTISTIC AND MONASTIC LINEAGE

Chapter 3

THE TRADITION OF
GIANT MEDIEVAL BIBLES

By Benjamin C. Tilghman

At first glance, *The Saint John's Bible* presents itself as a throwback to the books of the Middle Ages: it consists of text inscribed by hand on parchment using hand-carved quills and augmented by unique imagery painted in brilliant colors incorporating gold leaf. In these general terms, it sounds just like the great illuminated manuscripts of the medieval period. But a quick glance inside *The Saint John's Bible* quickly reveals that it is no mere antiquarian exercise. The imagery is strikingly modern: we see the loose brushstrokes and quickly rendered figures of expressionism, the pell-mell collision of images typical of surrealism, and the appropriation of photo-based imagery from popular sources that marked postmodernist painting in the 1980s. Even the integration of writing into the imagery, which would seem to harken back to the decorated initials and calligraphic forms of medieval manuscripts, in fact has much more in common with the use of language in cubism, pop, and conceptual art than it does with the older tradition. Beyond the stylistic elements, the fundamental conception of the illuminations in *The Saint John's Bible* is also very different from what we see in most medieval manuscripts. Both the CIT and the artists themselves have conceived the imagery as open-ended and indeterminate. The illuminations and special text treatments serve more to inspire and enrich personal meditation on Scripture than they do to communicate a certain prescriptive meaning for a given passage. In contrast, the great majority of medieval illuminations, with a few notable exceptions, were conceived and executed with an eye

toward expressing a certain exegetical idea or constellation of ideas, or even simply to provide a straightforward illustration of the accompanying text.

That *The Saint John's Bible* should not be a piece of medievalist revivalism is not all that surprising. The community of Saint John's is well known for its dedication to modern and contemporary art, which can be seen, in turn, as a reflection of its progressive tendencies in liturgical reform and the pursuit of social justice. Historically, artistic revivals of medieval art have been tied to conservative or traditionalist ideologies. In England, France, and America, the Gothic Revival of the nineteenth century was fueled by a nostalgic view that saw the Middle Ages as a time of simplicity, spirituality, and cultural stability. The English pre-Raphaelites, for example, included deeply moralizing medieval imagery in their works as a means of calling attention to the decadence of their own time and inspiring a return to stricter moral codes.

Even those involved in revolutionary activities looked on the Middle Ages with nostalgia. The socialist William Morris, for example, championed medieval art and craftsmanship as an antidote to the dehumanizing effects of the industrial revolution, both for those who made things in factories and for those who lived with mass-produced objects. For Morris, the Middle Ages represented a time of greater dignity for workers, even if the social stratification was even greater in medieval culture than in Victorian England.

The seemingly medieval format of *The Saint John's Bible* embodies none of these nostalgic impulses. While the community at Saint John's is deeply aware of the centuries-old tradition in which it takes part as a Christian monastery and university, and while the Hill Museum & Manuscript Library is actively involved in projects to document and preserve historical collections of manuscripts, the style of *The Saint John's Bible* clearly signals the contemporary concerns of the community. And while making a book by hand certainly must be seen as a comment on changes in information technology, the willingness to use computers and other technologies in the creation and reproduction of the book signals an appreciation for what new technologies make possible. The project reflects not an effort to return to the ways of the past but a desire to move into the future.

If *The Saint John's Bible* differs so markedly from both the medieval tradition of manuscript illumination and modern trends of medieval revival, should we then see it simply as a twenty-first-century book that just happens to be handwritten on parchment? Considering the explosion of digital media and the still-important role that print plays in the intellectual culture of our time, this would seem to miss the point, but I think we would be equally in error to see the medium as the only, or even the primary, parallel between *The Saint John's Bible* and the medieval traditions of bookmaking. I think here it

is important to consider several other aspects of *The Saint John's Bible* that are sometimes overlooked. The most important is the fact that it encompasses all the books of the Bible. As we shall see, this was a rarity in the Middle Ages. Another factor is its gargantuan size: the pages are as large as a high-quality sheet of parchment can possibly be, and the Bible as a whole encompasses seven individual volumes. Just as important is the manuscript's position not as a stand-alone work of art but as the core of a much larger endeavor that includes the production of the Heritage Edition—a series of near facsimiles of the book—and also of smaller books of photographic reproductions of the Bible's individual volumes. These subsidiary publications were conceived as part of the project from the very beginning and are the primary way that most people experience the book. When we think of *The Saint John's Bible*, we should perhaps think of the totality of all its forms, not solely the manuscript. Both its impressive scale and the efforts at dissemination signal to us that *The Saint John's Bible* is an ambitious project: it has aims that extend beyond the mere fabrication of a fancy book. By looking at some parallel moments in the Middle Ages, where monks and others created and circulated large and extravagant Bibles, we can set the ambitions of the project in a wider historical perspective.

In considering how *The Saint John's Bible* is like medieval Bibles, we should first review the ways that medieval Bibles are not like most modern Bibles. While in contemporary usage the word "Bible" calls to mind the image of a book containing the various writings that comprise what Christians know as the Old and New Testaments, such single-volume Bibles, also called "pandects," were a relative rarity in the Middle Ages and completely unknown in the early years of Christianity. For most of its history, the word "Bible" has referred to collections, not to a single unitary form. Several centuries before the time of Jesus, Hellenized Jews were using the Greek term *ta biblia*, meaning "the books," to refer to their sacred writings, and Christians had adopted the term to refer to their newly conceived Scriptures by the early third century. "Book" in the ancient world was more of a literary term than the name of a concrete object: writings were understood to consist of one or several "books" that could be collected together in volumes consisting of individual scrolls. It would have been impossible to fit all of Judaism's sacred writings onto a single scroll, and so individual books of the Bible maintained a strong individual identity even as they were recognized to exist within a larger group. Even when Christians adopted and popularized the somewhat more capacious codex (our bound book) in the first centuries, the Bible still had to exist in multiple volumes. A medieval monastery, if it had a complete Bible (and it is unclear that every monastery always did), possessed it in several codices, usu-

ally consisting of discrete subgroups of biblical texts: the gospels, the psalms, the epistles, etc. There were no set groupings of texts: for example, Genesis might stand alone within a volume, or it might be part of the Pentateuch[1] (first five books of the OT), or the Hexateuch (Pentateuch plus Joshua), or the Octateuch (Hexateuch plus Judges and Ruth). Nor were biblical books usually made together as a full set. More often they were made on an *ad hoc* basis in response to the needs of a particular moment (for example, for the dedication of a new church) or desire of a patron (such as a king who wanted to show his support of the institution). A gospel book here, a Hexateuch there. Multivolume Bibles conceived and made as a set in a single campaign, like *The Saint John's Bible*, were something of a rarity.

We can thus start to narrow down our consideration of the medieval antecedents for *The Saint John's Bible* to focus on those occasions when Christians took it upon themselves to make a full Bible, whether in a single volume or in many. At several distinct moments over the course of the Middle Ages, monasteries and cathedrals—sometimes at the behest of rulers and popes—undertook to revive and renew the central place of the biblical text in Christian spirituality by producing new editions of it and sharing them with others. These projects were very often associated with reform movements and reflected the ecclesiological goals of the reformers.[2]

TRADITION AND NEW DIRECTIONS

Constantine

In 331, the emperor Constantine sent a letter to Eusebius, the bishop of Caesarea in Palestine and an important scholar and church leader. In the letter, the emperor explains that his newly founded capitol, Constantinople (present-day Istanbul), is seeing the construction of many new churches, and, as a result, he orders Eusebius to

> order fifty volumes with ornamental leather bindings, easily legible and convenient for portable use, to be copied by skilled calligraphers well trained

1. Known as the "Torah" in Judaism.

2. This tendency is explored in Diane J. Reilly, "Lectern Bibles and Liturgical Reform," in *The Practice of the Bible in the Middle Ages: Production, Reception, and Performance in Western Christianity*, ed. Susan Boynton and Diane J. Reilly (New York: Columbia University Press, 2011), 105–25.

in the art, copies that is of divine scriptures, the provision and use of which you well know to be necessary for reading in church.[3]

The term "divine scriptures" is ambiguous; while it seems natural to assume that Constantine is asking for Bibles, we should remember that full Bibles were very rare at this time. As he is specifically asking for books to be used in churches, it is possible that he is asking for gospel books or lectionaries. I think, however, that there is reason to believe that he means to ask for full Bibles; if that is the case, it is significant that he put this request to Eusebius of Caesarea. Though Eusebius would spend his later life in Constantinople attached to the emperor's household, at this point he was still in Palestine, or perhaps Antioch. That would be a long way for Constantine to go for books that could otherwise be copied in the metropolis; the emperor must specifically have wanted Eusebius to oversee the project. Though Eusebius is now largely remembered as the first historian of the church and Constantine's court biographer, at the time he was better known for his work as a textual critic, having produced editions of the Septuagint and the gospels, which he divided into subsections that prefigured modern chapters and verses and would be used throughout the Middle Ages. It could be that Constantine contacted Eusebius because he trusted him to produce complete and carefully edited Bibles. Constantine was concerned about orthodoxy: in 325, he convened and helped preside over the first ecumenical council in Nicaea, resulting in clarifications about the doctrine of the Trinity, the calculation of Easter, and the first version of the Nicene Creed. We might see his commissioning a leading scholar to produce Bibles for his churches as an extension of his concern that the newly sanctioned church be unified on matters of teaching and dogma.

What would Constantine's fifty Bibles have looked like? We can discern a few general characteristics from the text of his letter. They must have been rather handsome, as Constantine specifies that they have "ornamented leather bindings" and insists on well-trained scribes. As in *The Saint John's Bible*, scribal excellence probably served two ends: first, as Constantine states, to ensure that the text is legible (perhaps for public reading), and second, to convey the dignity and beauty of the biblical narrative within the words. This latter concern is more one of interpretation, but it is clear in the text of the letter that Constantine sees the utility of fine scribes extending beyond the needs of accuracy and legibility. Like the ornamented binding, he wants the inside to be beautiful too. What he does not mention, and what was almost surely

3. Eusebius, *Life of Constantine*, trans. Averil Cameron and Stuart G. Hall (Oxford: Clarendon Press, 1999).

excluded from the end product, is any kind of illustration or figural decoration. The emphasis is solely on the words.

No surviving manuscript can be definitively identified as one of Constantine's fifty Bibles, though we might imagine them looking something like the Codex Sinaiticus (fig. 1), an extraordinary manuscript that survives today in fragments scattered among London, Leipzig, St. Petersburg, and St. Catherine's Monastery in Sinai, where the manuscript was originally discovered in the nineteenth century and whence it received its modern name.[4] Datable to the middle of the fourth century, the Codex Sinaiticus once consisted of the entirety of the OT (according to the Septuagint) and the NT in Greek, as well as two extrabiblical texts known as the Shepherd of Hermas and Epistle of Barnabas. It spanned an estimated 730 parchment folios, of which only 390 survive. Three, or perhaps four, accomplished scribes wrote the text on rather large sheets (38 x 33 cm. or 15 x 13 in.) of very good parchment, representing about 365 animals. The preparation of the manuscript must therefore have required a considerable investment of resources. It has often been thought actually to be one of the fifty Bibles commissioned from Eusebius, though this supposition is generally discounted on textual grounds, since certain passages within the codex differ from those quoted by Eusebius in other of his writings. Nonetheless, it provides a glimpse into what an early effort to make a pandect might look like.

4. See chapter 2.

Figure 1: Codex Siniaticus, Open. British Library, London.
© The British Library Board. Add. 43725ff. 244v–245. Used by permission.

Though almost devoid of decoration of any kind, the book has an austere beauty. The nearly square format of its pages reflects an aesthetic choice, since the shape of animal skins lends themselves to pages that are rectangular, requiring special trimming to produce square sheets. The wide margins serve to call attention to the fineness of the parchment and also effectively frame and feature the columns of text, giving them a strong sense of presence. Unlike most early manuscripts, the margins and individual lines marked out with careful ruling lines indicate a desire to create a particular effect through the layout. Indeed, arranging the columns four to a page (three to a page for the Psalms) is rather unusual, and the eight columns marching across each opening give the impression of an unfurled scroll—perhaps as an effort to recall the venerable history of the text. The Greek uncial script itself is remarkably even and dignified, carefully balancing the needs for clarity with a subtle kinetic energy in the individual strokes: an austere book need not be dead. But while the text is highly aestheticized, the makers were also concerned that this be an accurate copy, as the original scribes scrupulously corrected the text in many places by checking it against other sources (no scribe being perfect, however, later corrections were added over the course of the fifth and seventh centuries). Even if it is not likely to be one of Constantine's fifty Bibles, we can see in it his ideals of legibility, artistry, and orthodoxy.

We can see some interesting parallels and important differences among *The Saint John's Bible*, Constantine's Bibles, and the Codex Sinaiticus. Although the illuminations of *The Saint John's Bible* tend to dominate our attention, they should not completely obscure the importance of the script and the text in particular: for every page that is decorated, there are several that consist entirely of text. Donald Jackson, the artistic director of *The Saint John's Bible*, has discussed how carefully he considered the layout of the page, and though he drew most of his inspiration from the great illuminated Bibles of the twelfth century (discussed below), we should also see earlier manuscripts such as the Codex Sinaiticus as an important precedent.

More important is the handling and dissemination of the text. Constantine's desire to distribute complete and correct biblical texts reflects a desire to endorse a certain canon of Scripture. He wanted his churches all to be on the same page, so to speak. Such ecclesiological concerns also informed the CIT's decision to use the New Revised Standard Version in *The Saint John's Bible*. The text is already recognized for use by most Christian denominations, but its use and propagation through the various editions of *The Saint John's Bible* could be seen as an effort on the part of Saint John's to build and reinforce a Christian community in the same way that Constantine's Bibles did.

The Double Monastery of Wearmouth-Jarrow

In the early eighth century, Abbot Ceolfrith at the monastery of Wearmouth-Jarrow on the edge of the North Sea in present-day England undertook to have three giant pandects created, one for each of his two monastic communities and a third to be sent to Rome as a gift for the pope. As recounted by one of the monks in his charge (the brilliant scholar known as the Venerable Bede), Ceolfrith retired from his abbacy to deliver the manuscript to Pope Gregory II in person but perished during the journey. The two he left in England have disappeared except for a few fragmentary leaves, but the third, by great good fortune, survives today in the Laurentian Library in Florence as the Codex Amiatinus.

Ceolfrith and his community clearly conceived of their gift as a means of demonstrating to the papal court the great heights of learning and craftsmanship that had been achieved in what was then seen as the very edge of the world. They did this not by introducing new and innovative artistic forms, as their contemporaries at the nearby island monastery of Lindisfarne would do in the famous Lindisfarne Gospels, but by reflecting back to Rome the grandeur of its classical heritage. In fact, the Codex Amiatinus so faithfully mimics the script and artistic styles of late classical Rome that it was not until the late nineteenth century that the codex was recognized as a product of Anglo-Saxon England. A reverence for Rome and its cultural products was an important part of the identity of Wearmouth-Jarrow. In his history of the monastery, Bede recounts how Benedict Biscop, the founder and first abbot, imported stonemasons to build a church "in the Roman manner" and later traveled several times to Rome to acquire "spiritual goods" for his new institution, including panel paintings, relics, liturgical objects, and many books. The Codex Amiatinus was thus a missive meant to convey that a miniature Rome had been built in the wilds of the north. The dedicatory poem that opens the manuscript states that the manuscript is offered to "the venerable body of Peter" by "Ceolfrith, Abbot from the furthest regions of the Angles," with the hopes of forever being in the memory of the Roman see.

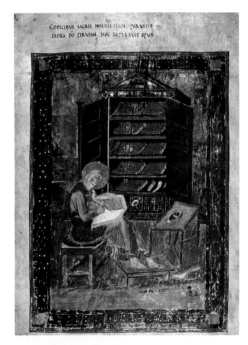

Figure 2: Folio 5r, Codex Amiatinus, Portrait of Ezra. Biblioteca Medicea-Laurenziana, Florence.

Facing this humble dedication is a picture of a seated man writing in a book (fig. 2). Behind him is a large bookcase brimming with volumes, and another book and writing utensils are scattered about the floor. An inscription at the top of the page identifies the man:

> When the sacred codices were burned by the enemy horde
> Ezra, glowing with God, repaired this work[5]

The text refers to the Jewish scribe Ezra, whose deeds are recounted in the books of Ezra and Nehemiah, although the specific incident recounted here does not appear in either book. Rather, it comes from 4 Esdras, an extra-biblical text that circulated in early medieval Europe. In that book, Ezra is commanded by God to gather around him a team of scribes to restore the Scriptures destroyed during the Babylonian captivity. Fittingly, the intricate headpiece and breastplate that he wears mark him as a Jewish high priest, at least according to contemporary iconography, but his garment is the habit of a Benedictine monk. What we have, then, is an assimilation of Ezra the ancient protector and restorer of Scripture to the monks working in the scriptorium at Wearmouth-Jarrow. Coming near the end of several centuries of tumult following the dissolution of the Roman Empire, Ceolfrith and his monks seem to be setting themselves up as latter-day Ezra, sharing with Rome the Scriptures that they have protected and restored. In fact, it has been proposed that the inscription and miniature so closely reflect the scholarship of Bede that he may have been directly involved in their creation, perhaps even wielding the pen and brush.[6]

As the frontispiece to the volume, the portrait of Ezra the scribe marks the Codex Amiatinus as a work of bibliography; the text may be that of the Bible, but this particular edition of it is deeply concerned with bookmaking. Just a few pages after the portrait of Ezra we find a succession of diagrams that show different ways of grouping the books of the Bible according to Augustine, Jerome, and Epiphanus, and then a further diagram showing the books of the Pentateuch. The scholarly mind-set of these diagrams is also reflected in an extraordinary image of the tabernacle, fully annotated, that

5. Translation from Celia Chazelle, "Ceolfrid's Gift to St Peter: The First Quire of the *Codex Amiatinus* and the Evidence of Its Roman Destination," *Early Medieval Europe* 12 (2003): 129–57, at 149.

6. For a complex and fascinating consideration of Bede's possible role in the creation of the Codex Amiatinus, see Paul Meyvaert, "The Date of Bede's in Ezram and His Image of Ezra in the Codex Amiatinus," *Speculum* 80 (2005): 1087–1133; and Meyvaert, "Bede, Cassiodorus, and the Codex Amiatinus," *Speculum* 71 (1996): 827–83.

spans a two-page opening. This book is not just another copy of the Bible but a reference work equipped with an apparatus for scholarly study.

Scholarship, then as now, calls for the thoughtful investigation of older writings. Our appreciation for the scholarship that went into the Codex Amiatinus is deepened when we investigate its sources. Among the many books that Benedict Biscop brought back was apparently another large pandect of remarkable provenance: the Codex Grandior. Although it does not survive today, the Codex Grandior is known through a description of it by the sixth-century monk and scholar Cassiodorus, who commissioned the book for the library of his monastery in southern Italy known as the Vivarium. Cassiodorus actually commissioned three Bibles: the Codex Grandior ("the larger book"), the Codex Minor ("the small book"), and the Novem Codices ("the nine books," a multivolume Bible). Cassiodorus's description of the Codex Grandior indicates that it shared many features, such as the diagrams and the picture of the tabernacle, with Amiatinus. In fact, the depiction of Ezra with a large book on his lap, a small book lying on the floor, and nine books behind him in the cupboard has led many to conclude that the portrait is based on one of Cassiodorus from the Codex Grandior, a suspicion supported by faint impressions on the page that indicate it was traced from another source. In preparing their Roman-style book, the monks of Wearmouth-Jarrow looked to a great example of the real thing. It would be wrong, however, to see the Codex Amiatinus as nothing but a copy of the Codex Grandior. For one, it appears the monks at Wearmouth-Jarrow reinterpreted the portrait of Cassiodorus into one of Ezra, adding the inscription at top and the priestly ornaments to the figure. Even more important is that the Codex Grandior contained the old Latin translation of the Bible, whereas Amiatinus features one of the most reliable early copies of Jerome's Vulgate. In other words, Ceolfrith and his monks copied the form of the Codex Grandior but not its text, using instead the newer, officially sanctioned edition. The scholarship that went into the Codex Amiatinus was not simply a matter of repeating what had come before but creatively reinterpreting older sources to create something new, and true.

Though a great revival of classical styles, the Codex Amiatinus was very much an exception in its time. Books, including biblical books, in the seventh and eighth centuries did not look like their Roman ancestors but were instead written using new scripts that had been developed in Irish and Merovingian scriptoria and decorated with ornamental and figural forms that derived from the ancient metalworking traditions of pre-Christian northern Europe. Densely packed with complicated patterns of intertwining beasts and highly stylized human forms, masterpieces such as the Book of Kells and the Lindisfarne Gospels visually declared an independence of thought on the part of

the monks who made them. They were clearly aware of the Roman artistic tradition—the portrait of Matthew in the Lindisfarne Gospels is based on the same image from the Codex Grandior as that of Ezra in Amiatinus—but chose instead to forge something new and distinctive.

Charlemagne and His Heirs

As great as they were at making manuscripts, however, the scriptoria that produced Kells and Lindisfarne seem not to have made any full Bibles, or at least none that have survived. To see the tradition of Bible making continue, we need to move to continental Europe and the new empire established by Charlemagne in the late eighth century. Seeing themselves as the heirs to and saviors of the great lost Roman imperial traditions, Charlemagne and his court undertook a campaign of *renovatio*, "renewal," in the administration of both secular and ecclesiastical affairs. While the monasteries in the British Isles had been thriving intellectually, many of those on the continent had fallen into a state of decay. Consequently, Charlemagne gathered around himself many of the leading scholars of Europe and charged them with restocking monastic and royal libraries with accurate copies of both religious and secular texts, including many by classical authors. Within these books, the project of *renovatio* found visual expression in the general suppression of northern "barbarian" styles such as interlaced animals in favor of classical ideals of harmony, clarity, and illusionism. At the same time, the illuminators took care to integrate the new learning gleaned from ancient books into their illustrations of the biblical text.

The development of the Carolingian Bible depended on contributions from many people over the course of sixty years. The first great scholar in this process was Abbot Maurdramnus of Corbie. In about 772, Maurdramnus and his scriptorium undertook to make a new copy of the Old Testament spanning at least twelve volumes, of which five and portions of a sixth still survive. This was not a full Bible, nor is it nearly as beautiful as those that would follow, but it undoubtedly prepared the way for its successors. It was, first of all, a work of serious textual criticism, with Maurdramnus and his colleagues apparently drawing on multiple copies of each OT book to determine the correct text. Just as important, the Corbie scriptorium also developed a new script for the project, known to modern scholars as Carolingian minuscule[7] (fig. 3). The script common to books from the British Isles, Insular half-uncial, was too strongly associated with northern lands to conform to ideas of *renovatio*, but

7. The book hands of antiquity are defined by their size and form. *Majuscules* correspond to what we call "capital letters," and *minuscules* are analogous to our "lowercase letters."

Figure 3: Maurdamnus codex, text page with Carolingian minuscule. Manuscrits—Latin 13174. Actes des apôtres; épîtres de S. Jacques, S. Jude, S. Pierre et S. Jean; apocalypse. Xe s. folio 138v. Used by permission. Bibliothèque Nationale, Paris.

the proper uncial[8] of antiquity was time consuming to write and required too much space to be practical for most Bibles. The script they developed is a model of clarity, proportionality, and concision, and its descendants include the font you are reading right now. Similarly, Donald Jackson also believed that the creation of a new Bible called for a new script that would distinctly embody the ideals of the project as a whole.

Carolingian minuscule would continue to be refined in the ensuing decades, as would the project to produce new Bibles. Soon after Maurdramnus commissioned his OT, two scholars closely tied to Charlemagne, Theodulf of Orléans and Alcuin of York, both directed new Bible projects. Theodulf's project may perhaps be considered more scholarly, involving a deeper critical investigation of ancient sources in an effort to resolve contradictions among them, but Alcuin's had a longer lasting impact, particularly in the history of illuminated manuscripts.

Alcuin was already a distinguished scholar and teacher at the renowned cathedral school of York when he met Charlemagne in Parma in 781. Recognizing his intellect, Charlemagne invited Alcuin to join his court in Aachen as the head of the palace school, where he would serve as tutor to the king himself and his sons. When he retired from his post in 796, Alcuin assumed the position of abbot of St. Martin's monastery in Tours. At Tours, he continued to write and teach, and he also devoted considerable energy to building a great library at the monastery through both copying and acquisitions. He also directed the scriptorium there to start making Bibles. Over the next sixty years, the scriptorium at Tours churned out Bibles of varying levels of sumptuousness for distribution throughout the Carolingian Empire and elsewhere. Forty-six Bibles survive either in whole or in part from Tours, and when we account for losses we can estimate that the scriptorium averaged two or more Bibles a year over this period.[9] Considering that it took Donald Jackson and his team over ten years to produce a single Bible, we can appreciate the scale

8. An *uncial* is a majuscule written in a slightly cursive hand.

9. These figures follow David Ganz, "Mass Production of Early Medieval Manuscripts: The Carolingian Bibles from Tours," in *The Early Medieval Bible: Its Production, Decoration, and Use*, ed. Richard Gameson (Cambridge, England: Cambridge University Press, 1994), 53–62.

of the operation. The scriptorium at Tours must have been huge, staffed by highly skilled craftsmen, and very well-funded.

In many respects, the Tours Bibles are remarkably consistent. They were generally large (around 450 leaves, measuring about 48 x 38 cm. or 19 x 14¾ in.) but not huge. They employed a clear hierarchy of scripts to help in navigation, usually employing Roman square capitals marking off the beginnings of new text sections. Nonetheless, every manuscript is necessarily unique, and these were no exception. The Bibles produced under Alcuin seem not to have been heavily decorated, whereas his successors, Abbots Fridugisus, Adalhard, and Vivian, developed extensive and sophisticated programs of illumination. Nor does there seem to have been a set order of texts: the Pauline epistles were often placed at the very end of the text and extrabiblical scholarly apparatus was not consistently included. So while we might be tempted to see this as a publication enterprise similar to that developed for *The Saint John's Bible*, we must also bear in mind that the ninth-century endeavor allowed for greater flexibility of form and content than twenty-first-century reproductive techniques could allow. Every copy of the Heritage Edition is basically the same, despite the individualized stamping and sanding of each volume, whereas every Tours Bible was custom-made for its recipient.

Perhaps the best example of such customization is the book known as the First Bible of Charles the Bald; it is also commonly called the Vivian Bible after the abbot of Tours who directed its creation in 846. A miniature at the very end of the book commemorates its presentation by Count Vivian and his fellow monks to Charles the Bald not long after his ascension to the throne; it is perhaps the earliest surviving presentation scene in a manuscript (fig. 4). Charles extends his own hand to convey acceptance of the book, which is so large that it must be carried by two monks. Vivian, identifiable by his lack of tonsure or monastic dress (he was a lay abbot), can be found on the opposite side of the page, where he presents his monks to the king with a gesture that mimics Charles's; indeed, the numerous outstretched hands, turned bodies, and expressive faces give the impression of a lively encounter. But it is clearly Charles who is the star of the show: he is the largest figure, centrally located, and depicted in brilliant yellow robes. The book had been prepared

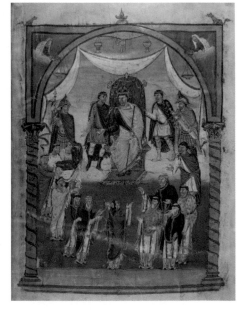

Figure 4: First Bible of Charles the Bald, Presentation. Manuscrits—Latin I. Folio 423r. Used by permission. Bibliothèque Nationale, Paris.

for Charles as a way to curry favor and ensure continuing royal patronage for Tours, and this miniature flatters Charles in several ways. Personifications of virtues at top left and right extend crowns toward Charles as the Hand of God extends downward from the heavenly sphere to convey divine sanction. Even more forthright is the strong resemblance of Charles to King David as he is depicted earlier in the book, an association made as well in the dedicatory poem that precedes the miniature. Throughout the Middle Ages, David was held up as the model of kingship: strong, cunning, pious, penitent, and what every Christian ruler should aspire to be. Within this miniature, Charles, all of twenty-three years old at the time, is depicted as already having achieved such distinction.

This book, without a doubt, was meant to be a ravishingly beautiful gift. The cover in the presentation miniature is highlighted with gold leaf to represent what must have been a very opulent binding (now lost). But it was also very much a copy of the Bible, and one that was meant to mold the young king's mind and heart just as it pleased his eyes. A fine example of this effort may be seen on the first page of the letter from Jerome to Desiderius, which serves here as a preface to the Pentateuch (fig. 5). At first glance, it is the lavishness of the page that catches the eye, with letters of silver (now sadly tarnished) and gold floating above a ground of deep purple, all set off by the creamy parchment underneath. The color scheme harkens back to manuscripts written on purple-dyed parchment from the late Roman Empire, an allusion to antiquity reinforced by the classical ornamental patterns in the borders and the square capitals in the lines at top. But, as with Carolingian *renovatio* in general, this is not simply a mindless aping of ancient masterpieces. The minuscule script for the main text and the historiated initial D, which fills the left-central portion of the page, are thoroughly Carolingian conceptions. The D, in fact, is a very complicated figure, incorporating roundels depicting signs of the zodiac and, in its bowl, personifications of the sun (as Apollo in a chariot) and the moon. These images are derived from late Roman astronomical tracts in the library at Tours and serve here to connect the events of the Bible with the rhythms of the cosmos. Although moderns have yet to reconstruct a full interpretation of this image, it does serve to demonstrate the

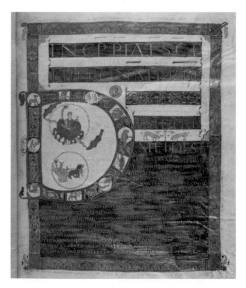

Figure 5: First Bible of Charles the Bald, Beginning of Jerome's Letter to Desiderius. Manuscrits—Latin I. Folio 8r. Used by permission. Bibliothèque Nationale, Paris.

idea among medieval scholars that those who wish to understand the Bible must also educate themselves about the world around them.

At this time, such education was based on the seven liberal arts, divided into the *trivium* (grammar, rhetoric, and logic) and the *quadrivium* (arithmetic, geometry, music, and astronomy). That such learning was to be found in the pagan authors of antiquity was not seen as a problem, just as *The Saint John's Bible* incorporates imagery from contemporary scientific inquiry; the line between secular and sacred knowledge, both books assert, simply does not exist.

The Romanesque Era

If Carolingian Bible production reflected the reformist aims of a small, secular, and ecclesiastical elite and was largely carried out by one particular scriptorium, the next great flowering of Bibles is notable for its diffusion and diversity. Starting in the middle of the eleventh century and extending through the twelfth century, monasteries, cathedrals, and secular aristocrats across Europe commissioned and produced hundreds of giant Bibles, both in pandect and multivolume form. Like the Carolingian Bibles, however, the inspiration for new books in the Romanesque era came from calls for reform, spearheaded by the papal court in Rome, especially under Gregory VII. The ecclesiastical reform of the eleventh century initially responded to pervasive abuses among the clergy, particularly sexual misbehavior and simony, the selling of sacraments and ecclesiastical offices. These specific failings, however, were generally seen as symptomatic of a general disregard for the spiritual responsibilities of the clergy. Many monasteries had gradually come to disregard more and more of the duties laid out for them in the RSB, including the need to engage in *lectio divina*, both communally and individually. The new large Bibles made in this era, many of them intended for a lectern from which they could be read aloud to the community, reflect a rededication by hundreds of institutions to their spiritual duties.

As with the Bibles we have already examined, as well as *The Saint John's Bible*, the considerable heft of these books was just as much a symbolic choice as it was a functional one. Yes, larger books are easier to read from (especially, it must be remembered, in the low light of medieval buildings), but they also materially announce a considerable redirection of resources away from luxuries and comforts toward the spiritual good of the institution. Much of the money for these projects came from royal courts, individual wealthy benefactors, or the institution itself, but this was not necessarily always the case; people of more modest means might contribute funds for the good of their souls or those of their loved ones. One particular manuscript, the Calci

Bible, recounts in detail such a fund-raising effort.[10] The project to make the four-volume Bible was initiated by one Mattilda Veckii, who donated one hundred *solidi* to the church of San Vito in Pisa in 1168. This sum served to purchase 240 parchment sheets for the new Bible, which eventually required an additional 188 sheets to complete.[11] Some of the money for parchment and other expenses came from Mattilda's neighbors, sixty of whom contributed a further 313 *solidi* in small sums. Records show that 446 *solidi* were paid out to scribes, illuminators, and other craftsmen contracted specifically for the project and advised by a priest, Gerardus, who worked as a project manager. We do not know where these further funds came from, but it is clear that a significant portion of the 759 or more *solidi* spent on the Bible came in the form of small donations from the surrounding community, just as *The Saint John's Bible* has been funded by donations large and small. Thus, when the Calci Bible took its place in San Vito, it represented the spiritual aspirations of a large part of their community—both lay and clerical.

A sense of community identification seems to have been important for many of these manuscripts. There was clearly a belief that a Bible meant to mark the renewal of an institution should be *of* that institution, not just owned by it, and one of the primary ways of marking this affiliation was by drawing on venerable books held in the library. The texts for these Bibles almost always derived from biblical texts at hand in existing volumes. Somewhat surprisingly, considering the history of Bible projects, only a few of these new Bibles demonstrate any particular effort at refining or purifying the biblical text; the anxiety at this time was not so much that the biblical text had become corrupted, but that it was being ignored by the clergy and others who were expected to know it intimately. The makers of the books may also have felt reasonably confident that they had good texts to copy, and many of them did: several of the Romanesque Bibles in northern Europe show signs of having been copied from Carolingian exemplars, and a small group in Italy seems to have come from the monastery at Monte Amiata, where the Codex Amiatinus spent the later Middle Ages.

10. Fuller accounts of this Bible can be found in Christopher de Hamel, *The Book: A History of the Bible* (London: Phaidon, 2001), 88–91; and Lila Yawn, "The Italian Giant Bibles," in *The Practice of the Bible in the Middle Ages: Production, Reception, and Performance in Western Christianity*, ed. Susan Boynton and Diane J. Reilly (New York: Columbia University Press, 2011), 126–56.

11. For some perspective, Yawn helpfully notes that one hundred *solidi* at this time would also serve roughly to buy twenty-five casks of wine, twenty-five pounds of honey, or one slave.

If they generally deferred to existing textual precedents, however, the patrons and makers of the new Bibles seem to have valued innovation and invention in the aesthetic qualities of the books. Again, the lack of a central organizing body for the project is significant, since it meant that nearly every project was to some extent *ad hoc*, giving rise to an immense diversity in textual contents, imagery, and scribal and painterly styles. We can nonetheless see a clear desire for contemporary currency in the scripts, ornaments, and figural styles within the books. The patrons of these books wanted them to look new. It seems, in fact, that the "look" of these books was just as important as the text they contained. While many of them seem to have been prepared for public use (by including, for example, markings for liturgical readings), the Romanesque scripts found in these books are sometimes so stylized and small that reading aloud from them would have been difficult. The vibrant pigments and gold, intricate ornaments, and complicated compositions all seem to have been created with an eye toward public display. These were books to be shown and seen, besides being read from.

The imagery in Romanesque Bibles shows a strong tendency toward narrative images and author portraits. Many of these images appear not as stand-alone miniatures but within initials marking off the beginning of a section. Historiated initials likely served as a way of helping readers find their way through the text, a suspicion borne out by the fact that many of the scenes simply depict the first narrative moment in the section, and not necessarily the most important. It would be rash, however, to dismiss historiated initials as purely and "merely" functional, nor should we view them through modern notions of illustration, which generally assume narrative depictions to be a straightforward visual representation of what is described in a text.

Many of these initials were deeply informed by traditions of biblical exegesis. In the Stavelot Bible, for instance, the initial "I" at the beginning of Genesis depicts not the story of creation, as many Romanesque initials do (and as does the frontispiece in *The Saint John's Bible*) (fig. 6). Instead, we see three sets of roundels depicting, at center, the life of Christ; at left, scenes from the whole of Genesis; and, at right, the Parable of the Laborers in the Vineyard (Matt 20:1-16). All of these narratives run upward from the base of the letter, culminating in the Last Judgment at top. The scenes of Genesis can be read as introducing the present book, but what of the scenes from the NT? The depiction of the life and return of Christ (with the crucifixion prominently placed at center) may serve to emphasize the Christian interpretation of the OT within the context of salvation history. More obscure and intriguing are the scenes from the Parable of the Laborers. Their relevance here is difficult to discern, but one of the most convincing modern interpretations notes that medieval

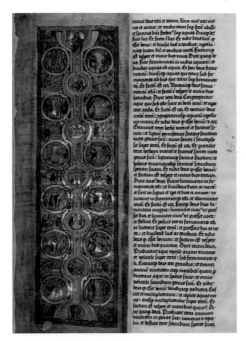

Figure 6: Stavelot Bible, Initial I from Genesis.
British Library, London. © The British Library
Board. Add. 28106, f. 6. Used by permission.

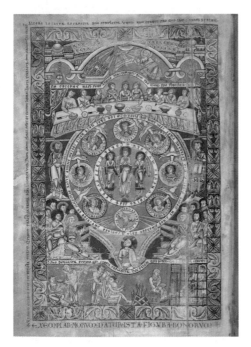

Figure 7: Floreffe Bible, frontispiece.
British Library, London. © The British Library
Board. Add. 17738 f. 3v. Used by permission.

exegetes saw the parable as an allegory for five different periods of biblical history; the reference to the parable here, at the very outset of the Bible, would thus invite the reader to keep the historical schema in mind while contemplating the events of the Bible.[12] The initial thus works on multiple levels: as a signpost marking the beginning of the text, as a preface introducing the events that follow, as a cue to the reader about how to interpret those events, and, more broadly, as a reminder of the very necessity of interpretation when reading the Bible.

The giant Bibles of the eleventh and twelfth centuries are, in many ways, the most direct medieval ancestors to *The Saint John's Bible*. Donald Jackson has often cited the Winchester Bible, produced between 1160 and 1175, as a major influence on his page layout and script. It might seem that *The Saint John's Bible* departs from their precedent in its general avoidance of narrative imagery, perhaps in an effort to discourage overly literal interpretations of the biblical text. As we have just seen in the Stavelot Bible, however, images in medieval Bibles could be and were considered as a means of expressing the ultimate complexity of biblical meaning. In the second volume of the Floreffe Bible, for instance, we find a complicated full-page frontispiece that depicts, at top, Job sacrificing and feasting with his sons and daughters (fig. 7). The sections below, however, move beyond narrative depiction to include portraits of Saint Paul and King David, the apostles receiving the gift of the Holy Spirit, allegorical scenes of the six works of mercy, and personifications of virtues. Taken together, the composition can be seen as diagrammatic picturing of the *vita activa*, reflecting currents of thought in monastic writings of the time. This carefully constructed visual discourse needs to be parsed and

12. Walter Cahn, *Romanesque Bible Illumination* (Ithaca, NY: Cornell University Press, 1982), 133–36.

interpreted with thought and reflection. In contrast to the imagery in *The Saint John's Bible*, there is a set message for its beholders to discern, albeit a highly complex one. The illuminations in both books, however, ultimately share the goal of spurring continual reflection on the themes of the Bible.

The examples we have considered in this chapter represent only one perspective from which we might consider the relationship of *The Saint John's Bible* to its medieval heritage. Questions of iconography and symbolism and the role of images in Christian devotion could also productively be considered in this context. It might seem that comparing *The Saint John's Bible* to other large Bibles is somewhat of a simplistic parallel, based merely in a coincidence of size. But the idea of the Bible as a "big book" continued to be an important part of how it was conceived through the later Middle Ages and the Early Modern period. Even as bookmakers around Paris developed the compressed script and ultrathin parchment that allowed them to produce the so-called pocket Bibles of the thirteenth and fourteenth centuries, these books were distinctive precisely because they *were not* big (fig. 8). The cramped, highly abbreviated script of these books is such that only someone who knows the text well can read it; they served primarily as *aides-memoire*, or even perhaps as personal attributes, marking those who carried them as "bearers of the Word." The books seem primarily to have been made for itinerant preachers among the mendicant orders. The condensed pandects they carried with them served as a portable version of the lectern Bibles that people saw in churches; the small books drew on the symbolic power of the larger ones to mark anywhere the friars went as a place of the Word.

Similarly, it is no accident that Johannes Gutenberg modeled his first major demonstration of movable type on the huge manuscript Bibles popular in his day, such as the Giant Bible of Mainz in the Library of Congress (fig. 9). Gutenberg the entrepreneur needed to make an impression, and the idea of the book had become so inextricable from the Bible, and particularly large versions of it, that it was the most fitting way to demonstrate his skills as a bookmaker. The fact of the Bible as a book is so crucial to its conception that all the books we have reviewed, in one way or another, refer to the circumstances of their making: think of Ezra the scribe in the Codex Amiatinus, or Charles receiving

Figure 8: Paris Bible, open. Manuscript fragment aap1306 from the Area Artium Collection, Hill Museum & Manuscript Library. Saint John's University. Gift of Frank Kacmarcik.

his Bible from Vivian, or the list of contributors and scribes in the Calci Bible. In the Middle Ages, to treasure the Bible was to make a Bible.

It has been over five hundred years since an abbey commissioned a Bible in the tradition of the giant medieval Bibles. The printing press could do the job much more economically, and, indeed, more Bibles found their way into the hands of more people because of it. Now, electronic versions are replacing even the best produced by a press. Yet, in this our new millennium, beauty that can inspire the mind and soul still comes to us through thought, reflection, and art, and these three rely heavily on the tradition our forebears have handed down to us. Tradition, by nature, is composed of much that is old plus a little that is new. As we gaze into the future and wonder what thing of value we can possibly leave for the generations coming after us, adding to the patrimony we have received would be a worthy investment. Thus, Saint John's Abbey and University decided to make a Bible.

Figure 9: Giant Bible of Mainz.
Library of Congress, Washington.

Part 4

HERMENEUTICAL GUIDE

Chapter 4

LEITMOTIFS

Sacred Scripture is an ancient book that has been a source of divine revelation to humankind for thousands of years. At every moment of its history, people have found it necessary to go beyond the written word on the page and interpret its meaning. The Bible itself provides a good example of such in 2 Kings 22:10-20, where King Josiah sends his advisers to the prophetess Huldah for an interpretation of a scroll found in the temple treasury, even after they had read the whole text to him. The saints and theologians of the early church spent hundreds of hours poring over the Bible. People like Origen, Macrina, the Cappadocian Fathers, Jerome, Augustine, Ambrose, and Cyril of Jerusalem not only wrote interpretations of texts but also devised means and procedures to help others interpret the other biblical texts. Some of their practices are employed to this day—as in the case of Origen, his methods of textual criticism. In our own time, universities, seminaries, and schools of theology continue this great tradition with their own faculties and students.

When reading Scripture, monks and nuns of the early to late medieval period followed the tradition of the church's theological forebears, a tradition more attuned to seeking wisdom than factual knowledge. Their reading and study came to be called *lectio divina*, wherein, as you may recall, one strives to have one's whole being become infused with the sacred text. Because the cloister determined so much of the culture, the whole society was awash with Christian symbolism—much of it prompted by Scripture. *Lectio divina* created a worldview, or interpretive matrix, whose effects are evident in the art, architecture, music, and literature of the past.

In church tradition, *lectio divina* has never been considered a simple or uncomplicated process in which a person isolates him- or herself from worldly distraction and knowledge only to read the Bible and interpret it without the aid of any commentary. On the contrary, the people of late antiquity through the Renaissance and up to the Enlightenment studied commentaries and

other works to help them decipher the biblical texts, and the great libraries of the monastic houses are ample evidence of the seriousness of this endeavor. Indeed, serious students and scholars still employ a variety of secondary literature to help them through a difficult text.

The monks and nuns also carried their world into Sacred Scripture. Thoughts, meditations, and responses to creation and its seasons found biblical metaphors on which to rest, while, simultaneously, these same metaphors arose almost subconsciously to interpret one's daily life. There was no such thing as a distraction in prayer or reading; everything that entered into their mind was for a reason, and it was the back-and-forth nature of *experience—created world—liturgy—Bible—reading* that constructed their thought system, which was always directed toward union with Christ. Far from being a simplistic answer to biblical interpretation, *lectio divina* demanded one's best efforts, mind, intelligence, imagination, and senses in order to find meaning in Sacred Scripture.

In the first chapter, I discussed the ancient fourfold way of interpreting Scripture, and I suggested how it is receptive to modern and postmodern means of biblical interpretation. The fourfold way allows us to respect and be inspired by Christian tradition while adding to that very tradition. It draws from both contemporary and traditional scholarship as well as all of our daily experiences, for nothing is a distraction; so-called distractions are thoughts that need interpretation.

READING *THE SAINT JOHN'S BIBLE*

Most often we read individual books or sections of the Bible; rarely does anyone read it from cover to cover. An outcome from this habit is that we can conclude that the Bible's individual parts really do not form a whole. Even commentaries are written specifically for this book or another, and if one has a commentary on the whole Bible, each book is treated as an individual unit, with only the slimmest connection to any other book.

In their theological and exegetical input to the artists working on *The Saint John's Bible*, the CIT has maintained that the Sacred Scripture is a unified work[1] that, despite or rather because of its ambiguities, contradictions, and various errors in facts and details, tells a complete story of salvation and redemption from the first word in Genesis to the last word of Revelation. All the individual books have a link or a series of links with each other, including a theological connection between the Old and New Testaments. The foundation of interpreting *The Saint John's Bible* rests on the interplay of text and image; the handwritten text of the NRSV informs the image, and the image informs the text.

1. *Unified* by no means implies *uniform*.

In order to prepare its theological briefs to the Scriptorium in Wales, the CIT employed four discussion categories:

1. historical-critical exegesis situating the text in its time, place, and authorship as far as any of these can be determined
2. scriptural cross-references, by no means exhaustive, offering selected citations of other books and verses in the Bible that shed light on the interpretation
3. local associations referring the reader to anything in the Bible having particular meaning for Saint John's, its environs, or the upper Midwest
4. free associations describing the stream of consciousness within the CIT's common *lectio divina*

I have attempted to provide information for nearly every visual interacting with the text, from marginalia to full-page illumination; yet not every piece has the same degree of explanation. Some texts are more complex than others, and while all were chosen to correspond to the framework of the project plan, there are biblical passages that have greater resonance in doing so. In addition, as artistic director of the project, Donald Jackson made many decisions for the sake of maintaining the artistic integrity of the volumes. Some images are laden with theological significance, and others are simply for enjoyment, this is itself a spiritual and theological virtue which can also lead to greater theological and spiritual insight.

In the following pages, I have combined the categories historical-critical exegesis, local associations, free associations, and scriptural-cross references. For each of the depictions in *The Saint John's Bible* there is a corresponding commentary, each possessing the same form:

1. *Title* presenting the piece, biblical citation, and name of the artist
2. *Background* featuring a general historical-critical explanation
3. *Image* alerting the reader and viewer to what is taking place on the page. This section also includes the other categories used by the CIT, such as local and free associations
4. *Scriptural cross-references* providing a selection of other biblical passages that theologically either recapitulates, foreshadows, echoes, or expands what is on the current page. If they seem haphazard, they are so because of the CIT's *lectio divina*. Readers should be inclined to add their own.

At no point will the reader find a complete explanation of what the image means. There is very little one-to-one correspondence between a depiction and its definition. All the visuals are polyvalent; they can have different meanings

in different places in the Bible, or they can have the same or nearly the same meaning as they move from one image to the next. They are, however, related to the overall interpretation of the text. The critical factor that completes the interpretation is what the viewer brings to the text. As with *lectio divina*, we give meaning to our experiences through the encounter with the Bible, and from that encounter, our experiences help to give the Bible meaning. With historical-critical exegesis grounding the text, with the scriptural cross-references supplying the intratextual input, and with our own thoughts and experiences collectively or individually offering the intertextual influence, engaging *The Saint John's Bible* will be a most enriching exercise. Reading and viewing it is not a static experience.

I have listed here a series of visual leitmotifs[2] that should be of great benefit in helping the reader see the related nature of the whole Bible as well as interpret a great many passages. I offer some explanation of them, but, aware of their polyvalent nature, none of us can say that "x" means "y" in every occurrence in *The Saint John's Bible*. The meaning will shift depending on whether "x" is in the foreground or background, is large or small, is dark or light, etc.

Readers might find some explanations abrupt, misplaced, or incongruous. Bear in mind that the information provided represents elements of streams of consciousness. If they are jarring, let them feed your consciousness, too.

Whether or not the viewer is Christian, the only requirement is that he or she realize this is a *Christian* Bible. The general frame of reference is the two thousand years of Christian faith, theology, liturgy, and art from both East and West, Catholic and Protestant. In addition, because Christianity cannot be understood outside the context of biblical Judaism, there are Jewish reference points as well.

While some books in *The Saint John's Bible* do not contain images or special treatments, readers are encouraged to study the calligraphy within them. Inks and quills form their own interpretation of the Word of God.

Visual Leitmotifs

abbey and university church. The Catholic Church is both particular and universal. Christianity is found everywhere across the globe, on six continents and in nearly every culture and land. References to Saint John's Abbey and University surface in images of the bell banner, fluted walls, hexagonal beehive patterns, and ceramic flues, either individually or in any number of combinations. The Stella Maris chapel, erected over 130 years ago on the shoreline of Lake Sagatagan opposite the abbey and university church, also appears in some depictions. We cannot look at these features without thinking of the local faith community as well as global Christianity.

2. *Leitmotif* is a recurring theme in a musical piece, usually associated with a particular character. I have adapted it for hermeneutical use by applying it to visual reference points running through the whole of *The Saint John's Bible*.

angels. From the Greek word meaning "messenger," these supernatural beings are expressions of God's grace wherever they appear. They cannot and do not live apart from God and are found in both the OT and NT.

Aramaic lettering. As an acknowledgment of the language Jesus used in his ministry as well as that of the earliest Christian communities, and to draw attention to the precarious existence those same Christian communities find themselves in today, *The Saint John's Bible* includes the Aramaic versions of texts wherever any of the evangelists have transliterated them: Mark 7:34; 15:34; John 20:16. By this effort, we hope to show the universality and continuity of the church.

book headings. Every book in *The Saint John's Bible* opens with a heading. Each is unique, and some are either decorative or historiated. Likewise, every chapter begins with a decorative capital, and in the whole *Saint John's Bible*, no two capitals are the same.

bread. Wheat has been called the "staff of life," and anthropologists tell us that it was among the first cultivated grains. No other cereal contains as many nutrients as wheat. Wheat's other great advantage over every other grain is how its high gluten content responds to the fermentation process engendered by yeast. When the mixture of flour and water rises, the grains' sugars release carbon dioxide, causing the moist dough to expand. The process makes the bread digestible and tasty. Unleavened bread is one of the elements for the Christian Eucharist, though in the Christian East, the bread is generally leavened to reflect the risen Christ.

buildings. The backdrop for a number of images shows buildings in a variety of architectural styles and from different historical periods, often with the double-arched doorway of the Basilica of the Resurrection (Holy Sepulchre) among them. Some of the constructions appear as houses, others as churches or houses of worship, and still others as commercial structures. Buildings are among the most enduring witnesses of human habitation through time. We shape them and they, in turn, shape us. They express our hopes and dreams at a particular point in time, and they relate those same hopes and dreams to future generations. Archaeology has shown that civilizations often incorporate the material from earlier buildings into the foundations and walls of new ones.

butterflies and butterfly wings. The work of the botanical artist Chris Tomlin graces many of the pages in *The Saint John's Bible*. While there are various species of both plants and animals, the most noteworthy seen in this Bible are butterflies, specifically monarchs. Highly poisonous, the monarch butterfly's brilliant orange and black coloration warns birds and other predators that to eat the monarch is to die. The monarch itself imbibes the toxins from the milkweed plant, the preferred food source for its larvae.

These butterflies migrate from north to south in the late summer, and in the spring reverse their course, spanning from northern Mexico to southern Canada. It is not unusual to see the forest trees at Saint John's covered with their fluttering bodies in August as they prepare for the journey. Remarkably, the roundtrip occurs over three or four generations, for a monarch lives but two months as a butterfly, having first passed through the stages of egg, caterpillar, pupa, and chrysalis. Butterflies are constantly undergoing a transfiguration or metamorphosis of some kind.

calligraphy. Literally, "beautiful writing," the term describes the penmanship used in the folios of most medieval manuscripts, and so too in *The Saint John's Bible*. The elegance,

balance, and rhythm of the calligraphic pen strokes help to ensure that the medium is also the massage: the Word of God is beautiful to behold.

Calligraphy in the West changed over time according to the established centers of learning and influence throughout Europe. These centers, most often monasteries, produced the Bibles that have been handed down to us, and while these works are in various scripts, they share a point in common in that the calligraphy reflects the peculiarities of Latin. The earlier scripts, therefore, would not function well for a Bible handwritten in English. The strength of the English language is its short, strong, monosyllabic words. When these words are written across sheets of vellum, however, they appear as dots and blotches. To remedy the problem, Donald Jackson developed the unique hand employed in *The Saint John's Bible*, and every one of the calligraphers had to be able to replicate it meticulously. Its firm and delicate quality assists the eye and ear in presenting each folio with the resolved tension of a symphonic chord.

In studying the folios, readers should delegate time to focus solely on the written text from such a distance that the words appear illegible. Doing so will allow the harmony of ink upon vellum to make itself known. In addition, readers should be attentive to the slight variations in the calligraphy where the literary genre switches from prose to poetry, for example, from the Historical Books to the Psalms. In like vein, all should be aware of the special treatments that occur frequently throughout these pages as a means of spotlighting or increasing the volume of any number of passages.

carpet page. This is a technical term. Historically, when scribes reached the last page of a particular book, they would fill in any remaining open space on the parchment with a design that visually would complete the folio. In the case of *The Saint John's Bible*, the scribes employed some element from other sections and volumes as the basis for a certain carpet page's artwork such as angel wings and trees.

cherub. We sometimes think of a cherub (plural, cherubs or cherubim) as a chubby little angel looking up at paintings in a baroque church. In the Bible, however, cherubs belong to the second highest choir of angels, and their job is to guard God in the heavenly court. For this reason, they make it into the design for the ark of the covenant and, ultimately, within the architecture for the Jerusalem temple. Unlike a seraph, a cherub has only two wings, but within *The Saint John's Bible*, the cherub wings are indistinguishable from those of the seraphs.

DNA. Biology tells us that DNA is a molecular strand organized into a double helix that determines who we are and everything in our biological makeup. Both mother and father contribute to a child's DNA. Genealogies in the Bible are found throughout the Pentateuch, the historical books, many of the prophets, and even in the gospels of Matthew and Luke, and their use underscores that the God of Abraham and Sarah, Isaac and Rebecca, Jacob and Rachel is one who acts in history. The story of the Bible is the story of God's relationship with his own created humankind. Look for how Jesus' DNA blends both human and divine natures.

double-arched doorway. The Basilica of the Holy Sepulchre or the Resurrection (Basilica of the Anastasis in the Eastern Church) currently marks the oldest and most venerated site in Christianity since before Constantine (i.e., the place of Calvary and Christ's resurrection). While Constantine's basilica was destroyed by the Muslim Fatimid Caliph Hakim in

1009, parts of it have been used in the basilica's Crusader-era reconstruction done in the Gothic style. The double-arched doorway is a recognizable feature of this edifice to this day, and it forms a stamped background to many of the images in *The Saint John's Bible*.

enthroned God. In the accounts describing the heavenly court or temple visions, God sits high above, appearing in the artwork as blinding white light framed by a window.

fish. Scientific evidence shows that all life began in the sea. The apostles were fishermen. Jesus sailed on the Sea of Galilee, walked on it, and miraculously multiplied loaves and fishes on its shoreline. For the early church, the Greek letters for the word "fish" (*IXΘΥΣ*) stood for *Iesus Xristos, Theou Uios, Soter*—that is, *Jesus Christ, God's Son, Savior.*

The stamped print of fish surrounding a basket is based on a Byzantine mosaic in the stone under the altar at Tabgha, Galilee. From earliest days, this mosaic located the spot where (tradition says) Jesus multiplied the loaves and fishes. In 1982, German Benedictine monks built a new church on the foundation of the Byzantine ruins for use in daily worship by the monks and visiting pilgrims, preserving all the priceless mosaics in the process. Thus, the fish mosaic pattern links the Gospel to the Christian tradition of pilgrimage to the Holy Land as well as highlighting the Benedictine connection to Scripture, hospitality, pilgrimage, and natural beauty accented by outstanding architecture.

flora and fauna. There are many gardeners, on both sides of the Atlantic, involved with *The Saint John's Bible*, and the love of their gardens often surfaces in the images. We also constitute animal lovers. Saint John's has an arboretum and wetlands on its property, influencing much of the flora- and fauna-related imagery. The plants, insects, and many of the animals reflect the goodness of God's bountiful creation. Flora and fauna are not without their own problems, however, as the presence or absence of species from one group can sometimes mean death to another; such is life in the natural world. With the exception of the Historical Books where insects and animals in the margins move the narrative line forward, the flora and fauna in the Bible form part of the marginalia and are there to please and delight. Despite their necessary blood in tooth and claw, according to Romans 8 both plants and animals also have a place in the redemption. Throughout *The Saint John's Bible*, they indicate where to insert into the text verses that the scribe accidentally forgot. See **butterflies**.

garden. Gardens are among the most restful, beautiful, peaceful, and refreshing spots where people can repose themselves. In the hot climate of the Holy Land and the neighboring countries, gardens filled with flowers and fruit trees reflect heaven on earth. Indeed, the word "paradise" means "garden" in Persian. In Christian tradition, *paradise* refers to eternal life with Christ; Luke, Paul, and the book of Revelation use it exclusively in that sense. A garden within the monastic cloister was often called the *paradisus*, for it was seen as the incarnation of what lay in store in heaven.

gold, silver, or black bars. These artistic flourishes are cast across a number of pages, some within a depiction and others along the margins. They serve a number of purposes. Foremost, they are used at the discretion of the artist to balance the shape, color, and presentation of an image. In addition, they sparkle and shine, delighting the eyes. Finally, they can have a theological purpose, which becomes evident within the respective image. Often, the bars may be fulfilling all three purposes simultaneously. Whatever they do, they further the experience and the interpretation.

lace pattern. As one of the great artistic media perfected by women the world over, lace patterns of different variety mark the composition of many of the images throughout *The Saint John's Bible*. The lace pattern is often, though not exclusively, used with images involving women. Things of beauty made by human hands not only reflect the grandeur of God but also reflect the dignity God has bestowed on humankind.

Lady Wisdom or Wisdom Woman. God is all-knowing and the source of all wisdom, as the biblical texts make clear. This understanding of God's wisdom develops to the point that wisdom becomes personified as Lady Wisdom (Wisdom Woman) by the time of Christ's birth. Early Christian theologians, reflecting on such biblical books as the *Wisdom of Solomon* and *Proverbs*, express the idea that Lady Wisdom is actually the preexistent Christ, that is, Christ before he becomes incarnate. This Christology lays the foundation for trinitarian theology. The venerability of this tradition is seen in the magnificent church built by Emperor Constantine and remodeled by Emperor Justinian in ancient Constantinople, Hagia Sophia. In *The Saint John's Bible* the Wisdom volume emphasizes Lady Wisdom.

lambs and sheep. Among the earliest of all domesticated animals, sheep and lambs are mentioned throughout the Old and New Testaments. Lambs are associated with Passover and the Eucharist, therefore becoming identified with Christ, the Lamb of God. In these pages lambs and sheep do not appear with their tails bobbed. It is too painful for them, and shepherds do not practice it anymore in Great Britain.

leaf. A single green leaf, either alone or in clusters, is stamped on a number of pages and images in *The Saint John's Bible*. The leaf's veins are evident. The energy a leaf takes from the sunlight releases the oxygen from the water within the plant, and, in so doing, the leaf absorbs the earth's carbon dioxide so that the plant can make the sap to feed itself. Moreover, plants become food for animals. Where there are plants, there is life. See **flora and fauna** and **garden**.

menorah. A seven-branched candelabrum that has become a central symbol of Judaism.

monsters. Be afraid; be very afraid. These creatures are always evil and never good. If they remind you of Satan and his ilk, do not doubt your intuition. Nonetheless, there is nothing so hard that Christ's love cannot melt.

prehistoric pictographs. Scientists tell us that *Homo sapiens* walked the earth before recorded history. Indeed, humankind's paintings and carvings on the walls of caves and cliffs are among the earliest record we have of human existence, and they date from about 197,500 years before the first word of what we consider a biblical text was ever written. Just because earlier species of *Homo sapiens* lived before people like Abraham and Moses does not mean that they are excluded from God's plan of salvation.

rainbow. God is light,[3] and when light is refracted through a prism (i.e., water droplets) it appears in the full spectrum of its component wavelengths; in *The Saint John's Bible*, seven colors predominate. A rainbow is one of the attributes of the heavenly court.[4] In addition, it represents God's covenant with all humankind after the flood.[5] In literature, the rainbow is often a metaphor for ultimate fulfillment. Likewise, the *telos* or "goal" of the

3. Tob 5:10; Ps 18:28; 118:27; Wis 7:26; John 3:21; 2 Cor 4:4, 6; 1 John 1:5; Rev 21:23.
4. Rev 4:3; 10:1.
5. Gen 9:11-13.

Christian life is union with Christ made possible by his dying and rising for all human-kind. The rainbow, therefore, can also represent the loving, inclusive union with Christ.

raven. We might be inclined to mistake a raven for a crow, but they are birds of a different feather, even though they might look very similar. Ravens appear in the Bible. One is the first bird Noah sends out from the ark (Gen 8:7), and a flock of them bring food to Elijah in the desert (1 Kgs 17:4-6). Even Jesus uses ravens by citing them as examples of faith in God (Luke 12:24). Perhaps because of their gregarious behavior and high intelligence, much folklore views ravens as all-knowing; one story relates how a raven carried off and hid a poisoned loaf of bread intended for Saint Benedict.[6] And, of course, who can think of a raven without also thinking of Edgar Allan Poe's poem *The Raven*—a masterpiece of internal rhyme and alliteration.

Saint John's cross. Artists' interpretation and imagination over the centuries have changed the design of the cross upon which Christ was crucified. The cross that represents Saint John's is recognizable by the flanges on each of its ends and by the small spike at the bottom. It is modeled on the crosses Christian pilgrims carried with them to the Holy Land as well as other religious sites. At night the thin spike was pushed into the dirt near their bedding so that pilgrims could be under Christ's gaze while sleeping. A clear example of the Saint John's cross sits atop the bell banner of our church.

In the pages of *The Saint John's Bible* the Saint John's cross in the margin marks biblical verses quoted and used in the RSB. Within the images themselves as well as representing the passion and death of Christ, this particular cross associates this Bible with the place that sponsored it.

seraph. A seraph (plural, seraphs or seraphim) belongs to the highest choir of angels whose job it is to sing eternal praise to God. Isaiah describes them as having six wings, as does Revelation. Ezekiel mentions creatures with four wings and four faces. Art from ancient Mesopotamian civilizations depicts six-winged creatures with features composed of the faces of lions, humans, and eagles. *The Saint John's Bible* shows them as wings.

Stella Maris Chapel. The term *Stella Maris*, meaning "Star of the Sea," is an ancient title attributed to the Blessed Virgin Mary. Mariners throughout the ages often looked to the Blessed Mother to guard and guide them on the high seas, hence the appellation. On the southern shore of Lake Sagatagan, opposite the Breuer-designed church, sits the small Stella Maris Chapel; it is one of the most beloved spots on campus and, in a certain way, a pilgrimage site for students, monks, faculty, oblates, staff, and visitors. See **abbey and university church**.

tapestry. As with lace, tapestry weaving has been a woman's occupation in preindustrial societies. Carpets, cloths, wall-hangings have been coveted treasures for royalty and the wealthy for centuries. On a more modest level, women have supplied their families with clothing and shelter through their abilities at the loom. As the handicraft of domestic love and for the protection they provide, tapestries and the ones who make them reflect the love of Christ.

temple. The Jerusalem temple has fed the imagination of theologians, exegetes, poets, artists, and architects for thousands of years. David wanted to build a house for the

6. See Gregory the Great, *Dialogues*, 2.8.

ark, but the Lord gave that honor to his son, Solomon. The Bible goes to great length explaining the various features, size, materials, and means of construction that went into this edifice (1 Kgs 5–7). Unfortunately, the Babylonians destroyed it all in 586 BC, when they took Jerusalem and deported its inhabitants.

When Cyrus the Great of Persia allowed the populations captured by the Babylonians to return to their respective homelands, the Jews planned to rebuild the Lord's house. Much of that effort is described in Ezra (ca. 465–424 BC), and from that point until the reign of King Herod the Great (ca. 73 BC–AD 4), it was rebuilt and remodeled at least once, under the Hasmonean dynasty (164–163 BC).

Herod the Great undertook the greatest rebuilding of the temple, however, so that by every description, both biblical and nonbiblical, it was considered one of the most beautiful marvels of the age. Completed in AD 63, long after Herod's death, this glorious structure was utterly destroyed by the Romans during the First Jewish Revolt in AD 70. From this point on, Judaism went from religious practice centered on the sacrifices and rituals of the temple cult to a faith based on fulfilling the precepts of the Torah or Jewish Law, known as rabbinic Judaism. The temple ruins are visible to this day.

wheel. As one of the great inventions in human civilization, and so important for travel and transportation, wheels as symbols exist in nearly every culture, including Egypt and Mesopotamia. These great powers, with their thousands of chariots, constantly threatened Israel. Wheels turn, and so does fortune.

wind. God's creative breath. See **Lady Wisdom**.

wine. The psalmist says, "You cause the grass to grow for the cattle, and plants for people to use, to bring forth food from the earth, and wine to gladden the human heart, oil to make the face shine, and bread to strengthen the human heart" (Ps 104:14-15). An Italian saying states, "A meal without wine is like a day without sunshine." Jesus drank wine and evidently enjoyed it very much (Luke 7:34). Wine is one of the essential components of the Eucharist, and it is promised that the heavenly banquet will flow with wine.

Special Treatments

Throughout *The Saint John's Bible*, special attention is given to particular verses of Scripture. No image accompanies these verses; rather, the script differs noticeably from the surrounding text in size, shape, and color. Called "special treatments," these verses increase the volume of the passage so that the reader can give them focus and attention. The CIT chose the verses for special treatment based on the significance of the text for Christianity and history. The rules of interpretation for a special treatment are the same as those for full images: context, both immediate and broad, determines the meaning.

Chapter 5

PENTATEUCH

INTRODUCTION

Whenever the people of any civilization reflect on the universe and their place within it, creation stories arise. The first eleven chapters of Genesis, often called the primeval history, are but one example of such cosmic creation myths. Many of the accounts we read in these chapters stem from the Gilgamesh and Enuma Elish epics of Mesopotamia. That these stories came to be part of the Judeo-Christian tradition is not too surprising since the land and people from which they sprang were part of the Fertile Crescent. Trade and war always yield cultural exchange and adaptation. The remarkable feature is not that the foundational myths of our faith have their origins in a polytheistic milieu but rather that they were significantly changed to reflect love and goodness of the one God whom the forebears of our faith worshiped. The central theme of Genesis, therefore, is that God and his creation are good; evil enters when prideful humans, the noblest of the creatures, decide to go their own way. Genesis not only relates humanity's fall from grace but also begins the saga, in chapters twelve through fifty, on how God begins to redeem his people.

As narratives in Genesis and Exodus unfold, the names of the men and women foundational to the faith surface. These individuals, along with their progeny and relations, will increase in number as they become the chosen people of God. While Leviticus contains mostly cultic legislation for the temple priesthood, its purpose is the well-being of the community. Numbers expands the stories of the desert wandering of the Israelites, while Deuteronomy reiterates much of Exodus but from a different perspective.

GENESIS

Creation frontispiece
Genesis 1:1–2:3; Artist: Donald Jackson, with contributions by Chris Tomlin

Background

If one were to rank the most controversial passages in all of Sacred Scripture, the creation passages in Genesis would be first among the top ten. How to interpret an account that speaks about the fashioning of the cosmos from

chaos, in the course of six days, while evolutionary biology has convincingly demonstrated that it has taken billions of years for the earth as we know it to come into existence? For many people, these first chapters of Genesis scratch the line in the sand between believers and atheists. Either we believe in God and hold to the creation of the universe as spelled out in Genesis, or we stand with the secular humanists and declare God a hoax and delusion.

The CIT sought to rectify this false dichotomy. The Galileo debacle and other wrong decisions notwithstanding, the two thousand years of Christian tradition have not been hostile to scientific inquiry, and scientific inquiry has not been hostile to belief in God. Most tensions between the two arose after the Enlightenment, with the fracturing of knowledge into certain disciplines, and fracturing, all too often, breeds suspicion and arrogance. The CIT, as part of the spirit of the Bible project, wanted to continue bridging the gap that has developed between the theological and scientific disciplines.

Science and theology pose to us two different yet complementary questions. Science asks the question, "How?" How do we have the universe as we see it? How were the universe, the solar system, the earth, plant, animal, and human life formed? Theology on the other hand asks the question, "Why?" Why a universe, a solar system, an inhabitable life-supporting earth in the first place? Why are humans sentient, conscious, and self-reflective beings who long for completeness, salvation from death, and life without evil and suffering? Theology cannot adequately respond to the questions science poses, and science cannot sufficiently reply to the probing issues theology raises, although with the discovery of the Higgs-Boson particle and continued findings in quantum theory, the lines separating the two disciplines are becoming more permeable. The answers of one do not disprove the evidence of the other. How these two fields of inquiry support and enhance each other is best done by metaphor, which the full-page illumination attempts to develop.

Image

Functioning as the incipit or first page of Genesis, this image shows seven vertical bands representing the six days of creation plus the Lord's day of rest, running from left to right. The first panel corresponds with the opening Genesis 1:1-5. The Hebrew lettering in the lower left corner spells *tohu wa bohu*, a term that means "formlessness, confusion, chaos, and emptiness," best rendered in English by the phrase "formless void" (1:2). God breaks into this cold and empty chaos by causing light to enter the darkness. How does God do so? Astronomers and astrophysicists have developed the Big Bang Theory, which describes a moment—a nanosecond—in which an explosion sent all matter racing from its core. Their estimates place the Big Bang twelve to fifteen billion years ago.

The Big Bang Theory is constantly being revised and honed as new evidence comes to the fore. Rather than disprove what these scientists are saying, however, the new information shows the delicate complexity of the theory and ultimately demonstrates the grandeur of God. Scientific theories about the origins of the universe also honor humankind to whom God has given the abilities to probe and ponder the great mystery of God's creation. Once again we are left asking, "Why?"

The second panel presents the separating of the waters by creation of the sky (Gen 1:6-7). To understand this image, we have to look to how the ancients conceived the world. Earth and everything in it was like a geodesic dome. Inside the dome, all was good and ordered. Field, farm, mountain, river, and everything needed for survival were contained within the dome; even the sun and moon moved within the sphere. This dome, sometimes referred to as the "firmament,"[1] rested on the "pillars of the earth."[2] Surrounding the outside of the dome was chaos and water. Rain occurred whenever God opened the skies, like windows, to let the water shower in.

We have to credit the ancient peoples for considering the world in such a way. From the observable data available to them, a dome in the midst of a great ocean makes a great deal of sense. The uncontrollable power of the ocean represented unbridled chaos for the people, and it is God's act of love that brings order out of that chaos. Today, as we have more ways to gain data as well as observe it, we know that the universe is tremendously larger and our solar system ordered in a system entirely different from the way the people in the Fertile Crescent imagined it during antiquity.

The third panel continues with the dome model, and in this act of creation, the water remaining within the dome is put in order (Gen 1:9-10). The image used for creation of dry land is based on a satellite photograph of the Ganges Delta. This depiction gives not only a good rendition of land-water separation but also a visual reference to modern science by utilizing the Ganges Delta as viewed from space. In addition, it moves the horizon of God's creation from the lands of the Mideast to another civilization. Now that God has fashioned the sea and land, God calls vegetation into being (Gen 1:11-12). The lush greens of the image characterize a land in which there is no want. This panel and the narrative form a beautiful picture of the dependence of all life on water, both for its origins and for its sustenance.

The fourth panel for the fourth day of creation evidences one of the great inconsistencies in this first chapter of Genesis. The creation of the sun, moon,

1. Ps 19:1; Ps 150:1.
2. 1 Sam 2:8; Job 9:6; Ps 75:3.

and stars on the fourth day (Gen 1:14-19) forces the reader to inquire about the source of the light on the first day. It is a perfectly legitimate question to ask if we are reading the text as a literal history of the universe. In fact, the question itself shows the flaw of such a reading. Interpreting the whole Genesis account goes much better if we stick to this passage as the *why* and not the *how* of creation.

In day one, the light symbolizes the love of God that penetrates the dark and meaningless chaos so that created order can follow. In day four, the sun, moon, and stars ensure that chaos will not return by providing human beings the means to navigate through darkness as well as mark hours, days, and seasons. They are part of the created order that guarantees order. The image is very subtle, with the large disc representing the sun fixed above the smaller disc representing the moon. Moreover, these heavenly bodies are all under the dome of the sky, well within the realm of created order.

The fifth panel, day five, seems to burst with life, both in the sea and sky. In a wonderful display of the life-giving potential of the sea, the fish come upon the scene before anything else (Gen 1:20-23). Scientists tell us that all forms of life on earth originated in the sea. The panel acknowledges that detail by using fossil images of fish, now extinct, dating millions of years back into history. Birds swoop through the air above, giving this panel great life and energy.

The sixth day brings the climax of creation. God calls into being all land animals as well as humans (Gen 1:24–2:1). Prehistoric cave paintings supply the human images, again as a way to acknowledge our evolutionary forebears. Taken in its totality, this story of creation progresses in a hierarchy from physical and inanimate creation, through all the things necessary for a good life (ordered universe, lush vegetation, abundant sun and water) to mammals and, finally, human beings. There is no doubt that the Genesis writer sees humankind at the top of the hierarchy, and the text strongly suggests that the same writer underscores gender equality. Humankind is first created as a species and then differentiated between male and female.

The text speaks about the dominion that humankind is to have over the animals and the rest of creation. This dominion is not exploitative. From humans, as creatures to whom the most has been given, the most will be expected. In addition, God sees this creation as "very good" (1:31), and humans have no right to destroy it; indeed, they have an obligation to safeguard it and see that all creatures live the lives for which God created them, to be fruitful and to multiply (1:28). This theme recurs in other parts of the Bible.

To crown the glory of God's creation, the writer makes special note that God rests on the seventh day. This day of rest belongs totally to God, hence the abundance of gold, but it is connected to the creation of the universe,

as it stands as the successive and final panel. According to Jewish tradition, the Sabbath day is human participation in God's rest. It is a blessing that God extends to human beings.

The inspiration for many of the images comes from a variety of sources, which in their own right provide the theological and interpretive vision of Genesis. In Genesis 1:1–2:3, the stars, moon, and sun in the cosmos echo the star maps of the heavens over the centuries. The attention focused on the sea reflects evolutionary theory, which maintains that all life began in the oceans. Humankind's creation at day six features figures from early cave paintings in Nigeria. A woman holds the hunter's bow while other men and women occupy the lower register of the panel. At their feet is a very slight design of the snake, which makes its appearance in Genesis 3. The upper register shows the background of a volcanic eruption. The gold, imageless shaft for day seven marks rest, renewal, and the presence of the Spirit. Great movement marks these images as if to say creation is ongoing; it is never static.

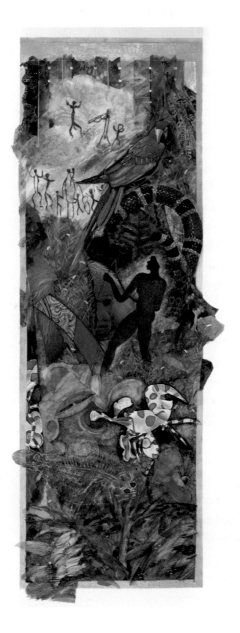

Scriptural Cross-references
1 Samuel 2:8; Job 9:6; Psalms 19:1; 75:3; 150:1

Adam and Eve
Genesis 2:4-25; Donald Jackson with contributions from Chris Tomlin

Background
In the textual tradition, there are two creation passages: Genesis 1:1–2:3 and Genesis 2:4-25. These come from two different sources and from different times. At a later stage in the development of the Pentateuch, they were combined, and combined so well that readers and worshipers barely see the break. Theo-

logically, people have read them as one and simply glossed over the inconsis-
tencies; doing so is not a problem as it merely demonstrates once again the
richness of the tradition.

In this second account, the man and woman are created first, and then
the rest of the living creatures, the reverse process of Genesis 1:1–2:3. In each
case, the human being is considered the crown of creation. In Genesis 1:1–2:3,
the line of development is from least to greatest, and in the second, Genesis
2:4–3:1, it is greatest to least.

When first created in 2:7, the living being, although called "man" in the
text, is without gender. There is no individualization and thus no full person-
hood until 2:23, when the woman is presented to what is now a gendered man.
She does not come from the head or feet of the human being, but from the
rib, the very side. The man and the woman are equals with equal honor and
responsibility. The differentiation of the woman and man from the original
human being completes the creation of humankind.

Image

We see the lush, blossoming, and rich Eden in all its splendor. There is no
want, pain, or suffering, for all creation is innocent of evil. Only one thing is
necessary: the man and the woman are not to touch the tree of knowledge of
good and evil in the center of the Garden. The cave art and the color palette
connect this creation story to the one in Genesis 1:1–2:3.

While separate accounts, the faith community has long seen the two as a
unified story, and the visuals for the Genesis creation narratives follow suit.
Donald Jackson fuses the two versions through the color and texture of the
images. Moreover, both accounts acknowledge the divine purpose in the
evolutionary process, from physical creation to human life.

The Fall
Genesis 3:1-24; Donald Jackson with contributions by Chris Tomlin

Background

The image of the Fall stands as a complementary panel to the second
creation story. The Lord God gives the command not to touch the tree in the
center of the Garden, that is, the tree of knowledge of good and evil (Gen
2:16-17). Thus, by knowing all that is both good and evil, we can also know
everything between. The prohibition is more a proclamation that humans,
despite all the tremendous gift of intellect has given to them, are not to know
everything. Only God knows everything.

Enter the serpent. Playing on the pride of human beings, the serpent craftily twists the curiosity inherent in the beauty, joy, and wonder of creation into overreaching arrogance by casting the Lord God as a manipulative deity: "You will not die; for God knows that when you eat of it your eyes will be opened, and you will be like God, knowing good and evil" (Gen 3:4-5). The ruse works, and the first couple follow the serpent's perverse advice with barely a reservation.

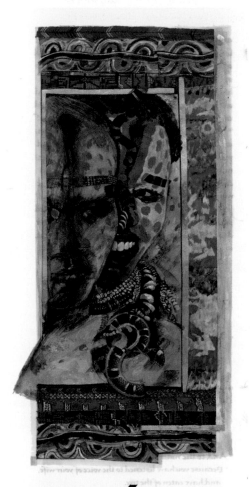

Image

Their insatiable pride undoes the goodness of the created order. In this image, Adam and Eve have lost eye contact with the viewer and with each other. Anger and distrust registers on their faces of deathly pallor. The serpent, represented by a coral snake, one of the most poisonous reptiles in the world, lands like a broken necklace and separates Adam and Eve from each other. Even the vegetation has lost its luster. Fabric patterns, a Peruvian feather boa, and African body paint reference the sewing of "fig leaves together" for clothing (Gen 3:7).

This illumination depicts the fracturing of the ordered goodness of God's creation. The couple's face-to-face relationship with the Lord is broken, their trust and devotion to each other is severed, and their oneness with the rest of creation is cut into pieces. The three images—Six Days of Creation (1:1–2:3), Creation of Adam and Eve (2:4-25), and the Fall (3:1-24)—are a triptych telling a single story of the goodness of creation and its undoing. As a result of pride and arrogance, paradise is lost.

Banishment from the Garden of Eden is a form of excommunication. For citizens of ancient Rome who could not be tortured or crucified, banishment from the community to an unknown land was the supreme form of punishment. In the RSB, excommunication is a form of banishment from the monastery, leveled against those who have committed a serious fault and who refuse to repent. It is considered the worst punishment an abbot or abbess can mete out to a recalcitrant monk or nun. In both cases, people are banished from the very place that gives their lives meaning, comfort, joy, and support—attributes found in the Garden of Eden, which in this account of Genesis, is lost forever.

As the Christian tradition develops, the Garden becomes less a place from which humans were expelled and more the existence for which they are destined, which is exactly the theology of Revelation 22. For example, in the Roman Catholic funeral rite, the *In Paradisum* is the last hymn sung in the church before the body is taken to the cemetery.

> In Paradisum deducant te Angeli;
> in tuo adventu
> suscipiant te martyres,
> et perducant te
> in civitatem sanctam Jerusalem.
>
> Chorus Angelorum te suscipiat,
> et cum Lazaro quondam paupere
> aeternam habeas requiem.

> May the Angels lead you into Paradise;
> at your arrival
> may the martyrs receive you,
> and lead you
> into the holy city, Jerusalem.
>
> May the chorus of Angels receive you,
> and with Lazarus, who once was poor,
> eternally may you have rest.

Scriptural Cross-references

Exodus 20; Isaiah 35; John 20; Romans 8:19; Revelation 21–22

The Call of Abraham
Genesis 15 and 17, Donald Jackson, artist

Background

Reading through Genesis we see at chapter 12 a shift in the genres of the stories. The first eleven chapters deal with biblical myth. The details are not factual, the language is metaphoric, and the themes are existential; these chapters explain the "why" of creation.

On the other hand, as a literary genre, the material found in Genesis 12–50 is legend, whose details lie within the realm of possibility and probability. For Abraham and Sarah, Isaac and Rebekah, Jacob and Rachel to have existed accords very well with the history of ancient Mesopotamian culture. The details deal with "who" and the "how" of a nation. The themes focus on the truth of God's abiding love for his people within the midst of human failing.

God calls Abraham, and it is through Sarah that the election is established. The text reads, "I will bless her [Sarah], and she shall give rise to nations; kings of peoples shall come from her" (Gen 17:16). To underscore the importance of

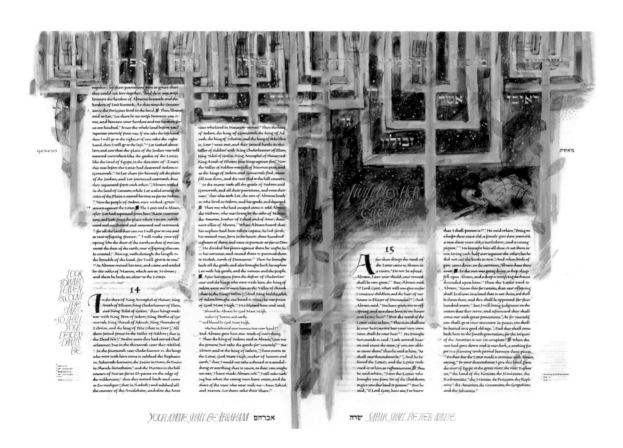

God's choice, God changes the names of both: Abram to Abraham, meaning "father of a multitude," and Sarai to Sarah, meaning "princess" (Gen 17:5, 15).

The Lord establishes a covenant with Abraham, which is outlined in the full-page illumination. It is actually one covenant with Abraham told in two different versions, a result of the two different sources, Genesis 15:5-21 and Genesis 17:1-27. In each, God promises Abraham both land and descendants.

In the first account, there is an existential experience in which Abraham, gazing at the nighttime desert sky, is awestruck. This experience leads to a description of an ancient covenant ceremony in which two parties of a covenant—that is, an agreement to share land and resources or even to maintain peace—would slaughter animals, cut them in half, and walk between the carcasses to symbolize that the agents of the contract would rather face a similar fate as the beasts than break the covenant. In these verses, the Lord God is represented by a flaming brazier.

The story in Genesis 17 shows a more communitarian approach to the covenant by having the Lord God calling for all males within the extended family and clan to be circumcised. The promise of the covenant is the same in each: The Lord has chosen Abraham from among all the inhabitants of the earth to be the father of many nations and thus promises him both land and descendants. This covenantal promise will not be broken despite the many trials both Abraham and his progeny must undergo. The first great test surfaces in the Binding of Isaac (Gen 22:1-24), when God seems to ask the impossible of Abraham.

Image

The Call of Abraham incorporates elements from both stories into a unified whole. The patriarch Abraham is represented on the left leaf of the two-page spread, while the right page forwards the matriarch Sarah. The shaded colors have the hue of twilight, and the shapes strongly suggest a menorah. Within the branches of the candelabrum are the Hebrew names of the Twelve Tribes of Israel, which trace their roots through Jacob, Rachel, Leah, Isaac, Rebekah, Abraham, and Sarah. The Lord God's words to Abraham float in the margins and on the center of the page. The names of both Abraham and Sarah are written in Hebrew at the bottom.

Seen on the right page is a bramble with a ram entwined inside; it is the visual reference to the binding of Isaac, Abraham's son through Sarah. God's command to Abraham not only threatens the very covenant just established but also puts to the test humankind's relationship to God. This story has two levels. On the historical plane, we should be aware that the neighboring cultures engaged in human—most often child—sacrifice. Because the angel prevents Abraham from killing his son, this account serves as an instruction to the Hebrews that their God does not expect such barbaric practices but rather forbids them. On the level of faith, the reader is drawn into the full implication of what a relationship with God means. Here, the angel stays Abraham's hand against Isaac, and a ram caught in a thicket is the substitute sacrifice. The day may come, however, when we might be asked to sacrifice something most dear to us, and there will be no staying of the hand. While the depiction contains no explicit scene of the binding, the reader knows that the narrative will soon turn to it. Moreover, in Christian tradition, the binding of Isaac is analogous to the sacrifice of Christ on the cross.

Jews and Christians look to Abraham and Sarah as their forbearers in the faith, and Saint Paul builds his whole theology of salvation on the witness of Abraham's faith. The green leaves sprouting from the old vegetation anticipate the palette in the Pauline Letters.

Scriptural Cross-references
Judges 13:2-24; 1 Samuel 1:1-23; Matthew 27:45-56; Mark 15:33-41; Luke 1:5-25; 23:44-49; John 19:25-30; Romans 4:1-25; Hebrews 11:8-15

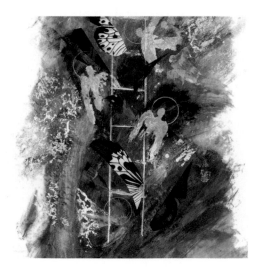

Jacob's Ladder
Genesis 28:10-16; Donald Jackson, artist

Background
The stories of Jacob's Ladder and Jacob Wrestling with an Angel (Gen 32:22-32) flank the main narrative dealing with the patriarch Jacob (Gen 29:1–31:55). Together, the three sections form a valuable lesson on how God can use weakness, failure, and even dysfunction to bring about a good end. By encasing the account of Jacob's familial dealings within two divine experiences, the affairs, tensions, and sins of this world are set

within a divine perspective; at the end, Jacob receives the name "Israel" as his progeny multiplies.

This story has a mystical quality. The covenant made with Jacob's grandfather, Abraham, is reiterated within a dream. The vision not only frames the experience of the covenanted people but also reaches the experience of holy people to this day. The interpretation of Jacob's dream is not obvious, but it is deeply significant. The angels stepping up and down the ladder sew together heaven and earth. It is a perfect visual rendition of the purpose of human life. Humankind finds its ultimate meaning in its unity within the abode of God.

Image

The fragmented butterfly wings flying or fluttering along the rungs of the ladder mix with the angels. The winged patterns, the gold, and the night sky translate the mystical quality of these verses even today. Jacob's Ladder as a monastic metaphor has a history nearly as old as Christianity itself. The great theologian and mystic Saint John Climacus of the monastery of Saint Catherine's at Mount Sinai wrote a spiritual treatise based on this passage, which, in turn, became the subject of a famous icon of a ladder reaching to heaven with most monks making it to the top and others falling off. Scholars believe that the story of Jacob's Ladder is the inspiration for chapter 7 in the RSB, the "Twelve Steps of Humility." It is also the subject of the great African American spiritual, "Climbing Jacob's Ladder," and inspires the song's beautiful imagery.

Jacob Wrestling with an Angel
Genesis 32:24-32; Donald Jackson, artist

Background

Not avatars, not independent beings, not secondary divinities, angels are instead manifestations of the presence of the one true God. As with the image of the ladder, this passage has deep spiritual and mystical overtones. If this angel comes from God, why is he wrestling with Jacob? The reason is not so clear except for the fact that the encounter well describes the experience many, if not all, have in his or her relationship with God. Jacob is not a likeable fellow. In collusion with his mother, Rebekah, he not only

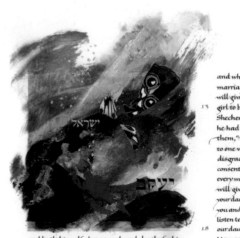

and wh
marria
will giv
girl to b
Shechei
he had
them,"
to one w
disgrac
consent
every m
will giv
your dau
you and
listen to
our dau
Hamor

and built himself a house, and made booths for his

steals the birthright of his brother Esau but also rigs it so that Esau cannot even receive a blessing from his father.

Jacob may be a consummate con artist, yet he morphs into a major player in the divine plan despite it all. At the end of the contest he is named "Israel" or "one who contends with God." In his struggle with God, Jacob becomes a role model for everyone seeking a relationship with God. God takes the humans he has created seriously, and if we are to take God seriously, we will have to wrestle hard and long—indeed our whole lives—to develop that relationship in the face of ambiguities, anger, and inconsistences.

The legal tenet about not eating the thigh muscle is an etiology.

Image

The twilight tones and the butterfly wings produce a panel that visually balances this story with *Jacob's Ladder*. As encounters with the divine, the two are connected; often, only when we fall do we begin wrestling with God. This piece is also one of the most abstract in *The Saint John's Bible*. God's role in human existence has many facets, both personal and communal, and yet no single description or rendition can explain them all.

EXODUS

Damsel Flies
Exodus 6 and 7; Chris Tomlin, artist

Flora and fauna decorate the pages throughout *The Saint John's Bible*, especially those species from Minnesota and the upper Midwest of the United States. The creatures pictured in the marginalia are damsel flies.

The Ten Commandments
Exodus 20:1-17; Thomas Ingmire, artist

Background

The Ten Commandments or Decalogue is known across the world in nearly every tongue. Within Judaism, they are the foundation of the Torah or Law, and within Christianity, they are the seed for Christ's moral teaching. Together with Roman and Anglo-Saxon law, the Ten Commandments have also been an important influence on the development of jurisprudence in Western society.

Scripture can only be interpreted by its context, and the context for the Ten Commandments is tied to the creation account in Genesis, the covenant with Abraham, and the people's liberation from Egypt along with their forty years of desert wandering. In light of the biblical narrative, the story of Mount Sinai is the creation of the moral order. Just as in the Genesis creation account we see God bringing physical order from primordial chaos, in the Decalogue we see the birth of the moral order from the immoral abyss of chaos. Law is constitutive to the formation of humanity, and without it human beings

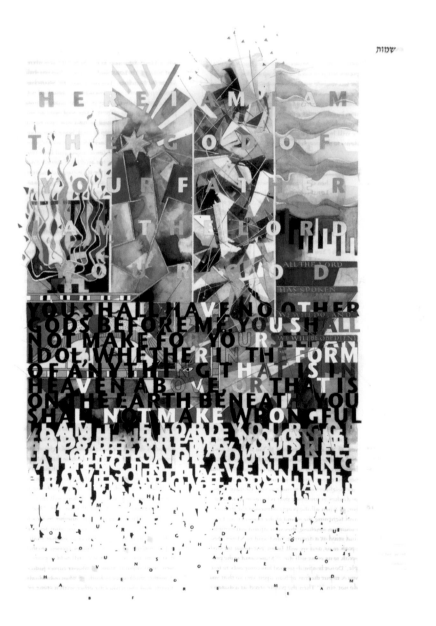

are little better than brutish beasts. That God's self-revelation to the Israelites occurs when God gives them a moral code implies the divine presence is manifest in right human conduct.

Image

The image is the work of San Francisco–based artist Thomas Ingmire, one of the artists in Donald Jackson's scriptorium team. At the upper register, God reveals himself with the words, "I am the LORD your God, who brought you out of the land of Egypt, out of the house of slavery; you shall have no other gods before me" (Exod 20:2-3). The commandment not to worship any idols or images follows. This passage gives us all the absolute tenets of the law, and they are tied to a theophany or God's self-revelation on Mount Sinai.

Once the reader arrives at the bottom register, however, the sentences deconstruct into phrases, and the phrases into letters, and the letters into disparate, chaotic dots. The image theologizes that the closer we are to God, the greater the moral order, while the further we retreat from him, the greater the chaotic disorder. The genius of the depiction is that it can also be read in reverse, from chaotic disorder at the bottom approaching moral order at the top.

Thomas Ingmire comments, "I am interested in the idea that God presented himself as an abstraction and the abstraction was the Word. There is a cold clarity to the idea reinforced by the Commandments—no images or any 'likeness of anything that is in heaven above or earth below.' . . . To reinforce the sense of abstraction, power and promise, I wanted the letters to be in the Latin alphabet and with use of typography."

LEVITICUS

You Shall Be Holy
Leviticus 19:2; special treatment; Sally Mae Joseph, artist

Background

In the book of Leviticus, there are no images. As part of the Pentateuch, Leviticus contains important elements of the Holiness Code or commentary on the Decalogue. The Holiness Code outlines the application of the Ten Commandments and, for this reason, is very important to Judaism in that it constructs the dietary and other regulations inherent to the faith. Christianity, while having no obligation to follow the Jewish code, nonetheless finds certain elements applicable, and those receive special treatment here.

Originally serving as God's instructions to Moses for the Israelites, the Holiness Code continues to call believers to be transformed and to obey God's commandments. The Lord tells Moses, "Speak to all the congregation of the people of Israel and say to them: You shall be holy, for I the LORD your God am holy" (Lev 19:2). To be created in the image and likeness of God is a call to holiness, for when we act in holiness, we reflect God to others.

As we read these verses we can also admire the architecture of the page. The impression made by the colors, shapes, and positions of the special treatments, including the design in the lower left corner, guide the reading of the text in unspoken ways and are fundamental to its interpretation.

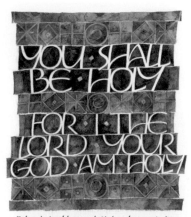

You Shall Not Take Vengeance
Leviticus 19:18; special treatment;
Sally Mae Joseph, artist

The next highlighted verse gives us at least one example of the holiness code, "You shall not take vengeance or bear a grudge against any of your people, but you shall love your neighbor as yourself: I am the LORD" (Lev 19:18).

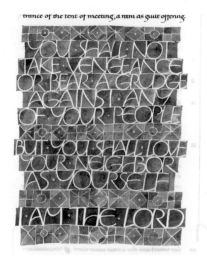

Loving our neighbor as ourselves is a familiar theme, which reprises at several places in the Bible. Here, it concentrates on one particular human tendency, which prevents us from extending this love. We humans are prone to see vengeance as justice, but it is not. Spite and violence are not the ways of God. If they were, there would be no such thing as an all-loving God; divine action would be pure caprice. Showing and demonstrating that there is a loving order at the core of creation is the whole purpose of the Pentateuch, not to mention the whole of Sacred Scripture. Without this loving order, everything returns to the great primordial chaos we saw in the first chapter of Genesis. We are asked to leave vengeance in God's hand because he alone can transform violent emotion and raise it to the level of justice and redemption. Injustice is addressed and rectified, and there may even be punishment involved, but there is no annihilation of the other.

The Alien Who Resides in You
Leviticus 19:34; special treatment; Sally Mae Joseph, artist

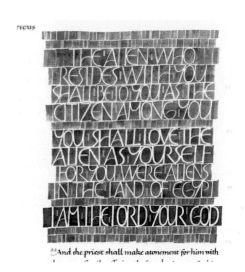

Special attention is given to many verses of the Bible that relate to the RSB and to Scripture passages that have significant meaning to the monks. Hospitality is a Christian charism of great importance to monasticism, and the acts of respecting, sustaining, and helping those in our midst who differ from us in race, faith, ethnic background, gender, or sexual orientation have their origin in Sacred Scripture. Hospitality is a part of the call to holiness and includes welcome to the widow, widower, orphan, elderly, disabled, vulnerable, and immigrant; indeed, everyone poor and defenseless.

Scriptural Cross-references
Matthew 5:43-44; 6:14-15; Luke 10:27-37

NUMBERS

The Lord Bless You
Numbers 6:24-27; special treatment; Suzanne Moore, artist

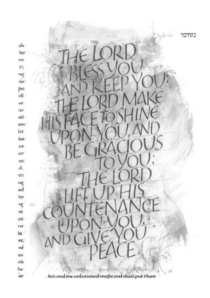

Called the "priestly blessing," this formulaic prayer originates with Moses' brother Aaron, who was the forebear of the Israelite priesthood. Aaron was in charge of the cultic ceremonies during the desert exodus. When the people settle in the Promised Land, Aaron's descendants, along with the descendants of the sons of Levi, take charge of the temple worship just as the Lord ordains.

This familiar passage is often heard at the conclusion of Christian liturgies, including evening prayer at Saint John's Abbey.

You Did Not Trust in Me
Numbers 20:12; special treatment; Thomas Ingmire, artist

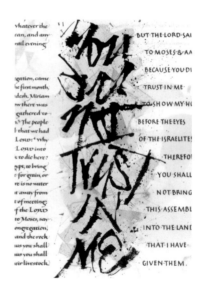

This calligraphic special treatment of the text reminds us of the importance of trust. Its context is the people's contention with God and Moses in the desert (Num 20:5-12). The Lord has led them from Egypt and has protected them at every step of the way, from the Passover through the Red Sea crossing, yet the people still do not believe or trust.

Many will cite this verse as the reason the Lord God does not let Moses enter the Promised Land. The Lord commands Moses to strike the rock once, yet he hits it twice. Therefore, the reasoning goes, Moses dies before crossing the Jordan in Deuteronomy 34. Stories such as these are pious meditations and explanations. Nothing in the biblical text supports the interpretation, and, indeed, in another version of the story, Moses strikes the rock only once (Exod 17:6). This special treatment directs the verse toward us.

Contesting in the Desert and Burning Serpents
Numbers 21:5-9; special treatment; Thomas Ingmire, artist

It is natural for people to complain, even when they are the recipients of a great gift, as the Israelites are. The Lord God may have brought them out from enslavement and into freedom, but things are difficult. Snakes are a part of the desert environment. This story is an etiology explaining how and why the chosen people are bitten by snakes; it is because they complain about the conditions they must face.

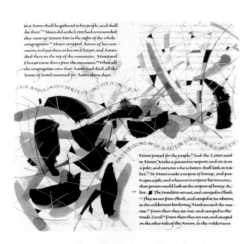

The resolution of the problem is the reason for the special treatment, however. The Lord commands Moses to forge a serpent and to place it on a pole, with the promise that those looking at it will be cured. Moses does so and things go according to plan. For Christians, this event is considered a prefigurement of Christ's crucifixion: the one despised and hanged becomes the source of salvation. Indeed, on Mount Nebo in Jordan, the place that commemorates the death of Moses, there is a modernist sculpture of a serpent on a pole erected to commemorate the place where Pope John Paul II stood during his millennial visit. Likewise, Pope Benedict XVI also stood at the spot when he visited Mount Nebo in May 2009.

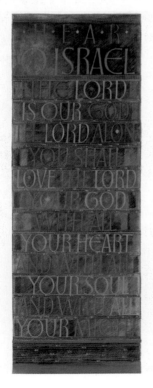

DEUTERONOMY

Hear, O Israel
Deuteronomy 6:4-5; special treatment;
Hazel Dolby, artist

The "Hear, O Israel" special treatment appears in Deuteronomy 6 and is known in Hebrew as the *Shema*, meaning "to hear or listen." As an affirmation of Judaism and a proclamation of faith in one God, this verse in Deuteronomy commands that the Jewish

people pray the Shema every morning and evening. The Shema itself, however, is based on the first and second commandments in Exodus 20:1-3.

The Lord is the ruler of the universe, and any competitor is counterfeit. This assertion entails a response, hence the second half of the call to love God above everything. It expresses the relationship between the Lord and his people, a detail that makes it a scriptural cross-reference to Leviticus 19:2, "You shall be holy for I the LORD your God am holy." What is said in Leviticus influences the interpretation here and vice versa.

This verse also has significance for the Saint John's Abbey monks, since "listen" is the first word in the RSB. The rule, which governs the communal life of the monastery, implores the monks to "listen with the ear of your heart."

Scriptural Cross-references
Proverbs 8:32; Sirach 39:13; Matthew 22:37; Mark 12:30; Luke 10:27

Choose Life
Deuteronomy 30:19; special treatment; Suzanne Moore, artist

Much of the book of Deuteronomy recapitulates the material in Exodus. One of the recurring actions we see here is the people's ratification of the covenant, first made to Abraham and then refined and reaffirmed with Moses on Mount Sinai. Following the Lord brings abundant life, and abandoning his ways leads to death. The Lord God is the author of life, who calls us to holiness. We reflect the divine face when we promote life in all its dimensions, physically, spiritually, and morally. Many will recognize this phrase as a call to cherish life from conception to natural death. It is foundational to teachings against abortion, capital punishment, euthanasia, and war. It is also a call for social justice, respect for the environment, just wage, and affordable health care as well as other quality of life issues. The biblical context here helps the interpretation of the passage today.

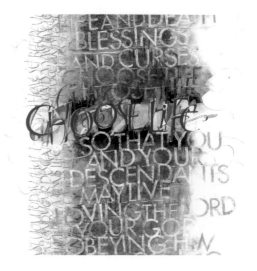

Death of Moses

Deuteronomy 34; Donald Jackson, Aidan Hart, Sally Mae Joseph, Thomas Ingmire, artists

Background

A tradition is that the Lord prevents Moses from entering into Canaan because he disobeyed the Lord by striking the rock twice instead of once, as commanded (Num 20:11). Nothing in the biblical text supports this conclusion, however. Another interpretation is that Moses completed his charge by

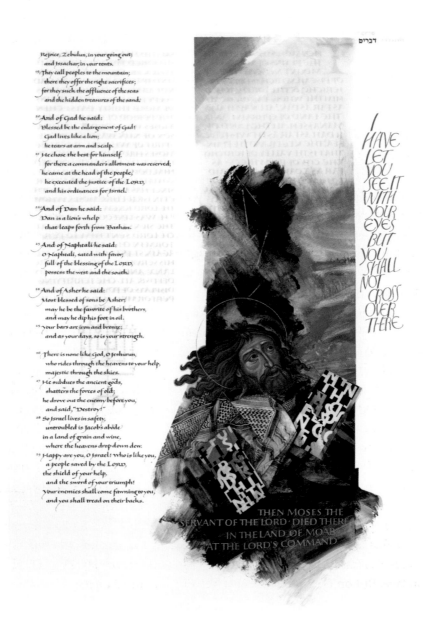

successfully bringing the people to the border. He sees the Promised Land and completes his mission.

Tradition locates Moses' death on Mount Nebo in Jordan.

Image

Thoughts immediately turn to stories of people whose lives are examples of patient endurance but who die just short of reaching their deliverance. It is faith in the redemption that completes what one lacks in this life. In this line, Moses' death on Mount Nebo can be considered a blessing. Moses had worked long and hard to see the people through. He had to put up with their ceaseless murmuring, settle all their arguments, look after their food and shelter, and command their armies. They will enter the Promised Land, to be sure, but that endeavor will bring all its own problems. When all is said and done, dying on Mount Nebo is a bittersweet end to a life lived in faith and in hope of redemption. Our lives are often like Moses'. We each have something to do in life, so we do it and die because we are too old to start again.

From atop Mount Nebo, one can see just about everything described in Deuteronomy 34, the whole length and breadth of the land of Canaan; the narrative is only slightly exaggerated. On a clear day, Jerusalem, about forty miles away, comes into view. Starting with the Byzantine period and running all the way through contemporary time, Mount Nebo, located in present-day Jordan, has been a highly popular pilgrimage site. There are the ruins of several great basilicas on the spot with superlative mosaic floors. A newly constructed church protects them now.

Moses and this image call upon the richer countries of the world to be attentive to the plight of immigrants the world over. God's gifts are for everyone, and wealthy countries have an obligation to share their blessings with people coming to their borders.

For black Americans, Moses has been the central icon of their liberation since before the Civil War (1860–65). Martin Luther King Jr.'s famous speech at the civil rights march in 1963 continues to ring in the ear: "I have been to the mountain top, I have seen the Promised Land." And, of course, like Moses, he died before entering it, metaphorically speaking. In the Catholic Basilica of the Immaculate Conception in Washington, DC, the chapel of the Black Virgin has a bas relief of black slaves marching out of servitude, and at the top of the line are a mother, father, and child in contemporary dress. Harriet Tubman, a free black woman in the North, was called the "Moses of her people" because she continued to venture into the South to rescue blacks still held in bondage. Bishop Desmond Tutu did likewise in South Africa.

The presence of the kayfiyeh, or headscarf, in the image shows us Moses' importance to Jews, Christians, and Muslims, as one of the prophets of monotheism.

Chapter 6

HISTORICAL BOOKS

INTRODUCTION

The Historical Books includes Joshua, Judges, 1–2 Samuel, 1–2 Kings, 1–2 Chronicles, Ezra, Nehemiah, Tobit, Judith, Esther, 1–2 Macca-bees. They comprise the largest volume in *The Saint John's Bible*, and because of the wars, bloodshed, and violence, they are the most controversial. For both the CIT and the Scriptorium, the Historical Books comprise the most difficult of all the volumes to work with. Not only does the subject matter cover such a great breadth of history, but it also contains stories very disturbing to read, interpret, and paint. In a note to the CIT, Donald Jackson wrote, "There are many depths, indeed veritable crevasses of human and emotional experience to be plumbed by an artist seeking for appropriate visual responses to the violent and anarchic subject matter."

Within these pages, the Israelites undertake a religious war, driving out the inhabitants: Canaanites, Amorites, and Amalekites along with everyone in between. Not only are opposing armies defeated but also, as a religious war, the whole non-Israelite population is banned. Any old men, women, children, sick, or infirmed people left standing are annihilated. Animals too. To make matters worse, these stories have been used over the centuries to condone and even bless wars of conquest not only in the Holy Land but also throughout the Jewish, Christian, and Muslim world. It is a bloody affair and these accounts, perhaps more than anything else, have turned many people against organized religion. How can God condone such a thing?

To ask if God is the one actually performing such heinous crimes would be the better question. In the ancient world, people believed their gods fought with and beside them, and if a nation were defeated by another, that nation's gods also went down in defeat. The deities, therefore, had a vested interest in winning a battle, and it took very little rationalizing for the Israelites to present their battles as the result of God's command.

It would be a great mistake, and one to our everlasting detriment, however, to walk away from these books by relegating them to an ancient past in which

people, not as sensitive as we, justified their violence by ascribing it to God's will. If we find ourselves at such a juncture, we are at the place where the Historical Books show us their true value, for they provide a check on our own behavior.

We are still capable of acting in the manner described in the Historical Books, though perhaps in a modern guise. Every war has a surfeit of innocent victims, and in our own time people celebrated in the streets when Osama bin Laden was killed. We all find ample reasons to justify our actions. It is very easy, too easy in fact, for us to turn our will into God's will instead of letting God's love for all God's people fill our lives and guide our actions.

This last point leads to a second, theological issue. The work of biblical exegetes is to find the Word of God within the text, which is not always easy. While there are many books in the Bible, there really is only one story, and that story is one of God's self-revelation of his unlimited and unbounded love, which is why we call the Bible the "Word of God." If the Bible is the Word of God, then it is the Word of God in human words. As a result, the texts we read are colored, if not obfuscated, by a human agenda as well. A thorough reading of the whole Bible, from Genesis to Revelation can give us the complete picture, however, and it is this picture that *The Saint John's Bible* tries to uncover.

When we are reading the Historical Books, we are observing the initial ways in which the people understand their relationship to the Lord God. As in every relationship, the understanding and knowledge of the other grows and matures. If the Historical Books show a God who acts violently, it is because the writers expect him to act that way, for everything in their culture tells them this is how gods act. Yet, subsequent books in the Bible challenge this whole assumption. God is constantly and unremittingly confounding the people's assumptions about him, and they are left reconfiguring their experience of him.

In reading the Historical Books, therefore, we should always be aware that what we are perusing is a snapshot of an overly zealous people who are growing in their relationship with God. By the end of the whole biblical narrative at the book of Revelation, we will see God understood quite differently. Moreover, the Israelite community's growth in the understanding of the relationship with God may very well reflect our own personal journeys in learning to be in the presence of God and let God's love shape us.

Anthology Pages

The Historical Books introduce *anthology pages* to *The Saint John's Bible*. These artistic treatments incorporate material from the respective book into a particular image. In each case, I give the verse number followed by a short, respective explanation. After the explanations, I discuss the image and conclude with the scriptural cross-references.

JOSHUA

Joshua Anthology
Donald Jackson, artist

The Joshua Anthology is the first of several such collections displayed in *The Saint John's Bible*. Three different passages contribute to this anthology: Josh 3:14-17; 8:30-35; 24:20-24.

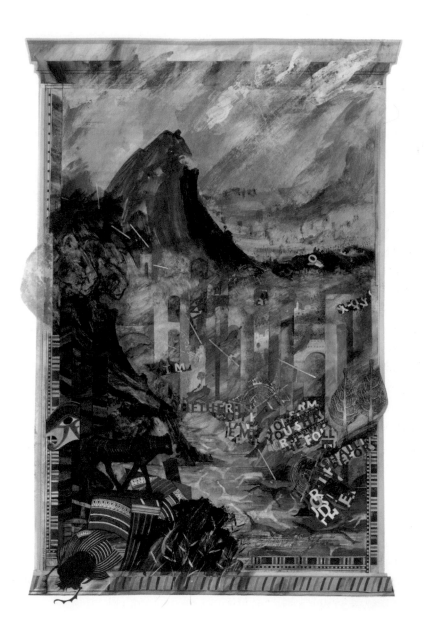

Background to Joshua 3:14-17

The Lord commissions Joshua, son of Nun, to lead the people into the Promised Land (Deut 31:23); after forty years of desert wandering, the Israelites cross the Jordan. Traversing the Jordan to enter the Promised Land is not the most direct route between Egypt and the land of Canaan. The simplest way would be for the people to march directly up from the Sinai Peninsula through the Judean Desert. Because there are strong fortifications blocking their way, however, they must detour around the northern tip of the Gulf of Aqaba, proceed north into Edom (Num 21:1-8), and finally cross over into Canaan near Jericho. Although this change of direction is the wise, strategic choice, it upsets the people and they protest Moses' leadership, an action that causes the poisonous serpents to attack the encampment. Once Moses dies, it is up to Joshua to complete the journey.

In all literature, crossing water is an action fraught with symbolism: new beginnings, new life, a sense of risk combined with a sense of rescue. Here, the Israelites are changing from nomads into settlers. They are going from a liminal existence in the desert to a central position in the Promised Land. The crossing over the Jordon River forms a bookend to the traversing of the Red Sea in Exodus (Exod 14:22). Whereas Pharaoh's pursuit in Exodus makes the Red Sea a symbol of rescue from death, moving through the Jordan River into the Promised Land becomes a step into new life.

The ark of the covenant, a portable sanctuary that the priests alone can carry, is made of wood overlaid with gold. This ark contains the two tablets on which Moses had written the Ten Commandments.

Background to Joshua 8:30-35

After the victory stemming from the destruction of the city of Ai, Joshua builds on Mount Ebal an altar of unhewn stone upon which he burns offerings. Joshua inscribes the stones with the law written by Moses and then reads it aloud to the entire community, including the women, children, and the strangers who accompany Israel. The notion of writing the word focuses on the establishment of the community. The oral becomes written and then again becomes oral. In the ancient mind-set, spoken words were living entities in their own right, and once proclaimed could never be recalled. This moment, therefore, is very important for the people.

The physical setting is also important. The Bible contains many stories of one or another person erecting standing stones to commemorate this or that event. Here the twin mountains of Gerizim and Ebal take on such a function. The law given to Moses features both blessings and curses, and the two companies of peoples, half on Mount Gerizim and half on Mount Ebal, by

witnessing the reading of the law, ratify it. By this action, Gerizim and Ebal become permanent testimonies to remind people of the law. Their importance in this role is accentuated by the fact that, because a major East–West trade route passes between the two mountains, many of the domestic and international traders would have the opportunity to reflect upon the law as well.

Mount Gerizim maintains its importance throughout history. Its summit becomes the sanctuary of the Samaritans who, by the fourth century BC, built a temple there. To this day, the Samaritans gather there to celebrate their Passover according to the prescriptions outlined in Exodus 12:1-28.

Background to Joshua 24:20-24

Joshua's recitation of Israelite history takes place in Shechem, which lies between Mounts Gerizim and Ebal, very near the spot where the covenant was renewed upon the people's entering the land (Josh 8:30-35). Joshua sets up a standing stone as a witness. Whereas the previous ceremony at the two mountains featured the reading of the law, here Joshua gives a rendition of Israelite history. The people's response signals an acceptance and renewal of the covenant, "The LORD our God we will serve, and him we will obey" (Josh 24:24).[1]

Image

The whole movement into the land of Canaan has deep theological significance, which the book of Joshua relates. We see the theology etched in the Joshua Anthology page (Josh 3–4). The ritual of crossing the Jordan has elements of crossing the Red Sea as well as the revelation at Mount Sinai interwoven with it. The primary symbol is the river water. The flow stops until all the people are on the other side. The tablets of the law are within the ark of the covenant, shown as arches of gold; God is present.

The ark is not the only thing traveling with the people. The text tells us that the Israelites lived in Egypt for 430 years (Exod 12:40). For all practical purposes, they absorb the Egyptian culture at least on an unconscious level. Moreover, we read that they make a conscious decision to take some of the better things of Egypt with them (Exod 3:21-22). All this baggage accompanies the people across the Jordan and into the Promised Land; the image here shows

1. Some scholars feel that the hand of the Deuteronomistic editor—that is, one who follows the theology found in the book of Deuteronomy—is especially noticeable in these verses and that they are written while the people were suffering the Babylonian exile. The lesson is that their servitude in Babylon is a result of their disobedience toward the covenant. Nonetheless, these captives hope that the covenant can be renewed and the exile brought to an end. This story from Joshua is a way to encourage that hope.

the cultural interchange with idols and statues. The less obvious elements are indicated by the palette of sky blue, blood red, and buff yellow, colors that are found on Egyptian temples to this day.

The full-page image reflects tremendous energy. The lettering from the Ten Commandments page reprises here and represents the ark of the covenant. The people cross the Jordan River near Jericho (3:11-17). The flaming yellow and gold in the background presage the war, death, and destruction of the impending Israelite conquest. The decorative segment with Egyptian motifs framing the left column on the following page completes the anthology.

The rest of the book of Joshua has a series of quotations written within the margins of several pages stating what God has done for the people. These words are a steady refrain found throughout the text of Joshua reminding people that God is the one in charge, not they. These marginalia prepare the reader for the next book—Judges.

Scriptural Cross-references
Exodus 14:21–15:21; 19–20; Matthew 3:13-17; Mark 1:9-11; Luke 3:21-22; John 1:32-34; Romans 6:3-5

JUDGES

There is a constant theme running through Judges exemplified in two phrases: (a) "Then the Israelites did what is evil in the sight of the Lord"[2] and (b) "In those days there was no king in Israel; all the people did what was right in their own eyes."[3] These phrases run across the pages in this section and are often the subject of marginalia; they provide the interpretive template for all the stories.

The book of Joshua presents us with the conquest of the land. The books of 1 and 2 Samuel relate the rise of the monarchy. The time span between the two, when authority is left in the hands of local leaders, is covered by the book of Judges. The judges themselves have little to do with jurisprudence. Rather, they were temporary leaders called to take command of a particular region during a time of emergency, and once the emergency passed, the leader went back to civilian life. There were no capital city, no established dynasty, and no standing army. Judges were commissioned by the Lord and had no political authority. The narrative presents the period of the Judges as ending in chaos, which prepares the reader for the monarchy.

2. Judg 2:11; 3:7, 12; 4:1, 6:1; 10:6; 13:1.
3. Judg 17:6; 21:25.

Deborah Anthology
Judges 4–5; Donald Jackson, artist

Background

Deborah is one of the few women leaders mentioned in the Bible. She is the heroine who is able to unite the various tribes to drive out a foreign invader. Yet, the victory is God's, and this is the main emphasis of the canticle. This poem is considered by many to be one of the oldest Hebrew texts in the Bible. Because all the credit is given to God and not to the Israelites, it could have been a song that predates the monarchy.

The description of the Kishon in Judges 5:21, in which the stream sweeps away horse and rider, is very similar to the Israelites crossing the Red Sea in Exodus 14. So many parts of this book seem to have been lost, and it appears that much guesswork is necessary to bring it all together.

In Judges 4:4, Deborah is sitting under the palm tree where the Israelites could come to her for judgment. Even the names suggest that she had a reputation for inspiring leadership. "Deborah" in Hebrew means "honey bee," and her husband's name, Lappidoth, means "torches" (4:4). The Hebrew word for "wife" is the same as the Hebrew word for "woman." As wife of Lappidoth, "Deborah" could also mean "the fiery honey bee," a visually interesting reading. One of the great military leaders of the time, Deborah, along with another woman, Jael, defeats the Canaanite leader Sisera and his army in battle at the Wadi Kishon, at the foot of Mount Tabor. Aided by a thunderstorm that clogs the Canaanites' chariot wheels in the mud (5:4), Deborah's forces are able to overcome the invading army. Sisera flees on foot.

Seeking refuge from his pursuers, Sisera sees Jael, a member of a nonhostile tribe. Jael persuades him to enter her tent, and when he requests water to drink, she pours him milk instead, which induces him to sleep. While he dozes, she nails his head to the ground with a mallet and tent peg. For the story's purpose, however, death is not the worst of it. Sisera, a great Canaanite leader, runs away in mortal dread from one woman only to die at the hands of another. He and his army are thus doubly disgraced.

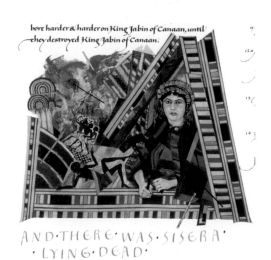

bore harder & harder on King Jabin of Canaan, until they destroyed King Jabin of Canaan.

AND·THERE·WAS·SISERA· ·LYING·DEAD·

Image

The central focus is Deborah in stately attire. Her regal, solemn countenance and colorful dress foreshadow the

woman in Revelation, as the geometric frame evokes Joshua. Depictions of the narrative surround her. The palette here and elsewhere connects these stories to the book of Joshua and even Exodus.

Scriptural Cross-references

Book of Judith, Book of Esther

Abimelech

Judges 9:14-57; Donald Jackson, artist

Background

Jotham speaks from Mount Gerizim, the mountain of blessing (Josh 8:30-35), and curses Shechem from there, an action that would not be lost on the people. His speech illustrates a valuable lesson, for when the good shirk their duty, the bramble will take over. There is also a telling comment about power: those who should have it, do not want it; while those who should not have it, do. The trees described in these lines are wonderful metaphors about human personalities. We also see here a hierarchy of trees in ancient Mediterranean society, with the olive being the most noble.

We come across a series of stories in which individual, localized rulers assert their authority over a region. Unlike true judges, they are not contending with foreign aggression inasmuch as they are combating other Israelites for control over the territory. Abimelech kills even his own kinspeople. Because of a power vacuum, Abimelech is able to augment his rule. Jotham, well-acquainted with the personalities involved, addresses the people with the parable about the trees and what might happen when the good and the able do not recognize the summons to duty. If the olive, the fig, and the wine grape do not step to the fore, the undesirable will do so. No one heeds Jotham, and violent matters take their course—ending only when a woman in a tower that Abimelech is besieging drops a millstone on his head.

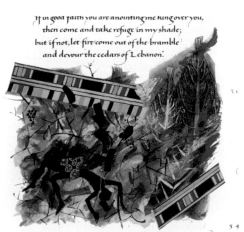

If in good faith you are anointing me king over you, then come and take refuge in my shade; but if not, let fire come out of the bramble and devour the cedars of Lebanon.'

16 "Now therefore, if you acted in good faith & honor when you made Abimelech king, and if you have

Image

The thrust is toward good monarchy. The olive, fig, and vine were important trees in the ancient Near East and, indeed, for all Mediterranean cultures. Not only are olives themselves used for food but

their oil is also a domestic mainstay in cooking, medicine, cosmetics, fuel, soap, and ceremonial anointing. Figs are a sweet, succulent fruit which, when fresh, often symbolize plenty and luxurious abandon, and since they can be dried, they can last thousands of years in the desert climate. The vine, of course, yields wine.

These plants are juxtaposed alongside the bramble bush—most probably the buckhorn—a plant that blossoms with beautiful flowers every spring only to become a weed. The bramble not only chokes out necessary plants in the scarce, arable land but also pierces through skin with its long thorns. Despite its blooms, it is both a distasteful and painful nuisance. The imagery in Jotham's speech descends from the noble olive down to the despicable bramble. The irony is that the "noble" trees do not act so nobly. The olive tree refuses to stop producing its rich oil; the fig tree refuses to stop producing its sweet and delicious fruit; the vine refuses to stop producing its heady wine. They refuse to see the crisis and want life to go on as normally as possible. The trees' blindness, however, is the bramble's opportunity to reign by doing what it has always done—that is, choking out the good.

The image is riddled with violence. The palette, one of the distinctive characteristics of this volume, maintains the continuity with the Israelites' former lives in Egypt. They have yet to conform their actions according to the covenant.

Scriptural Cross-references
Joshua 8:30-35; 24

Jephthah's Daughter
Judges 11:10-40, Donald Jackson, artist

Background

Jephthah promises God a sacrifice in exchange for victory. "If you will give the Ammonites into my hand, then whoever comes out of the doors of my house to meet me, when I return victorious from the Ammonites, shall be the LORD's, to be offered up by me as a burnt offering" (Judg 11:30-31). One could perhaps make the case that it was not Jephthah's plan that the intended victim would be a human being—specifically, his daughter. However, the ancient custom was that the women and children were the first out of

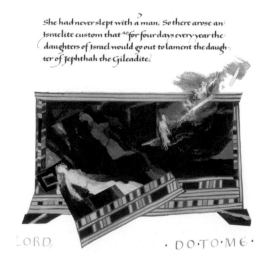

She had never slept with a man. So there arose an Israelite custom that for four days every year the daughters of Israel would go out to lament the daughter of Jephthah the Gileadite.

LORD, · D·O·T·O·M·E ·

the house to greet the warrior when he returned from his campaign. If Jephthah is aware of this, his vow becomes disturbingly sinister, as well as being a grievous transgression against the law of Moses.

In the ancient culture of the Middle East, an oath or a curse once made cannot be revoked; it has a life of its own. Jephthah must follow through or expect the worst to happen to him, his family, and his community. His daughter knows this, which is why she is so complacent and acquiescent. Because it was a disgrace for a Hebrew woman to die childless, Jephthah's daughter asks for time to bewail or grieve her virginity. Even more than a disgrace, the childlessness of Jephthah's daughter is a curse that leads her to oblivion, which the women's annual commemoration is meant to preclude (11:40). Without a child to remember her, she has no afterlife. Paradoxically, by sacrificing his daughter (his only child), Jephthah brings the same curse upon himself.

Any interpretation of this story must take into account that the Lord does not ask Jephthah to sacrifice his daughter and, indeed, is silent about the whole affair. In addition, human, and specifically child, sacrifice, engaged in so heavily by Israel's neighbors, is one of the greatest abominations the Israelites could commit. We are forced to ask whether Jephthah, despite being called to judge his people, really exercises disobedience toward God. Likewise, we can ask whether or not this story shows a people growing in their understanding of what it means to live in the light of God, for in the biblical narrative, no other Israelite act of human or child sacrifice goes unpunished. Ultimately, no explanation suffices for Jephthah's heinous deed.

Image

The starkness of this depiction of Jephthah's daughter reflects one of the most chilling stories in Judges, if not in the whole Bible. It is a tale that rightly repulses the reader, and it has caused many to doubt if not abandon their faith in a loving God.

Scriptural Cross-references

Genesis 22:10-12; Exodus 20:13; Deuteronomy 18:10; 2 Kings 16:2-4; 17:9-17; 21:1-6; 23:10; Ezekiel 20:30-31; Matthew 18:1-6; Luke 18:14-17

Samson
Judges 13:24–16:31; Donald Jackson, artist

Background

The story of Samson begins with a familiar Old Testament scene. A couple is childless, and the woman, who is thought to be barren, receives a divine communication that she will bear a son. Within this literary genre of the sterile,

elderly couple are included the Old Testament stories of Sarah and Abraham (Gen 18:9-15), Hannah and Elkanah (1 Sam 1:1-23), and here, Manoah and his wife (she goes unnamed). In the New Testament, Luke makes use of the genre in describing John the Baptist's birth, whose parents are elderly Elizabeth and Zechariah.

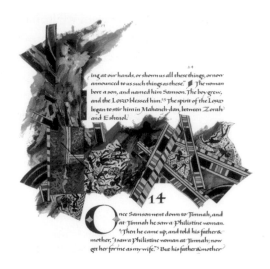

All the discussion on the boy's consecration to God, even from within the womb (Judg 13:5), is a reference to the Nazirite vow outlined in Numbers 6:1-8. God has selected this son of Manoah and his wife to deliver Israel from the enemy Philistines. For such a task, Samson, as the child will be called, must abstain from wine and strong drink, must keep his hair unshaven, and must avoid all contact with the dead. No sooner than Samson reaches young adulthood, however, does he break each one of the stipulations that has maintained his sacred character.

Image

Despite his heroics in slaying one thousand Philistines with a donkey's jawbone (15:14-16), Samson is still very much a teenager, bringing chaos wherever he goes. He deceives his parents (14:8-9), demeans his wife (14:17–15:6), and creates havoc in the countryside (15:1-5) that disturbs even the Israelites (15:11-12). Despite such a life, or maybe because of it, he becomes a sympathetic character in that he is victim of all his misbehaving. His great strength and moral weaknesses have made him famous.

Camille Saint-Saëns's opera, *Samson et Dalila*, has done much in making these stories so popular and well-known.

Conclusion to Judges
Judges 20:14-48 and Judges 21:1-25; Donald Jackson, artist

Background

Judges ends on a refrain that has been constant throughout the book: "In those days there was no king in Israel; all the people did what was right in their own eyes." See also Judges 2:1-20; 3:7; 4:1; 6:1; 13:1; 19:1. The role of an earthly king is rather ambiguous in Judges. The Lord is Israel's true king, but the people are continuously transgressing his commandments. Would an earthly king help maintain the covenant? The promonarchist would answer

affirmatively, while many of the prophets will resolutely hold that trusting in an earthly king is forsaking the Lord.

The conclusion to the book of Judges is uncertain. On the one hand, it seems to end with the promise of hope, which, up to this point, is all but gone. On the other hand, any hope that surfaces periodically throughout Judges is built on faulty foundation. The tribal confederacy is chaotic—the very opposite of God's intention for his people (Gen 1–2; Exod 20–21), yet kingly figures

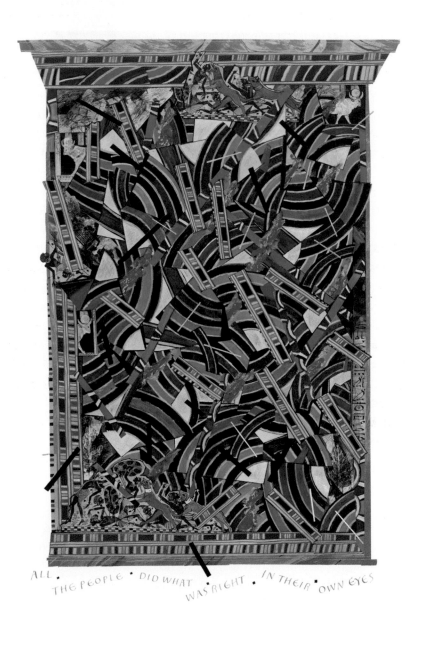

ALL · THE PEOPLE · DID WHAT · WAS RIGHT · IN THEIR · OWN EYES

are either despotic (Judg 9) or ineffectual (Judg 13–16). The lesson suggests that the people should have put their trust in God, but they looked for a king instead, and if Abimelech is any indication, kings turn out worse.

Image

The marginal writings play on the running theme throughout Judges, which is, "in those days there was no king in Israel; all the people did what was right in their own eyes." The palette as well maintains the tension. In addition, the columns from Samson's destruction of the temple of Dagon (Judg 16:30) spill over onto the last page. The chaotic nature of people disobeying the Lord's commandments is given a contemporary ring in the illumination at Judges 20; there is no way of knowing the identity of the young man running in the lower right corner. The last page composed of geometric shapes arranged in a haphazard pattern explains the whole situation. The people have gone their own way, leaving a very deceptive imprint of peace and harmony. It may be pleasing, but it is fragile and has no substance. It forms a perfect lead into the story of King David's great-grandmother in the next Old Testament book—Ruth.

RUTH

A short book and a well-loved story, Ruth sets the stage for the rise of the united monarchy under King David, the royal house from which the Messiah comes. While the core of the narrative focuses on the love and loyalty the widowed Ruth shows toward her mother-in-law, Naomi, the salient point of the story for the Jewish line is that Ruth is a Moabite, and the Moabites were one of Israel's enemies. Ruth takes a great chance in following Naomi back to Judah, for there are no guarantees that the people would allow her to live among them, let alone warmly receive her. In the end, Ruth finds a husband, Boaz, and they have a son, Obed, who becomes the father of Jesse, the father of David. Within the historical books, the book of Ruth upends the calls for war and replaces them with an example of hospitality.

Ruth and Naomi
Ruth 1:1-22; Suzanne Moore, artist

Background

Bereft of her husband and two sons in a foreign country, the Jewish Naomi, mother-in-law to Ruth, decides to return to Bethlehem during a time of famine. Ruth remains loyal to Naomi despite her lack of obligation to do so; Ruth's love and fidelity for Naomi goes beyond what is demanded. For her part, Naomi will be returning to Bethlehem in disgrace, for she is without the husband and two sons with whom she departed. This situation explains the reason for Naomi's name change in 1:20; she is no longer "pleasant" but "bitter." She had gone away with abundance but now returns destitute. Despite the setback, she is determined to survive.

Image

The two support each other in pain and uncertainty; and because they stick together, they as well as others are blessed for it. Boaz, as Naomi's kinsman, is bound to protect and shelter her and Ruth. He goes beyond what is prescribed, however, and fulfills his obligations with generosity. The merging of two nationalities in this story is a central image.

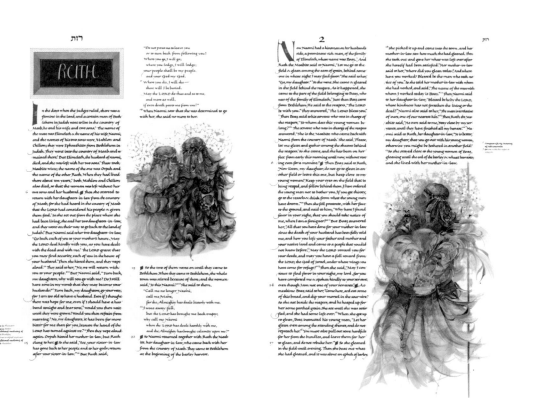

Ruth Gleaning among the Reapers
Ruth 2:1-23; Suzanne Moore, artist

Background

We have here the first meeting between Ruth the foreigner and Boaz the Jew; Ruth and Boaz eventually marry. Boaz extends magnanimous hospitality toward Ruth in 2:8-9 and again in 2:14-15. The custom of allowing the poor and the alien to glean the fields of the farmers is guaranteed by Jewish law (Lev 19:9-10 and Deut 14:21). Ruth's seeking permission from Naomi is not necessary. Even here, Boaz does not let himself be limited by the law but rather instructs the harvesters to let Ruth glean in the midst of the fields and even to drop some grain for her to take. Tradition locates the field of Boaz in Beth Sahur, a small village outside of Bethlehem. Bethlehem is, of course, the city of David.

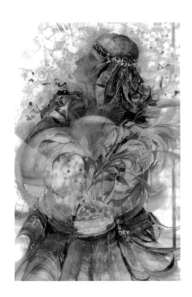

Image

The relationship between these two women is delightful. *Bethlehem* means "house of bread," or "house of food," a name that accentuates the fact that Naomi and Ruth depart from the land of famine to arrive at Bethlehem during the barley harvest (1:22) of Passover, the great Jewish feast celebrating deliverance. Moreover, in 3:15 Boaz sends Ruth home with her cloak full of grain. The grain will certainly provide food for Ruth and Naomi, but it is also symbolic of fertility and abundance. The context here suggests that it represents a pregnancy.

Scriptural Cross-references

Ezra 9–10; Proverbs 9:1-12; Matthew 1:5; Luke 1:39-56

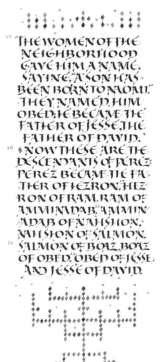

Ruth Genealogy
Ruth 4:17-22; Donald Jackson, artist

These genealogical verses list the ancestors of King David, which come from the union of Ruth and Boaz. Because these personages are also the forebears of Jesus, Christians have seen them as a foreshadowing

of the opening lines of Matthew's gospel, called to mind by the menorah leitmotif.

1 SAMUEL

1 Samuel is an account of the rise of the monarchy in Israel and as such deals primarily with King Saul. The series of stories in this section reflect the tension in Israel between those who want a monarchy (the people) and those who do not (reflected by the prophet Samuel). The story begins with the birth of Samuel to the elderly Elkanah and Hannah, and it shortly turns to this prophet's role in the selection of the nation's first king, Saul. Saul's dynasty shortly comes to grief when he oversteps his position, despite the fact that he is popular with a large segment of the population. When Saul transgresses and offers the sacrifice unauthorized, Samuel predicts his downfall and anoints David in secret.

David's reputation as a skillful lyre player comes to Saul's attention, and the king summons David to court so that he can play music when Saul is troubled. Pleased with the young musician, Saul promotes David to be his armor bearer. This position leads David to the battlefield, where he takes up the Philistine challenge to fight Goliath the giant. David is victorious and becomes a national hero, provoking Saul's jealousy just as David and Saul's son, Jonathan, develop a strong and loving friendship. David uses Saul's war with the Philistines to nurture his own power base in Judah and the south. When Saul and Jonathan are killed in battle, David steps into the power vacuum and becomes king.

The instability, strife, and poor administration marking Saul's reign raise many theological questions for Samuel and the people about kingship; these questions run through 2 Chronicles. The Lord God is Israel's king, and the people's allegiance and trust in earthly rulers are seen by the prophets, such as Samuel, as a betrayal of the covenant.

Hannah's Prayer
1 Samuel 1:1-28; Thomas Ingmire, artist

Background

This passage belongs to the biblical genre of the miraculous birth to the barren couple. Particularly touching is the love that Elkanah has for Hannah. This love contrasts with the cruelty to which Elkanah's other wife, Penninah, subjects Hannah (1:6-7). The scene is not without its humorous moments, either. Hannah is pouring her heart out to God, but Eli thinks her drunk (1:14). In the Christian tradition, Hannah becomes the forerunner of Elizabeth, John

the Baptist's mother (Luke 1:5-14). At the birth of Samuel, Hannah sings her song of praise (1 Sam 2:1-10), which is itself the prototype for the *Magnificat* or Mary's Canticle (Luke 1:46-55). In an ironic twist Hannah's son, Samuel, grows to be one of the great prophets of Israel, while we know nothing of Penninah's sons, not even their names. Notice, here again we have the Nazirite vow. In Judges 13:4-5, the angel of God calls for Manoah's wife to dedicate her son accordingly. Here, however, Hannah promises that, if granted a son, she will dedicate him as a Nazirite.

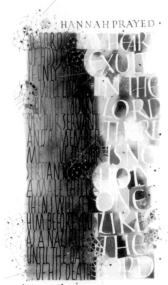

· HANNAH PRAYED ·

·I REJOICE IN MY VICTORY·

"Hannah was praying silently; only her lips moved, but her voice was not heard; therefore Eli thought she was drunk." So Eli said to her, "How long will

Image

There is a quarter-page illumination for Hannah's Prayer succeeded by various verses as marginalia showing the major theological themes of the text. The contrast between the gray palette on the left and the bright colors on the right complements the text of Hannah's song. The stamped, radiating images also appear in Ingmire's messianic predictions at Isaiah 9.

Scriptural Cross-references

Genesis 18:9-14; Judges 13:1-25; Psalm 113:9; Isaiah 54:1; Luke 1:36-37

Call of Samuel
1 Samuel 3:1-18; Hazel Dolby, artist

Background

Samuel, son of Elkanah and Hannah, is now a boy in the temple at Shiloh (recall that the Jerusalem temple has not yet been built). Eli and his two sons, Hophni and Phinheas, are the priests in charge of the temple. Unfortunately for Eli, his two sons are about as worthless as any two sons could be, stealing food from the sacrifices to the Lord and seducing young women within the temple precincts. Eli reprimands them to no avail. Such is the environment in which the boy Samuel is living as a Nazirite.

In this passage, both Eli and Samuel are sleeping in the temple when the Lord calls out to Samuel. There is some comic relief in the mistaken identity of the voice, but the message, when it eventually comes out, is quite severe: the house of Eli will be wiped out for its sins. The next morning, when Samuel tells Eli of the message, the old man accepts it with equanimity. As for Samuel, he will grow from a prophet to a political leader who sees the rise not only of

the monarchy but also of two different dynasties: Saul's and David's. Furthermore, he will anoint both kings.

Image

The voice comes to Samuel as he sleeps. Is he dreaming? Like many dreams or even troubling thoughts on a sleepless night, total confusion mixes with absolute clarity.

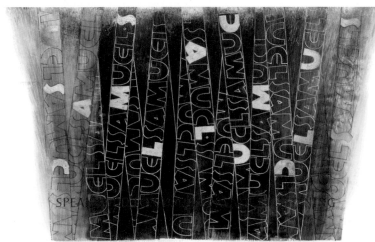

Scriptural Cross-references

1 Kings 3:5-15; Matthew 1:18-25; 2:12, 19-22; Acts 10:1-19

Saul Marginalia
1 Samuel 31; Donald Jackson, artist

Background

An integral part of the Saul Anthology are the marginal verses. The CIT selected these texts for their ability both to outline the theology of 1 Samuel and to give context to the visual interpretation at the end of the book. As a collection, they summarize the tension between faith and politics that a monarchy brings to God's people. I cite and briefly explain the verses, which the reader should keep in mind when viewing the Saul Anthology.

> And the LORD said to Samuel, "Listen to the voice of the people in all that they say to you; for they have not rejected you, but they have rejected me from being king over them." (1 Sam 8:7)

So much of the history of the monarchy reiterates a foundational question: to what extent is the people's call for a king a rejection of the Lord God? There seem to be two political and theological poles on this point. On the one hand are those who feel that Israel needs a strong king if the nation is ever to defend itself against its enemies. On the other hand are those who believe that the Lord God is their king. The prophet Samuel fights hard to keep the Lord God as the ultimate spiritual and national leader, but there is such a movement toward earthly kingship that he begrudgingly anoints Saul.

> Samuel said to Saul, "You have done foolishly; you have not kept the commandment of the LORD your God, which he commanded you. The LORD would have established your kingdom over Israel forever." (1 Sam 13:13)

Part of this verse is written on two separate folios and cites the defining moment of Saul's reign; it is the great turning point against Saul's fortune and favor. Saul is a king and military ruler, not a prophet or priest. The Philistines are moving against Saul, yet Samuel has determined that Saul should not do anything until he arrives, when Samuel can offer sacrifice to the Lord before the battle. Saul waits for the prescribed seven days, but Samuel delays (on purpose?), and Saul's army begins to abandon the effort in the face of the stronger Philistine force. Saul decides to offer the sacrifice himself. Samuel, upon his late arrival, discovers the disobedient act, for which there are severe consequences: Saul's dynasty is doomed, and nothing he can do or say will save it.

> David said, "The LORD, who saved me from the paw of the lion and from the paw of the bear, will save me from the hand of this Philistine." (1 Sam 17:37)

As David volunteers to battle Goliath the Philistine, the narrative makes a subtle switch from King Saul to the man who will replace him on the throne, David.

> Saul answered, "I am in great distress, for the Philistines are warring against me, and God has turned away from me and answers me no more, either by prophets or by dreams; so I have summoned you to tell me what I should do." Samuel said, ". . . The LORD has done to you just as he spoke by me; for the LORD has torn the kingdom out of your hand, and given it to your neighbor, David." (1 Sam 28:15-17)

Saul has a conversation with Samuel's ghost, which the female medium at Endor conjures for him. The irony in this scene is that King Saul has banned all mediums and acts of necromancy throughout his kingdom in compliance with the Mosaic Law. And yet, Saul, who has forsaken the Lord and has no one else to whom he can turn, save the dead Samuel, disobeys his own legislation and apostatizes by seeking out the medium for answers.

It is a dreary and desperate moment. Samuel, now irate at having his rest disturbed, tells Saul that on the following day, victory will go to the Philistines, while both the king and his sons die at the hands of the enemy on Mount Gilboa. Samuel has no words of consolation, only words of reproach, and Saul is despondent.

Saul Anthology
1 Samuel 31:1-13; Thomas Ingmire, artist

Background
True to the medium's word, Saul and his sons are killed on Mount Gilboa during the battle with the Philistines. In this account, Saul commits suicide by falling on his sword after receiving a mortal wound. The story is told differently in 2 Samuel 1. The Philistines desecrate his body and the bodies of his sons by stripping them of their armor, decapitating them, and impaling their torsos to the wall of the city of Beth Shean. Israelites from Jabesh-gilead, on the eastern side of the Jordan River, march all night to retrieve the corpses and bring them back to the city for a decent burial. This act constitutes just about the only redemption of Saul's memory. As the events in 2 Samuel show,

however, Saul's popularity with a certain contingent of the Israelites remains strong even after his death.

Image

The marginalia build toward the scene presented here. The bottom register of this last illumination shows the collapse of Saul's kingdom as well as the reasons leading up to it. Studying the image recalls much of the tension between Samuel and Saul.

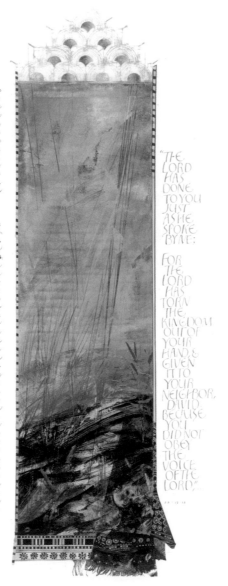

2 SAMUEL

David's Lament
2 Samuel 1:1-27, Thomas Ingmire, artist

Background

David's ambition, solidified by alliances, geography, and intrigue, comes with a price. The Philistines win the war against King Saul, thus allowing David to take the throne, but there is no peace. Soon, he will be battling a rebellion

שמואל ב

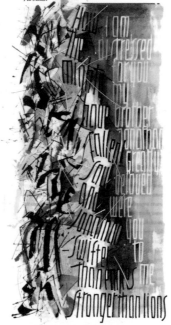

said to him, "Your blood be on your head: for your own mouth has testified against you, saying, 'I have killed the LORD's anointed.'" David intoned this lamentation over Saul and his son Jonathan. He ordered that The Song of the Bow be taught to the people of Judah; it is written in the Book of Jashar.] He said:

After the death of Saul, when David had returned from defeating the Amalekites, David remained two days in Ziklag. On the third day, a man came from Saul's camp, with his clothes torn and dirt on his head. When he came to David, he fell to the ground & did obeisance. David said to him, "Where have you come from?" He said to him, "I have escaped from the camp of Israel." David said to him, "How did things go? Tell me!" He answered, "The army fled from the battle, but also many of the army fell and died; and Saul and his son Jonathan also died." Then David asked the young man who was reporting to him, "How do you know that Saul & his son Jonathan died?" The young man reporting to him said, "I happened to be on Mount Gilboa; and there was Saul leaning on his spear, while the chariots & the horsemen drew close to him. When he looked behind him, he saw me, and called to me. I answered, 'Here sir.' And he said to me, 'Who are you?' I answered him, 'I am an Amalekite.' He said to me, 'Come, stand over me and kill me; for convulsions have seized me, and yet my life still lingers.' So I stood over him, and killed him, for I knew that he could not live after he had fallen. I took the crown that was on his head & the armlet that was on his arm, and I have brought them here to my lord." Then David took hold of his clothes and tore them; and all the men who were with him did the same. They mourned and wept, and fasted until evening for Saul & for his son Jonathan, and for the army of the LORD & for the house of Israel, because they had fallen by the sword. David said to the young man who had reported to him, "Where do you come from?" He answered, "I am the son of a resident alien, an Amalekite." David said to him, "Were you not afraid to lift your hand to destroy the LORD's anointed?" Then David called one of the young men and said, "Come here and strike him down." So he struck him down & he died. David

^a Heb *that The Bow*
^b Meaning of Heb uncertain

¹⁹ Your glory, O Israel, lies slain upon your high places!
 How the mighty have fallen!
²⁰ Tell it not in Gath,
 proclaim it not in the streets of Ashkelon;
 or the daughters of the Philistines will rejoice,
 the daughters of the uncircumcised will exult.

²¹ You mountains of Gilboa,
 let there be no dew or rain upon you,
 nor bounteous fields!
 for there the shield of the mighty was defiled,
 the shield of Saul, anointed with oil no more.

instigated by his son Absalom. This abstract image captures the tensions that define David's life, especially war and peace, loss and gain, hatred and love.

The story of David and Goliath occurs in 1 Samuel (17:19-58), but because it is the origin of David's rise in Saul's court as well as a reason for Saul's jealousy toward him, the divisive force of that heroic victory carries over to the introductory page to 2 Samuel. David's victory over the giant is certainly a foundational element in his life as it gained him the adulation of the people and, eventually, the crown. This story is so well known that it has become a central metaphor for overcoming overwhelming odds.

Image

David's elegy over the death of Saul is one of the most poignant poems in the Bible and in all of literature. Many threads from Israelite history join here, forming an interesting paradox. David mourns the house of Saul, whose founding member is his bitter foe (Saul), while another member is his most beloved friend (Jonathan). David can only be conflicted. Furthermore, not only is David lamenting personal loss, but he is also considering the nation's interest: How will the Philistines mock the Israelites, "Tell it not in Gath . . . or the daughters of the Philistines will rejoice, the daughters of the uncircumcised will exult" (2 Sam 1:20)? How will the Israelite women react to the deaths of their husbands, sons, and brothers, "O daughters of Israel, weep over Saul" (2 Sam 1:24)?

The elegy reaches a climax in verse 26. Here, David switches to a first-person account, "I am distressed for you, my brother Jonathan; / greatly beloved were you to me; / your love to me was wonderful, / passing the love of women" (2 Sam 1:26). Nowhere else in the Bible is there such an encomium to male love and friendship, and, indeed, the death of Jonathan may very well be the greatest pain David feels in his life. David will have further cause for grief and mourning when his rebellious son, Absalom, dies at the hands of David's own army (2 Sam 18:33).

Scriptural Cross-references

Song of Solomon; Isaiah 16:9-14; Jeremiah 9:1; Lamentations 1:16-22; Matthew 5:4; Luke 6:21; John 11:35; 1 Corinthians 7:8-9; 1 Corinthians 13

I Will Raise up Your Offspring
2 Samuel 7:8-27; special treatment; Sally Mae Joseph, artist

David has secure borders, relative peace, and his own palace. The ark, which he brought to Jerusalem, however, has no permanent resting place, so he would like to build a temple for the Lord.

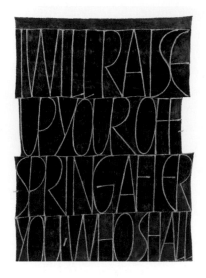

The Lord, through the prophet Nathan, however, expresses his displeasure at the prospect. He has dwelt in a tent from the day the people left Egypt and does not expect to live in a temple (2 Sam 7:6-7). David is not to build such an edifice, but there is more to what the Lord has to say to David.

This passage cites what has come to be called the "Davidic Covenant." The Lord promises to raise up a descendant who will "establish his kingdom" forever (7:11-13). Although the Davidic line turns out to be one of the longest dynasties in history (over five hundred years), it comes to an end with the Babylonian conquest in 586 BC. That Christ is from the house and lineage of David, however, demonstrates for Christians that this promise of a descendant who will lead an eternal kingdom is a reference to Christ and his redemption.

David Said to Nathan
2 Samuel 12:13; special treatment; Donald Jackson, artist

This treatment reflects the central lesson of the story of David and Bathsheba (2 Sam 11:1-27). Sin leads to sin. With his army on an extended campaign, David shamelessly takes Bathsheba, the wife of Uriah, one of David's officers. In an attempt to cover up her pregnancy, he calls Uriah home and induces him to sleep with Bathsheba. Uriah, as loyal to his own men as to the king, does not, despite David's three attempts to convince him otherwise. David then devises what constitutes Uriah's execution, moving from adultery, to deception, to murder. Uriah's fine moral backbone makes an excellent foil to David's low character at this point.

When confronted, David admits his wrongdoing: "David said to Nathan, 'I have sinned against the Lord'" (2 Sam 12:13). This acknowledgment of guilt over the adulterous affair separates David's moral character from his predecessor Saul, and for that reason, Nathan the prophet is able to say, "Now the Lord has put away your sin; you shall not die" (2 Sam 12:13), that is, he will not die because of his sinful action.

Scriptural Cross-references

Matthew 3:1-11; Mark 1:1-4; Luke 17:1-4; Romans 2:4

David Anthology

2 Samuel 16; Donald Jackson, artist

Background

Considered the greatest monarch in all of Jewish history as well as within the Christian tradition, King David's reign has both high and low points. David has unified the kingdom and has brought the ark of the covenant to Jerusalem from Kiriath-jearim (1 Sam 7:1; 2 Sam 6), a deed that recalls the covenant at Mount Sinai, outlined in Exodus 20 as well as the Davidic covenant prophesized by Nathan in 2 Samuel. Yet, as the narrative in this chapter also describes the low points of David's rule, here we see its nadir. His son Absalom, who has waged an open rebellion against his father, attacks Jerusalem, forcing David and his court to flee—a disgrace for any sovereign.

Image

For this anthology page we see a juxtaposition between the two sides to David's life and throne. Seven panels run vertically across the page, tying the Davidic monarchy to the perfect number, seven. The image alongside the text presents Jerusalem, not under siege as one would expect, but as a city in its dignified glory. Set between two valleys with a third running through it, Jerusalem's streets climb and descend among the resulting hills. Arches, steps, and retaining walls are prominent features, augmented by the native limestone, whose color runs between pink and orange, depending on the sunlight. All of these features are captured in Donald Jackson's full-page image. The most important element for the city—indeed the one that makes it the Holy City—is the ark of the covenant. King David brings it to Jerusalem, but because his hands are so bloody from battle, the Lord does not allow him to build the temple in which to house the sacred tablets of the covenant. That task falls to his son, Solomon.

The image of the ark, though only a thumbnail portrait in comparison to the rest of the illumination, is in the lower right corner of the left page. It provides the thematic, historical, and theological continuity to the whole piece. The special treatment, in the left page margin, is a quotation from David's prayer (2 Sam 22:2-3, 7). It underscores the relationship he wishes to have with the Lord, and may even have tried to have with him, despite all of David's personal failings. Ultimately, his prayer is a reliance on God's mercy.

In Jewish history, King David remains the greatest of kings. In Christian theology, he foreshadows Jesus Christ, the Messiah, whose reign is everlasting. In the Middle Ages, King David was considered the model monarch.

Scriptural Cross-references

Ruth 4:17; Psalm 110; Matthew 1:1-17, 20; 9:27; 22:42-46; Luke 1:30-33

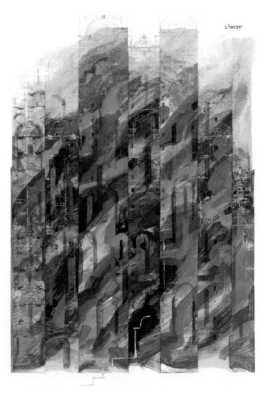

Marginalia: Ants Attacking a Grasshopper
2 Samuel 24; Chris Tomlin, artist

2 Samuel closes with ants feeding on a dead grasshopper. The images of the natural world within the Historical Books depict nature "red in tooth and claw" as a way to emphasize the violence and degeneration of God's chosen people. Instead of trusting in the Lord God as their ruler, the people have thrown their allegiance to a king, whether that be Saul, David, or Solomon. Looking to the Lord would have kept the people aware of the "widow, orphan, and alien" in their midst, and their actions would have corresponded with their beliefs (Deut 27:19). Instead, they follow a path of political expediency with its disastrous results for social justice. In the anti- and promonarchist tension exhibited throughout 1 and 2 Samuel, it appears in this account that the promonarchists have won the day.

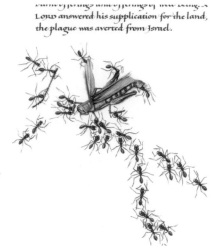

Scriptural Cross-references
Numbers 13:32; Joshua 24:13

I KINGS

Solomon's Wisdom
1 Kings 3:16-28; Hazel Dolby, artist

Background
The story of two prostitutes, each claiming to be the mother of the one child, is probably the most famous account associated with King Solomon. The episode is situated within the context of Solomon's wisdom, the one gift the king previously asks of the Lord (1 Kgs 3:5-12). Solomon, as king, is the servant of the Lord.

Image

The threat of the sword, which prompts the real mother to forsake her child rather than see it killed, determines the outcome of the story and is prominent in this strong and decisive depiction.

Scriptural Cross-references

Psalm 131; Isaiah 66:13; Tobit 5:18

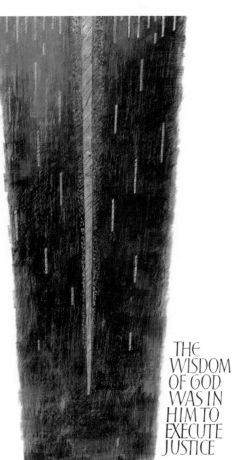

THE WISDOM OF GOD WAS IN HIM TO EXECUTE JUSTICE

Solomon's Temple
1 Kings 8:1-66; Donald Jackson, artist

Background

The dedication of the temple fuses together several elements in Israelite history. The promonarchist faction has been prominent in the land since the time of David. In this passage, the faction receives approbation in that, by building the temple, King Solomon engages in a great act of devotion—as if to say that he may be glorious, but the glory belongs to the Lord. The political capital now also becomes the religious capital; both the king and the Lord inhabit the same city, and all the elders, tribal leaders, and ancestral heads are assembled to witness the event (1 Kgs 8:1). The glory and majesty of this moment, however, are short-lived. The unified kingdom crumbles upon the death of Solomon with one son, Jeroboam, leading the breakaway tribes of the north (Israel) and Solomon's other son, Rehoboam, reigning over the south (Judah). The narrative rolls on describing the misfortunes of both.

Solomon's prayer and blessing before the people establishes his legitimacy as king and sanctions his decision to build the temple by citing the Lord's

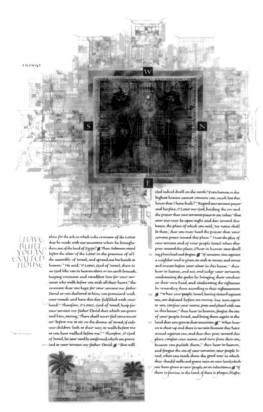

promise to his father David (2 Sam 7:5-16). He then turns to God and begs forgiveness for sins both personal (1 Kgs 8:31) and national (1 Kgs 8:33-46). In addition, he asks for pardon when sins bring calamities: drought (1 Kgs 8:35), famine (1 Kgs 8:37), and war (1 Kgs 8:44). The gathered community assents to the prayer by acclamation (1 Kgs 8:56-66), offering sacrifices (1 Kgs 8:62) and feasting (1 Kgs 8:65-66).

Image

Throughout history, the temple has been an object of fascination for many. It is said that when the emperor Justinian completed Hagia Sophia in Constantinople, he stood under the great dome and exclaimed, "Solomon! I have outdone you!" Such is the place the Jerusalem temple has had in history.

Artists over the ages have tried to reconstruct Solomon's temple according to the description and measurements in 1 Kings 7–8. It has been a nearly impossible task. Scholars do not even know the size of the cubit for certain, though it probably was the length from one's middle finger to the elbow, but then, whose arm becomes the standard? In fact, other ancient texts speak of the "royal cubit" when it comes to the temple. Is this royal cubit larger than the regular one, and if so, by how much?

The four-square design here is based on some of the historical renderings of Solomon's temple. As with nearly every religious site throughout history, the cardinal points of the compass also have great importance for the Israelites, as indicated in this rendering. The temple architecture in this depiction is balanced by continuing an abstract floor plan of the building into the other three corners of the folio. Across the image is a muted oscillographic pattern of the Saint John's monks singing, similar to the one in Psalms.

The special treatment on the right page containing the verse, "He said, 'O Lord, God of Israel, there is no God like you in heaven above or on earth beneath, keeping covenant and steadfast love for your servants who walk before you with all their heart'" (1 Kgs 8:23), asserts the primacy of the covenant as the foundation that the people, represented by Solomon, should have with the Lord God.

Scriptural Cross-references

Ezra 3; Nehemiah 2–3; Isaiah 6:1-8; Ezekiel 40–42; Revelation 21

Elijah's Theophany
1 Kings 19:4-18; Donald Jackson and Aidan Hart, artists

Background

At 1 Kings 17, the story switches from the kings of Judah and Israel to Elijah, one of the greatest prophets in the Old Testament, who, in time, becomes an eschatological figure. To this day, Jews believe that his return will usher in the Messiah. In this scene, Elijah, hounded by both Ahab and his wife Jezebel, flees for his life to Mount Horeb (also known as Sinai). This mountain is the

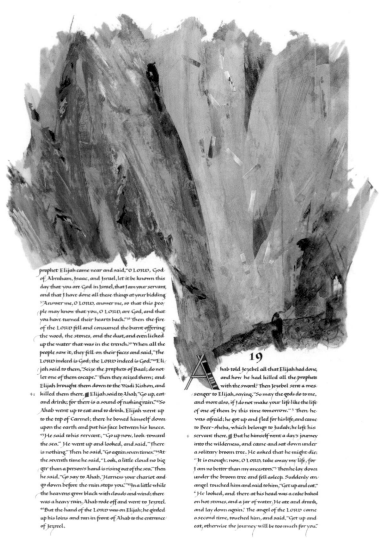

same as the one upon which the Lord gives his law to Moses (Exod 20–21). The Lord now directs a fortified and reinvigorated Elijah to Damascus where he anoints Hazael as king of Syria and Jehu as the new king of Israel (in opposition to Ahab). Elijah also anoints his successor, Elisha. Eventually, each of the individuals will fulfill the will of the Lord by eradicating the wicked Ahab and Jezebel from the throne of Israel. Elisha then replaces Elijah.

Image

The mountain appears as a frightening and foreboding place, which adds to Elijah's desire for death. He does not die, however. Rather, angels come to Elijah's assistance by providing food and water, and a theophany or appearance of God occurs. The Lord is not in the wind, earthquake, or fire but in a calming quiet. The special treatment at the bottom of the text emphasizes Elijah's experience of God: "and after the fire a sound of sheer silence" (1 Kgs 19:12).

Scriptural Cross-references
Genesis 15:3-5; Exodus 19–20; Mark 9:2-9

2 KINGS

Elijah and the Fiery Chariot
2 Kings 2:1-14; Donald Jackson and Aidan Hart, artists

Background

Elijah is one of three messianic figures who does not meet a human death; God takes him into heaven.[4] Elisha, the successor to Elijah chosen in 1 Kings 19, walks with Elijah when the elder prophet is assumed into the heavens. In the midst of the whirlwind, Elijah drops his mantle, which Elisha picks up—a symbolic gesture of passing on the gift of prophecy. The text records that fifty prophets along a riverbank tell Elisha what to expect from his life's work. Although they witness the event, only Elisha is Elijah's successor. Elisha now has the double portion of Elijah's spirit that he asked for in 2 Kings 2:9.

Image

Elijah and Elisha are important prophets in both the East and the West. To show their universal appeal, the composition employs Greek iconographic methods and themes. Their prestige in the prophetic tradition is underscored by the passing of the mantle from Elijah to Elisha. This depiction evokes great energy and motion; prophecy engages one to action. Elisha's excitement and shock

4. Enoch (Gen 5:24) and Melchizedek (Gen 14:18; Heb 7:1-3) are the two others.

are captured with the quotation, "Father, father! The chariots of Israel and its horsemen!" (2 Kgs 2:12).

This scene has cross-references with other passages in Scripture in which humans either see, acknowledge, or respond to the transmission of divine glory and authority from one individual to another.

Scriptural Cross-references
Matthew 3:11-17; 16:14-19; Luke 9:28-36; Acts 2:1-21

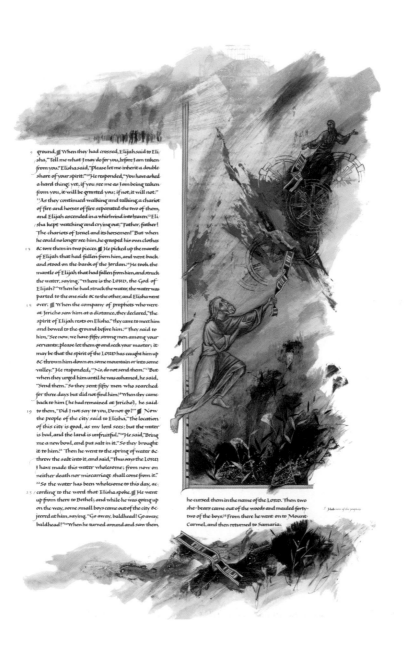

Elisha Anthology

2 Kings 4–6; Donald Jackson and Aidan Hart, artists

2 Kings 4:1-7

Like his mentor, Elisha has a soft spot in his heart for widows and orphans, the two most vulnerable members of society. In this passage, Elijah performs a miracle to keep a widow's two children from being sold into slavery. The use of olive oil underscores the salvific and venerable properties the ancients associated with it.

Producing the olive oil from nearly empty jugs is the miracle. The materials and the oil produced are earthly and ordinary things present in every household. The miracles Jesus performs in the gospels resonate with the great stories of Israel, of which this is one; Jesus too helps widows. We see here the development of a relationship between the widow and the prophet. God, through the prophet, touches an individual personally.

2 Kings 4:8-37

A little-known story of a miraculous birth of a son to a couple well past the age of child-bearing, this account continues with a second miracle of resuscitating the child after he dies of sunstroke. The locale where this miracle takes place, Shunem, is in the same mountain range as Nain, the village where Jesus raises the widow's son in Luke's gospel (7:11-15). Elisha resuscitates the boy by lying on his body. Jesus, however, raises the dead son of the widow of Nain by only a touch. The people in Jesus' ministry would have made the connection with Elisha.

2 Kings 4:42-44

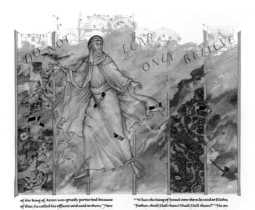

These verses from 2 Kings also parallel the miraculous feeding stories in the gospels. Elisha feeds one hundred people with twenty loaves of barley and fresh ears of grain. Important to see here is the fact that the food was a gift expressly for Elisha. He decides to share it with others, a notion that lends itself to a eucharistic theme.

2 Kings 5:1-27

Naaman, army commander of the pagan king, goes to Elisha seeking a cure for his own leprosy. At first he is angered

by the prophets' simple instruction to bathe in the Jordan seven times, but his servants prevail upon him, and he follows Elisha's advice. Once cured, Naaman proclaims the God of Israel and forsakes his pagan ways. Elisha refuses payment for what the Lord has done, but Gehazi, his trusted servant, succumbs to avarice and concocts a story to tell Naaman so he can take the remuneration originally intended for Elisha. Elisha, the man of God, can see the truth, and Gehazi, now caught in a lie, is stricken with Naaman's leprosy.

The glory of the Lord extends all the way to Damascus in this story. This is a pagan land, well beyond the borders of Israel, and actually is itself enemy territory. God's goodness knows no bounds.

2 Kings 6:1-7

God works miracles through his prophets. As we see in this short account, the wonders are not confined to matters of life and death as seen in the story of the boy of Shunem (2 Kgs 4:8-37). Retrieving an axe head may only be an act of convenience, but the real purpose of this episode is to direct glory and honor to God who uses his prophets as instruments of his goodness. Many of these passages are echoed in the New Testament. There is also a similar story in Gregory the Great's *Life of Saint Benedict*, in which one young monk, Maurus, by sticking a handle in a lake, causes a lost axe head to float to the top of the water.

Image

The five episodes are represented by five, vertical panels; Elisha himself stands in one of them. They are arranged sequentially, left to right. The leitmotifs will resurface in other places but will be most pronounced in the Gospels.

Scriptural Cross-references

1 Kings 17:8-24; Matthew 14:13-21; 15:32-39; Mark 6:30-44; 8:1-10; Luke 7:11-17; 9:12-17; John 5:1-14

Huldah the Prophetess
2 Kings 22:1-20; Suzanne Moore, artist

Background

King Josiah (648–609 BC) is eight years old when he begins his reign; this passage takes place in his eighteenth year. This story is so vivid. Hilkiah the high priest, commanded to count the money in the treasury, finds a book. Realizing the importance of the contents, he hands the scroll over to Shaphan the secretary. He, in turn, takes it and reads it to King Josiah. King Josiah,

worried that punishment is imminent because no one has been observing the laws outlined in the text, has his officials take it to Huldah the prophetess for interpretation. Her words, only slightly consoling, assure safety and security for King Josiah but foretell absolute destruction in the days following his reign. Huldah is referring to the conquest of Jerusalem brought by the Babylonians. In 586 BC, the Babylonians invade and destroy Jerusalem, killing some of its inhabitants while enslaving others.

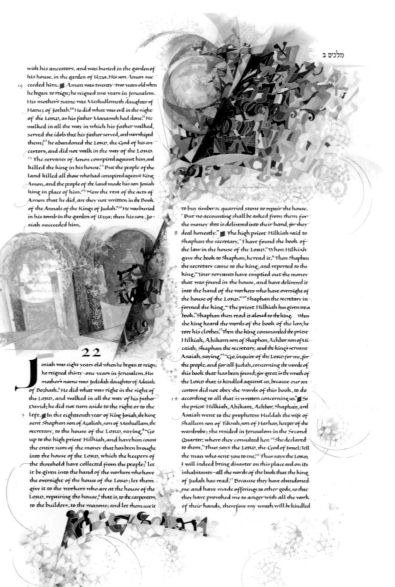

Because King Josiah repents (cries and rends his garments), the Jewish tradition considers him the greatest king after David. In fact, the rest of the chapter and nearly all of 2 Kings 23 relate the great reforms Josiah implements unhesitatingly.

Scholars believe that the book found in the treasury is the one we currently call "Deuteronomy." The importance of Deuteronomy on Judaism, and even Western civilization, cannot be underestimated. How did it get lost? When the Assyrians threatened the north kingdom in 722 BC, the refugees fled to Jerusalem, probably taking the book with them. Scholars speculate that the southern kingdom did not have this text. It was placed in the treasury for safekeeping and then forgotten.

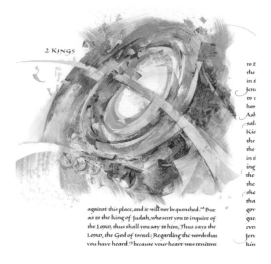

against this place, and it will not be quenched.'⁶ But as to the king of Judah, who sent you to inquire of the LORD, thus shall you say to him, Thus says the LORD, the God of Israel: Regarding the words that you have heard.'⁹ because your heart was penitent.

Prophecy is a genre of Scripture that shares some qualities with other ancient writings and practices but that also shows remarkable differences. In the biblical tradition, true prophecy never strays from the covenant and its message, whereas false prophecy has another agenda.

Image

Huldah is a woman prophetess of considerable importance, as this text shows; her words are responsible for moving Josiah to initiate reforms for the whole society. Even the temple at the time of Christ, approximately six hundred years after Josiah's reforms, had a spot marked where Huldah once sat, and the front gates facing them are named after her. Although her message and charism are tied to the teachings of the Lord God, her status appears to have been one similar to the Oracle of Delphi. Unlike the Delphic Oracle, however, Huldah would have been steeped in the Israelite teachings and traditions and would not have engaged in fortune-telling, as did the prophets of the surrounding cultures.

The layout of the piece characterizes a scroll and stylus. Suzanne Moore used the letters of ancient manuscripts to render the fragments of the sacred texts. In turning the page to 2 Kings 23, we see a rolled scroll, the form books took in the ancient world; it completes the image.

Scriptural Cross-references

Judges 4–5; Nehemiah 6:14; Proverbs; Wisdom; Isaiah 8:3; Micah 6:4; Luke 2:36

1 AND 2 CHRONICLES

First Chronicles lists a long series of genealogies and then reprises the stories of King Saul and King David. Second Chronicles retells much of the material found in 1 and 2 Kings. These two books are connected to the historical narrative through the illustrations of the insect world. See comments for 2 Samuel 24.

EZRA

An account of the restoration of the Jewish kingdom under the Persian King, Cyrus the Great, the book of Ezra contains no images. The text, however, is based on repopulating the land and rebuilding Jerusalem and its temple. Hence, this book has a strong narrative connection with Nehemiah.

NEHEMIAH

Square before the Water Gate
Nehemiah 8:1-12; Hazel Dolby, artist

Background

Like all ancient cities, Jerusalem's lanes and pathways were crowded and cramped. Because the space in front of a gate was comparatively large, law courts, markets, and official business often took place there. As a piece of civic architecture, the square at a city gate was a real gathering spot for any community, and so too here, where the square before the water gate would be an area able to accommodate a large number of people.

Biblical exegetes remind us that the Word is most truly the Word of God when proclaimed in the midst of the community.[5] The passage specifically describes the community as comprised of "both men and women and all who could hear with understanding" (Neh 8:2); it is a most inclusive gathering. The people weep when they hear the words of the law (8:9). Undoubtedly, they do so because they know their sinfulness in not fulfilling the Lord's prescriptions. The response from Nehemiah, Ezra, and the Levites is wonderful. They tell the people to celebrate (8:10), and there is great rejoicing (8:12). It is a marvelous scene of holy feasting. The law certainly does point out sinfulness and

5. See Sandra M. Schneiders, *The Revelatory Text: Interpreting the New Testament as Sacred Scripture* (San Francisco: HarperSanFrancisco, 1991).

wrongdoing, but it also leads to redemption and deliverance.

The people are fed with both the Word and with food (8:10). Real celebration is associated with hearing the Word of the Lord. Furthermore, the people rejoice because "they understood the words that were declared to them" (8:12). This passage stands in sharp contrast to Ezra 10, where in order to observe the law, Ezra forces all the men who had married foreign wives to divorce them and to renounce any children resulting from the foreign marriage.[6] The book of Ruth, in which a foreign woman becomes the great-grandmother of King David, counters the theology behind Ezra's draconian measure.

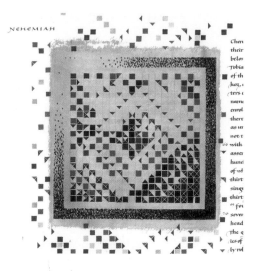

Image

The reading at the square before the water gate forms the Jewish nation after the Babylonian exile. Everyone there participates in following the law. Because these events define the people going forward, we can say that they function as the exodus event does: it builds and shapes the community. Christians see the events of Pentecost doing the same thing for the church (Acts 2:43-47), where the community is fed at the common table with Christ the Word made flesh at the center.

Elegant in its simplicity, the quarter-page square is busy with activity as it draws colored geometric shapes to itself like iron filings to a magnet. Viewers will note that the pattern evokes images of both Jerusalem and the temple found elsewhere in *The Saint John's Bible*. Parts of the depiction flow over to the facing page. The special treatment at the bottom of the facing page is from Nehemiah 8:10.

Scriptural Cross-references

Exodus 12, 14; 2 Kings 22:1-20; Acts 2:43-47; 1 Corinthians 11:23-26

6. Nehemiah 8 curiously downplays this harsh legislation in comparison to Neh 9:1-2.

ESTHER

Esther
Esther 5:1-14; Donald Jackson, artist

Background

Esther saves her people from annihilation by the Persians, an event still commemorated as the Jewish feast of Purim. Along with Judith, Esther is one of the great Jewish heroines. Esther's access to King Ahasuerus allows her to

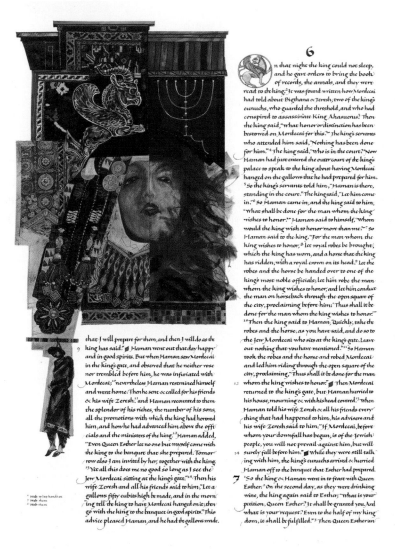

YOU·KNOW·MY·NECESSITY—THAT·I·ABHOR·

be the savior and protector of the Jews in the face of the evil machinations of Haman. The story is good drama. Haman expects that the gallows he has ordered will be used for Mordecai. In the twisting plot, however, Haman will be the one to hang on them.

In the Jewish tradition, Esther is a redeemer figure, often portrayed reciting Psalm 22. The near brush with extinction, which the Jews in the story undergo, has made this narrative the lens through which many interpret the Holocaust. "All Israel cried out mightily, for their death was before their eyes" (Esth 13[C]:18).[7] Yet, death does not win. The rescue is affected by the fact that Esther invites Haman to dinner. The dinner, which Haman attends with great glee, ends with his own death on the gallows he has built for Mordecai.

Image

Many will readily recall Gustav Klimt's *Judith I* when looking at this figure of Esther. The face here is divided, with one side showing Esther as a regal queen and the other as a strong, Jewish woman. In order to save the people, she needs both attributes simultaneously. Persian artifacts and traditional Palestinian women's adornments compose Esther's jewelry and clothing. The special treatments on the right page, including both "You know that I hate the splendor of the wicked" (Esth 14[C]:15) and "O God, whose might is over all, hear the voice of the despairing, and save us from the hands of evildoers. And save me from my fear!" (Esth 14[C]:19) provide the voice for the image.

2 MACCABEES

Prayer for the Dead
2 Maccabees 12:42-45; special treatment; Sally Mae Joseph, artist

The two books of Maccabees record the successful Jewish revolt against Seleucid Greeks (175–134 BC) led by the Jewish leader Judas Maccabeus.[8] In

7. Readers are often puzzled by the confusing chapter headings in the work. These are the result of the various additions. The book of Esther exists in two versions, Hebrew and the Greek Old Testament (Septuagint). The Greek, as a translation of the Hebrew, includes additional text and information. The layout in *The Saint John's Bible* follows that of the NRSV, which is guided by the chronological sequence of the story.

8. While both 1 and 2 Maccabees were originally written in Hebrew, they come to us through Greek translation. They are considered deuterocanonical for Catholics and Greeks, while Protestants consider them apocryphal.

rabbinic tradition, the feast of Hanukkah traces its origins to the rededication of the temple after the Jewish forces drive out the Greeks (1 Macc 4:59).

The special treatment here is connected to a battle against the Greeks in which Jewish soldiers fall in the city of Adullam. Judas Maccabeus and his men come to collect the bodies in order to bring them back to their ancestral homes for proper burial. To their horror, they find their fallen Jewish comrades wearing pagan amulets, something forbidden by Jewish law.

2 MACCABEES

³⁷In the language of their ancestors he raised the battle cry, with hymns; then he charged against Gorgias's troops when they were not expecting it, and ³⁸put them to flight. ¶ Then Judas assembled his army and went to the city of Adullam. As the seventh day was coming on, they purified themselves according ³⁹to the custom, and kept the sabbath there. ¶ On the next day, as had now become necessary, Judas and his men went to take up the bodies of the fallen and to bring them back to lie with their kindred in the sepulchres of their ancestors. ⁴⁰Then under the tunic of each one of the dead they found sacred tokens of the idols of Jamnia, which the law forbids the Jews to wear. And it became clear to all that this was the reason these men had fallen. ⁴¹So they all blessed the ways of the Lord, the righteous judge, who reveals the things that are hidden; ⁴²and they turned to supplication, praying that the sin that had been committed might be wholly blotted out. The noble Judas exhorted the people to keep themselves free from sin, for they had seen with their own eyes what had happened as the result of the sin of those who had fallen. ⁴³He also took up a collection, man by man, to the amount of two thousand drachmas of silver, and sent it to Jerusalem to provide for a sin offering. In doing this he acted very well and honorably, taking account of the resurrection. ⁴⁴For if he were not expecting that those who had fallen would rise again, it would have been superfluous and foolish to pray for the dead. ⁴⁵But if he was looking to the splendid reward that is laid up for those who fall asleep in godliness, it was a holy and pious thought. Therefore he made atonement for the dead, so that they might be delivered from their sin.

13

In the one hundred forty-ninth year word came to Judas and his men that Antiochus Eupator was coming with a great army against Judea, ²and with him Lysias his guardian, who had charge of the government. Each of them had a Greek force of one hundred ten thousand infantry, five thousand three hundred cavalry, twenty-two elephants, and three hundred chariots armed with scythes. ³¶ Menelaus also joined them and with utter hypocrisy urged Antiochus on, not for the sake of his country's welfare, but because he thought that he would be established in office. ⁴But the King of kings aroused the anger of Antiochus against the scoundrel; and when Lysias informed him that this man was to blame for all the trouble, he ordered them to take him to Beroea and to put him to death by the method that is customary in that place. ⁵For there is a tower there, fifty cubits high, full of ashes, and it has a rim running around it that on all sides inclines precipitously into the ashes. ⁶There they all push to destruction anyone guilty of sacrilege or notorious for other crimes. ⁷By such a fate it came about that Menelaus the lawbreaker died, without even burial in the earth. ⁸And this was eminently just; because he had committed many sins against the altar whose fire and ashes were holy, he met his death in ashes. ¶ The ⁹king with barbarous arrogance was coming to show the Jews things far worse than those that had been done in his father's time. ¹⁰But when Judas heard of this, he ordered the people to call upon the Lord day and night, now if ever to help those who were on the point of being deprived of the law and their country and the holy temple, ¹¹and not to let the people who had just begun to revive fall into the hands

¹ 163 B.C.
²⁶ Or the worse of the things that had been done

The reaction of Judas and his men to this breach of the commandment is most important in the development of theology. The survivors pray to God to forgive the dead for the sins they have committed. Likewise, they call on the people to pray for the sake of the fallen, and they also take up a collection for a sin offering. Furthermore, the text mentions that Judas acts so in the hope that these men might have a share in the resurrection.

This incident becomes one of the bases supporting the Christian belief in the communion of saints and the practice of prayers for the dead. It relays the belief that our shortcomings and sins can see restitution and forgiveness in the next life if not in this one. Traditionally, this concept is the same as the Roman Catholic teaching on purgatory.

Chapter 7

WISDOM BOOKS

INTRODUCTION

Within the Wisdom Books of *The Saint John's Bible*, at least three themes weave back and forth: creation, practical wisdom, and the practical nature of the divine. In the case of the latter, we see the feminine character of God. One of the great problems with human language in any description of God is that words ultimately fail. There is no single term, phrase, sentence, or book that can fully and completely describe God or the human experience of God. The world's greatest theologians took over four hundred years to formulate and develop the words of the Nicene Creed, and believers are still left struggling in any attempt to explain the Trinity. So great is the love and mystery of God.

The same can be said of anything that defines God's gender, despite the use of masculine nouns and pronouns. God is neither exclusively masculine nor exclusively feminine. God is fully both without being half of one or the other or without being hermaphroditic. An often overlooked passage in Exodus 3 is how God reveals God's self to Moses. God does not give a name, lest that name be construed as masculine or feminine. Rather, God says, "I am who I am" (Exod 3:14)—neither male nor female but being or existence itself. For the same reason, images of God are forbidden in the Old Testament so that the Israelite God would maintain its inclusive status above the gods of the surrounding cultures, which had both male and female consorts.

The ancient church recognized this capacious quality in God, and it placed great emphasis on Scripture's Wisdom tradition to address it. Wisdom is God's way of interacting with the created world. Because Jesus Christ is the ultimate revelation of God in creation, and because his passion, death, and resurrection are the ultimate act of God's love, the church sees a connection between the Second Person in the Trinity and Wisdom. The Wisdom books in the Bible concentrate on developing that connection by giving example and explanation. The important point to keep in mind is that the Wisdom tradition stresses that

the transcendent God also has an incarnational quality, which deals with the practicalities of everyday living. Moreover, this incarnational feature within this tradition is characterized as Wisdom and is personified as a woman, sometimes called "Lady Wisdom" or "Wisdom Woman." As the life-giving spirit, Wisdom is with God from the very beginning of creation (Gen 1:2).[1]

JOB

Job Frontispiece
Job 1–2; Donald Jackson, artist

Background

The opening scenes alternate between Job's life on earth and God's court in heaven. At Job 1:13, the action switches to Job's sons and daughters. In its structure, this story is like a parable in which the narrative is used to enhance the dialogue between God and Satan.

The presentation of Satan has particular importance in the development of theology. Job is a very old story (ca. seventh and fifth centuries BC), and at this point in the development of Judaism, Satan is portrayed more as an adversary than the personification of evil. In Job, he appears similar to a legal prosecutor trying to prove his case. He is also a bit of a trickster who sets up conditions to confound people. He is the ultimate contrarian who thwarts the aims and wishes of others. Only at a much later time in history does Satan become the embodiment of evil seen in the other books of Scripture.

The book of Job opens with Satan defending God. He intimates that Job is taking advantage of God, and for this reason, Job is faithful to the Creator. Withhold or even remove the blessings from Job, Satan suggests, and God will see just how loyal Job truly is (1:11-12).

This literary plot presents us the question of theodicy, the major theme in Job. Why do innocent people suffer?

As the story unfolds, Job's wife and friends try to convince him that he must be guilty of something or he would not have met such a fate. Job protests his innocence all along and is vindicated at the end.

The theodicy theme also raises the question of whether it is possible for human beings to serve God without hope of reward, or are we always in it for what we can gain for ourselves?

In Christian tradition, Job becomes a Christ figure.

1. See Sergius Bulgakov, *The Lamb of God* (Grand Rapids: William B. Eerdmans Publishing Company, 2008) and Judith Deutsch Kornblatt, *Divine Sophia: The Wisdom Writings of Vladimir Solovyov* (Ithaca: Cornell University Press, 2009).

The first two chapters of Job move from one calamitous occurrence to another; when chapter 3 opens, Job curses his own birth (3:1-3). In the outline of the book, the action starts out festive, turns gloomy and remains so for most of the narrative, and then ends with a positive resolution.

Image

The first page we see is the "incipit" or beginning of Job. The double panel sets the tone of the book. On the left, we see bright, lively colors, fish,

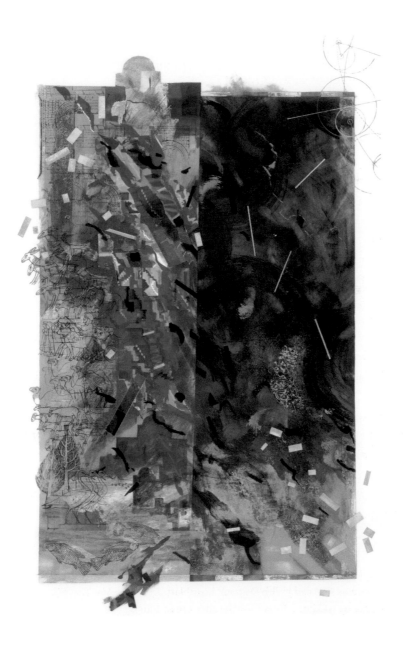

waterfowl, herds of domestic animals, beautiful buildings, and blue sky. In deep contrast, the right half presents complete destruction and chaos with smoke, fire, and falling debris. Separating the two panels is a razor-thin line: one minute there is life, order, and beauty; the next moment that life is swept away in smoke. We are looking at an image of human experience that we all fear but which Job actually undergoes.

The special verse treatment in the margin on the right facing page gives Job's response to the disasters that have befallen him: "Shall we receive the good at the hand of God, and not receive the bad?" (Job 2:10).

Scriptural Cross-references
Psalms 22, 88, 130; Isaiah 52–53; Matthew 26:36–27:56; Mark 14:32–15:41; Luke 22:39–23:49; John 18:1–19:30

Marginalia at Job 15
Wisdom 6:12; Sally Mae Joseph, artist

This special treatment in the margin at Job 15 is a response to the harangue that Job's arrogant friend, Eliphaz the Temanite, delivers as an attempt to explain the situation to Job. The verse, "Wisdom is radiant and unfading, and she is easily discerned by those who love her, and is found by those who seek her," comes not from the book of Job but from the book of Wisdom (6:12). It is an example of intratexuality in Sacred Scripture—that is, using a verse from one book of the Bible to interpret another.

of the sword,
so that you may know there is a judgment."

FOR I KNOW
that my Redeemer lives,
and that at the last
he will stand upon the earth.

20

Then Zophar the Naamathite answered:
² "Pay attention! My thoughts urge me to answer,
because of the agitation within me.
³ I hear censure that insults me,

Job 19:25
Special treatment; Diane van Arx, artist

"For I know that my Redeemer lives, and that at the last he will stand upon the earth" (Job 19:25).

Prior to this well-known statement of faith is Job's reply to Bildad. In words consistent with 19:25. Job is calling out for vindication (19:22-24). At 19:25 he expresses his absolute faith in God; with all things showing the contrary, Job states

with surety that his suffering will not have the last word. His Redeemer will set the record straight even if it happens after Job is dead and gone. No one knows to whom Job is referring by the word "Redeemer." While Christians have always seen it as a reference to Christ, in Isaiah we discover that "Redeemer" is the Lord's ancient name (Isa 43:14; 44:6; 63:16). Job 19:25 is also the source of one of Georg Frideric Handel's arias from *Messiah*.

God's Response
Job 38:1–42:6; Thomas Ingmire, artist

Background

These chapters feature the longest discourse of God in the Old Testament. God begins by upbraiding Job for his temerity. God's argument is that he is the master of creation and knows things that Job does not. Maybe there are reasons for afflicting Job, and maybe there are not, but the answer is beyond Job's understanding anyway. God is telling Job, "Look where you really belong in the scheme of things!"

God mentions that he created Behemoth (40:15) and Leviathan (41:1). These monsters personify evil. No one really knows what in the natural creation they could be. Often Behemoth is considered a hippopotamus and other times a crocodile. Leviathan seems to be a sea creature that looks like the Loch Ness monster. In any case, God created them, and only God can control them. Job is powerless before them, which, since they are the symbols of evil, means that Job is helpless without God when confronting evil.

After God's discourse, the story comes to an abrupt turn with Job's response (42:1-6). Job admits his insignificance before God, and he repents for challenging him. The whole book comes to a climax with Job's words: "I had heard of you by the hearing of the ear, but now my eye sees you; / therefore I despise myself, and repent in dust and ashes" (42:5-6). In the end, Job admits that the relationship with God is enough; he does not need reasons and explanations.

Image

The depiction blasts us with a barrage of words, and we can hear the cacophony. When we are suffering or in need of correction, friends' words of consolation often fall far short of the mark. If anything, the explanations rattle and ring hollow and simply fill our heads with background noise. In this scene, the response comes from God, and all the phrases in the image can be

found in the text. The resolution to Job's situation and his response to God's discourse are found on the right page, seen in the pastel palette underlining a legible sentence.

To see the Lord is an experience of awe. Even Moses hides his face from the Lord (Exod 3:6).

Scriptural Cross-references

Exodus 3:2-6; Matthew 27:46-50; Mark 15:33-37; Luke 23:44-46; John 19:28-30

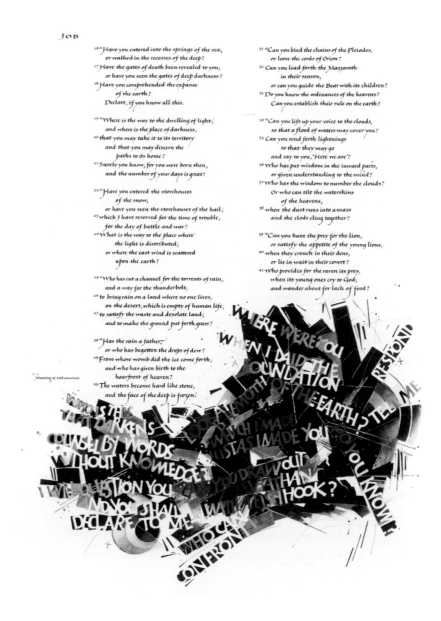

Job's Restoration
Job 42:7-17; Thomas Ingmire, artist

Background

Outside of the prologue, the protagonist, Job, is the only one who speaks *to* God; the friends speak only *about* God. Now, God commands these same friends to offer a sacrifice as a way to expiate the falsehoods they spoke about God in their dialogues with Job. To underscore the severity of their offense, the Lord has them petition Job to speak to God on their behalf.

²⁹ Clubs are counted as chaff;
 it laughs at the rattle of javelins.
³⁰ Its underparts are like sharp potsherds;
 it spreads itself like a threshing
 sledge on the mire.
³¹ It makes the deep boil like a pot;
 it makes the sea like a pot of ointment.
³² It leaves a shining wake behind it;
 one would think the deep to be white-haired.
³³ On earth it has no equal,
 a creature without fear.
³⁴ It surveys everything that is lofty;
 it is king over all that are proud."

42

Then Job answered the LORD:
² "I know that you can do all things,
 and that no purpose of yours can be thwarted.
³ 'Who is this that hides counsel
 without knowledge?'
 Therefore I have uttered what I
 did not understand,
 things too wonderful for me,
 which I did not know.
⁴ 'Hear, and I will speak;
 I will question you, and you declare to me.'
⁵ I had heard of you by the hearing of the ear,
 but now my eye sees you;
⁶ therefore I despise myself,
 and repent in dust and ashes."

⁷ After the LORD had spoken these words to Job, the Lord said to Eliphaz the Temanite: "My wrath is kindled against you and against your two friends; for you have not spoken of me what is right, as my servant Job has. ⁸ Now therefore take seven bulls and seven rams, and go to my servant Job, and offer up for yourselves a burnt offering; and my servant Job shall pray for you, for I will accept his prayer not to deal with you according to your folly; for you have not spoken of me what is right, as my servant Job has done." ⁹ So Eliphaz the Temanite and Bildad the Shuhite and Zophar the Naamathite went and did what the LORD had told them; and the LORD accepted Job's prayer. ¹⁰ And the LORD restored the fortunes of Job when he had prayed for his friends; and the LORD gave Job twice as much as he had before. ¹¹ Then there came to him all his brothers and sisters and all who had known him before, and they ate bread with him in his house; they showed him sympathy and comforted him for all the evil that the LORD had brought upon him; and each of them gave him a piece of money and a gold ring. ¹² The LORD blessed the latter days of Job more than his beginning; and he had fourteen thousand sheep, six thousand camels, a thousand yoke of oxen, and a thousand donkeys. ¹³ He also had seven sons and three daughters. ¹⁴ He named the first Jemimah, the second Keziah, and the third Keren-happuch. ¹⁵ In all the land there were no women so beautiful as Job's daughters; and their father gave them an inheritance along with their brothers. ¹⁶ After this Job lived one hundred & forty years, and saw his children, and his children's children, four generations. ¹⁷ And Job died, old and full of days.

Image

In the framework of the story, we see an A-B-A pattern: Job has prosperity in the beginning, loses it all, and then regains it at the end. God begins to restore to Job his lost good fortune. Verses from the opening scenes of the book fly into the upper register like arrows launched at a target. The bright colors in the lower register form the foundation for the depiction. Constructed of the words from Revelation 21:4, "[H]e will wipe every tear from their eyes. Death will be no more; mourning and crying and pain will be no more, for the first things have passed away," they are an intratextual reference. We, like Job, still do not know why such incalculable suffering occurred, but at least in Job's case, the answers are no longer important because he has found meaning in the abundant heart of God, and that is enough.

A good eye should be able to find the word "across" misspelled in one of the phrases comprising the image. Throughout history, among scribes and scholars who have worked with Sacred Scripture, such errors have been a constant reminder that only God is capable of true perfection. And as for Job, despite all his goodness, he is not as perfect as God, and he suffers even more than some less good than he.

Scriptural Cross-references
Matthew 28; Mark 16; Luke 24; John 20–21; Revelation 21–22

PROVERBS

Every culture has its proverbs and folk wisdom. It was no different for the ancient Israelites. There is a strong correspondence between the sayings found in the book of Proverbs and those sayings found in other surrounding cultures of the time. Wisdom itself is more than intelligence. Just as an intelligent person may not necessarily be wise, knowledge of God is not enough. We must take knowledge we have of God and apply it to the world in which we live. God, speaking as Lady Wisdom, shows us how this is done.

Fear of the Lord
Proverbs 1:7-8; special treatment; Thomas Ingmire, artist

This special treatment serves as the incipit to Proverbs. "Fear of the Lord" is not cowardice or infantile deference; it is a sense of awe and wonder. We humans are not the source and summit of the universe; God is. Recognizing our place before the transcendent God as well as recognizing the dignity and grace the transcendent God has bestowed on us makes us step back in holy fear, awe, and wonder. Only when we realize our insignificance in front of God and our place within the great scheme of God's creation can we even begin to open up to letting him into our lives. The sense is very much like the sentiment expressed in Job 42:5-6. Proverbs 1:8 is quoted in the RSB and is used in the rite of monastic profession.

Wisdom's House
Proverbs 8:22–9:6; Donald Jackson, artist

Background

The subject of the text is Wisdom, who is personified as a woman. Wisdom was with God at the creation of the earth. And she is the designer of creation, the master worker. She is also our bridge to God. Standing before God, she plays on the surface of the earth; she is God's delight, and she delights in us. Because of its allusions to the preexistent Word of God, Christians have long seen Proverbs 8 as particularly referring to Christ.

Pillars are among the oldest architectural features known to humankind; neolithic standing stones are still part of the landscape from the Middle East to Scotland. The number seven constitutes a perfect unit of measure within antiquity, and the Bible is replete with the number seven and its multiples. Wisdom's house also has eucharistic overtones.

Image

At Saint John's Abbey, the old and new abbey churches employ pillars of remarkably different styles and techniques. Like houses, these structures symbolize the world around us, and the monks have used this form to give structure to the most important part of their world, a place to encounter God. No less so in Proverbs.

In medieval and renaissance education, scholars memorized huge texts by mentally designing a house and rooms as the overall mnemonic device. Rooms would represent certain subjects, while shelves, armoires, and objects in the room would represent subsections of the subject. In a sense, it was a memory palace. In addition, the house is one of the fundamental structures for the imagination. After stick people, houses are one of the first drawings children sketch. One can also build a house through hospitality, as the protagonist does in the film *Babette's Feast*.

Lady Wisdom constructs her own house and opens its doors to others; she is very hospitable. Her lightness and joy is the bridge to wisdom (8:30-31). In this scene, we see another creation story in the biblical narrative. Here, God brings order from chaos with Lady Wisdom as the craftsperson, and, as such, the passage shows the maternal character of God in creation, a creation in which the practical is the image of the Divine.

Scriptural Cross-references
Genesis 1:1–2:25; Exodus 20:1-17; Wisdom 9; John 1:1-17; Revelation 12:1-18

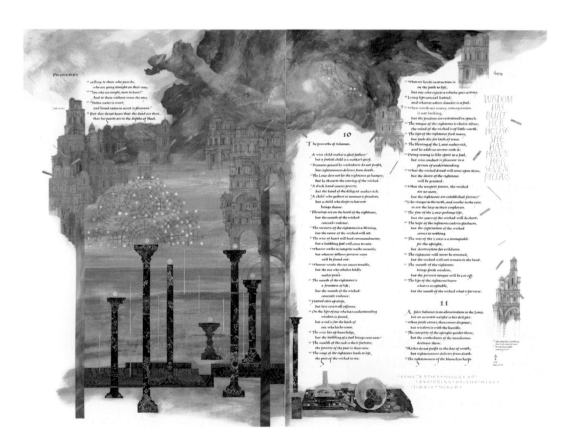

Woman of Valor
Proverbs 31:10-31; Hazel Dolby, artist

Background

The book of Proverbs rests on solid feminine imagery. In this chapter, the feminine imagery continues, but it has a more quotidian, practical emphasis. Nonetheless, in reading this text, it becomes evident that this woman is appreciated, not only for her ability to keep a good household, but for her wisdom as well. These verses describe the good that happens if she brings you into her house; hospitality is a divine attribute.

While the NRSV uses the phrase "capable wife," there are better terms rendered from the ancient Hebrew and Greek; even Latin employs *mulierem fortem*, or "woman of valor." This valiant woman of strength is Lady Wisdom or the Wisdom Woman. In this passage, therefore, God as the Wisdom Woman of Valor is now presented as the good homemaker, for we encounter God in the home.

The introduction to this poem is an admonition (31:1-9). In it, a mother gives advice to her son: a man needs to look for a good wife, for if a man wants wisdom, he should marry a wise woman. The passage stands as instruction to the young man on how to court wisdom. Beginning at 31:10, we see what happens if we follow the advice of Wisdom.

Lady Wisdom runs God's household, and the Greek word for household (31:15, 21, 27) is *oikonomia*, from which we get the words "economy" and "ecumenical." Setting up a good household is the symbol for creation and the world of human habitation. It echoes the Wisdom's house of seven pillars earlier in the book of Proverbs.

The "Woman of Valor" (31:10-31) is a passage recited at funerals for both Jewish and Christian women, and Jewish husbands sing it on Shabbat to honor the women and the wives. The creative images flow back and forth from the duties of the homemaker to the attributes of Lady Wisdom. The descriptions are of the activities of creation. The woman here protects the family and is an authority figure. She receives praise for her love, order, and oversight. She is a real communitarian and the prefiguration of the incarnate Christ. And she is known for laughter (31:25).

Image

The passage speaks about textiles and making garments. The woman makes fine linen garments and dyes them purple; purple and crimson were very expensive cloth. Proverbs takes strength and dignity and then moves them to another level. In knitting, weaving, and generally fashioning fabric and wool, the woman is taking care of the household, but on the symbolic level, the world becomes

her household; her productivity is tied to creation. Creation, however, is not neat and tidy, and the purple weaving portrayed here reflects such an effort.

The dyes of crimson, purple, and indigo never fade, but making them is dangerous work. Cloth of these colors would soak in a batch of scum where they would bubble and ferment. This process makes a potent and enduring dye but also one with a poisonous emission, from which people occasionally died. Purple and crimson are the two colors emphasized in this image. Both were made from small creatures: purple was made from thousands of shells

PROVERBS

⁸ Remove far from me falsehood and lying;
 give me neither poverty nor riches;
 feed me with the food that I need,
⁹ or I shall be full, and deny you,
 and say, "Who is the LORD?"
 or I shall be poor, and steal,
 and profane the name of my God.

¹⁰ Do not slander a servant to a master,
 or the servant will curse you, and you
 will be held guilty.

¹¹ There are those who curse their fathers
 and do not bless their mothers.
¹² There are those who are pure in their own eyes
 yet are not cleansed of their filthiness.
¹³ There are those — how lofty are their eyes,
 how high their eyelids lift!—
¹⁴ there are those whose teeth are swords,
 whose teeth are knives,
 to devour the poor from off the earth,
 the needy from among mortals.

¹⁵ The leech has two daughters;
 "Give, give," they cry.
 Three things are never satisfied;
 four never say, "Enough":
¹⁶ Sheol, the barren womb,
 the earth ever thirsty for water,
 and the fire that never says, "Enough."

¹⁷ The eye that mocks a father
 and scorns to obey a mother
 will be pecked out by the ravens of the valley
 and eaten by the vultures.

¹⁸ Three things are too wonderful for me;
 four I do not understand:
¹⁹ the way of an eagle in the sky,
 the way of a snake on a rock,
 the way of a ship on the high seas,
 and the way of a man with a girl.

²⁰ This is the way of an adulteress:
 she eats, and wipes her mouth,
 and says, "I have done no wrong."

Meaning of Heb uncertain

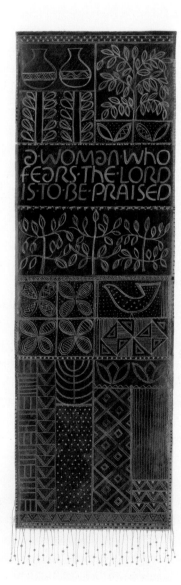

from the tiny murex snail and crimson from the dried bodies of the kermes insect. So expensive were purple and crimson that they became royal colors, as only monarchs could afford them.

The Woman Wisdom laughs at the days to come. To meet a strong, mature woman of universal appeal and character is to meet Christ himself.

Scriptural Cross-references

Genesis 1:1–2:25; Exodus 20:1-17; Wisdom 9; John 1:1-17; Romans 8

ECCLESIASTES

In the mind-set of Ecclesiastes, life is evanescent; God gives us only the present moment, a fleeting moment, whose end is death. The text discusses life turning to dust (3:20-22; 12:7), and the writer of Ecclesiastes has no reference to the afterlife. In all probability, he really does not think that there is an answer to the vanity of human existence, but is the writer a nihilist? We never really know.

Reading the text through the Christian lens, we hear the words, "The silver cord is snapped, and the golden bowl is broken" (12:6). After all the contrasts that Ecclesiastes describes, rich and poor, wise or foolish, etc., in the end, the writer concludes that whatever occupation we have or status we achieve, it does not matter; everything leads to the grave. Ecclesiastes is asking the question, what happens after "the silver cord is snapped, and the golden bowl is broken" (12:6)? It is an existential question that all people of faith must struggle with, and, ultimately, this difficult struggle can strengthen the faith we have.

Ecclesiastes Frontispiece
Ecclesiastes 1:1-11; Donald Jackson, artist

Background

The metrical rhythms in the very first verses of Ecclesiastes are as evident in English as they are in Hebrew; these words are well known and, therefore, this large image. The book opens with a teacher delivering his or her words. Indeed, the title *Ecclesiastes*, a term signifying "the one who assembles" or "the person of the assembly," is a Greek translation of the Hebrew *qoheleth*, "teacher," or the one around whom people gather, for teachers speak in front of a group of students. In the Christian as well as the Jewish traditions, teaching is always for the benefit of the *community*, and the communal element is the emphasized dimension, the dimension distinguishing Ecclesiastes from the solitary, isolated life of the modern existentialist. Hence the name of the book.

The text presents a series of contrasts. Everything that appears soon disappears. The sun goes up and the sun goes down. Unlike Proverbs, which is filled with concrete detail, this book is more speculative. In many ways Ecclesiastes presents the same theme as Job, but it does so without the concrete narrative and detail that Job has. Because Ecclesiastes deals with the meaning of life and of human experience, it is the closest thing the Bible has to a philosophy book.

Its main message, which is only suggested at the end of the book, is that the present moment is all we have, and that moment is a gift of God: eating, drinking, happiness, joy, or sorrow. *Vanity* expresses the nothingness that awaits all human endeavor; a person can lose everything in an instant, as we have seen in Job. For the writer of Ecclesiastes, therefore, it is far better to concentrate on the joy.

In chapter 3 there is a beautiful, poetic pattern with phrases composed of antonyms: born/die, plant / pluck up, kill/heal, break down / build up, weep/laugh, mourn/dance, throw away / gather, embrace/refrain, seek/lose, keep / throw away, tear/sew, silence/speak, love/hate, war/peace. The important point of this passage lies in its irony. As it underscores that there is an appropriate time for everything, it reveals an inherent dilemma in human existence. For most of us, no time is ever the appropriate time for what is taking place or what we are experiencing.

These word combinations continue the theme of the opening passage describing vanity. There is no permanence in any human situation; even the universe is constantly changing as nebulae continually expand and new planets are discovered. The thresholds of the inconstant physical world have yet to be identified in the macrouniverse and in the realm of nanotechnology. This awareness is something unique to our generation and yet is described essentially by Ecclesiastes.

There is a time for this and a time for that as we move through the rhythm of life. The enjoyment of youth is balanced by the caution of old age in the two matched selections (9:7-9; 12:1-8). Throughout history, the idea of a "wheel of fortune" has often been a part of art and iconography. Ecclesiastes is going deeper than the wheel of fortune by plumbing the depths of life itself. Nonetheless, we see a wheel turning. What has been on the bottom is now on top and vice versa. In any given moment sorrow will turn to joy and tears to laughter. In the realm of God's divine initiative, his grace can break in to any human situation—even the direst—at any given moment. This inbreaking of grace is what distinguishes these words of Ecclesiastes from the dark, pessimistic, depressing wheel of fortune that characterizes so much of both ancient and modern thought.

Despite all of our attempts to demonstrate the contrary, life is about death. This point is not pessimistic. Ecclesiastes is telling us that the movement through life is to enjoy the life we have instead of looking for the life we do not. The book ends by telling us to keep the commandments and fear God. The piece could be a dark book or a liberating one. In any case, it is a practical one. Our material possessions do not give us our freedom to enjoy today. Ultimately, our lives find their meaning in the loving relationships we have formed, not by our artistic, economic, or scholarly output. Everything but love turns to dust, and love is the highest moral standard for living. This interpretation is a monastic and Benedictine one and is a key concept to the RSB: "Day by day remind yourself that you are going to die" (4:47).

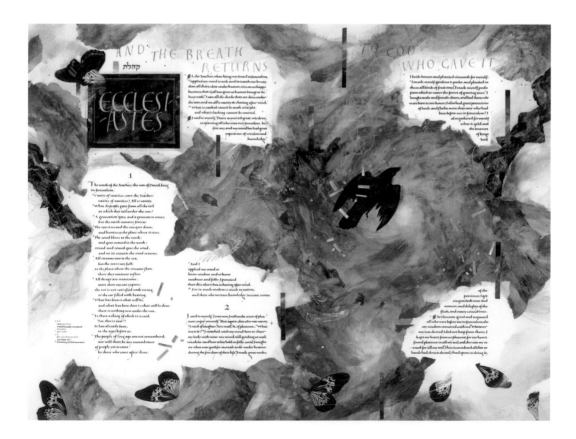

Image

We are left wondering whether the writer is hopeful or nihilistic; we do not know for sure. The image reflects such ambiguity. There is much movement and butterfly wings. Rainbow bars flutter about. A raven streaks across the page. Yet, there are also dark clouds signaling a pending storm.

Sometimes life can seem just as ambiguous. If we must keep Ecclesiastes within the context of the whole Bible, we should be just us ready to keep life within the context of salvation.

Scriptural Cross-references
Psalm 77:17-20; Job 38:1-2; Matthew 6:26-34; Revelation

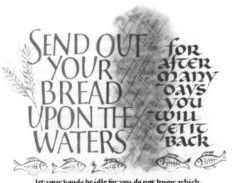

let your hands be idle for you do not know which
will prosper, this or that, or whether both alike will
7 be good. ▌ Light is sweet, and it is pleasant for the
8 eyes to see the sun. ▌ Even those who live many years
should rejoice in them all; yet let them remember
that the days of darkness will be many. All that comes
9 is vanity. ▌ Rejoice, young man, while you are young,

Send out Your Bread
Ecclesiastes 11:1; special treatment; Diane van Arx, artist

"Send out your bread upon the waters, for after many days you will get it back" (11:1) is the source for the expression, "Cast your bread upon the waters." It encapsulates a large part of the theme and intention of Ecclesiastes. When all has turned to dust, the good that we have done in life (bread is always good) will return to us and give our lives meaning. Naturally, there is a eucharistic overtone to this verse.

Scriptural Cross-references
Job; Matthew 26:26-29; 28:1-10; Mark 16:1-8; Luke 24:1-12; John 6:1-15; 20:1-18; 1 Corinthians 11:23-26

SONG OF SOLOMON

The Song of Solomon, also known as the Song of Songs and the Canticle of Canticles, is a love poem, and, as with most love poetry, it is substantially graphic. There is no lack of visual imagery here, and much of its interpretation depends on the speaker, for the book is constructed as a dialogue. Yet, sometimes it is unclear who the respective speakers are, and they may even change in midsentence. While we should not lose sight of the fact that before the work can be interpreted allegorically, it still must be respected as real love poetry.

The images for this book are rich, vibrant, and voluptuous. They accent and emphasize a quality of faith that we do not often think about or that we may even take pains to ignore, which is the affective side to the belief in God

and the relationship that such belief fosters. All too often we let difficult biblical passages, bad or false interpretations, or even church politics cloud and smother the whole reason of divine revelation and the human search for God. We must always keep in mind that it is because of *love* that God reveals God's self to humankind through Scripture, creation, and experience. The Song of Solomon must be interpreted within that great mystery summarized in a single verse of John's gospel: "For God so loved the world that he gave his only Son, so that everyone who believes in him may not perish but may have eternal life" (John 3:16).

Opening page

The light and lyrical geometric segments move the reader from the end of Ecclesiastes to the opening of the Song of Solomon and prepares us for the page turn.

Garden of Love
Song of Solomon 4:1-15; Donald Jackson, artist

Background

The central metaphor in this love poem is the conversation between a bride and a bridegroom. In the Christian tradition, the interpretation of this piece is that no matter who is speaking, the verses show the love Christ (the bridegroom) has for humankind (the bride), as well as humankind's loving search for Christ. Along these lines, a common term used by a husband to show his endearment for his wife was to call her, "my sister." Likewise, a wife would endearingly refer to her husband as "my brother."

Image

The very scents of the garden rise; we can smell the perfume. In the hot climate of the Middle East, gardens are seen as a foretaste of paradise, a point that surfaces in biblical literature. Within the Christian tradition, as well as the Jewish one, the Song of Solomon is seen as the expression of God's pursuit of the human soul, and the human soul's pursuit of God. This pursuit of God and God's pursuit of the beloved is also the subject matter of Francis Thompson's poem "The Hound of Heaven."[2] Furthermore, Saint Bernard of Clairvaux's *Talks on the Song of Songs*[3] uses the erotic imagery to interpret God's love for the human soul.

2. Francis Thompson, *The Hound of Heaven* (Mount Vernon, NY: Peter Pauper Press, 1960).

3. Bernard of Clairvaux, *Talks on the Song of Songs*, ed. Bernard Bangley (Brewster, MA: Paraclete Press, 2002).

The garden imagery gives this electric activity a real incarnational and sacramental intensity. Consequently, in monasticism, there has been the tradition of depicting the souls of monks and nuns as kissing Christ. Such a scene lies at the heart of monastic spirituality. Even monastic architecture reflects the attempt to be in union with God. The Song of Solomon mentions the garden, the pride of every monastic cloister. The garden in this poem also has a connection to the central metaphor of Proverbs—the house—for no house is complete without its garden. On a metaphorical level, the blooming garden can represent the cosmos. Likewise, the shape of the garden enclosure in the upper left corner of the page is a visual echo of the Jerusalem temple's architecture, with its own eschatological overtones.

The geometric figures in this image are based on a Rhajastani textile along with a series of Arab garden designs that were frequently enclosed within the house walls of the Near East. The garden imagery continues on the following pages with the special treatment of select verses.

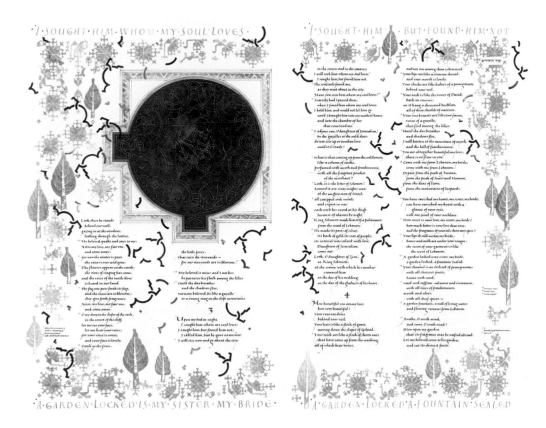

Scriptural Cross-references

Genesis 2:9; Matthew 26:36-46; Mark 14:32-42; Luke 22:39-53; John 3:16; 18:1; 20:11-18; Revelation 22

I Am My Beloved's

Song of Solomon 6:3; special treatment, Donald Jackson, artist

The abstract images on the page suggest a flower prevalent in Galilee in late winter and springtime, the "rose of Sharon," which is also considered the "Jerusalem lily." The image of a shepherd pasturing sheep is a central metaphor for Christ. The cross-references help to underscore God's love for his creation: Luke 15:3-5; John 10:11-14.

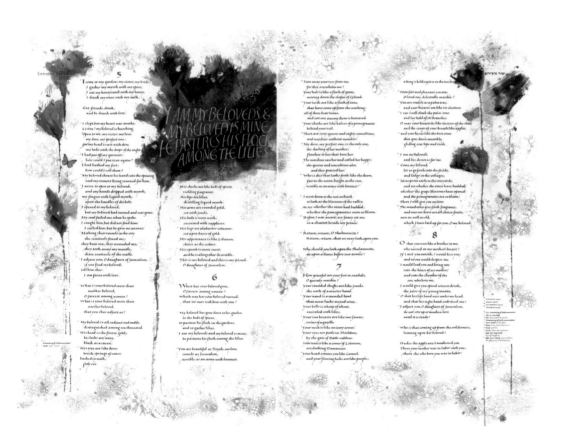

Set Me as a Seal
Song of Solomon 8:6-7; special treatment; Donald Jackson, artist

In ancient Mesopotamia the seal was either of ceramic or some semiprecious stone, often a tubular bead but sometimes square. At birth, an infant was given a seal containing intaglio carvings of images symbolizing the essence of that person. It was usually worn around the upper arm and impressions of it were used formally in place of a signature. The deepest expression of loving self-giving was to give one's seal to another—"Set me as a seal upon

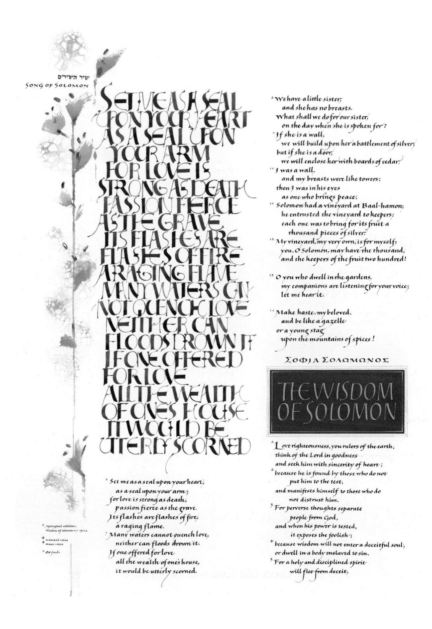

your heart, as a seal upon your arm" (Song 8:6). These verses give an intense description of divine love in the language of human love.

Robert Robinson's (1735–90) verses for the hymn tune, "Nettleton," paraphrase these lines in very fine English poetry. They capture the mood and tone that this special treatment of Song of Solomon portrays:

> Oh, to grace how great a debtor
> Daily I'm constrained to be!
> Let thy goodness, like a fetter,
> Bind my wandering heart to thee;
> Prone to wander, Lord, I feel it,
> Prone to leave the God I love;
> Here's my heart, oh, take and seal it,
> Seal it for thy courts above.

This special treatment closes the Song of Solomon with the seeker binding himself or herself to his or her beloved.

WISDOM OF SOLOMON

Wisdom is an Old Testament book but it exists only in Greek. For this reason, it is not included in Hebrew versions of the OT. Despite the fact that it was written well after his reign (970–931 BC), this book's material fits nicely into the Wisdom genre and, therefore, its authorship has been attributed to King Solomon.

Let Us Lie in Wait for Him
Wisdom of Solomon 2:16-24; Thomas Ingmire, artist

Background
This whole section, describing the unjust death of the righteous, foreshadows Christ's passion. The evangelists, particularly Luke, draw from these verses in composing their respective passion narratives. The text explains that the righteous suffer from the harm of the wicked. This passage evidences a dichotomy pitting good against evil, even citing the devil as the source of all evil on earth (2:24).[4]

4. *Diabolos* throughout the Greek Old Testament (Septuagint) most often means "lie" or "slander." Wisdom 2:24 is one of the few places where the devil (*diabolos*) is identified with Satan.

The strength of this passage is seen in the reference to immortality (2:23). On this point the dualism between good and evil, life and death no longer holds. God's supremacy over all creation is asserted; the divine purpose for creation transcends suffering and death. The theme and direction of the *Wisdom of Solomon*, therefore, go beyond the other Wisdom books (Job, Proverbs, Ecclesiastes, and Sirach) in which immortality does not enter the discussion.

The broader context of these verses shows that God will take care of those suffering. In a reversal of the moral order, the evil ones audaciously judge the righteous (2:10-20). This judgment is a repudiation of Ecclesiates' worldview where at least a proper moral order is assumed.

This travesty of justice still continues every time the righteous are falsely accused. Throughout many parts of the world, including the United States, innocent and righteous people have been killed at the hands of others who see themselves as upholders of law and order.

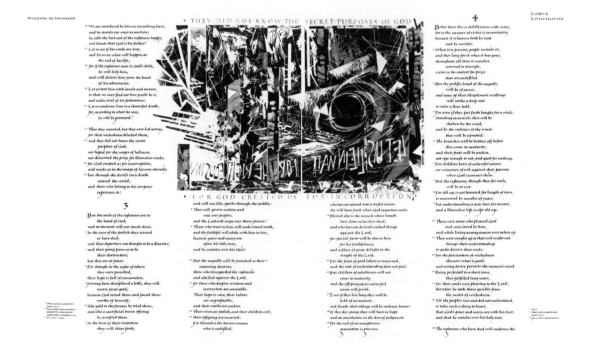

Image

The most prominent writing is backward and reads from right to left against a black and white background. Vertical columns are shattered or askew, and the movement within the depiction appears as a negative force. Verses 22-23 in strong, legible writing frame the work.

Who are these evil people in Wisdom? The artist Fra Angelico in his fresco the *Mocking of Christ* well identifies the evil person. Floating at eye level and surrounding a seated Christ are spittle, clubs, hands, and sneering faces. Because these faces are detached from bodies and the objects are disconnected from humans, they are made nonspecific and yet eternal. They are mystical yet concrete. The presentation constitutes a judgment against evil and unrighteousness by shocking the viewer with the absurd incongruity of having evil judge righteousness.

Scriptural Cross-references

Job 42:7-10; Isaiah 52:13–53:12; Matthew 27; Mark 14–15; Luke 22:47–23:49; John 18:3–19:34

Though They Die Early
Wisdom 4:7-9; special treatment; Sally Mae Joseph, artist

These two verses are a recapitulation of the theme dealing with the suffering of the righteous. In the Bible, old age is good, blessed, and honorable. Here in Wisdom, it is redefined in terms of the moral order. Righteous youth, by virtue of their moral living, have the blessings of old age.

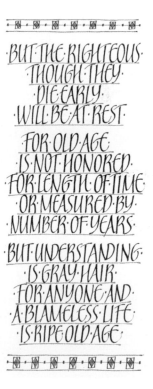

Wisdom Is Radiant
Wisdom 6:12-16; special treatment; Sally Mae Joseph, artist

Lady Wisdom or Wisdom Woman appears in the discourse. Her presence at the gate and her gentle manner make her most approachable. The refreshing imagery of these verses—she is easily found—balances those describing the ambiguity of good and evil surfacing in other parts of the book. They also continue the leitmotif of Lady Wisdom running through the Wisdom volume as a whole.

Desire for Instruction
Wisdom 6:17-20; special treatment; Sally Mae Joseph, artist

This treatment continues the previous discourse in Wisdom 6:12-16. Wisdom's radiance arises from her creative, generative love. Before righteous living come the love and desire for Wisdom's instruction.

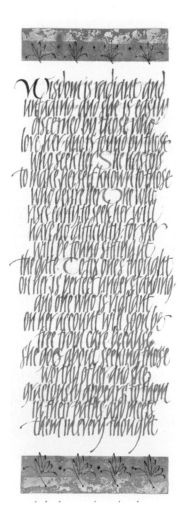

Belief in an afterlife is not explicit in Old Testament works; it develops in late Judaism, during the intertestamental period, but such an understanding was not universal. These verses are among the few outside of the New Testament that refer to some kind of afterlife. This existence is connected to love of Wisdom. Of particular importance is the mention of the word "kingdom." As

WISDOM OF SOLOMON

holy things in hol
and those who have bee
will find a defen
¹¹ Therefore set your desi
long for them, and you

¹² Wisdom is radiant a
and she is easily discer
those who love h
and is found by those
¹³ She hastens to make I
those who desire
¹⁴ One who rises early to:
will have no dif
for she will be found :
¹⁵ To fix one's thought on
understanding,

something quantifiable and concrete, the approaching kingdom of God becomes identified with eschatological life in Christ in the gospels. Those people listening to Christ's teaching would have made the connection to these verses in Wisdom and elsewhere.

Wisdom Woman
Wisdom 7:22b-30; Donald Jackson, artist

Background

Wisdom 7:22-30 constitutes a hymn praising Wisdom. In Christian theology, Wisdom exists as the breath and spirit of God, present at the moment of creation. For all of her wondrous qualities, she is the reflection of the eternal light but not the light itself (7:26). As with all explanations dealing with the sacred mystery of God's being, Scripture explains the exact relationship between Wisdom and God through metaphor; it searches for the truth beyond the facts, as we see in the recitation of adjectives in 7:22. Unlike the

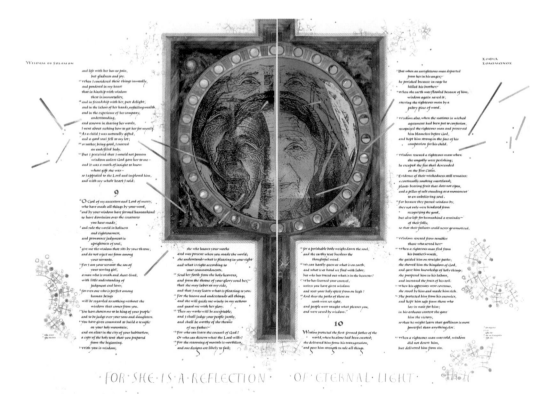

way Wisdom is described in Proverbs, which prefers to speak of Wisdom's practical side, these verses approach those qualities akin to Greek philosophy.

In reading this passage, we might quickly jump to Mary's hymn of praise in Luke's gospel. This response should not be surprising because there is a strong connection between Wisdom and Christ, a major link being Mary. In fact, throughout Christian history, Mary has been called the "Seat of Wisdom." The divine images of Wisdom are listed in the verses (7:22-25), yet Wisdom's relationship with God has often been seen as light and fluid. The nondescript quality is not so much the result of carelessness as it is a conclusion, reached after searching to define an ineffable mystery.

Image

To show this mysterious side of the relationship, there is a great deal of light in the imagery. This light, however, is reflected and refracted, for Wisdom is the mirror of God's face and power. Nonetheless, even this reflected light is more beautiful than the sun (7:29). The central image is a circle within a square. In the four corners are colors and patterns seen in other books of *The Saint John's Bible*; they have a cosmic quality. In fact, the upper left visually connects to the Cosmic Christ in the prologue to John's gospel. The round piece within the square is based on an Arab calendar showing moon phases.

Scriptural Cross-references

Mark 9:1-8; Luke 1:46-55; John 1:5; Colossians 1:15-20; Revelation 12

Shekinah[5]
Wisdom 13:1-5, Donald Jackson, artist

Background

"Shekinah" is a specific term referring to God's glory particularly manifested in the pillar of cloud by day and the pillar of fire by night that lead the Israelites through the desert (Exod 13:21-22). In these verses, the understanding of the Shekinah is broadened to include God's presence abiding among all people and through all time. Of particular importance is the verse "but they supposed that either fire or wind or swift air, or the circle of the stars, or turbulent water, or the luminaries of heaven were the gods that rule the world" (Wis 13:2). People of every land and culture have had an experience of God

5. Or *Four Elements*.

through the works of God, even though they may have mistaken these works to be God himself.

These verses speak particularly to our globalized culture. If God is supreme and unique in the universe, how do Christians (indeed, Jews and Muslims also) interact with religions and peoples who, through reasons of birth and culture, may not know of the one, true God? It is a most vexing question, but in this passage the writer of Wisdom attempts to deal with such a difficulty. Despite the conclusion given in Wisdom 13:8-19, the preceding verses 1-7, imply that people can and will know God through the handiwork of God's creation even if they do not and cannot admit it. Ultimately, the answer is in God's hands, and our vocation as believers is not to do anything that would turn others against God's loving mercy.

Wisdom is not only the designer of creation but also the agent of salvation. There is a movement from the cosmological to the historical, and through his incarnation, the God that we worship has made the creation of the cosmos a part of human history. Wisdom 13:1-5 underscores that agency of God within the universe.

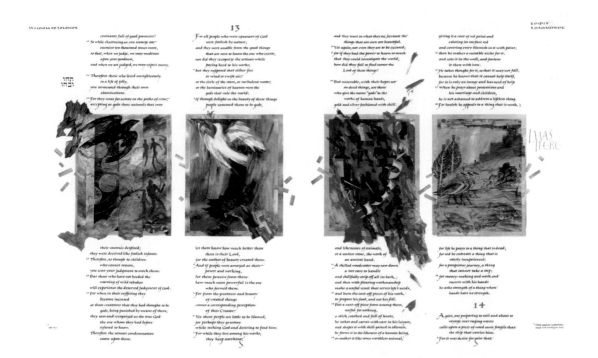

Conceptually, this agency of God is a move from the circular to the linear understanding of human history. In terms of human anthropology, the idea that the role of humans on earth has a beginning and an end is both a Jewish and a Christian one, and it is a major cornerstone of Western civilization. Life is not a treadmill or a wheel going around and around. It has a direction and purpose. For the Christian, the end point is union with Christ.[6] This section from Wisdom is one of the earliest expressions of such thinking.

As far as the end of human history is concerned, we are looking at eschatology, a term referring to the events and circumstances of the end times. They are verses that show insipient awareness of the universal character of God's boundless mercy and love.

Image

Each of the four panels represents one of the elements that ancients believed to be the fundamental building blocks of the cosmos. From left to right they are earth, air, fire, and water, as cited in 13:2. In the first panel, earth, we see the breath of God at the moment of creation in Genesis. This breath is the foundational reference for the Wisdom tradition, and it continues into the second panel, represented by air. Seen in the third panel is a reference to fire with Shekinah spelled in Hebrew and gold lettering. While the Shekinah leads, guides, and protects the people, it also abides with them as God in their midst. Water, portrayed as the source of all life, is the subject of the fourth panel. Readers will recognize parts or all of these depictions from other books in *The Saint John's Bible*, showing the fall, flood, Passover, and Red Sea crossing.

The title of this piece actually changed from the *Shekinah* to the *Four Elements* when the CIT broadened the texts used as the basis for illumination. Through a series of miscommunications, the new name and information were never applied until much later. As a further result, Donald Jackson used Wisdom 9:9, 10:4, and 10:18, respectively, as the inspiration for the images; from left to right, the images include the creation and Fall, the flood, Passover, and the Red Sea crossing. The CIT, on the other hand, relied on Wisdom 13:2. Remarkably, the image reads accurately no matter which set of verses are used, fulfilling the CIT's desire to increase the scope of the texts for the illumination, with one image incorporating the particular and universal thrust of Wisdom theology expressed in Wisdom 10–13.

6. Western civilization could possibly be considered post-Christian at this point in time, but even most secularists and atheists see a purpose to life, such as world brotherhood or harmony. Such a concept is not limited to Western cultures, but it is particularly pronounced in Western civilization and has Judeo-Christian roots.

SIRACH

Originally written in Hebrew, we know of Sirach only from its Greek translation, which, according to the prologue, was done by the grandson of Jesus, Son of Sirach.[7] As a composition, it is a wonderful meditation, reflection, and commentary on the Old Testament and the role of Wisdom in God's plan of salvation.

Fear the Lord
Sirach 1:16-17; special treatment; Brian Simpson, artist

At the very beginning of the book of Sirach, we see another reference connecting the "fear of the Lord" to Wisdom herself. In the Bible, "fear of the Lord" means standing in awe and respect at the majesty of God.

Scriptural Cross-references
Job 28:28; Psalm 111:10; Proverbs 1:7; 9:10; 15:33; Mark 16:8

Faithful Friends
Sirach 6:14-22; special treatment; Diane van Arx, artist

Wisdom Woman, who, as we have seen, has a prominent role in the Wisdom literature, gives practical advice on friendship, a cornerstone of life. Listening to Lady Wisdom throughout one's life will serve as a guide to the end of one's days. In American society, the rugged individualist has assumed a heroic role. Yet, such exaltation of the "loner" (not to be confused with a hermit) has also bred lives of isolation, anonymity, and loneliness in many. These verses extol the virtues of friendship and, in so doing, provide an alternative to such a lifestyle. Furthermore, they place friendship within the divine plan.

To fear the Lord is fullness of wisdom she inebriates mortals with her fruits she fills their whole house with desirable goods and their storehouses with her produce

7. A copy of the Hebrew version of Sirach, however, was found among the Dead Sea Scrolls in the last century. Jesus or Yeshuah (Hebrew and Aramaic respectively) was a common name at the time.

The background to the calligraphy contains many of the architectural features of the Saint John's Abbey and University church, such as the honeycomb pattern and terra cotta tiles.

¹¹Do not ridicule a person who is
 embittered in spirit;
 for there is One who humbles and exalts.
¹²Do not devise a lie against your brother,
 or do the same to a friend.
¹³Refuse to utter any lie,
 for it is a habit that results in no good;
¹⁴Do not babble in the assembly of the elders,
 and do not repeat yourself when you pray.

¹⁵Do not hate hard labor
 or farm work, which was created by
 the Most High.
¹⁶Do not enroll in the ranks of sinners;
 remember that retribution does not delay.
¹⁷Humble yourself to the utmost,
 for the punishment of the ungodly
 is fire and worms.

¹⁸Do not exchange a friend for money,
 or a real brother for the gold of Ophir.
¹⁹Do not dismiss a wise and good wife,
 for her charm is worth more than gold.
²⁰Do not abuse slaves who work faithfully,
 or hired laborers who devote
 themselves to their task.
²¹Let your soul love intelligent slaves;
 do not withhold from them their freedom.

²²Do you have cattle? Look after them;
 if they are profitable to you, keep them.
²³Do you have children? Discipline them,
 and make them obedient from their youth.
²⁴Do you have daughters? Be concerned
 for their chastity,
 and do not show yourself too
 indulgent with them.
²⁵Give a daughter in marriage, and you
 complete a great task;
 but give her to a sensible man.
²⁶Do you have a wife who pleases you?
 Do not divorce her;
 but do not trust yourself to one
 whom you detest.

²⁷With all your heart honor your father,
 and do not forget the birth pangs
 of your mother.
²⁸Remember that it was of your parents
 you were born;
 how can you repay what they
 have given to you?

ΣΙΡΑΧ

Faithful friends are a sturdy shelter: whoever finds one has found a treasure. Faithful friends are beyond price; no amount can balance their worth. Faithful friends are life-saving medicine; and those who fear the Lord will find them. Those who fear the Lord direct their friendship aright, for as they are, so are their neighbors also.

My child, from your youth choose discipline, and when you have gray hair you will still find wisdom. Come to her like one who plows and sows, and wait for her good harvest. For when you cultivate her you will toil but little, and soon you will eat of her produce. She seems very harsh to the undisciplined; fools cannot remain with her. She will be like a heavy stone to test them, and they will not delay in casting her aside.

For wisdom is like her name; she is not readily perceived by many.

Come to Me
Sirach 24:19; special treatment; Sally Mae Joseph, artist

This quotation from Sirach 24, appearing here at Sirach 13, functions as an intratextual cross-reference, namely, a verse from one section of a book is used to interpret a body of text in another part of the Bible. In the midst of this discourse, which compares and contrasts opposing traits such as pride and humility, Wisdom speaks the decisive word: partaking of her fruits and honey keeps us from self-aggrandizement as well as humiliation. This special treatment prepares us for the half-page image in chapter 24.

Wisdom at Creation
Sirach 24:1-34, Suzanne Moore, artist

Background

Various verses from Sirach 24 form the basis of special treatments in other parts of this book as a way to underscore the creative and generative properties of Wisdom; God can bring forth life physically, spiritually, artistically, and in ways we have never thought possible. The book of Sirach makes three key points about Wisdom: a) Wisdom as the Word of God present at creation, b) Wisdom as the love of God, c) Wisdom as the Word of God in Scripture.

Wisdom is the preexistent Christ. That is to say, Christ dwells with the Father in eternity before becoming incarnate on the earth. As such, Wisdom is present alongside God at the moment of creation (Sir 24:1-6). By further extension, theologians and biblical exegetes see Christ being expressed as Wisdom. Christ as the Word of God is present at the moment of creation and, therefore, is the Word of God, which brings creation into being. Eventually, in a historical moment, the Word of God takes on human flesh as Jesus, the Son of God.

Wisdom is the love of God manifested as the loving, creative work of God. She visits everywhere. Of particular importance is the fact that Wisdom is seen as feminine. This point extends the limits of specific gender traits of God to a more inclusive framework without compromising traditional trinitarian language of Father, Son, and Spirit.

The mention of water in Sirach 24:4-6 echoes Genesis 1:1-10. The new element here is that Wisdom is seen as the Word of God, and the Bible, though written in human words, is nonetheless the Word of God. With a

little imagination, we can see that, literally and figuratively, the Word of God exists among the living; it comes from life and it produces life.

On a material level, we can see this connection with the relationship of trees to books. Green leaves are a sign of life. The wood from a noble oak will form the bindings of *The Saint John's Bible*. The words on the pages between the bindings give hope and eternal life. Everything is interwoven, and nothing is static or stagnant.

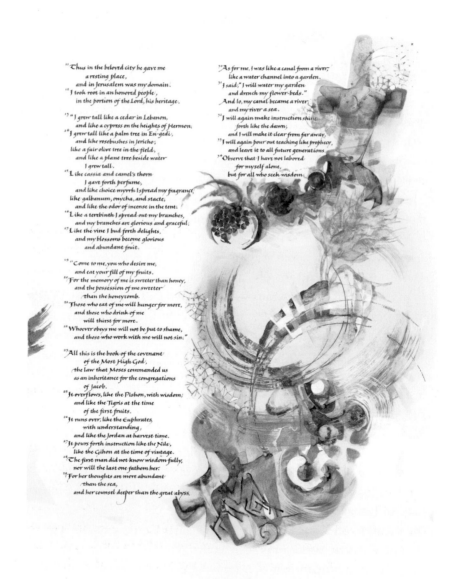

Among the ancient Egyptians, writing was done on papyrus, a swamp plant. Christian texts written on papyrus were the earliest codices (book forms), and these writings were often sewn between two boards to protect the contents. Even today, the word "leaf" is a synonym for "page."

Image

Voluptuous. Full-bodied, incarnational, inviting, rejoicing in the life of Christ at its best. Nothing stingy or mean-spirited about it. There are echoes here of the tree of life. In Sirach 24:9-22, Wisdom is personified as a dinner. We have seen the same attributes in Proverbs 9:1-6. This meal imagery runs between these two books in this volume. Here, Wisdom is the food, and, thus, the Eucharist is part of Wisdom.

Scriptural Cross-references

Genesis 1:1–2:3; Proverbs 9:1-5; John 1:1-14; 6:1-13; Matthew 14:17-21; 26:26-29; Mark 6:35-43; 14:22-25; Luke 9:12-17; 22:15-20; 24:13-35; John 6:1-13; 1 Corinthians 11:23-26

Like Clay
Sirach 33:13; special treatment; Donald Jackson, artist

The calligraphy in this special treatment resembles clay on a potter's wheel. Our life, personalities, talents, attributes—everything—comes from God. Despite similarities, each work of the potter is unique.

She Is the Reflection
Sirach 35; special treatment; Susie Leiper, artist

This quotation from Wisdom 7:26 functions as an intratextual reference external to Sirach but internal to the Wisdom tradition as a whole. There is no single interpretation, but the meaning is guided by the Christian tradition. It is helpful to take the contexts surrounding both this section of Sirach and the respective Wisdom verse and hold them up to our personal and communal experiences. The interpretation arises from the interplay of these various components. Performing deeds of righteousness, appreciating human beauty, and enjoying abundant food with rich and poor alike all reflect Wisdom and, therefore, all reflect God.

Listen to Me
Sirach 39:13-15; special treatment; Diane van Arx, artist

We notice that the garden has returned again, and with it a local association finds its way in *The Saint John's Bible*. At Saint John's Abbey, this passage is sung on the feasts of Saint Benedict (March 21 and July11); the latter date includes the rites of monastic profession. The wisdom tradition inheres within monastic life today; in fact, so much of the wisdom tradition gave birth to monastic life.

I Took Root
Sirach 44–45; special treatment; Sue Hufton, artist

An intratextual reference, this double-page spread presents quotations from Sirach 24. Both textually and visually, they act as a unifying element for this book.

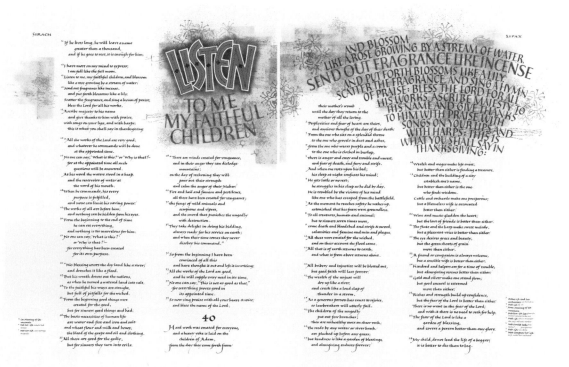

Sirach 51
Carpet page with scriptural cross-reference, Donald Jackson, artist

The example seen here follows the medieval tradition of using a design to complete a piece of parchment for which there is no text. Called a "carpet page," the quotation comes from Proverbs 3:18. "She is the tree of life to those who lay hold of her; those who hold her fast are called happy." The abstract pattern is in the form of a tree of life, and the stamp used to fashion it is employed elsewhere in *The Saint John's Bible* and should be familiar to the viewer.

In the Christian tradition, the tree of life has many interpretations. It can be a reference to Genesis 2:9, to one of the trees mentioned in Sirach 24, or to the tree in Psalm 1. It can also foreshadow the wood of Christ's cross, as it has in so much of Christian history. The carpet page at the end of Luke's gospel also features a tree and is a worthy comparison to the one here.

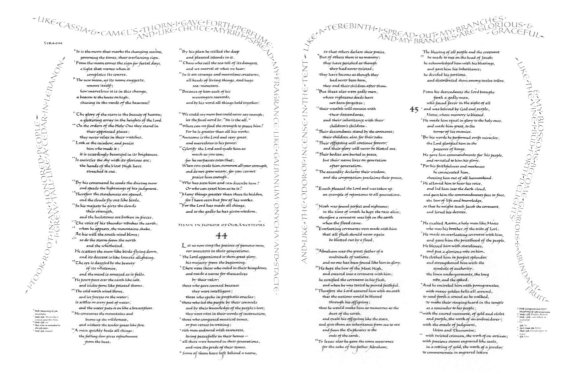

Chapter 8

PSALMS

INTRODUCTION

Often called the "hymnbook of ancient Israel," the Psalter, as the book is also known, has occupied a special place in the hearts of many. If the other books of the Bible are considered God's revelation to the people, then Psalms can be considered the peoples' response to God's presence in their lives; as such, they run the full gamut of human emotion.

The psalms are divided into five books, representing the divisions of the Pentateuch. The conclusion of each book is signaled by a doxology, ending in "Amen, Amen."[1] In addition, scholars have categorized the Psalter according to genre: hymns, lament, thanksgiving, royal, and wisdom. Examples of each genre are found in each of the five divisions, though in varying ratios of each.

The hymns were most likely tied to the temple liturgies in ancient Israel, though they may have been used in synagogues outside of Jerusalem as well. Various parts of the Psalms were redacted at different times. As hymns, they praise the Lord God. Of a similar nature are the thanksgiving psalms, with the difference being that hymns call forth praise while thanksgiving psalms express gratitude. The most frequent genre is the lament, and, in fact, nearly one-third of all psalms fit in this category; laments can be communal or individual plaints. Royal psalms, as the title indicates, center on the king and his concerns, such as coronations, weddings, and petitions on behalf of the state. The wisdom psalms, like Wisdom literature in general, reflect the reality of everyday life before the face of God and seek to understand evil, suffering, and even the meaning of human existence.

1. See Psalms 41:13; 72:20; 89:52; 106:48. The whole of Psalm 150 is the doxology that ends book 5.

The treatment of the Psalter, all of which was completed by Donald Jackson, is different from any other book in *The Saint John's Bible*. Rather than full-page, half-page, or quarter-page illuminations, nearly every page features a colorful adornment. Even the script is different from the prose sections of the Bible. We see that Psalms 1 and 150 stand independently from the collection, indicated by their golden lettering. The former begins with "happy," and the latter ends with "hallelujah!" or "Praise the Lord!" Thus, they function as bookends for the whole collection.

The book of Psalms is an essential piece of monastic life. In both Eastern and Western Christianity, monks and nuns around the world gather several times each day to chant and sing praise to God and offer their work and study to him and to the world; it is by far the most referenced and used book in the cloister. Because of monasticism, the importance of the Psalter for use in prayer entered the life of the whole church, and the reason for this importance can be found in the individual psalms themselves; they are the human response to God.

Since he was known for playing the lyre (1 Sam 16:15-23), and because the psalms are songs, the tradition arose that King David composed all the psalms himself. Indeed, he may have written some of them, but many of the psalms include in their introductory verses the names of the individual or school where the particular psalm originated.[2] Nonetheless, David has become indelibly linked to the Psalter.

The gospels of Mark, Luke, and particularly Matthew refer to Christ as the "Son of David," for Judaism at the intertestamental period held that the Messiah would be a descendant of King David. Hence, the life, thoughts, prayers, and actions of David within the OT soon became interpreted as a prefigurement of the Messiah, and the Evangelists employed them accordingly. In the great medieval Bibles, several psalms considered to have messianic references, namely, Psalms 1, 2, 22, 27, 39, 52, 69, 81, 88, 109, and 110, often opened with a historiated capital letter. Moreover, throughout history the church has used the psalms regularly in liturgy, especially 22 and 88 during Holy Week, thereby identifying them readily with Christ's passion, death, and resurrection. Finally, owing to the strong connection that the psalms have had to King David and Christ, Christians have found in them great solace and hope. The seven penitential psalms have been used since the Middle Ages as prayers of repentance and pleas for forgiveness.[3]

2. For example, see Psalm 42:1.

3. Pss 6, 32, 38, 51, 102, 130, 143.

BACKGROUND[4]

Book 1

Psalm 1 functions as an introduction not only for book 1 but also for the whole Psalter, which is the reason it stands as the text for the opening double page. Along with the messianic Psalm 2, Psalm 1 does not have a superscription above the text. All the rest of the psalms, except Psalms 10 and 33, have superscriptions referring to King David, mostly referring to events in David's life. From this evidence, scholars conclude that book 1, along with book 2, is probably a part of the original Psalter, with psalms collected while the Davidic monarchy was still prospering—sometime between the tenth and sixth centuries BC. Despite the fact that book 1 consists mostly of laments, all the laments end with a turn to hope; God always rescues King David. Indeed, thanksgiving psalms comprise a major piece of this book as well.

Psalm 1

Happy are those

Book 2

As with book 1, most of the psalms in book 2 have superscriptions indicating they belong in the Davidic collection. Psalms 42–50 belong to other collections from among the temple singers, as indicated by the names "Korah" and "Asaph." The messianic Psalm 72 concludes book 2 with the note, "The prayers of David son of Jesse are ended." Thus, if we look at books 1 and 2 together, they consist primarily of Davidic psalms. They begin and end with royal and messianic Psalms 2 and 72. Because the monarchy is presented in such positive terms, books 1 and 2 probably formed the original Psalter and were most likely the psalm book of the Davidic monarchy. As such, they belong to the period before the Babylonian exile, that is, before the sixth century BC.

4. This exegetical explanation reflects the work of Irene Nowell, OSB, who was the OT scholar on the CIT.

Book 3

Book 3 begins with a very positive statement of God's choice of David and promise of an everlasting dynasty, but it ends with the downfall of the anointed king and the cry to God, "Lord, where is your steadfast love of old, which by your faithfulness you swore to David?" (Ps 89:49). Because book 3 ends with the royal and messianic Psalm 89, it is very much like book 2. The superscriptions above the psalms, however, show an editorial attempt to interlock book 3 with the original Psalter found in books 1 and 2. For example, Psalms 73–83 show the superscription, "A Psalm of Asaph," which functions as a hook to Psalm 50 in book 2. Psalms 84, 85, and 87, on the other hand, read, "A Psalm of Korah," thereby linking them to Psalms 42–49, also in book 2. Psalm 86 alone stands as a "Psalm of David."

In book 3 the community is much more in evidence. Unlike the individual laments in books 1–2, the psalms of lament in book 3 are communal in nature (Pss 74, 77, 79, 80, 83, 85). Even 75, a psalm of thanksgiving, is a communal text. Psalm 78, the first historical psalm appearing in book 3, recites the community history and ends with God's choice of David as king, now colored by royal and messianic Psalm 89. It displays a monarchy that endured so well for so long, only to founder in the end.

The collection of psalms in book 3 was probably made during or right before the Babylonian exile. Everything that seemed so sure in books 1 and 2 has come undone. There are no hymns in book 3, no outright celebration of God's goodness, and no psalms of confidence. The single royal psalm (89) states that the monarchy is in trouble. Psalm 88 (one of only two individual laments in book 3—the other is Psalm 86) is the darkest piece in the entire Psalter. Psalm 75, the only thanksgiving psalm in this book, refers to the wicked, and even the two liturgical psalms, 81 and 82, ring with a note of doom.

Book 4

With book 4 comes the restoration. There is a noticeable focus on returning to the beginning of the community by the fact that it opens with Psalm 90, "Lord, you have been our dwelling place in all generations," the only psalm attributed to Moses. The piece underscores that the people should look to Moses for their restoration; David and his dynasty are gone forever. In book 4, Psalms 93 and 95–99 emphasize that God, the Lord, is king. Although only

Psalm 98 has no superscription, the theme is clear: Because human kings do not last, people should look to God as their sovereign.

At the conclusion of book 4, the "Hallelujahs" (in the NRSV written as "Praise the Lord," the English translation of the Hebrew, "hallelujah") end Psalms 104, 105, and 106. These last three psalms of book 4 also indicate a return to the people's initial relationship with God. Psalm 104 stands as a wonderful hymn to God as creator; Psalm 105, as a historical psalm, praises God's goodness to the people during the exodus; Psalm 106, another historical psalm, laments the people's unfaithfulness during the exodus.

The remaining psalms do not evidence any obvious thematic connections to the rest of book 4. Psalms 101 and 103 are attributed to King David, but Psalms 91, 94, and 104 have no superscription at all. By hearkening back to Moses in Psalms 90, 105, and 106 to retell the community history in the period of the exodus, book 4 shows that trust in human kings is ultimately futile. Only the Lord God is our king forever (Pss 93, 95–99). Book 4 reflects the period of restoration after the Babylonian exile.

Book 5

Book 5 opens with thanksgiving in Psalm 107 and ends with the great explosion of praise in Psalms 146–150. At the center of book 5 we find Psalm 119, a long alphabetical acrostic that echoes Psalm 1 by praising the law.[5] Psalms 120–24 are Songs of Ascent, a collection of pilgrimage psalms for the journey to Jerusalem, city of both God and David. In addition to being Songs of Ascent, Psalms 122 and 124 are psalms of David as well.

There is a tone of greater security in book 5. There are two small collections of Davidic psalms: Psalms 108–10 and 138–45. Psalm 132 repeats God's promise to David of an everlasting dynasty. Psalm 127 describes the building of the house, a term that refers both to the temple and to the dynasty; it is also cited as a psalm of Solomon, which connects it to Psalm 72 in book 2. Psalm 133 praises Aaron, the great high priest, and Psalm 134 praises the servants who stand

5. An *acrostic* is a poetic technique found in the Psalms in which each word or stanza begins with a letter of the Hebrew alphabet, starting with *aleph* and continuing to *tau*.

in the house of the Lord. This interplay between the Exodus and the Davidic monarchy brings the Psalter full circle. We seem to have moved from the exodus period of book 4 to a return to the monarchy. The temple is rebuilt and the promise of a dynasty is heard again, but there is a subtle difference between book 5 on the one hand and books 1 and 2 on the other. The earlier books reflect a nation that has not seen hardship, while the latter seems more mature in its joy.

There are other indications that we are returning to a state of peace and prosperity. The major presences of "Hallelujah" or "Praise the Lord" are found in book 5: Psalms 111–13, 117, 135, 146–50. The theme that God's love endures forever, which begins in Psalms 100 and 106, appears nine times in Psalms 107, 118, and 138. It is also the refrain of every verse in Psalm 136. To keep the historical perspective, there is a lament over the exile in Psalm 137.

The presentation of the people's history in Psalms 135–36 differs from the historical elements in the psalms found in book 4. Here in book 5, Psalm 135 is also a Hallelujah psalm, while Psalm 136 surrounds the people's history with the constant affirmation of God's love. Book 5 is a constant affirmation of God's blessings in restoring the people after their exile.

The rise, fall, and restoration of a Jewish monarchy have their parallels in the Christian life. The psalms outline the history of the people, who first live by trusting their own power, means, and greatness only to see their society and individual lives collapse. As a nation, they end up in exiled servitude. The people return to the land and rebuild, but they do so as ones chastised. The Psalter closes with rejoicing, because it is the people's trust in God and not in their own human designs that has saved them. Often, our own personal and communal lives parallel the experience of ancient Israel, which is what has made praying the book of Psalms such a powerful source of faith and strength for so many over the course of history.

By providing a different angle for us to see the psalms, this volume attempts to continue in the great tradition of interpreting them as an encounter with Christ, who also underwent violence, abandonment, and resurrection. Simultaneously, because they reflect the history of salvation, this Psalter forms one continuous hymn of praise glorifying the Lord God.

IMAGE

The display of five partially opened scrolls on the frontispiece is arranged as a menorah. Individual books of the Psalter are indicated by roman numerals. Beginning on the left and running horizontally across to the right are a

series of thin, golden, graph-like lines. These threads are an oscillograph[6] of the monks' voices at Saint John's Abbey chanting their daily prayer; the lines run through every page until the end of the volume.

A careful look will also show vertical lines of the same type intersecting with the horizontal ones. These verticals are also oscillographs of singing but of the Jewish Shema, the Muslim call to prayer, a Buddhist, Taoist, and Hindu chant, as well as a Greek anthem and a Native American song. God is Lord of creation, and all creation reflects his truth and goodness. The church always rejoices in truth wherever it may be found.

Each of the penitential psalms—6, 32, 38, 51, 102, 130, and 143—opens with a special treatment of the first words of the psalm. Many of the leitmotifs of

6. An oscillograph changes sound waves into electric current, which can then record the sound as a visual printout.

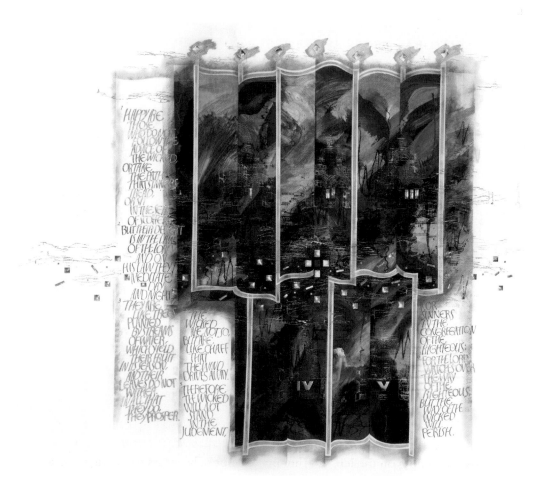

The Saint John's Bible are embedded within the rich and vibrant colors of the psalms, and the script is of a lighter weight than the one used in the prose sections of *The Saint John's Bible* in order to highlight the poetic nature of the text.

If the Psalter is the hymnbook of ancient Israel, we can consider it to be the source for every hymnbook, both Jewish and Christian, since then. Its 150 psalms have been sung or recited in nearly every liturgy since followers of Christ began to meet in house churches. The Psalter has furnished the texts for liturgies for two thousand years, from single verses for antiphons to complete psalms for polyphonic motets. Hymnals in nearly every Christian congregation or denomination have obtained their material from the book of Psalms. They give voice to every human emotion, from joy and gladness to anger and despair, and they have done so with God set firmly as both subject and object.

The Psalms volume displays the most abstract images of *The Saint John's Bible*, and in so doing, it allows for the great sweep and breadth of humankind's response to God's unstinting love.

SCRIPTURAL CROSS-REFERENCES

It would be impossible to list where various psalms are quoted or referenced in other parts of the Bible, for often their lines, either partially or entirely, have melded into other lines of text from other books—a situation that indicates their appeal throughout biblical history. A better approach would be to cite those psalms of note, particularly the ones considered messianic: Psalms 1, 2, 22, 27, 39, 52, 69, 81, 88, 109, and 110.

Chapter 9

PROPHETS

INTRODUCTION

Throughout the gospels and the writings of Paul, there are many references to the OT prophets and their prophecies; so many passages in Isaiah, for instance, seem to speak directly about Christ. Did Isaiah, or any other prophet for that matter, have the life of Jesus Christ in mind when composing the prophetic text? Are prophets the same as soothsayers and fortune-tellers? Is their job to predict the future, and if so, what distinguishes them from the palm and tarot card readers of today?

A reading of the lives of prophets shows that they were all too human, complete with emotions and temperament. The vocation of prophets is to hone and focus the Word of God and apply that Word to what they see before their eyes. If they see injustice, greed, violence, and societal iniquity, they say so, and, what is more, they draw attention to what will happen if people do not change.

For example, in the years and months leading up to the American Civil War, there were many politicians, religious leaders, and ordinary people who, in observing the horrors of slavery, cited its violent injustice, decried its existence as an affront to the divine order, and explained what would happen if things did not change. Just about everything they said came true: one nation cannot endure half slave and half free, populations will rise up to drive out slavery, and good will ultimately triumph over evil. Similarly, contemporaries such as Dorothy Day, Alexander Solzhenitsyn, and Martin Luther King Jr. have read the signs of the times and have made insightful statements about what the future would hold.

Biblical prophecy is similar, though there is an important difference: biblical prophets speak in the name of the Lord, and they say so. The people of ancient Israel were often confused about how to determine whether a prophet was

true or false. It was as true in ancient times as it is true today that many false prophets also claim to speak in the name of the Lord—Jim Jones and David Koresh, to cite two notorious figures. While at the moment it may have been a difficult question to discern, time shows the crucial, differentiating traits between the true and false prophets.

True prophets do not speak for their own gain. If wealth, prestige, popularity, and privilege come their way because of their prophecy, it can be considered a sign of falsehood. True prophets do not change their prophecy in the face of death or violence. They may remain quiet for a period if threats come their way, but they will not renege on their stance. Finally, true prophets suffer and die alone, and they do not demand others to suffer and die with them. Others might join them willingly, but a true prophet will not attribute such a choice to themselves. The biblical prophets meet these criteria.

When reading the prophets of the Bible, we must keep them situated in their historical context and interpret their sayings in light of that context. Hence, in Isaiah 7:14, when the prophet says, "Look, the young woman is with child and shall bear a son, and shall name him Immanuel," he is referring specifically to King Ahaz's young wife and the child she will bear: the future King Hezekiah. Yet, in reading Matthew 1:23 we see the same verse, practically verbatim, referring to Mary and her child, Jesus. It is even introduced with the phrase, "All this took place to fulfill what had been spoken by the Lord through the prophet" (1:22). These two citations, one from the OT and the other from the NT, provide a good example of how the evangelists, Saint Paul, and the church have interpreted prophecy from the beginning. In the Christian tradition, Christ dwells in the OT as the Word of God.

As we read the prophets in *The Saint John's Bible*, we should be mindful of the nature of biblical prophecy. A biblical prophecy endures through time. In order to understand and interpret it, we must know the history and culture in which it was first written, recognize its salient points (a call for social justice is the central message of nearly all the prophets), and then apply those points to our own time and place.

ISAIAH

The book of the Prophet Isaiah was written in three phases beginning in 732 BC and extending to 526 BC, a period of almost two hundred years. Dur-

ing this time span, the ancient world saw the rise and fall of both the Assyrian and Babylonian empires. Scholars have divided the book into three sections:

1. "First Isaiah" or "Proto-Isaiah" (chaps. 1–39), ca. 735–687 BC, contains warnings of God's approaching judgment on both Jerusalem and Judah against the background of the Assyrian conquests under Sennacherib and later under the rise of the Babylonian threat.
2. "Second Isaiah" or "Deutero-Isaiah" (chaps. 40–55), ca. 586–530 BC, speaks to the situation after the Babylonian conquest of Jerusalem, the subsequent exile, and the pending fall of Babylon.
3. "Third Isaiah" or "Trito-Isaiah" (chaps. 56–66), ca. 530–500 BC, proclaims God's restoration of Israel under the Persian, Cyrus the Great with allusions to the coming Messiah and the epoch of peace and justice that his reign will bring.

While the whole book has been ascribed to the one author (Isaiah), the time span of over two hundred years in which the passages were written makes single authorship impossible. The content across the three divisions, however, cohere theologically and thematically. The critical piece for the dating is the Syro-Ephraimite War (ca. 735 BC), the circumstances of which are outlined in Isaiah 7. Here we see Isaiah in a conversation with King Ahaz and thus would place the Prophet Isaiah as living before or even through the time of the Assyrian invasion of the north (ca. 740–722 BC).

According to the tradition seen in some pseudepigrapha, such as the Martyrdom of Isaiah, King Hezekiah's son, the evil apostate King Manasseh, martyred Isaiah by sawing him in half. Hence, the oracles against Assyria were most likely written after the Sennacherib's failed siege of Jerusalem (ca. 715 BC) and in light of the approaching Babylonian threat. Second Isaiah is written after Cyrus the Great conquers Babylon, and Third Isaiah shortly thereafter. It should be noted that many scholars see no distinction between the authorship of Second and Third Isaiah.

Isaiah Incipit
Donald Jackson, artist

The book of the Prophet Isaiah opens with a lightly decorated page. The first verse, emphasized by a special treatment, notifies the reader that Isaiah has received his prophetic message through a vision, which he is about to relate.

The text, however, seems more like a prophetic utterance than a mystical vision. The vision itself is described in Isaiah 6, which the five flaming torches above the book heading foreshadow, undergirded by the facing carpet page on the left with its stamped, seraphic wings. It provides a window into how the reader should approach Isaiah and most, if not all, prophetic literature.

We should not look for an unmistakable narrative line or logical flow. Rather, themes, accounts, and stories will rise, fall, circulate, and reprise with no apparent pattern, yet they contain logic and reason internal to the composition of the respective book. The result is a text filled with oracles, narratives, poems, and hymns bound together only by the central theme or intent of the prophecy. This construction keeps the reader attentive to the prophet's argument by casting it in an ongoing present tense, thereby making the message direct and dramatic.

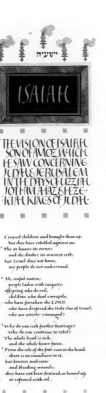

Wash Yourselves

Isaiah 1:16-17; special treatment; Sally Mae Joseph, artist

These two verses are central to the prophetic message, not only for Isaiah and nearly all the OT prophets but also for the church's teaching on social justice and the preferential option for the poor. Widows, orphans, and strangers were among the most impoverished and defenseless members of the society of that day. Just as the chosen people were called to be the voice of the voiceless then, we are called to the same standard today.

Swords into Plowshares

Isaiah 2:4; special treatment; Sally Mae Joseph, artist

Some of the most well-known biblical quotations come from Isaiah, this verse being one such example. In 1959, the then–Soviet Union, officially an atheistic state, gave the United Nations Plaza in New York City a bronze statue of a man hammering a sword. Written in the pedestal are the words, "Let us beat swords into plowshares." Despite the fact that the Soviet gesture was a stroke of genius in the area of international relations and propaganda, and many would cynically view it only in that way, the Kremlin's allusion to these verses from Isaiah demonstrates the resonance the text has with so many by reflecting the divine mandate for world peace.

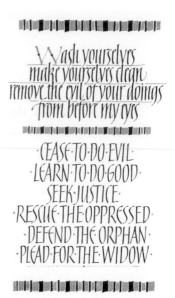

Isaiah's Temple Vision
Isaiah 6:1-13, Donald Jackson, artist

Background

We see the vision that Isaiah speaks about in chapter 1. The text is highly descriptive. Where do the images come from? Does Isaiah actually see what he describes or is he merely dreaming? These questions would seem to suggest that the chapter is a fictitious construction, but to dismiss it as such would do an injustice to both writer and reader. Indeed, there is much to support an experience that Isaiah himself had undergone.

Temples in the ancient world were the centers of the society, much like cathedrals in the medieval world. The Jerusalem temple, while unique in its focus on the monotheistic Lord God, nonetheless shared certain rituals and architectural elements with neighboring nations and their polytheistic worship, among these being a central locus for the deity, a sacrificial altar, gathering areas for worshipers, and copious amounts of smoke from both the burning of sacrificial animals and incense (used to cover the stench from the animal pens and crowds).

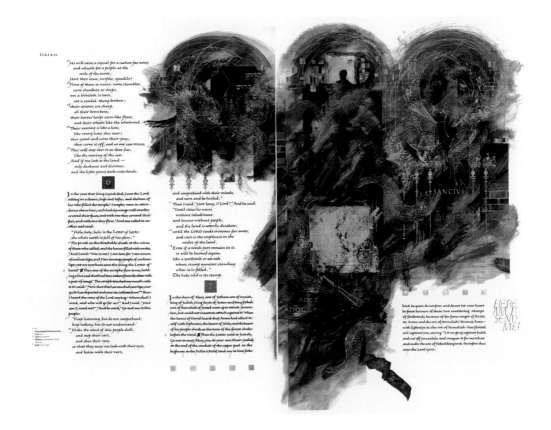

It is not difficult to imagine Isaiah the prophet, drowsy from fasting, standing amid wisps of swirling smoke, and hearing the ceaseless chant. As sometimes happens when people are tired, Isaiah could easily find himself in a somnambulant state and having a deeply religious experience. He interprets the whole event as a call from the Lord. Today, in our own emphasis on empirical evidence as the only basis for rational explanation, we might not see God working such an event. God, however, can use any and every means to communicate with us, and that is what seems to be the case here with Isaiah.

Image

Donald Jackson's depiction of Isaiah's experience, with all of its abstraction, follows the text closely. In engaging this illumination, we should pay close attention to the movement of the deep colors and the overall architecture of the page, such as the three pronounced arches in the upper register.

Isaiah 6:1 reads, "I saw the Lord sitting on a throne," yet he does not give us a description of God. We have only the depiction of the glorious court.

Isaiah 6:2 reads, "Seraphs were in attendance above him; each had six wings: with two they covered their faces, and with two they covered their feet, and with two they flew." Seraphic wings lightly cover the surface of this page. According to the tradition, seraphs or the seraphim are angels whose sole function is to guard and glorify the heavenly throne of God.

Isaiah 6:3 reads, "Holy, holy, holy." This phrase is repeated in the book of Revelation as well as in much apocalyptic literature and is written here in the three ancient languages of Hebrew, Greek, and Latin. In Christian churches, the phrase is used as a refrain within the Liturgy of the Eucharist.

Isaiah 6:4 reads, "The pivots on the thresholds shook at the voices." The shaking of the temple echoes the wind, fire, and earthquake of Exodus 19. All the senses are involved in the encounter with the divine.

Isaiah 6:7 reads, "The seraph touched my mouth with it and said: 'Now that this has touched your lips, your guilt has departed and your sin is blotted out.'" The scene is depicted in the lower register of the center arch. The prophet is sprawled on his back in utter helplessness as the seraph purifies his mouth with a burning coal.

Isaiah 6:8 reads, "'Whom shall I send' . . . 'send me.'" Isaiah shows the complete trust in God that all prophets share despite their misgivings and fears. In the prophets' weakness and dependency on God alone, and in the fruitlessness of finding anything else for solace, they find unfailing strength in their steadfast faith in God.

Isaiah 6:13 reads, "The holy seed is its stump." There is a long biblical tradition of roots and stumps forming new trees—a symbol that the people should continue the covenant the Lord made with them. Trees and vines are a prominent feature throughout *The Saint John's Bible*.

God peers out the window of heaven in the upper register of the center arch, a figure that is a leitmotif throughout the prophetic literature.

Scriptural Cross-references
Exodus 3:1-6; 19:16-25; 1 Kings 19:11-13; Revelation 12:1-5

Messianic Predictions
Isaiah 7, 9, 11, Thomas Ingmire, artist

Background
This full-page abstract of messianic passages is based primarily on three quotations in First Isaiah: 7:14-17; 9:1-2, 6-7; 11:1-9. As verses from the first part of the book, their immediate point of reference is of fear and tension arising within Israel over the impending Syro-Ephraimite war, as well as the imminent threat of the great and ruthless Assyrian Empire. Yet, later prophets and Jewish teachers readily applied these words to a future savior or messiah, whom the early Christian writers saw as Christ. This double use of a prophetic text is a way divine inspiration works.

Image
From earliest times, Christians have seen these verses in Isaiah as a direct reference to Christ. Handel used Isaiah 9:6-7 for one of the great choral sections in *Messiah*. The Christmas carol "Lo, How a Rose E'r Blooming" was inspired by 11:1-3. Devotion to the Blessed Virgin Mother finds part of its scriptural basis in chapter 7. This Scripture has not only a religious and theological function but also a historical one, exemplifying how Christianity formed and shaped culture by providing the thought and inspiration for art, music, literature, and dance.

In studying this image, readers might experience synesthesia, a phenomenon when one hears color, sees music, or smells words. Such a condition is not odd or alarming; it actually approximates what liturgical worship tries to accomplish. We can feel the rhythm of a dance and hear the sounds of Christmas. We can even bring our own experiences associated with family Christmas celebrations into the art, for our personal experience with the text is part of the church's experience with the text, and one will color the other.

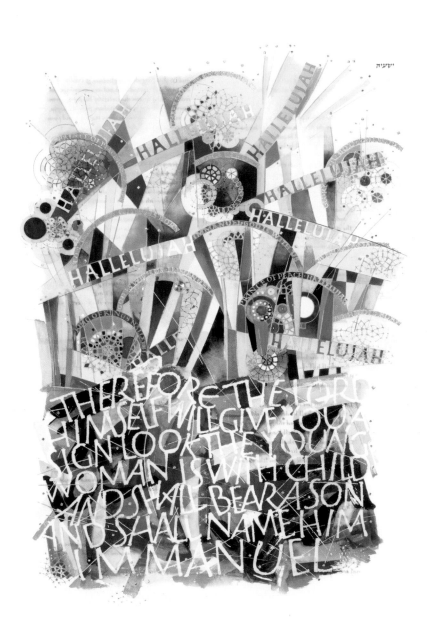

Scriptural Cross-references
Isaiah 6:13; Matthew 1:23; 4:14-16; Romans 11:16-18; 15:12; Revelation 5:5; 22:16

Comfort, O comfort my people
says your God
Speak tenderly to Jerusalem
and cry to her
that she has served her term
that her penalty is paid
that she has received
from the LORD's hand
double for all her sins

A voice cries out
In the wilderness
prepare the way of the LORD
make straight in the desert
a highway for our God
Every valley shall be lifted up

Comfort, O Comfort
Isaiah 40:1-5; special treatment; Sally Mae Joseph, artist

Isaiah 40 marks the beginning of Second Isaiah. This chapter serves as words of consolation to the Jews who are exiled to Babylon. The Lord has not abandoned them and, indeed, will lead them back to their homeland along a straight and level highway.

Part of this passage, "A voice cries out: 'In the wilderness prepare the way of the Lord, make straight in the desert a highway for our God'" (40:3), is quoted in Matthew 3:3, Mark 1:3, and Luke 3:4. The King James Version of these lines also forms the text for the aria "Comfort ye" in Handel's *Messiah*.

Listen to me
O coastlands
pay attention you peoples
from far away! The LORD
called me before I was born
while I was in my
mother's womb he named me
He made my mouth like
a sharp sword in the shadow
of his hand he hid me he
made me a polished arrow
in his quiver he hid
me away And he said
to me you are my servant
Israel in whom I will be

Listen to Me
Isaiah 49:1-4; special treatment; Sally Mae Joseph, artist

These verses comprise one of the four Suffering Servant passages. The others are Isaiah 42:1-4; 50:4-9; 52:13–53:12. Here, the Prophet Isaiah reflects on his call and defends himself against his detractors. The appeal to the "coastlands" lends a universal theme to the passage, which is confirmed at Isaiah 49:6. This passage is also used at Saint John's Abbey for the liturgy of the feast of Saint John the Baptist on June 24.

There is a dynamic tension in the OT between particularism and universalism. While all parties acknowledged that the Jews (as the Hebrew nation came to be called) were God's chosen people, there were two schools of thought in interpreting what being "chosen" meant. The particularists saw that God's promises applied to Jews alone, while the universalists, acknowledging their place in the divine order, saw the Lord's selection of the Jews to be for the purpose of spreading the name and blessings of God throughout

the whole world by telling others of the promise. The view of the particularists led to the growth of rabbinical Judaism, and the vision of the universalists gave birth to Christianity. Isaiah, more than any other prophet, speaks for the universalist position.

The Suffering Servant
Isaiah 52:13–53:12, Donald Jackson, artist

Background

A visual representation of all the Songs of the Suffering Servant is concentrated on this page. An enigmatic figure, the suffering servant in Isaiah is unidentified. Whom did the prophet have in mind? Himself, the people Israel, a messianic figure? No one knows for sure, but the situation and experience that Isaiah describes so well is something to which people can relate. Many walk a dark, grim journey, facing suffering, abandonment, and hopelessness. In addition to the biblical widow, orphan, and stranger, we have today political prisoners, debtors, the destitute and homeless, the displaced, immigrants, racial and sexual minorities, those with disabilities, and countless others without family, friends, or community who live in the shadow of fear and hatred.

A sharp contrast arises, however—"See, my servant shall prosper; he shall be exalted and lifted up, and shall be very high" (52:13)—suggesting that suffering is not the end of the story. This verse contributes to the long-held Christian understanding of the Suffering Servant songs; Christ is seen in the suffering servant, and, indeed, this passage is read in churches during liturgies of the Lord's passion, such as on Good Friday. The description in the account coheres very well with the gospel narratives of Christ's arrest, imprisonment, and crucifixion. Christ's life, death, and, above all, resurrection give meaning to the role of the suffering servant. Bleak doom is not the end, nor is it without meaning. Resurrection to eternal life reinterprets the suffering of this age, if not now, then in the life to come. As a Christ figure, the suffering servant has been identified with humanity's suffering throughout history. Christians believe that Christ, the Son of God, has walked through the same valley so that we would not have to walk it alone.

Image

The image reflects both despair and hope. It is not difficult to see within the piece the people of Sudan, Bosnia, and Afghanistan, along with those living in slums throughout the world. The hints of the chain-link fence seal off the person. We see only the back of the individual, a visual reference to Isaiah 50:6. Even the black, block lettering forms an imprisoning wall. The lamb led to the

slaughter, mentioned in Isaiah 53:7-8 and situated at the lower register of the illumination, is based on a photograph taken in Gambia by Sally Mae Joseph. The image has obvious eucharistic connotations and connects to Christ's passion. In the upper register, slightly above the prisoner's eye level, is a streak of color, perhaps a rainbow or a sign of hope, deliverance, and redemption.

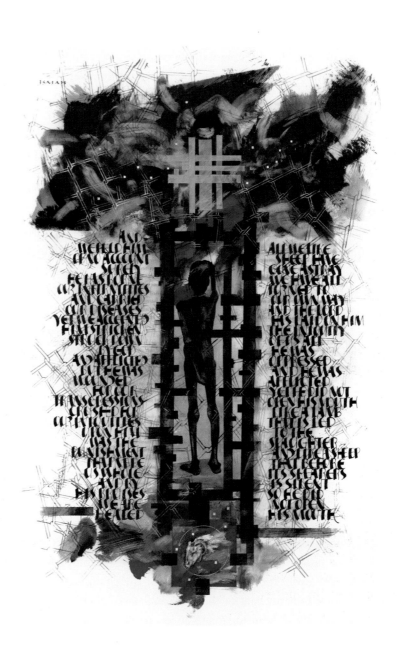

Scriptural Cross-references

Psalms 22, 88, 130; Wisdom 2:10–3:14; Lamentations; Matthew 26:55–27:50; Mark 14:46–15:37; Luke 22:54–23:46; John 18:12–19:30

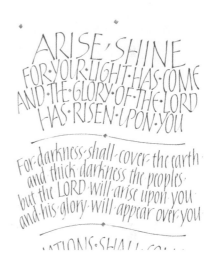

Everyone Who Thirsts

Isaiah 55:1-3; special treatment; Sally Mae Joseph, artist

A light red underline turns up the volume on these three verses. Used as one of the readings during the Easter Vigil, the metaphor operates by equating God's Word with physical nourishment. Simultaneously, it furthers the message of social justice by linking that same Word and our experience with it to God's command to feed the hungry.

Arise , Shine

Isaiah 60:1-3; special treatment; Sally Mae Joseph, artist

One of the brightest of all prophetic texts, "Arise, shine" introduces the last seven chapters of Isaiah's writing with the theme of universalism, a theme that continues to chapter 66. The text is used in the church's Christmas liturgy, and at Saint John's Abbey, it comprises one of the canticles for Solemn Morning Prayer on Christmas Day.

I Will Extend Prosperity

Isaiah 66:12-13; special treatment: Thomas Ingmire, artist

This piece not only frames the universalist passages in Isaiah but also concludes the book. The Lord God speaks as a mother to her child, which is the people. The imagery evoked by the verses is warm, maternal, and joyful. Thomas Ingmire sets the lines within a design that is reminiscent of Chinese calligraphy.

JEREMIAH

Jeremiah's vocation is a tumultuous one, living and preaching just before the Babylonian exile. One of his greatest obstacles is contending with false prophets who have the king's ear. These men are reluctant to see the harsh truth much less relate it to the king, and so they persist in relying on the fact that the Lord in his temple will protect Jerusalem from the enemy. Jeremiah counters that unless the leadership and the people turn their attention to matters of social justice, the Lord will not protect them (7:5-15). In the end, events prove Jeremiah right. Tradition has it that he and other refugees fled to Egypt as the Babylonians destroyed Jerusalem.

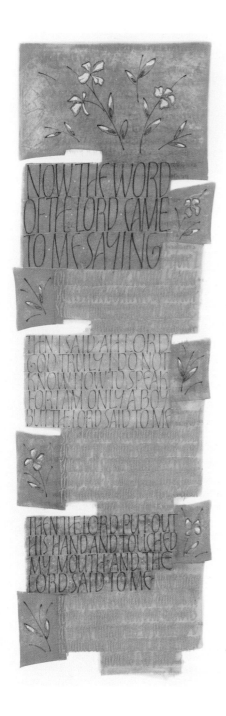

Word of the Lord
Jeremiah 1:1-10; special treatment; Sally Mae Joseph, artist

Though not as dramatic as Isaiah's temple vision, Jeremiah's call features many of the same elements: divine election for the task at hand, protest from the prophet himself, and God's reiteration of the prophet's divine election. In Jeremiah's case, the Lord consecrates Jeremiah before the prophet is formed in his mother's womb. This is a divine act of predestination.

In our day and age we may question the fairness of such predestination, but in the ancient understanding, all life comes from God, and humans exist for his purposes. In the OT and NT there are plenty of examples of people not acting according to the will of God. Not to do so is to humankind's loss. Moreover, all divine predestination is for goodness and salvation. God creates no one for condemnation.

EZEKIEL

The great prophet of the Babylonian exile, Ezekiel, has many visions and writes about them all. They seem hypnotic, fantastic, hallucinatory, and even psychedelic, leaving readers at a loss to explain what the prophet sees. Some doctors have suggested that he may have suffered from some form of epilepsy. No matter. God can use all human activity for his purposes, and Ezekiel stays on task by providing the captives with true and not false hope. While the imagery and motion of what he sees seem to us profoundly wild and bizarre at times, these visions provide the basis of hope for the captives in Babylon; Ezekiel's trance-like recitations are all connected to the message that God has not abandoned his people and that their deliverance ultimately is at hand.

Not much is known about Ezekiel the prophet except that he most likely lived with the exiled Jews in Babylon (Ezek 1:1-4). The Babylonians conquered Judah by a series of campaigns. At first, they captured and exiled only the courtiers and government officials; Ezekiel was in this group (1:1), then they returned for the artisans and others who had useable skills and talents. Thus, they worked their way down the socioeconomic line, leaving only the poorest of the poor to stay in the land. Simultaneously, they brought in other populations to settle in Judah; it was a policy often used in the ancient world by victors to maintain control. During these waves of forced exile, the city of Jerusalem and its temple remained relatively intact. It was only in 586 BC when King Zedekiah attempted to form an alliance with Egypt to rebel against his Babylonian masters that Nebuchadnezzar swiftly attacked the Jewish capital, leaving the city and its temple in ruins and ashes. When Ezekiel references the temple, therefore, he envisions a day when the Jewish captivity will end and the people will return to their homeland and rebuild all that had been destroyed.

proach in the land. Better, therefore, is someone upright who has no idols; such a person will be far above reproach.

Wing Stamp
Opening page, Donald Jackson, artist

In the lower left corner of the page opening the book of the Prophet Ezekiel, we see a reprise of the seraphic wing pattern from Isaiah. It is a visual leitmotif linking the lives and material of these two great prophets. This wing pattern occurs multiple times throughout *The Saint John's Bible*.

Ezekiel's Vision at the River Chebar
Ezekiel 1:1–3:11, Donald Jackson, artist

Background

A prophetic call starts with an encounter with God. Ezekiel is in Babylon, and the covenant with the Lord appears broken and lost forever. It would seem that Ezekiel himself was a captive (Ezek 1:1), but there are also passages that indicate he instead came from elsewhere to visit the captives, leaving the question of his whereabouts unanswered (2:3).

A dramatic vision from God at the River Chebar convinces the prophet that God is actually speaking to him. Eating the words of the scroll symbolizes the way in which Ezekiel makes the message a part of himself; literally, he becomes what he eats.

Image

In this vision, the four living creatures are seen in tandem with the often-mentioned precious stones of amber, crystal, and sapphire (1:4, 22, 26, 27). The descriptions of the creatures themselves have a similarity with the ancient

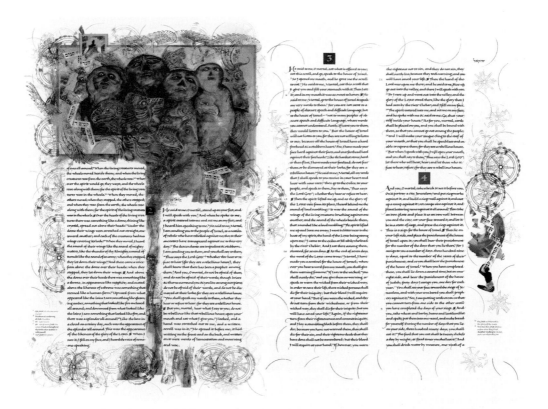

sculptures of chariots and griffins found within the archaeological ruins of Mesopotamian cities. When one looks at them from the side, they are four-legged; when we look at them from the back, they are two-legged. Their hands are stretched out as well. Added to these are four quasi-human faces similar to anthropoid clay faces impressed upon coffins found in Canaan near the Sinai Desert.

Chariot wheels and seraph wings fly with abandon, half-human and half-animal creatures fill the space, the amber sheen of the stones colors the background, and Ezekiel, seated in the right margin, eats the scroll, on which is written in Hebrew, "I looked, and a hand was stretched out to me, and a written scroll was in it. He spread it before me; it had writing on the front and on the back, and written on it were words of lamentation and mourning and woe" (Ezek 2:9-10). The leitmotif with God in the window of heaven is visible in the upper left register.

Scriptural Cross-references

Jeremiah 1:4-10; Isaiah 6:1-13; 49:1-4; Daniel 7; Revelation

Valley of the Dry Bones
Ezekiel 37:1-14, Donald Jackson, artist

Background

The gathering of the dry bones symbolizes the resurrection of Israel after the Babylonian exile. The concept of resurrection is a late development in Jewish theology, not surfacing until well into the postexilic period. Before that time, the belief was that the deceased lived on in their descendants. Ancient literature, substantiated by archaeological finds in the Holy Land, describes burial practices in which the bones of the deceased would be collected and placed in a repository along with all the bones of their ancestors so that descendants would always know where to find their family line. Hence, one would be gathered to his or her people (Gen 35:29). In Genesis, Abraham buries Sarah in the cave of Machpelah near Hebron (Gen 23:19), and this spot becomes his own burial place as well as that of his descendants, Isaac, Rebekah, Jacob, Leah, and Joseph.

In this scene, Ezekiel describes a vision he has through the "spirit of the Lord" (Ezek 37:1). Commanded to prophesy to the realm of the dead, Ezekiel sees and hears the revivification of the bones and speaks on behalf of the Lord, "I will put my spirit within you, and you shall live, and I will place you on your own soil; then you shall know that I, the LORD, have spoken and will act, says the LORD" (37:14). Their lives of slavery and exile in Babylon

will have redemption in which even the dead will share. It is a most hopeful vision and, for Christians, one that prefigures Christ's resurrection and our participation in it.

Image

The hopelessness, despair, and death in this image are contained in the lower register. The great atrocities of modern times are represented here: the Holocaust by the pile of eyeglasses, the killing fields of Pol Pot by the stacked skulls, the ethnic cleansing of Bosnia by the scattered bones, the Armenian genocide by the starved cadavers, and countless other cases of mass extermination in the shadows. Environmental disaster also gets play with the automobile. The rainbow, a perennial sign of hope for those who have endured tremendous suffering stands as the bright contrast to the despondent picture of human and natural destruction below. There is a subtle connection between the two with the reflection of the rainbow in the oil slick on the lower right; God's grace can permeate even the most abject evil.

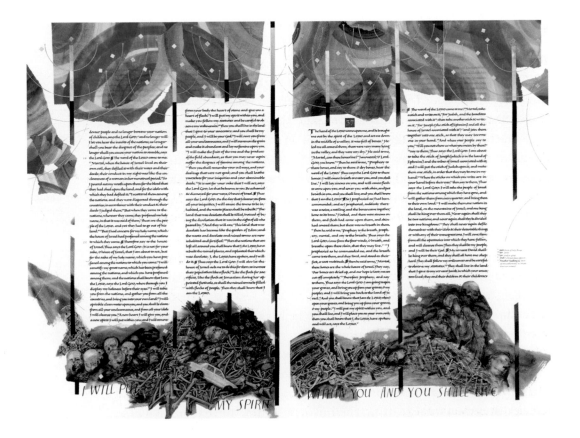

For us living in the twenty-first century, it is not difficult to relate to this depiction. The great crimes of the last century and some now in the present have been brought to our eyes nearly instantaneously through the internet. Collectively we can look to the Armenian genocide, the Holocaust, Hiroshima, Nagasaki, the Cambodian killing fields, Rwanda, Bosnia, 9/11, and the atrocities in Syria. With the rainbow, the *breath* of God that spreads over the waters in Genesis is not far away and can come down as tongues of fire at Pentecost.

Human bones in a dry climate will last an interminably long time, and in many of the Christian monasteries in the deserts of the Middle East—Saint Catherine's of Sinai, for one—the bones of all dead monks are gathered and sorted in a charnel house to await the resurrection. These charnel houses are mute reminders to all humankind that redemption and resurrection are our destiny through Christ.

Scriptural Cross-references

Genesis 1:1-5; 2:7; Psalms 33:6; 135:17; Wisdom 7:25; John 11:1-44; Matthew 28; Mark 16; Luke 24; John 11:1-44; 20; Acts 2:1-36

Vision of the New Temple
Ezekiel 40:1–48:35, Donald Jackson, artist

Background

No biblical writer has spilled more ink than Ezekiel in discussing the temple and its architectural intricacies. Yet, scholars are puzzled about what Ezekiel says concerning this edifice. It is nearly impossible to discern to what extent Ezekiel designs the temple in his own mind, recalls the old temple before its destruction, or describes part of the new temple as it was being rebuilt. The description we have here in chapters 40–48 can very well contain elements of all three understandings. A house reflects a human world, while the temple, as God's house, reflects God's world, and Ezekiel, the great visionary that he is, may be doing just that.

As with the description in 1 Kings 7, Ezekiel, too, provides many details about the temple. In addition to the layout presented in 1 Kings, artists and architects have tried to follow his design.

In Ezekiel 43:12, we read of the "Law of the Temple," in which all the territory on the top of the mountain is considered holy. Even today, religious laws based on Ezekiel 43:12 forbid Jews from walking on the Temple Mount (Harem al Sharif); Jewish veneration is restricted to the Western Wall.

In point of fact, there have been at least four or five temples on the sacred site. The first was Solomon's, which the Babylonians destroyed in 586 BC. This is the temple that Ezekiel wishes to rebuild. When the exiles return, they do rebuild (see

Ezra and Nehemiah), but it is not as ornate or stupendous as Ezekiel describes it. This temple was probably remodeled two or three times until King Herod constructed his temple on the site, whose edifice and complex came to be one of the most beautiful buildings in the Roman Empire, until it too was destroyed in AD 70.

Image

The illumination here is based on late medieval renderings of the Jerusalem temple. The measurements form a perfectly symmetrical cube with appropriate

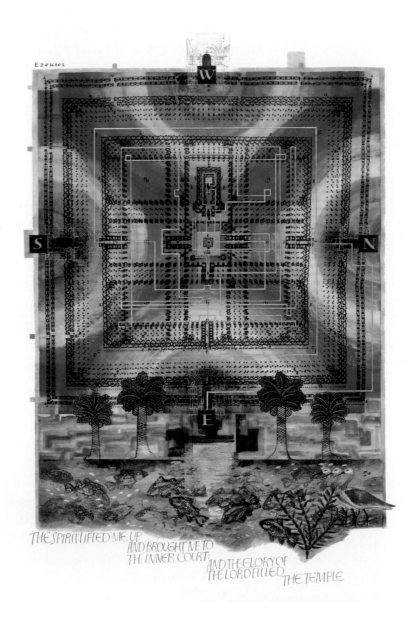

entrances on the north, east, south, and west sides. The Holy of Holies is in the upper register, just below the west door. In the center is the Altar of Sacrifice. The areas of demarcation are evident. Immediately within the first wall of the enclosure is the court of the Gentiles, where everyone was allowed. The next wall toward the middle encircles the court of the women. Through the following wall is the court of the men. Proceeding to the center, one comes to the court of the priests, who offer the sacrifices at the altar. Finally there is the Holy of Holies, where the presence of God resides and into which only the high priest can enter once a year.

The vegetation, fish, and birds in the lower register recall creation and are based on the flora and fauna depicted in the Genesis pages of *The Saint John's Bible*, for the temple, as the locus of God's presence on earth, evokes the lush and verdant ambience of paradise. In addition, we see great streams of water in this depiction. Abundance of water is important not only for temple rituals requiring water to cleanse the space from the detritus of the animal sacrifices, but also for the worshiper's refreshment. Under the four cardinal points, in Hebrew and English, are the tribes of Israel listed according the gate to which they are assigned (48:30-34).

There are many textual cross-references between Ezekiel's description of the temple and the temple of the New Jerusalem outlined in the book of Revelation, and what we read here helps with the interpretation of the Bible's last book.

Scriptural Cross-references
1 Kings 8; John 4:10-15; 7:37-39; 19:34; Revelation 21:6; 22:1, 17

Marginalia: Papaya Tree
Ezekiel 47:12, Sally Mae Joseph, artist

The papaya tree in the margin is a decorative element, which draws attention to the rich abundance of vegetation mentioned in this verse of Ezekiel's temple vision.

DANIEL

The book of Daniel is late in its composition. Although the subject matter of chapters 1–6 is set during the Babylonian exile, most scholars believe that it was written at the time of the Seleucid king and harsh overlord, Antiochus IV Epiphanes, who reigned over Judah circa 175 to 164 BC. The first half of the book, therefore, is a collection of legends and other forms of oral tradition gathered, edited, and employed at this later period to instill hope among the people during a time of oppression. It is contemporaneous with the period of the Maccabees.

The original languages in which Daniel was written, Hebrew for Daniel 1:1–2:4, 8–12 and Aramaic for Daniel 2:5–7:28, have led some scholars to hold to an earlier dating for the book's composition, namely, around 600 to 530 BC. If Daniel were written at a later time, the argument goes, Greek and not Aramaic would have been used in place of Hebrew for the middle chapters. Others counter that Aramaic was the lingua franca of the Babylonian and Persian empires and that it endured in this role for another five hundred years. For example, in Palestine at the time of Christ, Greek was the universal tongue of the Roman Empire, the daily language was Aramaic, and Hebrew was reserved solely for reading Scripture.

The questions about dating and language have bearing on the full-page illumination found in the book of Daniel. The Vision of the Son of Man culminates the Aramaic portion of Daniel, and the fact that it is in Aramaic points to a large audience beyond the borders of Judah. The Son of Man figure in Daniel is one of the great messianic prophecies within the Old Testament, with Christ referring to it during his trial before the Sanhedrin in the gospels of Matthew, Mark, and Luke.

Vision of the Son of Man
Daniel 7:9-14, Donald Jackson, artist, with Aidan Hart

Background

We encounter here a drawback in the NRSV's translation. The critical phrase reads, "I saw one like a *human being*" (7:13, emphasis mine). It should be translated as "Son of Man." Indeed, when the translators came to the Greek version of the phrase, *uios tou anthropou* in the NT, they chose to render it literally as "Son of Man." Although the term was a common phrase in the Hebrew and Aramaic, used roughly in the way we say "some guy" in the United States or "some bloke" or "chap" in the United Kingdom, but with a bit more gravity, within the gospel tradition it acquires a proper sense referring specifically to Christ. Indeed, one of the earliest theological interpretations of Christ's life

comes from the reading of "Son of Man" in Daniel 7 as a referent to Christ, especially in gospel passion and death accounts. For this reason, where the NRSV term "human being" surfaces in Daniel 7, the CIT reads "Son of Man" and has used it as the basis for all cross-references and interpretation.

Image

The Son of Man in Daniel has a divinity and a universality that has not yet been fully revealed in the text. Such a revelation becomes manifest at Christ's

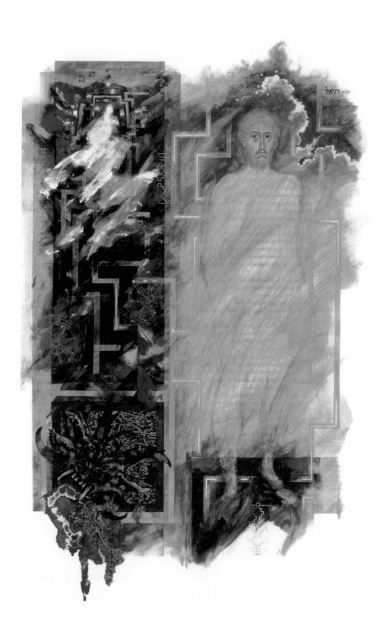

passion, death, and resurrection, and the depiction here foreshadows as much. The left panel shows the collapse of all rulers of the world in the face of the Son of Man. The text refers to the kings and rulers as *beasts*, and the monstrous creature in the lower register makes that allusion as well as connects with diabolical forces in the gospels and Revelation. At the top is a white figure framed by a window, a familiar leitmotif in the prophetic literature that recurs elsewhere.

The powerful yet serene appearance of the Son of Man figure in the right panel provides a stark contrast to the rulers of the world. To the Son of Man is given the everlasting dominion as he arrives "with the clouds of heaven" (Dan 7:13-14).

A careful study of the image reveals visual cross-references to other books and passages in the prophets as well as other parts of the Bible.

Scriptural Cross-references

Matthew 10:23; 12:40; 13:41; 16:27; 19:28; 24:27; 24:30; 24:37; 25:31; 26:64; Mark 8:38; 13:26; 14:62; Luke 9:26; 12:40; 17:22-24; 21:27; 21:36; 22:69; John 1:51; 3:13-14; 6:62; 12:23; 13:31; Acts 7:56; Revelation 1:13; 14:14; 20:4

AMOS

Amos preached to the people in Samaria, the capital of the northern kingdom before the Assyrian conquest of 722 BC.[1] In the northern kingdom at that time, some were living in the lap of luxury while others were starving. The rich were becoming richer at the expense of the poor. It was a time of great social injustice, and the book's criticism of rampant iron-age consumerism provides a good example of the applicability of OT prophecy to contemporary situations.

The Demands of Social Justice
Amos 3–4, Suzanne Moore, artist

Background

On the theological level, Amos is describing a situation that shows the opposite of the world described in the Wisdom books. Whereas the Wisdom tradition presents the reader with all the personal and social values necessary to construct a loving and nurturing home and society, Amos presents us with a bald image of

1. After the death of King Solomon, the united kingdom split. The northern half was called "Israel," with Samaria as its capital city, and the southern half was called "Judah," with Jerusalem as its capital.

what happens when we forget those qualities, and suffering becomes a state of being for the great mass of people. His descriptions have a contemporary ring with war and poverty sitting side by side with magnificent wealth of the rich and famous. In such a context, riches are a curse. This prophet sees the undoing of all the good Wisdom has done. In this scene, God is calling the people back with the refrain, "Yet, you did not return to me" (4:6, 8, 9, 10, 11); it is to no avail.

Image

Unlike the books of Isaiah and Jeremiah, the scenes of destruction here have a rural character in line with Amos's occupation as a "dresser of sycamore trees" (7:14). Destruction in the countryside features drought, brush fires, tornadoes, and floods. Nonetheless, the Assyrian threat is very real, and Amos poignantly describes the terror and destruction of Tiglath-Pileser's armies savaging the countryside. The depiction ends with abstract locust on the right page, the curse of farmers from antiquity until the present.

Scriptural Cross-references
Jeremiah 7:4-7; 22:3-5; Ezekiel 22:7-20; Zechariah 7:9-14; Matthew 5:1-12; 25:31-46; Luke 6:20-38

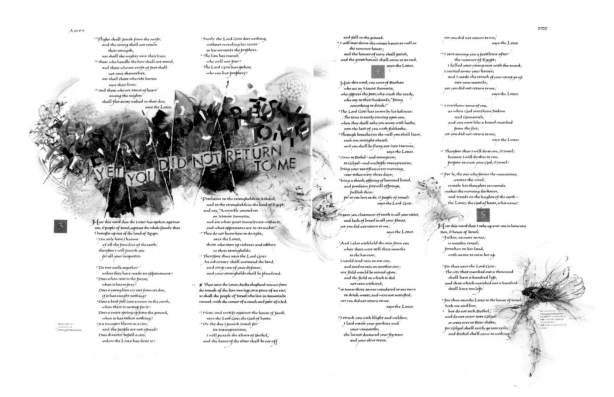

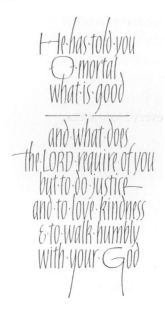

MICAH

He Has Told You
Micah 6:8; special treatment; Sally Mae Joseph

One of the Minor Prophets, Micah lived at the time of the Assyrian invasion, ca. 737–690 BC. All too often in history, moralism has replaced morality; proper and right action devolves into observable standards of behavior that obfuscate and diminish the truly moral life and the good deeds that arise from it. It is a condition to which organized religion is particularly prone. This verse from the prophet Micah captures the heart of the moral life, a life very close to Saint Augustine's teaching based on his famous quotation, "Love God and do what you will."

ZECHARIAH

Zechariah is one of the lesser prophets whose importance lies in his messianic prophecies, the most famous of which is shown here. He lived just after the exile.

Messianic Prediction
Zechariah 9:9, Hazel Dolby, artist

Background
In addition to the obvious cross-references to Jesus' passion in Matthew and John, this passage echoes the nativity in Luke with the donkey often depicted at the manger, which itself is an allusion to Isaiah 1:3. Although there is no crib here, one can imagine that the tired beast will soon have rest at its stall. One of the oldest interpretations of Christ's nativity in both theology and piety is that the wood of the crib becomes the wood of the cross. This passage from Zechariah, therefore, foreshadows the incarnation, the passion, and the resurrection.

Image
The donkey is an important animal in this passage, for it connects the joyous birth of Christ with the agony of his death. The image here is peaceful yet tinged with melancholy. The donkey's head is slightly bowed, as the animal at the crib is often portrayed in the artistic tradition. Unlike Christ's jubilant entry into Jerusalem, there are no crowds in this illumination, but the figure

riding the donkey is reminiscent of Christ just the same. This image is a fine representation of how prophecy works. It is true to the text and the context even while it has allusions, connections, and suggestions broader and larger than the particular moment in which the words were written.

The palm trees on the left page balance the image as it recalls the Christian celebration of Christ's passion, death, and resurrection every Holy Week.

Scriptural Cross-references
Isaiah 1:3; Matthew 21:5-7; Luke 2:7; John 12:14-15

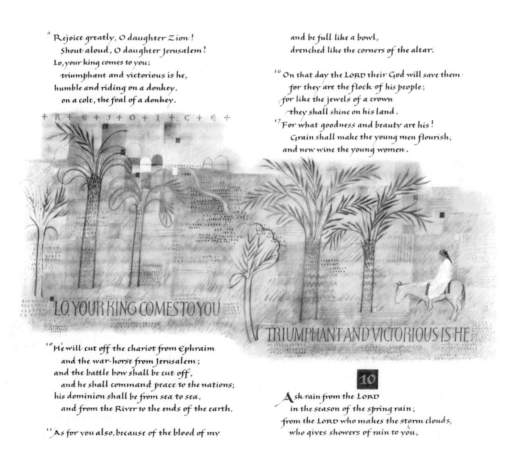

⁹ Rejoice greatly, O daughter Zion!
 Shout aloud, O daughter Jerusalem!
Lo, your king comes to you;
 triumphant and victorious is he,
 humble and riding on a donkey,
 on a colt, the foal of a donkey.

 and be full like a bowl,
 drenched like the corners of the altar.

¹⁰ On that day the LORD their God will save them
 for they are the flock of his people;
 for like the jewels of a crown
 they shall shine on his land.
¹⁷ For what goodness and beauty are his!
 Grain shall make the young men flourish,
 and new wine the young women.

"LO YOUR KING COMES TO YOU

"TRIUMPHANT AND VICTORIOUS IS HE

¹⁰ He will cut off the chariot from Ephraim
 and the war-horse from Jerusalem;
 and the battle bow shall be cut off,
 and he shall command peace to the nations;
 his dominion shall be from sea to sea,
 and from the River to the ends of the earth.

¹¹ As for you also, because of the blood of my

10

Ask rain from the LORD
 in the season of the spring rain;
from the LORD who makes the storm-clouds,
 who gives showers of rain to you,

Chapter 10

GOSPELS AND ACTS

INTRODUCTION

Historically and theologically, the birth, life, death, and resurrection of Christ separate the OT from the NT. *The Saint John's Bible* has divided the New Testament between two volumes: the four gospels and the Acts of the Apostles (volume 6), and Pauline and non-Pauline letters as well as the book of Revelation (volume 7). For Christians, the NT (especially the gospels) is the culmination of the biblical revelation. Many of the themes, visual leitmotifs, and references already seen and encountered in volumes 1 through 5 are reprised in the remaining books, just as the evangelists, Saint Paul, and the early Christian theologians used the OT to interpret the meaning of Christ's life, death, and resurrection.

In reading, studying, and praying through the NT, colors, symbols, and page architecture may prompt our minds and imaginations to recall and reconfigure images from the preceding volumes. The connections made by perusing *The Saint John's Bible* in its entirety open Sacred Scripture to the theology and history of its Christian context. The faith community has formed and shaped the Bible, even as the Bible forms and shapes the faith community. This interplay between the living Word of God and the Pilgrim People of God has resulted in a book of faith proclaiming the richness of Christ's salvation to all.

THE GOSPELS

Although the canonical order of the NT situates the four gospels first, they are not the first NT books to be written; Saint Paul's letters precede them, with scholars considering 1 Thessalonians (ca. AD 52) as the oldest NT

work.[1] The order in the arrangement of the books, however, follows theological importance and not historical order. Because the gospels relate the birth, ministry, suffering, death, and resurrection of Jesus Christ and even record many of his sayings and conversations (albeit with a great deal of theological overlay), they have long been afforded pride of place in Christian life and worship. For example, gospel books, also known as *Evangeliars*, first existed on their own with other biblical works forming separate volumes. Many churches still follow this practice today, by processing with the gospels to the ambo or lectern before the reading, incensing the page to be read, standing as the lesson is proclaimed, and exhibiting the book in a special place for private veneration.

Historically, each of the four books has its origin in a particular locale, with a particular writer or editor, and at a particular date. In addition, scholars are not in agreement on the order in which the gospels were written. At an earlier time in modern scholarship, and sometimes for political reasons, scholars held the dating of each gospel to be very important, and much valuable research has gone into the endeavor. To summarize succinctly here, for the first fifteen hundred years, everyone accepted that Matthew was written first, parts of it were copied by Mark, parts of the first two were copied by Luke, and, finally, all three were copied and reshaped by John. Inconsistencies and redundancies among the four were seen to be the result of each respective evangelist's take on a certain aspect of Christ's life and ministry. In the eighteenth century, new theories on gospel formation arose, with the two-source theory (Mark and Q) predominating well until today.

As major universities launched archaeological and historical explorations in many of the lands mentioned in the Bible, new information on certain biblical accounts, such as Jesus' birth or his Galilean ministry, became available to Scripture scholars and theologians. Knowing the history of the early Israelite, Jewish, and Christian communities opened new doors to interpretation of the written texts with beneficial results, and the research continues.

The layout of the illuminations and text within *The Saint John's Bible* reflects the time, place, and community for which each gospel was written. In addition, primary importance is given to awakening and vivifying the experience of faith that countless people have found within these texts. If the gospels were written at a certain period for a certain group of people at a certain place in the ancient world, they were also written for people way beyond the pale of the time and space of their original composition. Consequently, the following

1. For a fuller explanation of the formation of the canon, see Stanley E. Porter, ed., *The Pauline Canon* (Boston: Brill, 2004); and David Laird Dungan, *A History of the Synoptic Problem* (New York: Doubleday, 1999).

pages convey, to the extent possible, the reception of the evangelical message at this point in time, even as it draws from the previous twenty centuries. The hope is that future generations can build on this experience so that the faith of their forebears can also take root in them.

GOSPEL OF MATTHEW

The tradition is that Matthew writes his gospel in Palestine or southern Syria nearly exclusively for a Jewish community, ca. AD 75. No doubt this community of devout Jews has had some experience of Christ or has heard about his life through his disciples. Matthew's task is to demonstrate how Jesus fits into the context of Judaism. He does this by building on the prophet Isaiah, "On that day the root of Jesse shall stand as a signal to the peoples; the nations shall inquire of him, and his dwelling shall be glorious" (Isa 11:10). Jesus grows from the "root of Jesse," and to let us know how that has happened, Matthew starts the lineage with Abraham in the generations before Jesse and continues to Jesus' birth through Mary.

Frontispiece: Genealogy of Jesus
Matthew 1:1-17, Donald Jackson, artist

Background

Each of the four gospels has a full-page frontispiece based on the first verses and functioning as a grand announcement of the work. The Matthew frontispiece portrays the genealogy of Jesus. In a good number of illuminated Bibles and *Evangeliars*, the genealogy in Matthew is presented as a tree arising from Abraham's loins. While in most medieval Bibles, the tree is set within the first capital letter of the book of Matthew (usually "L" for *liber*, the Latin word for book), here, the family tree is a full page. In both cases, the idea of Jesus as the fruit of a long line of notables among the Chosen People is exactly what Matthew wants the reader to see.

Within the genealogy, Matthew emphasizes King David, who in Jewish tradition is the greatest and most pious of kings. The phrase "son of David" occurs at the very beginning (1:1) and is reiterated in reference to Joseph (1:20). The generations within the genealogy are calculated from David's reign (1:17). Moreover, the Hebrew number fourteen is written using letters that spell "David" and is the sum of the generations between Abraham and David, David and the exile, and the exile to the birth of Jesus.

Matthew shows the Jewish identity of Jesus from the very beginning of the gospel in order to convince the Jewish population that Jesus is the long-

awaited Messiah promised by God through their tradition. To believe in him
is to continue in the covenant.

Image

The illumination on this page adapts the family tree in a manner that takes
in the chemistry of generational lineage while drawing on one of the great-
est symbols of Judaism—the menorah. At the base of the menorah we read
the name of Abraham. The right foot of the base has the name "Hagar" and
the left foot shows, "Sarah." This move acknowledges Islam, which traces its
origin to Abraham through his son Ishmael by the maidservant, Hagar; these
names are written in Arabic. The Hebrew line, from which Jesus descends,
comes through Isaac, the son of Sarah and Abraham.

The rest of the tree grows from the base to the top, its central stem of
the menorah blazing with the name of Jesus. As with all the other names in
the depiction, "Jesus" is also written in its Hebrew form, *Yesuah*. Surround-
ing and spinning each arm of the menorah is an artistic version of the DNA
double helix. While the major share of the names cited are male, Jesus' actual

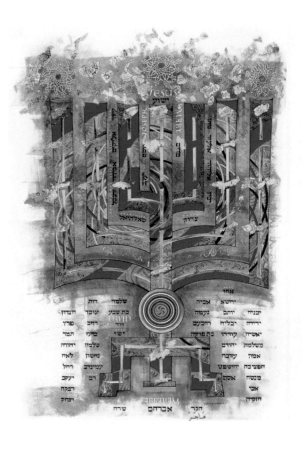

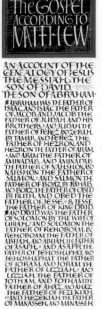

blood line comes through his mother Mary. Readers should note that Joseph is called "the husband of Mary" and *not* the father of Jesus (1:16). Matthew, as well as Luke, leaves no doubt that Jesus is divinely conceived. The text that accompanies this frontispiece is written in a script different from the one used for the rest of the text of Matthew.

Scriptural Cross-references

Genesis 46:8-26; 1 Chronicles 5–7; Ezra 8:1-36

The Beatitudes
Matthew 5:1-12, Thomas Ingmire, artist

Background

Continuing with his theological thrust to show the Jewishness of Jesus, Matthew constructs a literary parallel with another OT work in the Beatitudes. At Exodus 19, Moses climbs Mount Sinai (also called *Horeb*) as the people remain at the foot of the mountain. In Exodus 20, he receives the Ten Commandments from the Lord God and relays them to the people. Moses remains at the top of the mountain for forty days and nights (Exod 24:18). During this period he writes down statutes and ordinances that are given to him by God to serve as a commentary for interpreting the Ten Commandments.

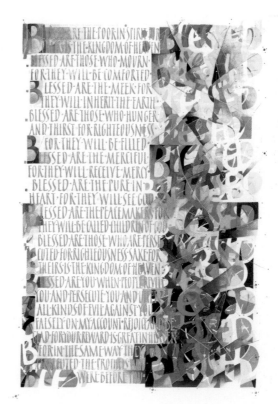

Likewise, Jesus climbs a mountain in Galilee, sits down as people gather around him, and instructs them. Once he finishes with the Beatitudes at Matthew 5:12, he gives examples of the new teaching that run for the next two chapters, and these examples function as a commentary on the Beatitudes themselves. In this context, Matthew is portraying Jesus as the new Moses, who does not so much give a new law as much as he gives a completed version of the law of Moses.

The very word "beatitude" may mean "blessed," but actually "happy" is the better definition. The Beatitudes open the Sermon on the Mount, which ends at Matthew 7:28 when Jesus finishes "saying these things." Everything from Matthew 5:13–7:29, therefore, serves to explain, demonstrate, and elucidate all that Jesus mentions in the Beatitudes. In summary fashion, we can say that the basic thrust of the Sermon on the Mount is the call to go beyond that which is merely necessary in one's dealings with God and neighbor. Doing so leads to the kingdom of heaven.

Image

Solid, legible, capital letters containing the text balance the rich, geometric designs, which, upon closer examination, prove to be letters themselves. The color palette is bright and evokes the sky. The composer Arvo Pärt, inspired by this text, wrote a piece called "Beatitudes," constructed on fifths. The special treatment of the Our Father on the following page completes the visual presentation of this section of Matthew's gospel.

Scriptural Cross-references

Exodus 20:1-17; Luke 6:17-23; Philippians 2:5-11

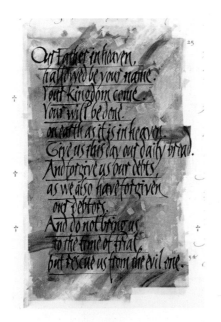

Our Father

Matthew 6:9-13; special treatment; Donald Jackson, artist

The climax of the Sermon on the Mount occurs within the Our Father (6:9-13). In this foundational prayer of Christianity, here highlighted by a special treatment, all the Beatitudes come together. Such terms as "kingdom," "earth," "heaven," and "bread" are used in the interplay of both present and future redemption. "Bread" is particularly important for its connection with hunger, thirst, and the poor as well as with the Eucharist. Verse 12 reads, "And forgive us our debts, as we have also forgiven our debtors," underscoring a most essential element of Christianity.

Calming of the Storm
Matthew 8:23-27, Suzanne Moore, artist

Background

In Scripture, the sea is the abode of all that is evil. Unknown and frightening, the depths are the primeval chaos where monsters and demons dwell. "Lord Save us! We are perishing!" evokes the centrality of the human need for help and for relationship (8:25). Jesus' reply, "Why are you afraid, you of little faith?" completes the picture (8:26).

We are lost and sometimes threatened by monstrous situations, and it is only our faith in Jesus that saves us. The church, as Christ's presence on earth within the community of believers, has often been depicted as a boat, saving us sinners lost upon the sea. Indeed, throughout history, the central part of a church building has been called a "nave," from the Latin word for "ship," as much as for the physical resemblance to a ship as for the metaphorical concept.

Image

This image contrasts the treacherous storm and its life-threatening power and waves with the secure safety of Jesus in the boat. This piece is full of action and movement. Christ's calming the water not only saves the boatload from certain death but also shows his lordship over all creation including the demonic forces of evil, darkness, and despair.

Scriptural Cross-references

Genesis 6:13–9:10; Exodus 2:1-6; Jonah 1:1-15; Mark 4:36-41; Luke 8:22-25

Peter's Confession
Matthew 16:13-23, Donald Jackson, artist

Background

The setting for Peter's Confession explains a great deal of the imagery. Caesarea Philippi lies at the foot of Mount Hermon and was a cultic center of the Greco-Roman world. In fact, archaeological evidence points to its being a venerated spot from earliest antiquity. A large cave is situated there, from which, at the time of Christ, issued one of the sources of the Jordan River. In this period, the area was under the control of Herod Philip, a son of Herod the Great. Herod Philip undertook a huge construction project in which he built, along with his palace, a temple to Pan, the Greek god of the forest and underworld.

When Christ speaks, therefore, he and the disciples are sitting in the midst of a pagan shrine with votive altars dedicated to various gods and goddesses. It is easy, therefore, to imagine Christ pointing to Mount Hermon when he calls Peter a "rock" (16:18). The following half of the verse takes in even more of the setting. Christ says, "I will build my church, and the gates of Hades will not prevail against it" (16:18). Water, arising from the cave, was seen as coming forth from the underworld. To the ancient mind, the people, by sitting at the cave entrance, were staring at the gates of Hades, or the underworld, all under the control of Pan. Christ's message, then, is heard as well as seen. The powers of Hades (*Sheol* in Hebrew), a reference to the realm of death and demons, along with secular powers represented by King Herod Philip, will not prevail against the church that Christ is founding on the apostles.

This interpretation heightens the sting of the rebuke in 16:23. Peter is not only chastised for not recognizing the necessity of Christ's upcoming suffering, but he is also compared to Satan at the very doorway to Satan's house. By this time in Jewish theology, Satan—that is, "adversary" in Hebrew—had

taken on the meaning of "deceiver" and thus was identified with the pagan gods, which were always viewed as deceptive entities.

Image

The image shows a contrast between the rock of the church and the gates of Hades. The latter is depicted on the left, where monstrously demonic figures, modeled on the griffins and grotesques from Mesopotamia, crawl and lurch out toward the viewer. The red-yellow worm-like blotch is the artist's rendering of HIV-infected cells. The bright colors on the right show a rock with an emerging figure, as in Michelangelo's unfinished work, the "Four Prisoners." On the left is *Sheol*, written in Hebrew.

Scriptural Cross-references

Exodus 17:1-7; Psalms 18, 19, 27, 28, 31, 40, 42, 61, 62, 71, 78, 81, 89, 92, 94, 95, 105, 114, 144; Isaiah 17:10; 1 Corinthians 10:4; Ephesians 2:20-21

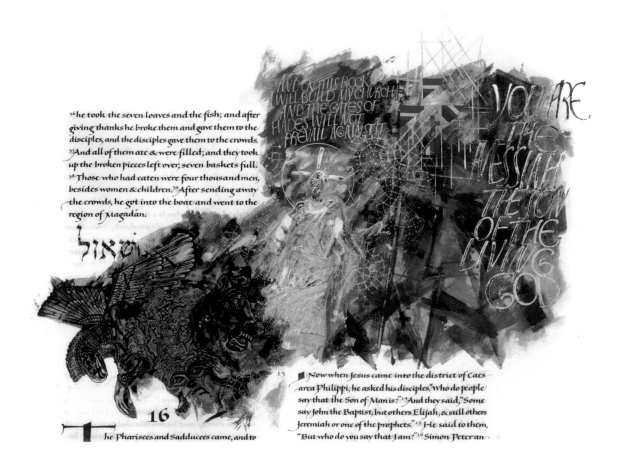

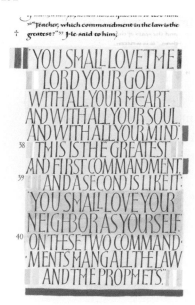

Great Commandment
Matthew 22:37-40; special treatment; Hazel Dolby, artist

Based on Deuteronomy 6:5 and 10:19, the Great Commandment encapsulates so much of Jesus' life and mission. Matthew, in particular among the other evangelists, shows how Christ's teaching arises from the context of Judaism, and his Jewish audience would have responded accordingly. From the Christian perspective, Christ is the supreme example of someone who loves both God and neighbor.

Last Judgment
Matthew 25:31-46, Suzanne Moore, artist

Background

Matthew, Mark, and Luke are called the "Synoptic Gospels" because so much of their narrative structure and material is similar, even with their differences. John's gospel, on the other hand, exhibits a different focus and presentation, despite sharing some elements with the other three. For example, the Synoptics all feature Jesus giving an apocalyptic discourse to his disciples,[2] but only Matthew includes the Last Judgment, while John has no apocalyptic material anywhere.

Matthew shows the relationship between the Christian virtue of charity and the end of time. What we do on this earth matters, and the Matthean gospel vividly develops this point with the judgment of the sheep and goats. The decisive factor in whether or not we stand with the saved or the condemned flock is how we respond to the hungry and thirsty in this life, two conditions mentioned and emphasized in the Beatitudes: "Blessed are those who hunger and thirst for righteousness, for they will be filled" (Matt 5:6). Moreover, this beatitude includes and also transcends physical hunger and thirst; the hungry and thirsty long for righteousness; there is a moral imperative as well. Matthew implies that people are physically hungry and thirsty because of a lack of righteousness; God's people are not meant to go unfed.

2. See Matt 24–25; Mark 13; Luke 21.

At the last judgment, Matthew shifts the focus. If those seeking righteousness do so as if they are trying to abate their thirst and hunger, they make themselves into true disciples, for by fighting injustice, they are feeding the hungry, refreshing the thirsty, and clothing the naked. By placing the Last Judgment within the discourse on the end of the world and connecting both to the Beatitudes in chapter 5, Matthew reverses the norms of earthly life in that the haves become the have-nots and vice versa. Matthew stresses the real importance of acts of charity *in this life*.

Using sheep and goats as the central metaphor for the Last Judgment furnishes us with another lesson. Upon hearing this story, the people would have known what every shepherd of that day knew: when flocking together, sheep and goats separate themselves on their own. Sheep stay with sheep, and goats stick with goats. Shepherds in the field never have to divide the two groups. Why does Christ do so in this parable?

We humans have a terrible inclination toward self-righteousness that manifests itself in judging others and ourselves. In fact, so serious is the sin of self-

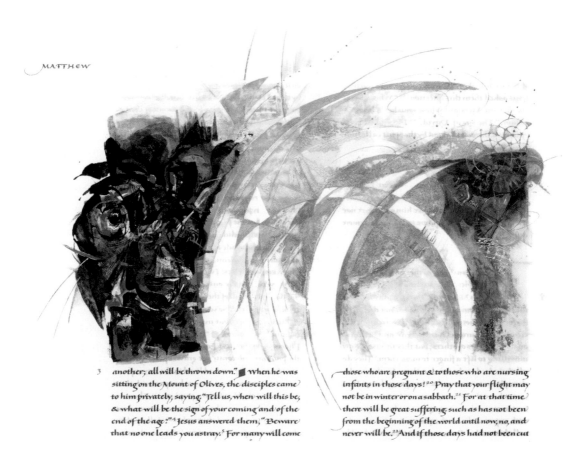

MATTHEW

3 another; all will be thrown down." When he was sitting on the Mount of Olives, the disciples came to him privately, saying, "Tell us, when will this be, & what will be the sign of your coming and of the end of the age?" Jesus answered them, "Beware that no one leads you astray. For many will come those who are pregnant & to those who are nursing infants in those days! Pray that your flight may not be in winter or on a sabbath. For at that time there will be great suffering, such as has not been from the beginning of the world until now, no, and never will be. And if those days had not been cut

righteousness, it can even blind us in recognizing Christ as our redeemer and savior. The parable used here for the Last Judgment emphatically states that Christ alone adjudicates the human heart, no one else. The one who seems like a goat to us may actually be a sheep. And we who assume we are sheep? It is in our best interest to follow the Beatitudes and leave the rest in Christ's hands.

Image

The image of the Last Judgment underscores these points. The left panel is reminiscent of Hades in Peter's confession (Matt 16); the colors are anything but inviting, and many have noticed a demonic face within the fires of hell. The larger panel stretches from the middle of the illumination to the right side. The bright tones used on the sweeping arches lead one into the realm of God. Presenting the illumination so that the heavenly kingdom occupies the greater space follows the long tradition of iconography and art in both East and West in which scenes of the Last Judgment always feature a countless number of the saved in comparison to a miniscule number of the damned. God's mercy always triumphs over God's justice.

Scriptural Cross-references

Mark 13; Luke 21; 1 Corinthians 15:51-52; 1 Thessalonians 4:15-18

Matthew 28:20

A quarter-page carpet image fills the space after the final chapter of Matthew's gospel and the beginning of Mark's gospel.

GOSPEL OF MARK

Considered by most scholars to be the first gospel written, Mark is also the shortest. Tradition tells us that it was composed in Rome sometime around AD 70 by one called Mark, who worked with Peter, although there is some evidence that all or part of it may have originated in Alexandria. Mark's writing style is concise, direct, and sometimes even harsh. We lose an opportunity for salvation in this life as well as the next if we hesitate to answer Jesus' call to his kingdom, which Mark presents with a sense of urgency.

Frontispiece: Baptism of Jesus
Mark 1:1-12, Donald Jackson, artist

Background

The opening verse of the Gospel of Mark can be interpreted in two ways. The first is to see the word "Beginning" as referring to the gospel itself. The second is to envision something closer to John's prologue (i.e., a new beginning of creation made possible by the gospel's message). Scholars are divided on this issue, but if we take the second interpretation, Mark presents Jesus as the "New Adam,"[3] thus beginning a new creation.

John's baptism of Jesus was a delicate issue for the early church. How could the lesser baptize the greater? The other three gospels handle this issue through circumlocution. Mark is the most direct in presenting the scene, and even he uses the passive voice (v. 9). Mark 1:2-3 is a mix of quotations from Malachi 3:1, Isaiah 40:3, and Exodus 23:20. This evangelist, as with other writers in the New Testament and early Christianity, shows the context of Christ's coming within the covenantal promises made throughout the Old Testament. The phrase, "Prepare the way of the Lord," has special resonance for the people since Isaiah uses it in speaking of the deliverance from the Babylonian exile in 526 BC. These are words of liberation and new life.

The action "torn apart" (1:10) refers to the heavens, and it underscores the cosmic nature of this event. Jesus, the Son of God, has become flesh. By taking on corporality, he unites all created matter with himself, and the divide between God and creation is mended. The voice from heaven, "You are my Son, the Beloved; with you I am well pleased" (1:11), spoken in direct address, is heard by Jesus alone, though the context suggests that those with Jesus would have witnessed the rending of the clouds and the descent of the dove.

The baptism ends with, "And the Spirit immediately drove him out into the wilderness" (1:12). The Greek verb employed here, *ekballo*, means "to push," "to impel," and even "to kick out." Jesus is baptized, but this is not the time to celebrate or relax.

The immediacy inherent in Mark's gospel surfaces here at the baptism, and it prepares the reader well for what to expect in the remainder of the book. Jesus has a mission, and nothing will dissuade him from it. His life on earth may be beautiful, but it is not pretty or nice. Christians, as his disciples, can expect the same.

3. "New Adam" is a term used by Saint Paul to describe the resurrected life of Christ, which is open to all humankind. Saint Paul contrasts it with the "Old Adam," which is a life of sin that would be the human state without Christ. See 1 Cor 15:20-26, 45-50.

Image

The illumination places John the Baptist in the foreground, walking away from the scene. His work is finished; the one "who is more powerful" than he is about to begin a ministry that replaces the Baptist and his work (Mark 1:7). The Jordan River induces the valley to flourish with all sorts of vegetation, and the resplendent colors in the image call attention to the blooming desert. In the center of the panel the clouds are torn, signaling the Spirit and the voice from heaven. Immediately below stands Jesus, bathed in gold, with angels swirling above. Surrounding him on the riverbank are John's disciples, who now become disciples of Christ. Left of center, ominous red dots catch the viewer's attention, and, upon closer examination, we can see that they belong to dark, shadowy beings entangled by large tarantulas. These demons foreshadow what comes next, now that the Spirit has driven Jesus into the wilderness: forty days of temptation by Satan (Mark 1:13).

Scriptural Cross-references

Exodus 23:20; Isaiah 40:3; Malachi 3:1; Matthew 3:1-17; Mark 9:1-7; 15:38; Luke 3:1-22; John 1:19-34

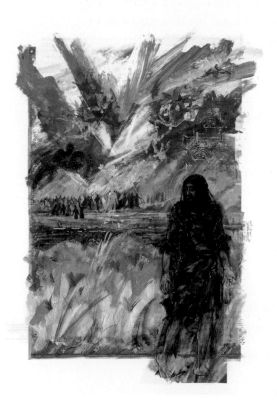

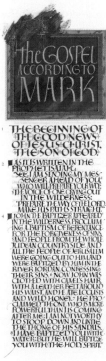

Sower and the Seed
Mark 4:1-9, Donald Jackson with Aidan Hart, artists

Background

Mark's parable of the "Sower and the Seed" is a commentary on Jesus' ministry to this point. Teaching, exorcizing, curing, proclaiming, and dining (Mark 1:21–3:31), Jesus leaves varied and checkered responses. Christ has had his experiences of good and bad soil, rocky and thorny fields. Now he reflects upon his ministry thus far and tells this parable. An important factor to keep in mind is that nowhere does Jesus say that sowing the seed is a one-time deal. The sower goes out every year, and if no seeds take root one year, they do the next. Good farmers, as the people around Jesus would have known, spend a fair deal of time improving the fields between the last day of harvest to the first day of sowing; bad and mediocre soil can improve with time and patience. From a monastic perspective, the dedication of the sower to go repeatedly over the same land is analogous to monks and nuns who dedicate themselves to their *lectio divina*, or sacred reading, by continually letting Christ sow the seed in their hearts.

Although the metaphor employed in the parable is self-descriptive, Jesus' disciples ask him for an explanation, which he freely gives, and it is a paradoxical one (Mark 4:10-20). The sower is both God the Father and Christ simultaneously; furthermore, the word is Christ and his ministry. These verses give us insight into some of the earliest reflections on the relationship between the Father and the Son; they are christological questions.[4]

Image

In this depiction, the four different kinds of soil are represented in the foreground: the path, the rocky ground, the thorns, and the good soil. Viewers will readily identify the features of this piece that place it within the tradition of icon writing, particularly strong among the Eastern churches. They will also notice an important divergence from that tradition: Christ's garb is contemporary, and the seed falls outside the margins of the illumination; in traditional iconography of the Eastern church, garb reflects Byzantine dress, and the borders of the icon are strictly defined.

The quotation, "Let anyone with ears to hear listen!" (Mark 4:9), seems cryptic. We see this phrase throughout various books in the New Testament, and it is based on a quotation from the prophet Isaiah, "He sees many things, but does not observe them; his ears are open, but he does not hear" (Isa 42:20). The saying places a certain responsibility on those listening to the Word. One

4. The christological and trinitarian formulae involved in explaining Christian faith were settled over the course of four hundred years by four ecumenical councils.

has to desire to hear in order to hear what is being said. Writing the verse upon the icon, counterpoised with "The sower sows the word," is an open invitation to the reader.

Fortunately for *The Saint John's Bible*, one of the birds takes the time to leave the seed and fetch parts of verses 20-21 that inadvertently dropped from the text.

Scriptural Cross-references
Isaiah 5:1-7; 42:19-20; Matthew 13:1-9; Luke 8:4-8

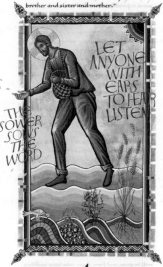

Two Cures
Mark 5:21-43, Aidan Hart, artist

Background

The scene features two cures. The narrative begins with the synagogue leader, Jairus, begging Jesus to help his very sick daughter; switches to the hemorrhaging woman, who is cured by surreptitiously touching Jesus' cloak; and then returns to the story of Jairus. This type of literary construction is called an "intercalation" or "sandwich" technique, whereby the middle story informs and helps to interpret the two halves framing the original account and vice versa. In both cases, all resolution turns on the matter of faith; Jesus is teacher and healer.

Jairus has faith in Jesus to even ask for his help. The woman, even without asking, expresses her faith by grabbing Jesus' cloak. In the ancient world, the cloak was a sign of one's personhood and status.[5] Her state of "fear and trembling" (5:33) when Jesus seeks the one who touches him indicates her humility and awe; she knows that Jesus comes from God. Jesus' reply, "Your faith has made you well," reassures her of his divine compassion (5:34), while it confirms for Jairus and the rest of the crowd the proper response to his ministry. When the time comes, he does not say anything similar to Jairus or his daughter; the explanation to the woman suffices for both.

The movement continues to Jairus's house. The crowds here, unlike the one surrounding the hemorrhaging woman, ridicule Jesus when he speaks words of consolation and reassurance, "Why do you

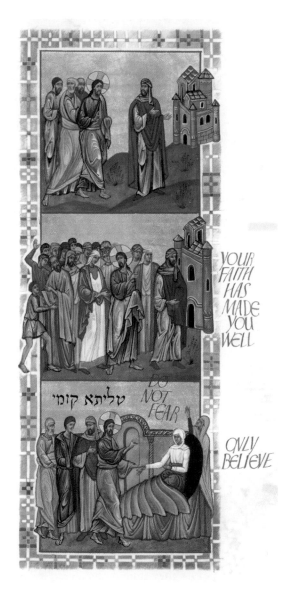

5. A cloak was worn over the tunic, and, for those of means, the signet ring was tightly sewn to the corner so that it could be used to seal letters and legal documents. By touching the cloak, the woman reaches directly for the symbol of Jesus' identity and authority.

make a commotion and weep? The child is not dead but sleeping" (5:39). Because they have no faith, he escorts them out of the house and takes only the faithful Jairus and his wife along with Peter, James, and John. They too, like the woman before them, are overcome with amazement. Jesus commands them first, not to tell anyone and second, to give the daughter something to eat.

The first command reflects the messianic secret, a feature found throughout Mark's gospel in which Jesus charges people not to speak of his miracles, even though it is impossible to keep the news quiet. In Mark, the messianic secret functions as a way to portray Jesus' divinity over and against those seeking a mere wonder-worker. The second command guards against those who would see the girl as a ghost and not a living being; ghosts do not eat. Thus, this story is also a precursor to Jesus' own resurrection in Mark 16.

In all four gospels, women touch Jesus a great deal. This desire to touch the holy is one of the bases of Christian sacramental theology. God's grace does not exist in the abstract. It is tangible and life-giving. Those who seek out the Eucharist or any sacrament, for example, are like the hemorrhaging woman reaching out to touch Jesus' cloak.

Image

This icon is done as a triptych, reading from top to bottom: Jairus comes to Jesus, Jesus speaks to the hemorrhaging woman as Jairus continues to walk ahead, and Jesus raises the little girl. The operative phrases, "your faith has made you well" (5:34) and "only believe" (5:36), stand outside the right of the margin. The script in the upper left of the lower panel is *talitha cum*, written in Aramaic.

Scriptural Cross-references

2 Kings 4:32-37; Matthew 8:5-13; Mark 16; Luke 7:1-10, 11-17

Multiplication of Loaves and Fishes
Mark 6:33-44; 8:1-10, Donald Jackson, artist

Background

Most probably, what we see here are two versions of the same story—in exegetical terms, a *doublet*. The feeding of the five thousand (6:35-44) takes place, by tradition, in the Jewish territory on the west side of the Sea of Galilee, specifically in Tabgha. There are eucharistic dimensions to this story that point to the messianic banquet. Even having the people sit in groups on the grass (6:39-40) shows a sense of order, hospitality, and decorum. This is not a mob; they dine and share. The gathering of the twelve baskets (6:43) provides an

eschatological dimension to the whole miracle; the number twelve represents both the apostles and the twelve tribes of Israel.

The feeding of four thousand (8:1-10) occurs on the east side of the Sea of Galilee, which tradition associates as the area touching upon the Decapolis and its pagan population. In this case, the gospel story is extending a hand to the Gentiles by portraying Jesus as ministering to them. The basketfuls gathered at the end also have an eschatological focus; seven is a perfect number symbolizing the complete ingathering of all nations as part of the church's mission. Once Jesus finishes there, he sails back to the west shore of Galilee to a place called "Dalmanutha" (8:10). No one knows where Dalmanutha was actually located, but tradition has situated it at Tabgha, the same place where it has set the feeding of the five thousand. This confusion of place names and locales is one of the reasons exegetes consider these passages a duplicated story.

Image

The architecture of the page emphasizes the two feeding accounts as a doublet: the left and right pages are mirror images of each other. Tabgha is

the sight of a Benedictine monastery today, and many consider it the most peaceful and beautiful of all the religious sites in the Holy Land. Its modern church is built on the foundations of an earlier Byzantine structure, with many of the original mosaics still intact, one of which is the piece depicting a bread basket flanked by two fish. This mosaic is set within the rock, which ancient tradition maintains as the place where Christ performed this miracle. The fish from the mosaic are represented within the upper left and right corners of this image—a motif replicated throughout different books in *The Saint John's Bible*. Anasazi basket patterns swirl throughout the depiction, and the gold flakes appear as breadcrumbs. The feeding stories inspiring this page foreshadow the eucharistic banquet.

Prayer books from the Middle Ages, called *Books of Hours*, often have elegant marginalia, as does this page.

Scriptural Cross-references
2 Kings 4:42-44; Matthew 14:15-21; Mark 14:16-26; Luke 9:12-17; John 6:1-13

The Transfiguration
Mark 9:2-8, Aidan Hart and Donald Jackson, artists

Background
The transfiguration appears in all three Synoptic Gospels. Elijah, considered in Jewish tradition to be the prophet of the Messianic Age, and Moses, representing the Jewish Torah or Law, are both strong presences in the story. The transfiguration in Mark, as well as in the other two Synoptics, functions as a manifestation of Jesus' divine nature following Peter's declaration of Jesus' messiahship (8:29). That the transfiguration occurs after Jesus predicts his passion (8:31) and after Jesus' rebuke of Peter for interpreting Jesus' mission from a human angle (8:32-33) undergirds the scene as a foreshadowing of the passion, death, and, especially, glorification of Christ at the resurrection.

The voice here (9:7) echoes the voice in the baptism scene (1:11). There is a thematic parallel between the two with "You are my Son, the Beloved; with you I am well pleased" (1:11) and "This is my Son, the Beloved; listen to him" (9:7). Judging by the context in each passage as well as the development of Mark's narrative line, it appears that in the former, only Christ hears the voice; in the latter, Peter, James, and John hear it as well, for it is addressed in the second-person imperative. Historically, iconic images depict Christ with bright rays of light standing between two prophets. Elijah stands on the left, noticeable with his ragged prophet's clothing, and Moses is situated on the right, with the book of law in his left hand.

Image

The traditional iconography for the transfiguration is one of the strongest within the Christian tradition, and so it forms the basic structure here. The event is a theophany, but only of Father and Son. Any reference to the Spirit relies on the verb "overshadowed" (9:7), marked by the clouded, indistinct form of Christ's physical presence; in fact, "overshadows" is used to describe the Holy Spirit in the Syriac tradition. Unlike a traditional icon, where the apostles

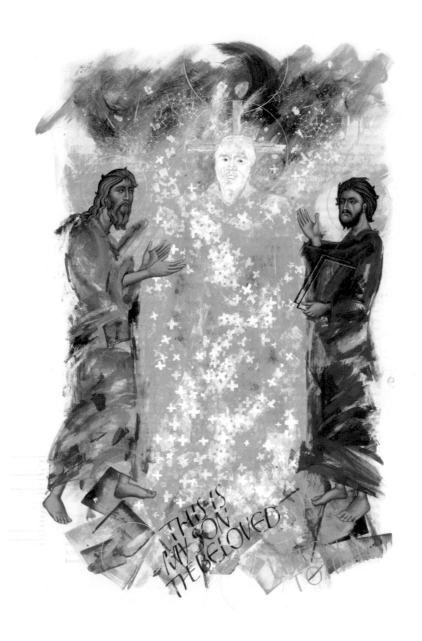

are situated at the bottom of the border, they are not visible here. Rather, we stand with them and witness the event.

The transfiguration is a central metaphor of the monastic life in both East and West; Saint Benedict refers to it in his *Rule*: "Let us open our eyes to the light that comes from God" (Prol. 9). As the divine light, the transfiguration is important to Christian deification. Indeed, the purpose of the Christian life is to be glorified in Christ, and thus, it is part of the broad human story. It has an eschatological focus—that is, an eye peeled on the end times. In our charity and concern for others, we are working now for what is yet to come. The veil is removed from the eyes of Peter, James, and John, and they see Christ's divinity fusing with the future glory of the universe in one moment. What they experience is our hope and purpose in life.

Scriptural Cross-references

Exodus 24:15-18; Matthew 17:1-8; Luke 1:35; 9:28-36; Acts 5:15

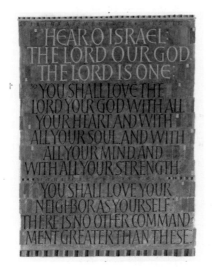

Hear, O Israel
Mark 12:29-31; special treatment; Hazel Dolby, artist

A second, New Testament version of the greatest commandment within Judaism, this one begins with the Shema, "Hear, O Israel," the creedal statement affirming the unique character of the Lord God. In Mark, it becomes an echo of Deuteronomy 6:4.

A carpet page, complemented by monarch butterflies in the marginalia, forms a graceful conclusion to Mark's gospel and prepares the reader for the Gospel of Luke.

GOSPEL OF LUKE

Along with Matthew and Mark, Luke is a Synoptic Gospel writer. Well known for his fine narrative style, Luke evidences a high level of theological development; his work is a favorite of many. Scholars place the composition of this gospel and his second volume, the Acts of the Apostles, at around AD 85 near present-day Beirut, Lebanon. Luke's use of Roman politics and civilization gives a strong incarnational focus to Christ's redemption.

Frontispiece: Birth of Jesus
Luke 2:1-14, Donald Jackson, artist

Background

The Gospel of Luke includes both a prologue and an introduction. The prologue runs from 1:1-4 and is addressed to someone named Theophilus, who was most likely a benefactor or a church official of some sort.[6] The introduction reads for the next two chapters, beginning at 1:5 and ending at 2:52. While this section functions as a prelude to Jesus' earthly ministry, it is best known as the "infancy narratives."[7]

In the composition of Luke's gospel, the infancy accounts are most important for understanding Luke's theological vision. Luke the evangelist is a masterful writer, and these first two chapters reflect his ability to relate deep theological positions in an engaging and artistic form. Since the birth of Jesus is the centerpiece of the Lukan infancy narratives, it comprises the text for the depiction used as the Lukan frontispiece.

On the theological level, these first two chapters of Luke's gospel contain a parallel relationship between John the Baptist and Jesus: the annunciation to John's father, Zechariah, is paired with the annunciation to Jesus' mother, Mary; Jesus' mother, Mary, visits John's mother, Elizabeth; Mary sings her *Magnificat*, and Zechariah sings his *Benedictus*. Within this textual unit, angels constantly announce messages, which have the quality of a theophany or appearance of God for the recipients. In fact, Luke features more angels than any of the other evangelists. Mary, Elizabeth, Zechariah, the shepherds, and even Simeon the temple priest and Anna the temple prophetess are players in the unfolding of the divine plan.[8] After these appearances and theophanies, there are usually marvelous songs of praise and thanksgiving.

By employing historical references to emperors, governors, and the like, Luke grounds the incarnation of Jesus in human history. The nativity scene is usually presented as a stable. A more likely structure, however, would be the Palestinian house, a building large enough for extended families. At least that is what the Greek word *kataluma*, translated as "inn," implies. If Joseph were returning to his hometown of Bethlehem, he and Mary were most likely staying with relatives. People would have lived upstairs and the animals would have occupied the lower floor. Mary and Joseph could have gone to this area

6. Because the name *Theophilus* means "friend of God," many scholars also believe that the name refers to anyone reading or listening to the gospel.

7. Matthew also has infancy narratives: 1:18–2:23.

8. No angel appears to Simeon or Anna, but they both are enlightened by the child Jesus to recognize him as the long-promised Messiah.

(families were very large and extended) below the loft in order to get some privacy. Thus, Mary "laid him in a manger, because there was no place for them in the 'loft' (*kataluma*)." Mary and Joseph simply went downstairs.

Image

The image for the birth of Christ emphasizes the theological content. All attention focuses on the center where the bright light bathes the manger. Joseph and Mary stand on the right, and shepherds, townspeople, and relatives are on the left. Another mother is there with a child in her arms. The donkey, sheep, and ox partially block our view as every living creature gazes at the makeshift crib. Tying this birth to its heavenly source is the beam of light; God and humankind are united in the incarnation. The beam goes in two directions, however. It forms an abstract figure reaching up to heaven as the same light descends upon earth; it is an expression of human longing meeting the divine initiative. On the horizontal plane, angels dart to and fro, and their movement, also in abstract fashion, forms a cross with the light beam. The interplay of the two

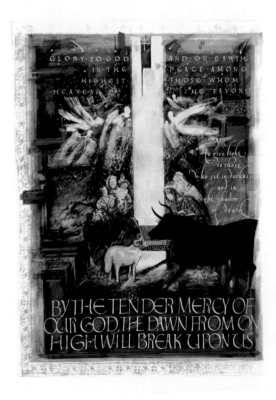

suggests the long understanding in the Christian tradition that the wood of the crib becomes the wood of the cross. That this cross is a brilliant gold completes the story of human redemption, for the suffering on the cross ends with the glory of the resurrection. The texts imbedded within the image are lines from the various canticles of the infancy narratives: the angelic choir at the top (2:14) and Zechariah's canticle on the right and bottom (1:78-79). The ox itself is actually a prehistoric aurochs depicted in the Lascaux cave paintings. It witnesses to the fact that Christ is the redeemer of all humankind, even those who lived and died before his birth.

Close investigation shows that there is no child in the crib—a puzzling detail. For two thousand years, Christians have portrayed the infant in countless ways, and even today families have their own version of the child whom they set in the crib at Christmas. This seemingly empty space allows us, the viewers, into the image and text. We ourselves place the newborn babe in the manger, whose appearance matches those who have been sources of God's grace in our lives. After all, Christ is the incarnation of God's glorious and unbounded grace in our human history.

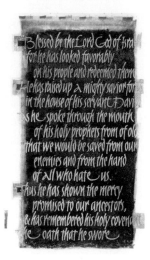

Canticles in Luke
Luke 1:46-55; 1:68-79; 2:14; 2:29-32; special treatments; Donald Jackson, artist

While the entire first page is filled with the illumination of the birth of Christ, the depiction continues to reverberate through the whole Lukan infancy narrative by the use of the special treatments, whose palettes match the colors in the Birth of Jesus illumination. The special treatments are from the four canticles

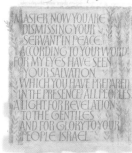

that people and angels sing in response to God's initiative in human history. In the church's prayer life today, these canticles are included in various liturgies: Zechariah's canticle, or *Benedictus*, at Morning Prayer; Mary's canticle, or *Magnificat*, at Evening Prayer; angelic choir at Sunday and other solemn eucharistic feasts; and Simeon's canticle, or *Nunc dimittis*, at Compline.

Scriptural Cross-references

Judges 13:2-5; 1 Samuel 2:1-10; Isaiah 1:3; Matthew 1:18-25; Luke 23:44-49

Excursus. The references to Emperor Augustus, Governor Quirinius, and the worldwide registration in Luke the evangelist's infancy narratives ground Christ's birth in human history. Emphasizing Christ and the redemption as a historical occurrence has been a major piece of Christian theology since the beginnings of Christianity. For Christmas Day, the *Roman Martyrology*, an ancient work that records the major feasts of the year, provides a passage similar to Luke's introduction by listing all the major dates in the Greco-Roman and biblical worlds. During Christmas Morning Prayer at Saint John's Abbey, a cantor sings the proper entry from the *Martyrology*. This work is one of the sources the CIT used in its discussion of the nativity illumination for *The Saint John's Bible*. The text is included here.

> *The Twenty-Fifth Day of December*
>
> In the 5199th year of the creation of the world, from the time when God in the beginning created the heaven and earth; the 2957th year after the flood; the 2015th year from the birth of Abraham; the 1510th year from Moses, and the going forth of the people of Israel from Egypt; the 1032nd year from the anointing of David King; in the 65th week according to the prophecy of Daniel; in the 194th Olympiad; the 752nd year from the foundation of the City of Rome; the 42nd year of the rule of Octavian Augustus, all the earth being at peace, Jesus Christ, the Eternal God, and the Son of the Eternal Father, desirous to sanctify the world by his most merciful coming, being conceived by the Holy Spirit, nine months after his conception was born in Bethlehem of Judah, made Man of the Virgin Mary. The Nativity of our Lord Jesus Christ according to the Flesh.[9]

9. Adapted from *The Roman Martyology*, ed. Canon J. B. O'Connell (Westminster, MD: The Newman Press, 1962), 279.

Dinner at the Pharisee's House
Luke 7:36-50, Donald Jackson, artist

Background

In our imaginations, we may always view the Pharisees in a bad light. Luke's gospel is ambivalent in its portrayal of this group, however.[10] Sometimes, they ask and answer questions with no motive other than the desire to learn, and at other times they try to trip Jesus up. As the story begins it appears that Simon is a good friend of Jesus and invites Jesus to his home.

Formal dining rooms at this time and place featured a horseshoe-shaped table called a *triclinium* set along the perimeter of the space, open at the center. Guests took their places along the outside edge of this table. Bolstered by large cushions, they would face the center, reclining on their left sides and

10. The other three gospels, however, especially John, are more categorical in their negative treatment of the Pharisees.

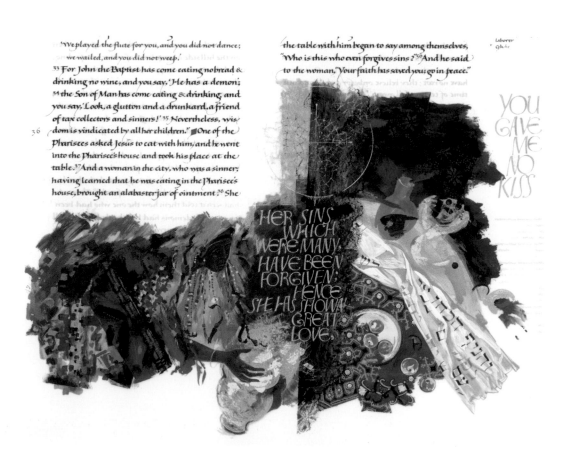

eating with their right hands; their feet would be along the outside wall. Servants would use the open center to set the various dishes before the guests.

This sinful woman would have encountered this arrangement when she crept into the dining room. To get to Jesus, she first would have had to sneak into the house, hide from any watchful eye, and crawl over the feet of all the guests until she reached the head of the table where Jesus, as the honored guest, would have been seated. Then she would have begun weeping over his feet, drying them with her hair, and anointing them with the oil. Even allowing for the cultural differences of time and place, her behavior is very, very odd. Jesus does not seem to be bothered and, perhaps wanting to avoid bringing attention to himself or embarrassing the woman, says nothing. Simon, as the host, however, is well within his rights to question the presence of this strange woman and her bizarre behavior.

The incriminating point is that Simon does not question the woman directly; rather, he mutters to himself about Jesus' lack of concern for her sinfulness and uses that lack of concern to condemn Jesus. What starts as a friendly meal has now turned into the host insulting the guest. Is that the reason Simon invites Jesus to his home in the first place, to test him? Jesus figuratively turns the table on Simon with a parable and by his acceptance of the woman, Jesus becomes the host.

The woman with the very expensive alabaster jar is a sinner (7:37). There is nothing to suggest that the sinful woman is guilty of sexual sin, not any more or less than anyone else. In Luke we are all sinners in need of redemption. The point of the story is her generosity, spontaneity, and love. The climax is in verse 47: "Her sins, which were many, have been forgiven; hence she has shown great love. But the one to whom little is forgiven, loves little." We can compare this to the parable in 7:31-35 where Luke uses a children's jingle to contrast the respective dietary habits of Jesus and John the Baptist. In both cases, the associations with table fellowship involve questions of moral behavior. Because banquet scenes in the gospels nearly always have eucharistic overtones, Jesus' response to Simon testifies to the Eucharist as the sacrament for those seeking forgiveness and reconciliation.

This sinful woman is like nearly all sinners in the gospel in that she comes to Jesus. The story is about humanity saved by a redemption that upsets all earthly order and rectitude. Jesus, extravagant in his love, welcomes sinners. Sinners so welcomed can be extravagant in their love as well, for nothing will ever be the same again once one is at the Lord's table.

Image

The illumination, set in the lower register, harmonizes with the text; it is literally at the foot of the page. The verse, "her sins, which were many, have been forgiven; hence she has shown great love" (7:47), separates the left panel from the right panel. On the left is the woman. Her garish clothing matches her unconventional behavior and personality. The alabaster jar is still in her hands. On the right, everything on the table is overthrown. The phrase, "You gave me no kiss," contrasts Simon's cold rectitude with the woman's abundant love (7:45). The Hebrew embroidered on the edge of the tablecloth is from Leviticus and is a reference to priestly cultic worship in the Jerusalem temple,[11] which was destroyed by the Romans in AD 70.

Scriptural Cross-references

Luke 24:1; Mark 16:1; John 7:53–8:11; 12:3

The Great Commandment
Luke 10:27; special treatment; Hazel Dolby, artist

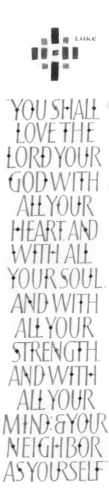

The great commandment occurs in all the Synoptic Gospels, underscoring both the Jewish context of Christianity as well as the importance of this text throughout the history of Judaism. However, in Luke, as in Matthew, it does not open with the *Shema*.

Luke Anthology
Luke 10; 15; 16; Donald Jackson, artist

Background

With the exception of the Parable of the Lost Sheep (15:1-7), this material, consisting of five parables and one story, is unique to Luke. A triptych, referred to as the "Parables of the Lost": *Lost Sheep*, 15:1-7; *Lost Coin*, 15:8-10; *Prodigal Son*, 15:11-32 addresses Christ's relationship with the forlorn sinner. Added to the triptych to become part of the illumination are two other parables found only in Luke: the *Good Samaritan* (10:29-37) and the *Rich Man and Lazarus* (16:19-31). The story of Martha and

11. The priest shall raise them with the bread of the firstfruits as an elevation offering before the Lord, together with the two lambs; they shall be holy to the Lord for the priest (Lev 23:20).

Mary (10:38-42) is included here as well. Though a story and not a parable, it too is unique to Luke.

The point of the *Parable of the Lost Sheep* (15:1-7) is that God loves the sinner to such a ridiculous extent that it defies human reasoning and comprehension. Similarly, in the *Parable of the Lost Coin* (15:8-10) we see the lost and forsaken as precious as silver coins in the eyes of God, while God is like a joyfully ebullient woman in successfully rescuing them. One of the most disturbing of all the parables, the *Parable of the Prodigal Son* (15:11-32) directs us to imitate the lavish love of the father for both sons; one is not loved at the expense of the other. The *Parable of the Good Samaritan* (10:29-37) does *not* say, "the Samaritan is your neighbor." Rather, the parable places the Samaritan on the moral high ground by showing that he has acted as a neighbor to the Jew, and all this takes place in what is, for the Samaritan, hostile Jewish territory.

Who or what fixed the chasm in the story of the *Rich Man and Lazarus* to make it impassable (Luke 16:19-31)? Everything indicates that by ignoring

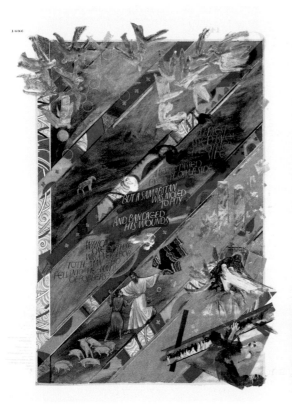
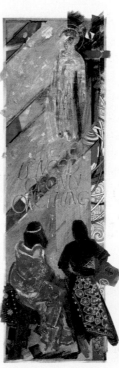

the plight of the poor Lazarus, the rich man started walking down the wrong path to the point of no return. Thus, the rich man's moral blindness, which continues in the afterlife, is responsible for his plight.

The story of Martha and Mary (10:38-42) follows immediately from the Good Samaritan parable. Jesus' response to Martha shows that all of our works must be centered on Christ and completed by his grace.

Image

The double-page spread produces an interplay of images, augmented by lines slanting toward Christ in the upper right. The *Good Samaritan* is set between the Parables of the Lost with the *Lost Coin* and the *Lost Sheep* on the left and the *Prodigal Son* on the right. The *Rich Man and Lazarus* (with Abraham written in Hebrew above Lazarus) close the illumination of parables, visually locking the *Good Samaritan* in the middle of the panel as if to say that we are all lost if we forget to be good neighbors to each other. We must remember that in the *Good Samaritan* the good neighbor is the Samaritan, an outcast who goes well beyond the conventions of society; we are to look to him as a model of behavior.

In this illumination, the viewer is led to consider that self-sacrificing neighborliness applies to the *Lost Coin*, the *Lost Sheep*, the *Prodigal Son*, and the *Rich Man and Lazarus*. The World Trade Center towers, outlined in gold, are set within the panel of the *Prodigal Son*. Donald Jackson was working on this piece on September 11, 2001; the events of that day must figure into any interpretation of the illumination as well.

The panel with Martha and Mary maintains the focus on Christ. We stand with them at eye-level, looking directly at the golden Christ, with the words "there is only one thing" floating in the middle of the depiction. These two women tell us that no matter what a person's occupation, Christ must be at the center of it all. It is encouraging to see that of all of the images of persons in this anthology, Christ is the most expansive.

These parables in Luke have been the source of exegetical and artistic interpretation from the earliest days of Christianity, and the CIT referred to some of the great works in their discussion. Tertullian, Clement of Alexandria, Ambrose, Jerome, and Augustine have commented on the Prodigal Son. Such artists as Dürer, Beham, Rembrandt, Bassano, and van Honthorst have depicted it, and Tudor dramatists have staged it. Balanchine choreographed a ballet by the name, and Animuccia, Prokofiev, and Britten have set the story to music.

The Latin term for "rich man" is *Dives*, and it appears thus in the Vulgate, thereby functioning as a proper name within discussions of the parable.

C. S. Lewis describes scenes similar to the outcome of the Rich Man and Lazarus in his novella *The Great Divorce*. The modern composer Ralph Vaughan Williams has an orchestral piece for strings titled *Dives and Lazarus*, which is based on the tune "Kingsfold."

I suggest that readers seek out these theological, musical, theatrical, and artistic pieces and others like them in their exegetical process; doing so is part of the *lectio divina* tradition as well.

Scriptural Cross-references

2 Samuel 12:1-6; Isaiah; Jeremiah; Amos; Matthew 23:11-12; 25:31-46; Luke 14:16-24; 18:10-14; John 10:11-18; James 2:14-26

The Last Supper
Luke 22:14-20, Donald Jackson, artist

Background

All four gospels relate the Last Supper, and all four have strong eucharistic themes throughout their accounts. Only the Synoptic writers, however, present Jesus breaking bread and sharing wine.[12] At least to the degree that scholars are able to determine, Luke shows the greatest reliance on the Jewish Passover ritual as it was performed at the time of Christ, and *The Saint John's Bible* shows some of that reliance in this illumination.

Image

Done as a triptych, the Last Supper is one of the earliest illuminations Donald Jackson did for *The Saint John's Bible*. The left panel shows the pitcher of wine and a cup. In the middle section, at the top, a slain Passover lamb bleeds into a second cup that overflows toward the viewer. On the right we see a ciborium (vessel for holding the

12. John's gospel is not as explicit. Rather, the evangelist presents the institution of the Eucharist very poetically in chapter 6.

bread). Noticeable is the fact that this scene concentrates on the blood. Other images within this volume address the bread of the Eucharist.

Scriptural Cross-references

Exodus 29:12-21; Jeremiah 31:31; Matthew 26:26-29; Mark 14:22-25; Luke 24:13-35; John 6:4-14; 1 Corinthians 10:16-17; 11:23-26

The Crucifixion
Luke 23:44-49; Donald Jackson, artist

Background

Awareness of the horrors of the crucifixion has been building up from the time Jesus sets his face toward Jerusalem in Luke 9:51. Before he utters his last words in 23:46, we read of three hours of darkness during which the temple veil is torn. The Jewish historian, Josephus, tells us that the temple veil itself was purple and had the stars and planets embroidered[13] on it, and this detail, which people at that time would have known, gives the death cosmic significance.

People have been mocking him all along; yet, despite the pain and suffering, Jesus forgives his tormenters (23:33-34). The moment he dies the centurion recognizes that Jesus is innocent (23:47), and the text starts to build up to the resurrection account in Luke 24.

Image

The depiction of the crucifixion concentrates on the moment between Jesus' death and the centurion's declaration, when the tense scene begins to resolve in the glory and hope of the resurrection. The illumination actually begins on the preceding page with the special treatment of Jesus' last words, which prepares us for the page turn. The death of Christ has broken through the darkness, defeating forever the forces of evil and death.

While the most enduring symbol of the Christian faith, the earliest depiction of the crucifixion dates only to the sixth century and is found on the doors of Santa Sabina in Rome. Other famous examples are the Gero crucifix in the Dom at Cologne, Germany, and the San Damiano crucifix in Assisi, Italy.

Golgotha, along with the Basilica of the Resurrection in Jerusalem, still draws tens of thousands of pilgrims every year. Bach's *Mattäuspassion* and *Johannespassion* are masterpieces of music, and contemporary British composer

13. Josephus, *Jewish War* 5, 5, 4 (LCL 3; 264.212).

James MacMillan has written *The Seven Last Words of Christ* for our time. The church's Good Friday liturgy captures the period of darkness and despair, which find release at the Easter Vigil.

Scriptural Cross-references
Ezekiel 43; Zechariah 14; Matthew 27:45-56; Mark 15:33-41; John 19:25-30

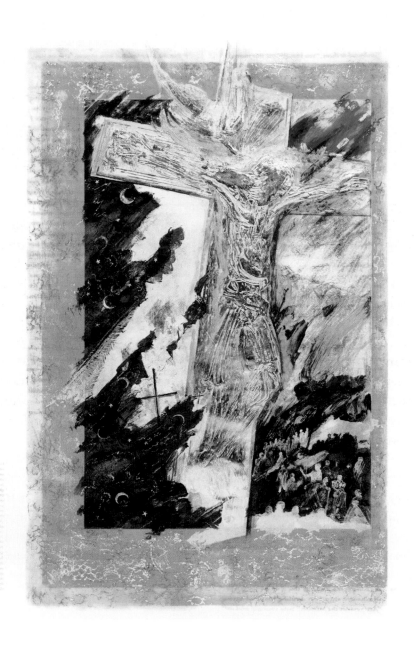

The Road to Emmaus
Luke 24:13-35; Donald Jackson, artist

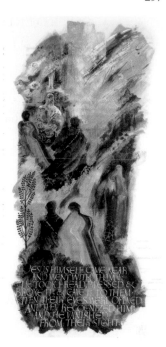

Background

We are told that two disciples are en route. One is named Cleopas, but the other is anonymous. In John 19:25, however, we read of "Mary, the wife of Clopas." If we allow for variations in pronunciation and spelling at this period of time, the unnamed disciple in Luke 24:13 could most probably be Mary, the wife of Cleopas, thereby making these disciples husband and wife.

In the midst of their puzzlement, Jesus begins to explain everything that has happened, beginning with Moses and the prophets. This explanation represents the earliest form of Christian exegesis, catechesis, and spiritual direction. All four evangelists interpret Jesus' life in light of the OT, and here we see the early church's development in the process.

Image

Visually, the Road to Emmaus works in tandem with the Crucifixion on the left facing folio; they help to interpret one another. Christ's death on the cross leads to the resurrection, and the resurrection interprets his death. Moreover, Christ's suffering, pain, and resurrection is the lens by which we view all human suffering and hope.

The depiction functions as a movement in time, starting in the lower register. The two disciples walk forward, toward the top of the image. Christ, first seen as a stranger to their eyes, stands off to the right. In the upper half, the same two disciples are gazing at Christ whom they now recognize as he breaks the bread. He then vanishes from their sight, and although the sun is setting, the two disciples run back up to Jerusalem, carried by the transformative joy of the resurrection.

Scriptural Cross-references
2 Kings 4:42-44; Matthew 14:14-21; 15:32-39; Mark 6:34-44; 8:1-10; Luke 9:10-17; John 6:1-14

A series of stamped images form a tree to function as the carpet between the gospels of Luke and John.

GOSPEL OF JOHN

Whereas the Synoptic Gospels of Matthew, Mark, and Luke share many stories and parables, albeit in slightly different arrangements and presentations, John's gospel, written ca. 90–95 BC, most probably at Ephesus, stands on its own. There is some crossover of material between the Fourth Gospel and the others, but the overriding impression is one of difference. There are very few, if any, parables in John, and many of Jesus' sayings appear cryptic and puzzling.

In its theology, John's gospel gives great emphasis to at least two points. The first is that the last days, or the *eschaton*, have already arrived with Jesus' incarnation. In other words, those who believe and follow Jesus are already living in the fullness of the kingdom of God. Second, John emphasizes Christ's divine nature.

In Jesus' speech there is a dualism of light and darkness, and he never minces words. His statements to others aim straight for the heart. The master/ disciple relationship is strong in John, yet very little pain and suffering mark this gospel. At the crucifixion scene we hear Jesus say, "It is finished" (19:30). Unlike in Matthew and Mark, or even Luke, Jesus' cry from the cross is not one of despair or abandonment; it is one of faithful resignation.

Frontispiece: Johannine Prologue
John 1:1-18; Donald Jackson, artist

Background

The opening words show an immediate connection to the opening verses of Genesis. John emphasizes Christ as the new creation by describing Christ's preexistence, thereby binding this gospel to the Wisdom tradition and the foundations of trinitarian theology. The climax of the prologue is John 1:14; the preexistent word becomes flesh. Christians call this moment the "incarnation," and throughout this gospel, John demonstrates that the incarnation has implications not only for human existence but also for all creation. The Gospel of John applies Christ's redemption to the whole cosmos.

Image

The cosmic nature of Christ's incarnation is evident by the background. In the center of the upper register is an artistic rendering of a dying star, based on a photograph from the Hubble telescope. Although the star devolved into a black hole billions of years ago, earth is still receiving its light; it is an apt reference to the Big Bang Theory, which explains scientifically the birth of

the universe. Coming from that swirl of cosmic matter is a figure gradually taking shape as a human being. From the verse written above the shoulders, we know that the figure is Christ. The highly decorative script on the left, appearing almost as ancient musical notation, consists of Saint Paul's words in his hymn from Colossians (1:15-20).

Franz Josef Haydn captures this moment perfectly in his oratorio, *The Creation*. The overture rambles randomly, soon backed by the angel Raphael's recitative of Genesis 1:1. In a single measure, when the chorus sings, " 'Es werde Licht!' Und es ward Licht" (" 'Let there be light,' and there was light"), the musical score bursts into a dramatic, harmonic chord. Ambrosian or Gregorian chant, Alan Hovhaness's *Mount St. Helen's Symphony*, and Charles Ive's *The Unanswered Question* are helpful for visualizing this scene John is painting for us.

Readers can decide the purpose for the keyhole on the left.

Scriptural Cross-references
Genesis 1:1–2:3; Wisdom 18:14-15; Colossians 1:15-20

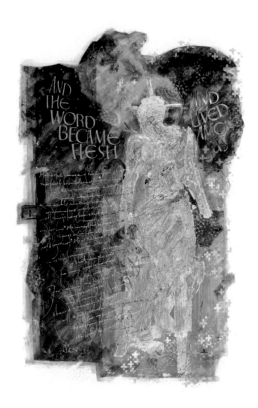

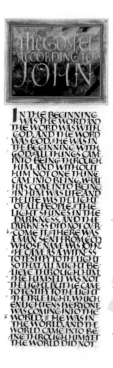

Call of the Disciples
John 1:35-51; Donald Jackson, artist

Background

The call of the disciples is a major piece of the gospel tradition. John describes the close relationship between the disciples of John the Baptist and those of Jesus. Sources independent of the gospels as well as research into the early church suggest that many of Jesus' own disciples were first followers of John the Baptist, and, indeed, Jesus may have been one of the Baptist's disciples as well, as we see in John 1:36: "and as he watched Jesus walk by, he exclaimed, 'Look, here is the Lamb of God!'" This phrase forms an involved connection between John the Baptist's exclamation here, Jesus' own use of sheep imagery elsewhere, the Last Supper, and the Christian Eucharist.

John the evangelist lists the names of the first disciples, as do Matthew and Luke. Not all the names match, however, leaving scholars to conclude that there were many more disciples than those cited in the gospels. In addition, Luke mentions women disciples separately from the men (Luke 8:2-3; 23:49). Paul also names women disciples throughout his writings.

Image

This image is framed by elements of the paschal mystery in the lower right corner and by angels in the upper register. The individuals etched in the yellow tones at the center of the illumination mark those whom Christ calls. To the left in the darker colors are disciples, figures stretching through time

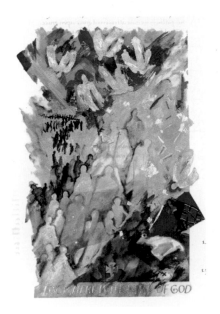

and history and from all Christian vocations: married couples, single people, monks, nuns, hermits, priests, and even children. The call to discipleship is rooted in baptism. Disciples throughout history are often but not always unconventional, and we would do well to think of them as such; those wishing to follow Christ may have to prepare themselves to be seen as characters in some of Flannery O'Connor's stories.

Scriptural Cross-references

Exodus 12:1-6; Proverbs 4:1-7; 7:24-27; Sirach 3:1; 34:14-19; Matthew 10:2-4; Luke 6:13-16; John 10:7-9; Revelation 5:12; 22:3

I Am Sayings Anthology
John 6:35; 8:12; 10:7; 14:6; 15:1; 18:5; Thomas Ingmire, artist

Background

The Lord's response to Moses at the burning bush (Exod 3:14) forms the key to understanding the "I am" sayings in John. In Exodus, when Moses asks the Lord to identify himself, the Lord responds, "I am who I am." This name, based on the Hebrew verb, "to be," is considered sacred by the Jews and would never be uttered in worship, let alone in conversation. John, writing in Greek,

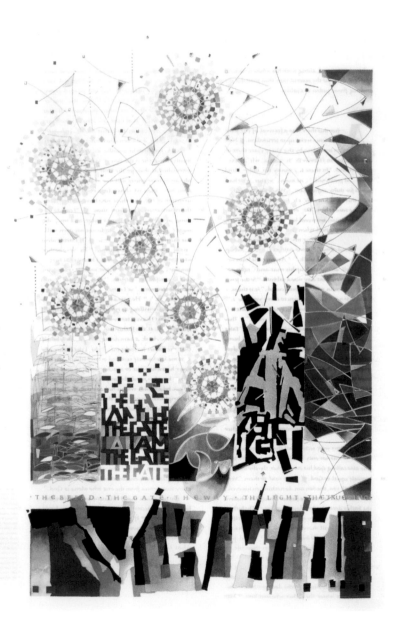

develops a series of metaphors from the Greek verb and places them in the mouth of Jesus. In each case, the metaphor is an assertion of Jesus' divine Sonship, and it culminates at his arrest, when in response to those stating that they are searching for Jesus of Nazareth, Jesus states, "I am he" (18:5); the very sound of his declaration causes the arresting authorities to recoil and fall down (18:6).

Image

The six "I am" sayings form the composition for the full-page illumination: *I am the bread of life; I am the light of the world; I am the gate for the sheep; I am the way, and the truth, and the life; I am the true vine; I am he.*

Each is foundational to the flourishing of sacramental theology, particularly the Eucharist, and consequently has become aligned with much of Christian art, from major works to architectural flourishes and decoration. They are all in use here in giving shape to the depiction. At the bottom in highly abstract letters is the Tetragrammaton, the Latin letter equivalent to the Hebrew verb, "to be," and thus the name of the Lord God.

Scriptural Cross-references

Exodus 3:13-15; Sirach 24:21

Woman Caught in Adultery
John 7:53–8:11; Aidan Hart with Donald Jackson and Sally Mae Joseph, artists

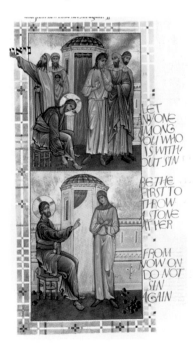

Background

This passage does not have a stable history in the text. In some early manuscripts it is found in Luke's gospel, and in others it is seen in various places in John's, but with asterisks or obelisks indicating that it is inserted material. The early church saw it as a part of the oral tradition, and its importance as such demanded that it be placed somewhere; it was set here in the Johannine text at an early date.

Image

We read the icon from the top down as a diptych. In the upper half, the woman, unveiled, turns away in shame from Jesus. The two elders on the left have rocks in their hands, while the two on the right push the woman in front of Jesus. As Jesus scribbles in the

sand, the elder behind him writes, "Adultery," in Hebrew outside the frame of the icon. The temple curtain is closed to all gathered; the elders, in their spite, are not following the Law either.

The lower half presents the scene after Jesus has spoken, and the elders have drifted away, dropping their stones by the woman's feet. As a sign of her reclaimed dignity, the forgiven woman is now veiled, and she is gazing at Jesus. The temple curtain is open; she has access to worship the Lord, whereas the elders have departed. The story speaks volumes about sin, forgiveness, guilt, shame, honor, and violence against the powerless, especially women.

Scriptural Cross-references
Matthew 7:1-5; Luke 6:37-42; John 4:6-42; 7:24; 1 Corinthians 4:1-3; James 4:11-12; 5:9

Raising of Lazarus
John 11:1-44; Donald Jackson, artist

Background
This is the greatest miracle in the earthly life of Jesus up until the resurrection, and only John records it. In the narrative of John's gospel, this deed is the act that propels Jesus to his crucifixion. It is also the passage with the shortest verse in the Bible, which reads, "Jesus wept" (Greek) and "Jesus began to weep" (11:35 NRSV).

Martha takes Jesus to task for delaying when she urgently summoned him, and she is most vocal in telling him so (John 11:21-27). Both faith and anger are expressed here. Martha's words also amount to a confession of faith, "She said to him, 'Yes, Lord, I believe that you are the Messiah, the Son of God, the one coming into the world.'" The only other person in any of the gospels to say anything similar is Peter (Matt 16:16), and Martha's response here is often used in research on the role and respect that women had in the early church.

The text underscores that Lazarus is truly dead in 11:39. It must be kept in mind that this is a resuscitation of Lazarus, distinctly different from the resurrection of Jesus that it foreshadows. The resurrected Jesus is a glorified body, whereas Lazarus will die again.

This passage ends at John 11:57, and it is clear that it is the choice of the people to believe or not to believe. There are those who come and see and believe, and there are others who come and see and inform the high priests. Even when seeing such a magnificent act of Christ's glory, there must be faith to believe in it.

Image

While most depictions of the raising of Lazarus have the viewer stand with the people outside the cave, this one has us next to Lazarus looking out of the tomb toward the light, where Jesus is standing. Research into near-death experiences describes a long tunnel with the light of a redemptive figure (in Christian terms, Jesus) at the end of it. Donald Jackson's mother nearly died when giving birth to her son and related such an experience to Jackson, who then used this memory to develop the imagery.

To the left of Lazarus is the etching of a death-head moth, which frequents the summer nighttime sky in Minnesota. The special treatment of John 11:25-26 on the opposite page balances the image by expanding the eye to include the double page.

Scriptural Cross-references

Matthew 16:16; 28:1-10; Mark 16:1-20; Luke 10:38-42; 24:1-12; John 20:1-18; Romans 16:1-23

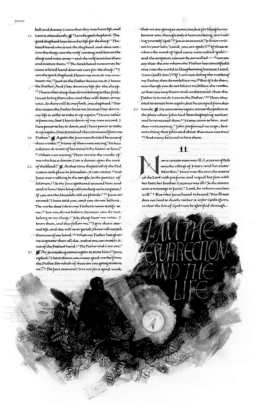

Resurrection
John 20:1-31; Donald Jackson, artist

Background

A distinction between John's gospel and the Synoptics is the emphasis given to the Beloved Disciple over Simon Peter. That this emphasis was a source of tension for the early Christian community is evident in the opening verses (20:1-6). Once Mary Magdalene discovers the empty tomb, she rushes to both Peter and the Beloved Disciple, who in turn run to the tomb. The Beloved Disciple, being younger, overtakes Peter and halts at the entrance. Once Peter arrives, however, he takes charge, steps into the tomb, and views the linen wrappings. Puzzled and bewildered, the two men return home, and they are gone from the scene until Mary Magdalene returns to them with the news of her encounter in the garden with the resurrected Jesus. In all the passion, death, and resurrection stories, women play crucial roles. They remain to follow Jesus to the crucifixion, stand by the cross, go to anoint his body on the first day of the week, and are the first to tell the others of the empty tomb. Each of the gospels highlights these points, but only in the Fourth Gospel does such a prominent role fall to Mary Magdalene; she becomes the Apostle to the Apostles. In the pre–Vatican II liturgy, she was the only woman other than the Virgin Mary for whose feast day the Nicene Creed was sung.

In order to be considered an apostle (the very word means "sent"), one had to see the risen Christ and be commissioned by him to tell others; it is a definition gleaned from Matthew 28, Mark 16, Acts 1, Galatians 1, and other places. Mary Magdalene fits this definition. She is the first to see the resurrected Christ, and he commissions her to tell the others, which she does, that "I [Jesus] am ascending to my Father and your Father, to my God and your God" (John 20:17).

Image

The text reads that Mary Magdalene goes to the garden before sunrise. She is caught off guard by the fact that the stone has been rolled away. After relating the news to Peter and the Beloved Disciple, she follows the two back to the tomb. They return home, bewildered; she, on the other hand, remains. In her grief, she peers inside the tomb and sees two angels. The next part of the narrative gives us insight into the nature of the resurrection. Jesus appears to her, but she thinks he is the gardener. Although she looks at him, he seems a stranger. Only when he calls her by name does she recognize him and call out to him with what must have been a familiar address, "Teacher!" Like a photograph, the illumination captures this moment, but unlike a photograph, the scene is reconstructed in the imagination of the artist.

Several things in the image and the text demand our attention. The encounter between Jesus and Mary parallels the interplay between darkness and light throughout John's gospel, where darkness is always bad and representative of evil forces, and light is always good and symbolizes Christ. Mary goes to the tomb in the darkness and meets Christ in the garden as the sun rises. Metaphorically, she moves from hesitant fear to falling at his feet and clutching him; he is both strange and familiar at the same time. Mary sees Christ's

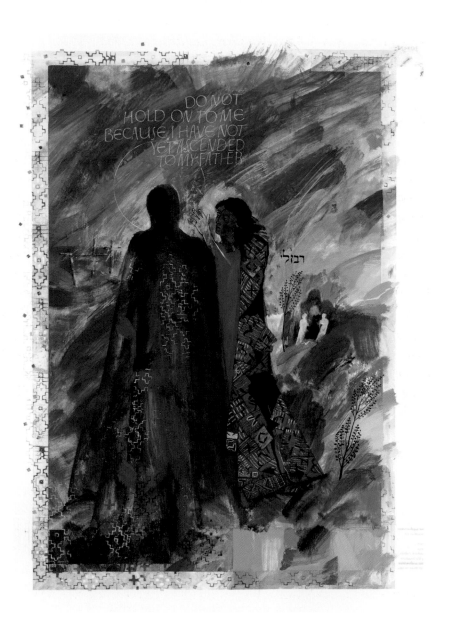

glorified body, a body that is at once unrecognizable and recognizable. In fact, it is the sound of Jesus' voice that alerts her to his identity.

The subdued colors replicate morning's first light. Everything else in the garden is but a shadow. The sole focus is on Mary and Christ; the narrative does not furnish any other distracting details. We see Mary's reaction but not Christ's. Based on this rendition of Mary Magdalene's experience with the resurrected Christ, the first account of such a human interaction with the risen Lord, we have the broad outline of the Christian understanding of the resurrection. We view Mary at the moment she sees what the resurrection entails, and it is an insight that can only surface from love. On the material level, the Jesus whom Mary sees is the same Jesus she has always known, yet he is different. That difference is the glorified state into which Jesus has been transformed. That glorified state comes about from transformational love; the love of Christ has transformed his body as it will transform ours. This is what Mary experiences when the Lord calls out her name and she replies with "Rabbouni" or "Teacher."

Throughout the gospels, *The Saint John's Bible* provides the Aramaic transcriptions of any Aramaic words spoken by Christ, and we do so here. Looking at the lettering on the image and in the margin, however, some will note that it appears to say, "Rabbouli." Research into this line reveals that Mary Magdalene would not have pronounced the title in Hebrew but in the language that Jesus, the apostles, and others in the region would have used: Aramaic. While Aramaic employs the same alphabet as Hebrew, the language underwent several phonetic changes, and one of those changes involved an orthographic shift between letters *nun* or "n" and *lamed* or "l." Although the written word seems to state, "Rabbouli," it is actually pronounced, "Rabbouni."[14] An analogy for English speakers would be the word "colonel," a term thus written but pronounced "kernel." The CIT felt that, in deference to the ancient witness as well as to current Christian communities in the Middle East for whom Aramaic or Syriac is the language of their liturgy, the spelling in the Bible should reflect such usage.

Scriptural Cross-references
Genesis 2:8-10; Song of Solomon 4:12-16; Acts 2:27-31; Ephesians 4:8-10; 1 Peter 3:18-20; 4:6

A carpet page of light, abstract design fills the right folio here and separates the end of John's gospel from the beginning of the Acts of the Apostles.

14. Personal correspondence, Craig Morrison, OCarm., Pontifical Biblical Institute, Rome.

ACTS

Frontispiece: Pentecost
Acts 2:1-39; Donald Jackson, artist

Background

As the second volume to Luke the evangelist's work, the Acts of the Apostles complements the Gospel of Luke. The evangelist says as much in the introduction to the Acts by addressing Theophilus (Luke 1:3; Acts 1:1). Part of Luke's literary and theological agenda in this book is to highlight the two apostles, Peter and Paul. Roughly, the first half of the Acts concentrates on the former and the second half on the latter. In addition, Luke gives us an account of the many tensions in the early church.

Peter, who has a prominent role in all four gospels, becomes the undisputed spokesperson in the opening chapters of the Acts. In this scene, the "devout Jews from every nation under heaven" are already in Jerusalem for the great Jewish pilgrimage feast of Pentecost, which occurs fifty days after Passover. Luke's catalogue of the nations (Acts 2:5-11), touches just about every people in the then-known world. This Lukan detail emphasizes the ingathering of the nations at Pentecost, thus making this event a fulfillment of Isaiah's prophecy (Isa 2:1-5). In Luke's view, Christ's resurrection, with this outpouring of the Holy Spirit at Pentecost, realizes Judaism's universalist fulfillment, long promised by the prophets but especially by Isaiah. With Acts, Luke supplies an interpretive account of the missionary efforts of the apostles, particularly Peter and Paul.

Christ himself at his ascension commissions the apostles to the mission and does so in response to their question, "Lord, is this the time when you will restore the kingdom to Israel?" (Acts 1:6). He answers, "But you will receive power when the Holy Spirit has come upon you; and you will be my witnesses in Jerusalem, in all Judea and Samaria, and to the ends of the earth" (Acts 1:8). Under Luke's pen, the narrative line in the Acts recounts this exact progress. Their proclamation of Christ and his resurrection begins in Jerusalem, spreads to Judea, reaches up to Samaria, and finally, with Paul, goes to the ends of the Roman Empire, which at that time was considered the whole world. Missionaries in subsequent centuries have continued where the Acts leaves off.

Both Matthew's gospel (28:19-20) and this passage give the most direct charge to the Christian mission. The life, death, and resurrection of Christ is to be proclaimed to all nations and brought to all peoples, a notion not particularly popular today owing to the misuse and oppressive nature of some missionary efforts over the course of time. These sad moments in history have caused many Christians to doubt the reason and means of all efforts to proclaim the good news of Christ. Should we force our beliefs upon others?

On the other hand, Christians can and should ask whether we have any right to hoard the life-giving message and grace, especially since, in Christianity, all goods are meant to be shared? The reason to evangelize, it seems, is a non-negotiable dimension of being a Christian, but how?

Peter speaks to the crowd at Pentecost. From that speech, we contemporary Christians can glean the proper means to evangelize. Luke places the theological explanation on Peter's lips starting in Acts 2:14. Drawing from the literary conventions of the Greco-Roman world, Luke underscores Peter's role by employing verbs used in classical literature to describe an orator, *"standing* with the eleven, [he] *raised his voice* and *addressed* them"* (emphasis mine). We can see this pose in classical statuary where the subject has his or her right hand outstretched; Luke makes good use of the culture in which he resides.

Peter places the events within the OT prophetic context, something with which the people would have been familiar (Acts 2:22-36). The prophecy from Joel 2:28-31 describes the Day of the Lord with all the traditional imagery: blood, fire, smoky mists, and heavenly portents. In this scene from Acts, Luke gives a new interpretation to the Day of the Lord. Rather than a day of gloom

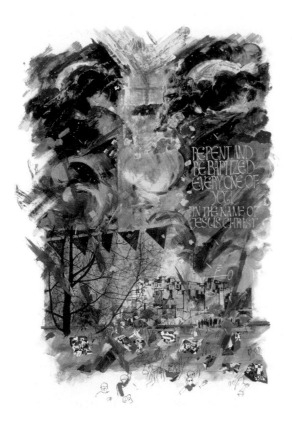

and judgment, Luke sees it as the fulfillment of time and history. There is awe and fear, but not terror. The people themselves then ask Peter what possibilities are open to them to avail themselves of salvation, and Peter replies with the hopeful call, "Repent, and be baptized every one of you in the name of Jesus Christ so that your sins may be forgiven; and you will receive the gift of the Holy Spirit" (2:38). The text notes, "So those who welcomed his message were baptized, and that day about three thousand persons were added" (2:41).

After making note of the phenomena that everyone in Jerusalem was experiencing (2:14-21), three thousand people were added, yet no one was forced to join. The operative word in the text is "welcomed"; the people were *invited* into the assembly and they were *welcomed*. As we Christians look to new ways to spread the Good News, we should remember the first Pentecost when people were not coerced by the Gospel but invited by its message. We should also keep in mind that if we invite someone, we must then show Christian-like hospitality.

Pentecost has long been considered the birth of the church. The main theme of Pentecost is communication, God communicating with creation and people, and people in turn communicating with each other. The three elements of a gathered people, the infused Holy Spirit, and Peter's explanatory speech all go together. While some may think the church must be smaller to be stronger, the Gospels and Acts tell us it must be wider and more welcoming to fulfill its mission.

Image

This full-page illumination functions as the frontispiece to the Acts of the Apostles. Visual references to the prophecy in Joel, which Peter makes in his Pentecost speech (Acts 2:17-20), occupy most of the piece. Fire and smoke dominate this image. In the upper register on the left, blood covers the moon, and on the right, the sun is darkened. Red flames dart down upon the landscape full of people. Were it not for the wide, golden beam filling the middle panel from top to bottom, this scene would be most dire. While the people certainly seem awestruck and confused, they do not appear panicked, despite all their movement.

The light beam slices through the Saint John's Abbey and University church, recognizable by its fluted walls. At the top of the light beam is the cross seen on the church's 150-foot bell banner. The silhouetted buildings to the right of the church are modeled on the city of Jerusalem, and to the right of that etching is a pair of papal keys with Peter's invitation written slightly above them.

The CIT asked that local associations be included in the illuminations wherever possible, and we see some of them in this piece. On one of his visits to Saint John's, Donald Jackson attended a homecoming football game on campus. The fans included a grandstand wave as part of their cheering. The fluttering of the blue and red school colors in their banners, flags, and sweaters created such a visual impression for Jackson that, when he came to the Pentecost passage, the experience of the football game came to mind.

The scene starts with chaos and ends with an orderly community eating together (Acts 2:42). The church presents to our world a model of diversity and multiculturalism (Acts 2:5-11). The multitude from every land has a common table with the Lord; people of different backgrounds are brought together as order arises from the chaos. The speech, narrative, and image all reference or show the primary elements of wind, fire, earth, and water. The Holy Spirit is affecting a new creation, which the rest of the writings in the New Testament will address.

The margin on the right folio recapitulates Acts 2:38, "Repent and be baptized," in a special treatment and is also considered part of the illumination.

Scriptural Cross-references
Psalms 16:8-11; 110; Wisdom 13:1-7; Isaiah 2:1-5; 60; Joel 2:28-32

Life in Community
Acts 4:32-35; Aidan Hart with Donald Jackson, artists

Background
In this passage, Luke describes the ideal community, not the experience of the believers at that time. In truth, the early church was fractious, disorganized, and argumentative. The greatest issue the early Christians had to face was how to deal with Gentiles who wanted to follow Christ. There were those who believed that these people first had to convert to Judaism before entering the Way, as the Christian movement was then called. Others held that baptism in Christ was sufficient to become a disciple. If Luke's portrayal of the church in this passage does not reflect the real situation at that point in history, it certainly shows a solid understanding of the direction the church should be going. At that time, there were many tensions in the church as it tried to come to terms with its experience of the risen Christ.

The tensions and the fractures that existed in the early church may have been resolved on a certain theological level, but the fact remains that there are a range of issues today that divide not only different Christian denominations from each other but also parishes, congregations, and religious communities

among themselves. In all too many cases, people feel compelled to abandon the church itself because of disputes and scandals. In these few verses here, Luke wants to point the fledgling community in the direction that will fulfill its vocation as Christ's disciples on earth, and he cites the attributes that mark those who claim to follow Christ: social justice (Acts 4:32, 34-35), honest and faith-filled leadership (4:33), and abundant generosity on the part of believers (4:36).

This passage has been the source of inspiration for Christians who, over the centuries, have tried to replicate Luke's description of the early church in monasteries, parishes, and communities. In addition, it is a foundational text for the church's teaching on social justice and the preferential option to the poor. Remarkable and refreshing in its scope, the vision of the church described here witnesses to morality over moralism, justice over privilege, and wholeheartedness over miserliness. It is a church that has joy—an open and hospitable joy—as one of its greatest hallmarks.

Image

The illumination, a circle with three concentric rings, reflects the classic Byzantine iconic style. Saints are gathered around a common table open to the viewer; we are invited to the banquet as well. Sitting at the center of the table is the queen of saints, Blessed Mother Mary. The six saints on either side of her are the twelve apostles followed by holy women and men, including Saint Benedict on the viewer's right and Saint Scholastica on the left; they are representing the communion of saints. The crescent table is set for a meal, and within the crescent is an altar with bread and wine upon it.

Directly above the Blessed Mother in another sphere is Jesus Christ as *Pantokrater* ("Almighty," or "Ruler of All"), flanked by two angels. In Christ's hand

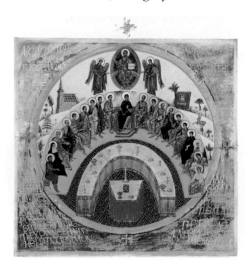

is a gospel book with the words "I am," an assertion of Christ's divinity through the "I am" sayings in John. On the upper left, in the third ring, and recognizable to those familiar with Saint John's Abbey is the Stella Maris Chapel. Corresponding to it on the right is the bell banner of the Abbey and University church. In the same register, stylized flora and fauna reference the woods on campus. A quotation from Acts 4:32-33 surrounds the illumination.

Viewed in its totality, this image of life in community embodies the communion of saints, wherein we on earth are united with those in heaven. Our lives now are very much a part of the life to come, even if still incomplete. We pray to those saints enjoying the fullness of eternal life, and they in turn walk closely with us; the Eucharist is our common table. This is the church as it should be, and knowing what the church community should be prompts us to make it so.

Scriptural Cross-references

Deuteronomy 15:4; Matthew 14:15-21; Mark 8:1-9; Luke 9:12-17; John 6:5-14; Revelation 7:9-12; 21:22-27

Paul Anthology
Acts 9; 15; 17; 22; 25–28; Donald Jackson with Aidan Hart, artists

Background

The first half of the Acts deals with Peter, and the second half concentrates on Paul. Paul is the one who brings the church to the Gentile world, and his effort was not without its difficulties. As someone who first persecuted the early church, he has a dramatic conversion on the road to Damascus (Acts 9:3-5). From that moment, his zeal for the law becomes zeal for Christ. In the Acts, Luke endeavors to resolve some of the tensions between Peter the compromiser, who tries to keep harmony between the Jewish and Gentile Christians, and Paul the visionary, who strives to bring the Gospel to all the nations of the then-known world. In the midst of this dynamic tension, we should remember that both Peter and Paul were Jews.

Acts tells a story with a definitive narrative line and plot; the story reaches its climax at Acts 15, for this is the major turning point in the early church, one that has huge ramifications for Christianity. In that chapter, we read of the Council of Jerusalem, when the early Christian community goes from being a Palestinian-Jewish sect to a religion reaching out to the whole world. Paul, more than any other apostle, is responsible for the outcome.

Paul is a mystic, a missionary, and an apostle of indefatigable energy. The vision on the road to Damascus in Acts 9 must have moved him tremendously. Though initially blinded by the light, the temporary blindness provides Paul with time to reflect on his experience, on his life as a Jew, and on his profession as a Pharisee or teacher and, ultimately, to cast his lot with the risen Christ. He is haunted by a vision that radically transforms him, and for the rest of his life, he was able to endure incredible hardship for the betterment of the

church. He is the church's first theologian and one of its greatest saints, able to take the universalist movement in Judaism and see its fulfillment in Christ.[15]

Paul's final residence was Rome, as was Peter's. This is one reason for viewing this city as the center of the church. Luke moves everything in this direction in Paul's travels (Acts 27:1–28:31). In great paradox and irony, both Peter and Paul, so unalike in personality and vision, suffer martyrdom under the same Roman emperor, Nero. Through the Holy Spirit, the church today is simultaneously nourished by both of their legacies—going forth while staying rooted.

Image

The Paul Anthology page has a cinematic quality. It deals with Paul the mystic and the tormented apostle, not Paul the theologian, the subject of his letters. Here we see Paul changed from a smug enforcer to a battered but resolute preacher by the events and places that brought him to this point.

The face and pose of Paul are in the style of a Byzantine icon; the apostle rests against a ship. Surrounding the portrait are churches and buildings both ancient and modern, representing all the lands to which he brought the Gospel. Some of the edifices are generic models of classical basilicas, gothic cathedrals, and baroque and modern churches. There are also secular spaces depicted. In his hands, Paul is holding the dome and nave of Saint Peter's Basilica in Rome, fractured from each other.

The center of Roman Catholicism, Saint Peter's Basilica carries the name of the man with whom Paul had a tense relationship. Paul the missionary wished Peter would be a bit more bending, and Peter the peacemaker wished Paul would not be so headstrong. While the basilica is built over Peter's grave and named after him, statues of each saint and of equal size flank the façade. Moreover, Paul's missionary activity established Christian communities at the ends of the Mediterranean world, and Peter's irenic personality made those communities Paul founded an institution.

In gold at the uppermost register is a verse from Paul's defense to Herod Agrippa in which he describes his conversion experience on the road to Damascus (Acts 26:13). The Scripture written at Paul's feet comes from Acts 13:47, where Paul turns to the Gentile mission.

15. See Isaiah in volume 5 of *The Saint John's Bible*.

Scriptural Cross-references

Psalm 117; Isaiah 2:1-3; 9:1-6; 43:9-10; 60; 66:18-24; Matthew 28:18-20; Luke
2:29-32; 22:54–23:25; Revelation 21:24-27

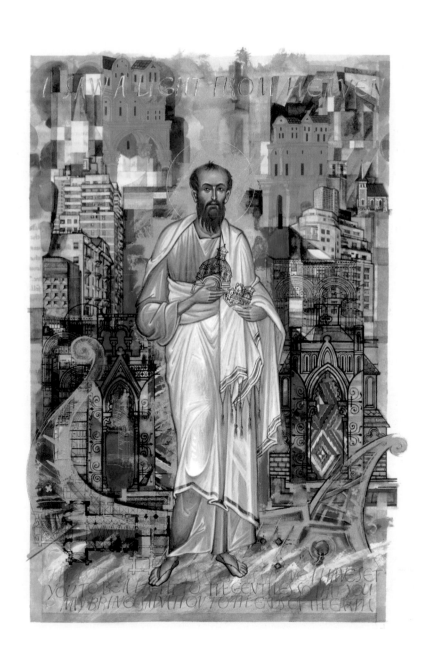

To the Ends of the Earth
Acts 1:8 and 13:47; Donald Jackson, artist

The last chapter in the Acts of the Apostles ends with Paul in Rome: "He lived there two whole years at his own expense and welcomed all who came to him, proclaiming the kingdom of God and teaching about the Lord Jesus Christ with all boldness and without hindrance"(Acts 28:30-31).

Many find this ending to the Acts abrupt. Is Luke holding out, and should something more be said? From a geopolitical and religious perspective, Rome was the center of the ancient, classical world. To bring the Gospel there is to fulfill the charge to bring the message to the "ends of the earth," for once in Rome, the word of redemption can go anywhere. Some scholars have speculated that Paul may have taken a missionary voyage to Spain, and there is some evidence, though scant, to suggest as much. Luke does not mention such a trip, but Paul expresses his desire to do so in Romans 15:23-29. It seems that with this conclusion in Acts, Luke is expressing the belief that Paul has been successful in spreading the Gospel, and the Holy Spirit will continue any work that still must be done. Luke has been proven correct in his assessment

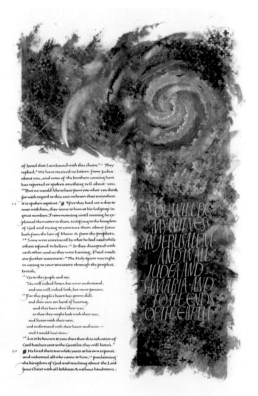

historically, and it seems that the Holy Spirit continues to move the church in this direction today.

Image

A double-spread illumination surrounding text concludes the Gospels and Acts volume. The lower left corner is based on photos of the earthrise from the Apollo spacecraft taken Christmas 1968; it mesmerized the whole world, for nothing like it had ever been seen before. Moreover, it showed then and continues to show us now how united and dependent upon each other the human race is.

On the right leaf, in the star-spangled swirl of the cosmos, the words of Christ to the Apostles receive special treatment. "[Y]ou will be my witnesses in Jerusalem, in all Judea and Samaria, and to the ends of the earth" (Acts 1:8). It is a fitting conclusion to the four gospels and the initial story of evangelization.

Scriptural Cross-references

Genesis 15:4-5; 22:16-18; Psalm 8; Isaiah 2:1-3; 9:1-6; 43:9-10; 60; 66:18-24; Daniel 12:3; Matthew 28:18-20; Revelation 1:16-20

Chapter 11

LETTERS AND REVELATION

THE NEW TESTAMENT

The seventh volume of *The Saint John's Bible*, opening with a carpet page, completes the New Testament with the epistles, letters, a homily, and a full apocalyptic; the gospels of Matthew, Mark, Luke, and John plus the Acts of the Apostles comprise volume 6.

The canonical structure of the New Testament itself forms a theological statement. The gospels proclaim the Good News by providing the account of Jesus' earthly ministry, passion, death, and resurrection. The Acts of the Apostles shows how the Holy Spirit guides Christ's fledgling faith community, with its all-too-human adherents, in its mission to the four corners of the known world—that is, the Roman Empire. The collection of epistles and letters set forth the theological questions and answers that arise when the early Christian church faces issues that demand a new response in the light of Christ. The single homily, i.e., Hebrews, also has this purpose. Finally, the New Testament ends with the book of Revelation—a vivid, energetic, and hopeful vision on the end of time.

PAUL'S LIFE

Saul was born in Tarsus early in the first century AD. He was a Pharisee and extremely zealous for the law (Torah). After the death and resurrection of Christ, the Christian movement grew. As with any new sect, the Way (as the movement was called) destabilized the larger group of Jews with which it first associated and then later challenged. For a small nation to have some of its members bring such volatility into its life threatened the fragile existence

that it had under the dominant and ruthless Roman occupiers. Consequently, worried that the empire would come down in full force, the Jewish leaders persecuted the followers of the Way in an effort to maintain the status quo. Saul of Tarsus was one such leader who was particularly unrelenting in his persecution of the Christians, arresting many to stand trial in Jerusalem. On his way to Damascus, Syria, around AD 32, Paul (the Greek equivalent of Saul) had a dramatic conversion after having an experience with the resurrected Christ (Acts 9:1-9; 22:1-21; and 26:9-19).

Paul then became an ardent missionary for the Gospel and, really, the church's first theologian. His travels took him all over the eastern Mediterranean and also got him into trouble with both Jewish and Roman authorities. Paul was also a Roman citizen, and he appealed to Caesar with hopes of getting a fair trial. He sailed to Rome in AD 59 or 60 and lived under house arrest for two years. Although it is far from certain, he may have brought the faith to Spain before returning to Rome in AD 64 (Rom 15:24-28), where three or four years later Emperor Nero executed him, Peter, and other church leaders.

The Pauline writings predate any of the gospels. Because of Paul's tenacity in the face of hardship, and his utter faith and conviction in the resurrected Christ, he was infused with an indefatigable missionary zeal that made Christianity a world religion.

PAUL'S WORKS

Most of the works outside the Gospels and the book of Acts can be attributed either to Saint Paul himself or to the school of Paul. Those texts held to be from Paul himself are called the "Pauline corpus," and those attributed to his disciples or writers under the influence of Paul's thought are called "deutero-Pauline." Scholars are not united in delineating which works belong in which category. The majority will hold that the Pauline Epistles consist of Romans, 1 and 2 Corinthians, Galatians, Philippians, 1 Thessalonians, and Philemon. This would leave Ephesians, Colossians, 2 Thessalonians, 1 and 2 Timothy, and Titus as deutero-Pauline Epistles, but many disagree over whether some of these, particularly Ephesians, Colossians, and 2 Thessalonians should be considered Pauline or deutero-Pauline.

Within this framework, three works are called the "Pastoral Epistles": 1 and 2 Timothy and Titus. They are so named because they are addressed not to congregations but to the leaders or pastors of the congregations. These Pastoral Epistles are also considered deutero-Pauline, which explains their classification under the two categories.

Finally, there is one letter, Philemon, containing a personal message to a single individual but which has had great ramifications in history; during the American Civil War, both slaveholders and abolitionists used it to support their respective causes.

CATHOLIC EPISTLES

"Catholic Epistles" is the name given to the seven remaining letters in the NT: James; 1 and 2 Peter; 1, 2, 3 John; Jude. They are non-Pauline, and the title refers to their universal character, in that they are not addressed to any particular community but to the church as a whole. Such a designation may actually be a misnomer, for it appears that they were addressed to individuals and certain communities. This objection notwithstanding, these works, containing lessons and theology important to the Christian faith, are accepted by the Latin, Greek, and non-Chalcedonian churches as canonical.

PAULINE THEOLOGY

Whether these works are Pauline or deutero-Pauline, they share nearly the same major theological themes. For Paul, Christ alone is the source of salvation. In arguing with the Jews, Paul states that neither the law, the works of the law, nor obedience to the law can save a person. When debating with Gentiles, Paul asserts that salvation cannot come through speculation, secret knowledge, or philosophical constructs. Pauline writings are suffused with the supremacy of Christ, and in his teachings he states that one must be baptized into Christ in order to be saved. While it may seem that such a theology is exclusivist, this same teaching has opened the way for an inclusivist and all-embracing theology of salvation.

Since Paul considers Christ to be Lord in every time and place, Christian theologians through the centuries see in his work what from earliest time has been called the "Cosmic Christ"—that is, Christ the Lord of the Universe, or, in Greek, *Pantokrator*. In this role, everything that is true, good, and beautiful enters the world through Christ, whether or not a person knows it, believes it, or recognizes it. From this basis, one can say that other faiths and religions, insofar as they contain the highest expressions of faith and belief, find their truth in Christ, no matter whether they preach or know Christ. In other words, through Christ's incarnation, death, and resurrection, God embraces creation, and from that embrace, God's truth flows where it wills. Hence, truth, love,

and beauty will flourish in various expressions and cultures, whether or not they are Christian. The Christian vocation is to show people Christ within their own respective culture and tradition, and to lead them to the fullness of Christ in the church.

Paul also sees Christ as effecting a new creation and a new humanity. Humankind has become one with Christ; there is no longer a divide between God and human beings. What Christ has done by his resurrection is done for all time and eternity, stretching back before he walked the earth and flying forward to the end of history. To use existential language, human beings are ontologically changed; their very being is reconstituted into a divine image and likeness from the very moment of Christ's resurrection. In this sense, Christ has re-created the universe and is its first "citizen." To use Paul's own terminology, Christ is the "New Adam" who has fashioned a "New Creation." We humans share in the New Creation. Sin, death, and decay belong to the Old Adam, while forgiveness and life are attributes of the New Adam.

The Pauline and deutero-Pauline writings have several controversial passages within them, especially in the area of sex and gender. Paul was a great theologian, but, as we are all products of our own age, he was a product of his. As sublime as his theology is, it becomes rather pedestrian when he addresses specific household questions within a community. Although the household questions tend to grab our attention, they do not constitute the depth or core of Pauline theology, and it is not wise to emphasize them more than they deserve.

THE APPROACH TO LETTERS AND REVELATION

The Christian biblical canon has determined the theological format of the final volume of *The Saint John's Bible*. The presentation of these New Testament works gathers the thought and development of every biblical work that precedes them. Illuminations reprise previous themes and images as they add new material to them. The series of special treatments and quarter pages are designed to lead into the grand finale—the book of Revelation.

In selecting verses for separate calligraphic treatment within this volume, the CIT determined that any verse or passage had to meet at least one of three criteria. A text should (1) reflect a particular aspect of Christian theology or Benedictine spirituality; (2) have a basis in Christian worship, art, or civilization; and (3) underscore, in some way, the all-inclusive love of Christ. Moreover, the verse or passage should foreshadow the consummation of history explicated in the book of Revelation.

Finally, Donald Jackson commemorated the CIT by burnishing a gold diamond above the first letter of the chapter representing the respective first initial of each committee member.[1]

D	Romans 7	David Cotter, OSB
I	Romans 9	Irene Nowell, OSB
A	1 Corinthians 3	Alan Reed, OSB
N	1 Corinthians 7	Nathanael Hauser, OSB
M	Galatians 4	Michael Patella, OSB
C	Ephesians 6	Columba Stewart, OSB
S	Colossians 3	Susan Wood, SCL
D	1 Timothy 5	David-Paul Lange, OSB
R	Titus 3	Roseanne Keller
E	Hebrews 4	Ellen Joyce
S	Hebrews 10	Simon-Hoa Phan, OSB
J*	James 1	Johanna Becker, OSB
		Jerome Tupa, OSB

*This initial has two burnished diamonds.

LETTER TO THE ROMANS

The major theological argument in Romans is that God wills the salvation not only of Jew and Gentile but also of all creation. Neither human action nor human will can bring about this salvation; only God's bountiful grace can, a grace brought into the world through the passion, death, and resurrection of Christ. When Saint Paul in Romans uses such terms as "law," "sin," and "death," therefore, he has in mind everything that held sway in humankind before Christ's act of salvation. In this vision, life without Christ is slavery to vain human attempts to bring about our own salvation, and life with Christ is freedom to live in Christ's grace, in which human salvation is assured. We manifest our faith in the irrefutable fact of salvation by cooperating with Christ's grace. Paul uses Abraham, who lived before the law was given to Moses, as the model of faith for all to follow.

1. Compiled by Alan Reed, OSB.

Paul employs certain terms in Romans that can be incomprehensible to the reader. When Paul cites the "law," he refers to the Torah or Jewish law. "Sin" for Paul is the human condition without Christ, and "death" is the ultimate evil, the exact opposite of life in Christ. "Justification" signifies how humans are saved, and, for Paul, justification for salvation comes from Christ's redemptive grace. Paul does not use "Adam" as a proper name. It is a term that represents all humankind and is not gender specific. In Romans particularly, and also throughout the Pauline corpus, Paul develops the typology of Old Adam (the human condition without Christ's grace) and contrasts it with the New Adam (Christ and the reconstituted human condition resulting from life in his grace).

Abraham and Righteousness
Romans 4:3; special treatment; Donald Jackson, artist

Paul establishes Abraham as the model of faith by emphasizing the patriarch's trust in God from the moment God called him out of Mesopotamia.

Faith of Abraham
Romans 4:16-17; special treatment; Donald Jackson, artist

Paul continues to demonstrate Abraham's faithfulness, and, in doing so, he alludes to the covenant God makes with Abraham in Genesis 15:5-18 and 17:1-10. Through Christ, says Paul, Gentiles can claim Abraham as their father in the faith.

Justified by Faith
Romans 5:1-21; special treatment; Donald Jackson, artist

Romans 5:17 is critical in understanding the theological development. Paul introduces the concept of the Old and New Adam. This chapter explains how Christ's passion, death, and resurrection release humans from their bondage to sin and death.

The cross at the top of the left folio and the image at the lower corner of the right folio punctuate the whole passage. The design and the colors recall different books and verses not only in the NT but also in the OT.

Freed from Sin
Romans 6:22-23; Thomas Ingmire, artist

Background

Being a slave to sin is living a life without Christ. The grace of the redemption is what changes one from such slavery to being bonded to Christ and sharing in his life. Paul uses irony, for being "enslaved" to God is not slavery at all but the guarantee of freedom in grace.

Image

The positive ramifications of this assertion are demonstrated visually in the layout of the folio. The special treatment for the last verse of chapter 6 stands at the top of the left page and is in visual conversation with the illumination for chapter 8. The cosmic image lies at the heart of the theological discussion.

Scriptural Cross-references

Genesis 3:1-24; Matthew 28; Mark 16; Luke 24; John 20–21

Creation Waits with Eager Longing
Romans 8, Thomas Ingmire, artist

Background

This chapter is the climax of Paul's argument in Romans and, indeed, is one of the greatest theological treatises in the whole Bible. In it, Paul explains Christ's role not only in human redemption but also in the redemption of all creation. So wide-sweeping is Paul's understanding that theologians today have built on his idea to construct a theology of redemption that incorporates the most recent findings of evolutionary biology and astrophysics.

Paul discusses a contrast between flesh and spirit. In his theology, the world of the flesh signifies the Old Adam and the world of the Spirit, the New Adam. Those who have been baptized are in the New Adam. Paul also expands and extends this logic by including the rest of creation into God's plan.

If Christ becomes incarnate—that is, a part of creation—then all creation has also become one in Christ. All creation is redeemed. If redeemed human beings, while on earth, still feel their shortcomings and undergo suffering, so does creation. In this passage, we see how Paul explains the "pains" of creation, such as natural disasters. Creation is on its way to being brought to completeness just as humans are. In other words, creation is still being created, and it will be fully created when it becomes one with Christ at the end of time.

We are a part of the evolutionary movement. We think that we are the culmination of creation, yet we constantly experience a longing. Ironically, we do not know for what we are longing. Ecclesiastes finds the same problem, but the writer really does not have any answers outside the fact that the longing will always be there. Here in Romans 8, the longing is expressed as

having a purpose; humans long to become fully human, and our full humanity is found in Christ.

The love of Christ makes such understanding possible, because all love comes from and is directed toward him; nothing can separate us from it (Rom 8:35). Consequently, love is never lost, for Christ lives eternally. Even the love we show to pets and animals (and they to us) is not lost. Somehow, redemption touches those relationships as well. This is what Christians mean when we say that all are born through Christ. Many believe heaven is a break from our current existence with little connection to our earthly beginning or end. Paul is saying here, however, that heaven exists as a continuum of our lives and not a separate, new place. For this reason, Christians speak of *eternal* life.

Image

Thomas Ingmire's illumination of Romans 8 is both rich and succinct. The cameo-like images on the lowest register connect this passage to Genesis 1. The deep blue background with astronomical bodies and forms draws us into the cosmos, while the digitized letters suggest the great unknown of time and space.

The "x" and "o" shaped forms, along with the triangles and squares suffused on the graph, relate how distances are measured to the stars. Arcs of gold filigree from the special treatment on the preceding page connect the two chapters. The whole piece pulls us into a deep meditation on Romans 8. Thomas Ingmire remarks, "My thought is to repeat the images of the stars as a way to push the idea that eternal life and the love of Christ are in everything and continue with everything . . . the birth of the stars, the advancement of knowledge."

Scriptural Cross-references
Psalms 8, 148; Wisdom 7:15-30; John 1:1-16; Colossians 1:15-20

Grafted Olive Shoot
Romans 11:17-24; special treatment; Donald Jackson, artist

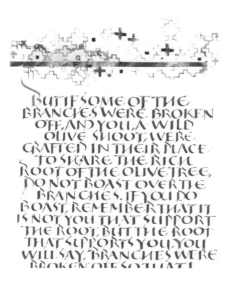

One of the most difficult theological questions to tackle is Christianity's relationship to Judaism, for Christianity can be understood only within the context of Judaism. From the Christian perspective, there is a bond between the two faiths that is unlike the understanding Christianity has with any other faith. Paul uses the metaphor of a tree graft. Christians are grafted onto the trunk of Judaism. Like a grafted branch, nourishment comes from the tree trunk. The resulting fruit, therefore, has the old qualities mixed in with the new. Paul concludes that God will resolve any difficulties and inconsistencies between the two covenants in God's own, good way.

LETTERS TO THE CORINTHIANS[2]

The ancient city of Corinth straddled the isthmus separating the Peloponnesus from the Greek mainland. With Lechaeum, its port on the western Gulf of Corinth, and Cenchraea, its port on the eastern Saronic Gulf, Corinth became an astoundingly wealthy city. The NT contains two letters Paul sent to

2. See Jerome Murphy-O'Connor, *Paul: A Critical Life* (New York: Oxford University Press, 1996) and *The Theology of the Second Letter to the Corinthians* (New York: Cambridge University Press, 1991).

the Corinthians. Evidence suggests, however, that the total sum of letters to the city numbered from three to nine, while the balance of scholarly opinion is that most likely there were a total of five letters: 1 Corinthians, 2 Corinthians 1–9, 2 Corinthians 10–13, and two other letters now lost.

Because Paul writes in order to answer questions put to him, reading these works can seem disjointed, especially 2 Corinthians, which is actually two separate letters combined into one. Despite these difficulties, the Corinthian correspondence has given us great insight into the church as the Body of Christ (1 Cor 12:11-31) and the human participation in the life and death of Christ (2 Cor 5:1-21). The special treatments in this volume accent these points.

Scribal Composition
1 Corinthians 9–11; six scribes

This spread contains the writing of all six scribes, with their respective colophons appearing at the bottom of the rightmost column; reading from left to right: Sally Mae Joseph, Angela Swan, Sue Hufton, Brian Simpson, Susie Leiper, and Donald Jackson. Scribes of the highest caliber have the ability to adapt their hand seamlessly to a particular script. This page proves their skill, as it marks the Eucharist, the great sacrament of unity.

Note as well the missing line being directed to its place.

Eucharist
1 Corinthians 11:23-26; Thomas Ingmire, artist

Background

These words of institution for the Eucharist are among the earliest in the Christian liturgy, and they form a very close parallel to the eucharistic text found in Luke 22:17-20. Because this Corinthian correspondence dates to approximately AD 56, it provides strong evidence that the first Christians were celebrating the Lord's Supper since before this date.

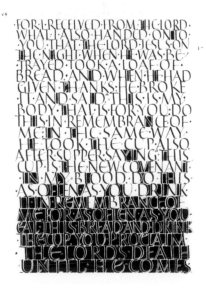

Image

The juxtaposition of this special treatment with those on the right folio allows for a visual interplay between the two texts. This one highlights the eucharistic meal and connects with the facing page addressing the qualities of love.

Scriptural Cross-references

Matthew 26:26-29; Mark 14:22-25; Luke 22:14-20; John 6:4-60

Definition of Love

1 Corinthians 13:1-13; Thomas Ingmire, artist

Background

A long and popular text, this paean to love is particularly popular at weddings. While it is certainly appropriate for a married couple, it is also an important mark of a Christian with many ramifications. It is all too easy for us to substitute moralism for true morality in both the private sphere and in the arena of social justice. Paul's critique of the noisy gong and the clanging cymbal forces us all to reconsider a conventional morality that lacks charity. The call for a mature, adult love goes beyond show and brings us to a relationship with those to whom we may not feel drawn: the outcast, the poor, and the sick. Paul outlines the attributes of what should be the basis of true Christian morality: love, a *just* love.

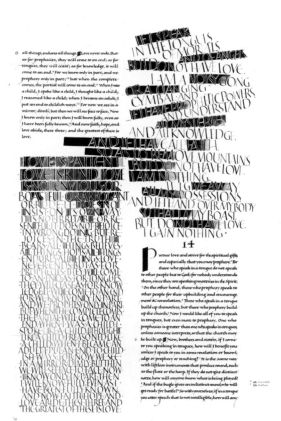

Image

Thomas Ingmire's visual rendition deftly works the Pauline argument into the design. The passage is read top to bottom, right to left. The incompleteness of great deeds without love is visible in the sharp, boldly angular, black-and-white lettering. Midway along the page our eyes must switch to the left column to continue reading as the text turns into the poetic definition of love. The letters and the colors appear to weave

themselves into a diaphanous silk scarf, the texture of which matches the eucharistic passage on the left folio.

Scriptural Cross-references
Ruth; 2 Samuel 1:17-27; Proverbs 9; Song of Solomon; Wisdom 9; Luke 7:36-50; 19:2-10; John 7:53-8:11

We Will All Be Changed
1 Corinthians 15:50-58; Hazel Dolby, artist

Background
In this passage, Paul continues his discussion on the Old Adam / New Adam typology. The change is real and it is instantaneous. He is speaking about death, and he can hardly contain his joy: twinkling eyes, trumpets, dead rising up. In this life, the Christian begins the conversion from death to life, but only at death is this process brought to perfection. We will all be changed, "in the twinkling of an eye" (1 Cor 15:52).

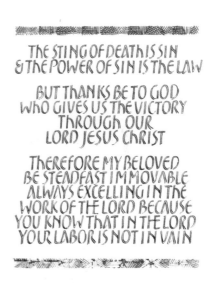

The future and the present become one. Our experiences in watching people die bear out this statement. The prayers for the dying are being recited, the breathing is sporadic, people know it can come at any minute, but the moment death comes, friends and loved ones are still a little surprised and shocked. At such times we witness the metamorphosis from earthly life to death to eternal life, all in a flash.

At death we become more of who we already are. In the gospel texts relating the resurrection appearances, Christ still has his wounds. He is the same person as before, and the wounds are still recognizable, but now they are glorified injuries on the glorified body of Christ. So too with the human race. Our fullest expression of selfhood is found in the change from the image of dust to the image of heaven (1 Cor 15:49). Christ is the New Adam.

Everyone is unique, with all the qualities of their respective histories, but all are radiantly united. We all take the lives we have lived and, with Christ, will continue living in a new, eternal existence.

Image

This composition occupies two pages. The reader sees the augmentation of the text on the corner of the lower right register. Upon turning the leaf, the blue tones and the geometric pattern continue the thought. The only phrase visible is "we will be changed," a repeated refrain (1 Cor 15:51, 52). Many will recognize these verses from the duet between alto and tenor in part 3 of Handel's *Messiah*.

The chapter heading for 2 Corinthians visually connects it with the conclusion of 1 Corinthians; it too is Hazel Dolby's work, with assistance from Donald Jackson.

Scriptural Cross-references

Judges 11:34-40; Job 19:25-27; Luke 24:13-35, 36-43; John 11:1-44; 20:11-18, 19-22; 21:1-14; Romans 8:31-34; 1 Corinthians 15:20-22; Revelation 5:12-14

LETTER TO THE GALATIANS

Although originally limited to north central Anatolia, the Roman province of Galatia stretched from the Black Sea to the Mediterranean. It received its name from the Celts (Latin, *Galli*) who invaded sometime after 280 BC. The inhabitants were still pagan when Paul missioned to them.

Paul was a great thinker, and like many great thinkers, his ideas germinated and grew over time. Much of what he writes to the Galatians he then refines and redevelops in his letter to the Romans, so what we see in this former letter is a blueprint for the construction of his later theology. In this brief, Paul is trying to instruct people who have accepted Christ but who have very little idea of the Mosaic law, which put them at a great disadvantage when others came through the territory and told them that they had to become circumcised before they chose to follow Christ.

One in Christ
Galatians 3:23-29; special treatment; Donald Jackson, artist

The Letter of Paul to the Galatians stresses faith in Jesus Christ as the means by which we are justified. In this passage, Paul explains how the Mosaic

law served as a guiding force for living within the Lord's covenant until the time of Christ. With baptism, we humans participate in the passion, death, and resurrection of Christ. This participation is what Paul means by "faith," and it is a new covenant. Consequently, our relationship with God changes and, therefore, so does our relationship with each other. We become members of the Body of Christ in which former moral distinctions among people vanish. Paul cites the major delineating categories of his day: Jew and Greek, slave and free, male and female. Because Sacred Scripture is the living Word of God, we can apply it to the distinctions among people that we have constructed in our time and place and ask ourselves whether we have made those distinctions barriers to Christian love and charity.

The top border with the stamped crosses and the butterfly forms a visual and thus theological cross-reference between this work and the treatment for Romans 11:17-24, the grafted olive shoot.

Scriptural Cross-references
Matthew 9:9-13; Romans 6:1-8; 8:1-3; 1 Corinthians 13; Ephesians 4:4-7

LETTER TO THE EPHESIANS

Ancient Ephesus was the fourth largest city of the Roman Empire; only Rome, Alexandria, and Antioch were larger. A major port for Asia Minor, it was also the pilgrimage center for the goddess Artemis, and the pilgrimage trade provided much of the city's income. To be a member of the Christian community there would bring a good deal of strife among both family and neighbor, as Paul himself discovers when his preaching causes a riot (Acts 19:24-41). The theology in Ephesians has a definitive Pauline tone even though some consider it deutero-Pauline. The baptized are one in Christ and share in his life, and life in Christ is a new human existence.

NOW BEFORE FAITH CAME WE WERE IMPRISONED & GUARDED UNDER THE LAW UNTIL FAITH WOULD BE REVEALED. THEREFORE THE LAW WAS OUR DISCIPLINARIAN UNTIL CHRIST CAME, SO THAT WE MIGHT BE JUSTIFIED BY FAITH. BUT NOW THAT FAITH HAS COME, WE ARE NO LONGER SUBJECT TO A DISCIPLINARIAN, FOR IN CHRIST JESUS YOU ARE ALL CHILDREN OF GOD THROUGH FAITH. AS MANY OF YOU AS WERE BAPTIZED INTO CHRIST HAVE CLOTHED YOURSELVES WITH CHRIST. THERE IS NO LONGER JEW OR GREEK, THERE IS NO LONGER SLAVE OR FREE, THERE IS NO LONGER MALE AND FEMALE; FOR ALL OF YOU ARE ONE IN CHRIST JESUS. AND IF YOU BELONG TO CHRIST, THEN YOU ARE ABRAHAM'S OFFSPRING, HEIRS ACCORDING TO THE PROMISE.

3

You foolish Galatians! Who has bewitched you? It was before your eyes that Jesus Christ was publicly exhibited as crucified!² The only thing I want to learn from you is this: Did you

There Is One Body

Ephesians 4:4-6; special treatment; Hazel Dolby, artist

This special treatment works in tandem with the one for Ephesians 5. The two inform each other, framing the double page with colors that lead the eye to read one continuous text. Ephesians 4:4-6 explains the efficacious nature of baptism in unifying all Christians.

For Once You Were Darkness

Ephesians 5:8, 14; special treatment; Hazel Dolby, artist

Saint John's uses these verses in its funeral liturgy, and other monasteries use them as part of their rite of religious profession. Because a Christian death leads the deceased into eternal life and fullness with Christ, the verses here have a strong connection to Ephesians 4:4-6.

Scriptural Cross-references

Matthew 3:13-17; John 11:1-44; 12:44-50; Galatians 3:23-29

LETTER TO THE PHILIPPIANS

Philip II of Macedonia founded Philippi in 356 BC, and by the time of Paul's arrival, Philippi had a large Roman population. After the civil war sparked by Julius Caesar's assassination, the ultimate victor, Caesar's nephew Octavian in 42 BC, gave Philippi to the soldiers who had remained loyal to him as payment for their services. Philippi was the first city in Europe to receive Christ through Paul's evangelization, ca. 50. It gained importance because it lay on the principal Roman highway, *Via Egnatia*, of which Paul took full advantage. Scholars believe Paul wrote the letter in the early 60s, during one of this many imprisonments.

And Every Tongue Should Confess
Philippians 2:5-11; Suzanne Moore, artist

Background

There seems to have been a competitive spirit among the Philippians that caused splintering among members of the early Christians. A problem Paul faced was how to combat the factionalism without contributing to it. He finds the solution by exposing the human condition. All humankind has been under the sway of sin, but now with Christ, there is a new humanity. With this hymn Paul develops the Adam typology, which becomes foundational to so much of his theology going forward. Scholars believe these verses were originally a Christian liturgical hymn, which Paul adapts for use here. The employment of the term "slave" imputes a notion of service to a community that has, until this point, competed with one another for prestige.

Image

The depiction has strong vertical lines. Using Philippians 2:10-11 as the point of reference, Suzanne Moore utilizes a variety of languages and scripts to write the name "Lord" in gold along the left side.

in heaven and on earth and under the earth;
" and every tongue should confess
that Jesus Christ is Lord,
to the glory of God the Father."

LET THE SAME MIND BE IN YOU
THAT WAS IN CHRIST JESUS
WHO THOUGH HE WAS IN THE FORM OF GOD
DID NOT REGARD
EQUALITY WITH GOD
AS SOMETHING TO BE EXPLOITED
BUT EMPTIED HIMSELF
TAKING THE FORM OF A SLAVE.
BEING BORN IN HUMAN LIKENESS.
AND BEING FOUND IN HUMAN FORM.
HE HUMBLED HIMSELF
AND BECAME OBEDIENT TO THE POINT OF DEATH
EVEN DEATH ON A CROSS.
THEREFORE GOD ALSO HIGHLY EXALTED HIM
AND GAVE HIM THE NAME
THAT IS ABOVE EVERY NAME
SO THAT AT THE NAME OF JESUS
EVERY KNEE SHOULD BEND
IN HEAVEN AND ON EARTH
AND UNDER THE EARTH
AND EVERY TONGUE SHOULD CONFESS
THAT JESUS CHRIST IS LORD
TO THE GLORY OF GOD THE FATHER.

Scriptural Cross-references

Acts 10:34-41; Romans 5:12-17; 1 Corinthians 15:21-25, 42-50; Colossians 1:15-20

LETTER TO THE COLOSSIANS

Colossae was located in the Lycus Valley of western Anatolia, a part of Ephesus's hinterland. In order to prevent uprisings of the locals and to cement his authority, the Seleucid king, Antiochus III, settled Jews from Babylon in Colossae around 213 BC. Although it had been an important center for wool products, by the first century Colossae had dwindled in importance.

He Is the Image of the Invisible God
Colossians 1:15-20; special treatment; Donald Jackson, artist

Epaphras, *not* Paul, founds the church at Colossae (Col 1:7; 4:12). Epaphras lacked the intellectual rigor, however, to deal with the problems besetting this church—namely, their overly spiritualized notions of Christ. It has always been too easy for Christians to forget that Jesus, the Son of God, has taken on human flesh. In order to balance the Colossian misconception of the nature of Christ, Paul uses one of their hymns and rewrites it to include Christian participation in Christ's salvation. The end result is that Christ's redemption is given a cosmic dimension.

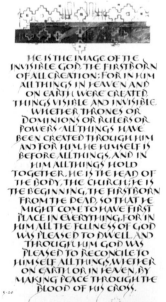

These same verses are written in gold and in a filigree-like script on the frontispiece to the Gospel of John.

Scriptural Cross-references

Wisdom 7; John 1:1-16; Romans 8; Philippians 2:5-11

LETTERS TO THE THESSALONIANS

Thessaloniki was one of the most important cities in the Roman Empire. Situated on the *Via Egnatia*, the city maintained its status as a commercial and administrative hub from antiquity into late medieval times. Thessaloniki's position made it a beneficial site for spreading the Gospel. Yet, this preeminence also caused problems.

Roman rule brought in many foreigners who were vital to governance and imperial hegemony; these foreigners held all the power and wealth. The natives were

relegated to such a lowly status that their condition was only a bit better than being enslaved, and it was in this native population that the Christian faith took hold. The nature of the Christian message gave the lower class hope and courage, which did not find a welcome among those more privileged. As a response, the powerful oppressed the Christians.

The theological problem for the Thessalonian Christians was that they believed that since Christ had already come, his kingdom should be established and there should not be any suffering. Moreover, the Thessalonians also feared that their deceased loved ones would not be saved because they had died before Jesus came into the world. Consequently, many were discouraged and left their newfound faith. As a result, Paul writes them a letter of encouragement and instruction.

For the Lord Himself
I Thessalonians 4:16-18; special treatment; Donald Jackson, artist

Paul discusses here the instantaneous moment when Christ will come again; it is an extended metaphor of death that we must read in connection with 1 Thessalonians 5 in order to understand it. Paul wishes to underscore to the living that their deceased forebears are not lost. We will all live eternally with each other in the coming kingdom. A key to understanding this passage (and the following chapter) is that the words "awake" and "asleep" are euphemisms signifying "alive" and "dead," respectively. With such an understanding, these verses are most beautiful and vivid.

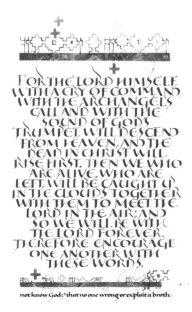

Many, particularly in North America, will recognize this section from popular literature as describing the rapture—that moment when the few good and just Christians will be swept up into heaven while all non-Christians and, indeed, bad Christians wallow on earth to await doom and destruction. There is nothing in the text or Pauline theology to support such a claim. Indeed, Paul says as much in the same text, "For God has destined us not for wrath but for obtaining salvation through our Lord Jesus Christ, who died for us, so that whether we are awake or asleep we may live with him" (1 Thess 5:9-10).

Scriptural Cross-references
Matthew 24; Mark 13; Luke 21; Revelation

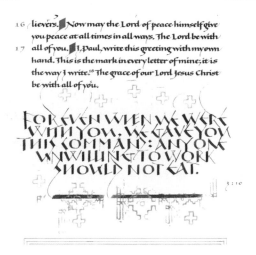

16 lievers. ¶Now may the Lord of peace himself give
 you peace at all times in all ways. The Lord be with
17 all of you. ¶I, Paul, write this greeting with my own
 hand. This is the mark in every letter of mine; it is
 the way I write.¹⁸ The grace of our Lord Jesus Christ
 be with all of you.

For When We Were with You
2 Thessalonians 3:10; special treatment; Donald Jackson, artist

Seemingly, there were a number of Christians within the Thessalonian community whose belief that Christ would come at any moment prompted them to relinquish all labor. When Christ did not return as quickly as they expected, they began to rely on others to feed them. Paul addresses the problem head on. Faith in the next life does not free Christians from living in this one.

LETTER TO THE HEBREWS

The authorship of the Letter to the Hebrews is unknown and, technically, it is not a letter but a homily. Though many in history have ascribed it to Paul, there is no foundation to support the claim. Even Origen contested that notion on the basis of the vocabulary and rhetoric. Because of its protracted argument that Christ's sacrifice on the cross has replaced the temple worship of the old covenant, most scholars believe that the Letter to the Hebrews was written as an exhortation to Jewish Christians who were reverting to Judaism, for they were not convinced that Jesus was the Messiah.

Hebrews is an elegant and persuasive *tour de force*, arguably exhibiting the best use of Greek in the Bible. While it certainly has been important for the development of Christian theology, it simultaneously has serious problems. There are some sections that are highly anti-Semitic, and dangerously so. Despite the fact that the cult and practice of the Jewish temple that the writer addresses came to a complete halt with Rome's brutal suppression of the Jewish revolt in AD 70—conditions that no longer exist and are anachronistic to the relationship between contemporary Judaism and Christianity—parts of the Letter to the Hebrews seriously taint the Christian message. Preachers and instructors must be vigilant not to let the language and presentation of Hebrews contribute to the detriment of another group of people—in this case, the Jews—and we who read these passages must always be mindful to prevent religious and racial bigotry from entering the darker recesses of our hearts.

This Is the Covenant
Hebrews 8:10; special treatment; Suzanne Moore, artist

This verse is practically an exact quotation from Jeremiah 31:33. It talks about how God will write his law on people's hearts. The writer of Hebrews uses the book of Jeremiah to make the case that Jesus Christ is the covenant about which Jeremiah speaks, therefore undergirding Christ as the Messiah, an interpretation of Jeremiah that Christians have always maintained. A Jewish interpretation would not read the book of Jeremiah in such a way, however. Rather, it would view Jeremiah as addressing the Jewish people within the context of their moral failings in the face of the impending Babylonian invasion.

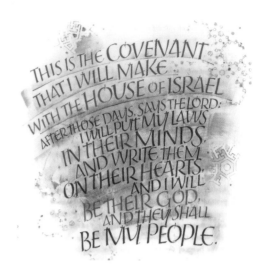

Now Faith Is the Assurance
Hebrews 11:1; special treatment; Donald Jackson, artist

One of the better known verses within Hebrews describes the experience of faith itself. Within its context, this verse opens an excursus on faith by recounting the experiences of OT figures, beginning with the creation of the world and continuing through the death of the prophets and the righteous.

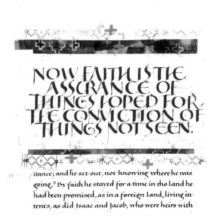

LETTER OF JAMES

Tradition has long considered the writer of this letter to be James, the brother of the Lord, also known as "James the Just." Some scholars have challenged this attribution primarily because of stylistic and historical reasons, maintaining that James is actually a pseudonym. The balance of opinion is that this letter was written either by James the Just or someone who shared his thought and theology. In any case, the letter was written before the close of the first century.

Because the Letter of James holds that we must combine our faith in Christ with good works, it became difficult for many church reformers to reconcile

James with their overriding dependence on the love and grace of Christ. Martin Luther called it "an epistle of straw"; though he never went so far as to delete it from the canon, he struggled with its theology.

From the Catholic point of view, people are saved by Christ's passion, death, and resurrection. This salvation, however, is not a theory; it must be lived, and the only way we can live a life of faith in Christ is by doing as he did: helping the widow, the orphan, the stranger—in a word, all the weak and helpless in God's creation—which is the point the Letter of James makes.

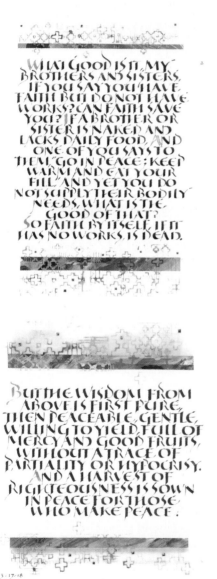

What Good Is It
James 2:14-17; special treatment; Donald Jackson, artist

These verses show the necessity of charitable works within the Christian life. It is Christ's grace that has saved us, not our good works. Yet, good works and charitable deeds are the way we acknowledge Christ's grace and participate in his salvation; they mark the way of a disciple.

Wisdom from Above
James 3:17-18; special treatment; Donald Jackson, artist

The appeal to wisdom connects the Letter of James to the Bible's Wisdom books and tradition. Because wisdom is an ideal in the monastic life, and because these verses express the attributes of wisdom so well, highlighting them as a special treatment resonates with the monastic character of Saint John's Abbey and all monastic communities.

Scriptural Cross-references
1 Corinthians 13:1-13

Are Any among You Suffering?
James 5:13-16; special treatment; Donald Jackson, artist

The Letter of James demonstrates how a life of faith is expressed in Christian practice. We minister to each other, and by such ministry, we reflect the love of Christ to others. The RSB lays great emphasis on the physical and spiritual care of the sick within the monastery and beyond. Moreover, these verses form part of the foundation for the Christian sacrament of anointing of the sick.

LETTERS OF PETER

It is difficult to say with any precision who wrote the First Letter of Peter. Its canonicity is not a problem, for it has attestation from earliest of times. Identifying the author of the letter, however, becomes difficult. While it is attributed to the apostle Peter, several details have led scholars through the ages to doubt this claim. The most glaring difficulty is the language: it contains some of the best Greek in the New Testament, even better than Paul's. By all historical accounts, Peter would not have had the education to learn Greek so well. In addition, someone from Galilee would have employed the Hebrew version of the OT, not the Greek. Third, some of the material in the letter is anachronistic with Peter's lifetime, specifically the references to Christian persecutions in Asia Minor (1 Pet 1:1-7 and 4:12-16). Finally, the theology in the letter is very Pauline, and it is puzzling to speculate why Peter would have copied Paul even if he could have. Nonetheless, the First Letter of Peter is part of the NT and has made valuable contribution to the development of Christian theology.

The Saint John's Bible has no special treatments or illuminations for 2 Peter.

Harrowing of Hell
1 Peter 3:18–4:6; Suzanne Moore, artist

Background

This passage is often referred to as the "Harrowing of Hell," in which the risen Christ rescues the souls of the righteous imprisoned there; they died before Christ's incarnation, and thus are being held captive by the fallen angels.[3]

The text has two sections, which have caused a great amount of debate from the time of Clement of Alexandria to the present. The first part reads, "In which also he went and made a proclamation to the spirits in prison, who

3. The Harrowing of Hell has a long history in both Eastern and Western Christianity. For an excellent treatment of the topic, see Archbishop Hilarion Alfeyev, *Christ the Conqueror of Hell* (Crestwood, NY: Saint Vladimir's Seminary Press, 2009).

in former times did not obey, when God waited patiently in the days of Noah, during the building of the ark, in which a few, that is, eight persons, were saved through water" (1 Pet 3:19-20).

Why and what would Christ proclaim to the sinful souls before the Flood, especially when this text says that only the eight people in the ark were saved? Over the centuries, the opinion has ranged from (a) no sinful person from before the Flood can be saved, (b) the people repented as they were drowning and so can be saved, or (c) Christ proclaimed his victory over death to the fallen angels to demonstrate that evil has no power over him. If these arguments appear harsh or fatuous to us, we have to remember that scholars ancient and modern wrestle with the texts they read, and even today there are those within our own society who see, for example, people guilty of capital crimes as being beyond redemption. Our idiom may be different, but we struggle with the same questions.

The second part, and the critical verse for understanding the Harrowing of Hell, occurs at 1 Peter 4:6, "For this is the reason the gospel was proclaimed even to the dead, so that, though they had been judged in the flesh as everyone is judged, they might live in the spirit as God does." Maintaining the context of 1 Peter 3:19-20 with 1 Peter 4:6, we can draw the following conclusion: This text from 1 Peter expresses two doctrinal teachings. First, Christ's descent into hell expresses the teaching that Christ as the Lord of Life is the savior and judge of both the living and the dead and is not beholden to Satan or any demon; the Devil has no authority or power to keep Christ out of hell. Second, those just people who died before Christ's incarnation also share in the eternal life he brings. The fruits of Christ's passion, death, and resurrection are for all people at all times; they are not temporally bound. That is, bodily death before the *parousia* (second coming of Christ) does not in any way preclude anyone from reaping the fruits of the resurrection. Even the dead have a chance to choose between good and evil.

Similar to the questions addressed to the community at Thessaloniki (1 Thess 4), this passage seeks to reassure the community that loved ones who predeceased them are not lost; Christ's redemption reaches out to them. It also serves to explain, in temporal vocabulary, where Christ was during the interstice between his burial and his resurrection. The answer is that Christ brought his victory into Satan's own realm and showed himself as the conqueror of sin and death to the very author of evil. In doing so, Christ liberated the just from both hell and Satan's clutches while disgracing Satan in front of every demon and unclean spirit. This text is part of the scriptural support for Purgatory.

Image

The image spreads across both pages. The division between hell and heaven is well defined and easily recognizable. The jagged red and black forms on the left present a visual cacophony opposing the bright stretches of blue and golden hues on the right, in which serene arches recall the grace of Gothic cathedrals. The illumination swings over to the right page and ends in a trellis with an abundance of greenery. The artist, Suzanne Moore, has a particular fondness for gardens and states that she cannot imagine paradise without one.

The viewer will notice a similarity between this work of Suzanne Moore's and her other piece dealing with good and evil—the calming of the storm in Matthew. There too is a sharp divide between a dark, threatening pit and the divine abode.

Despite the great debates this passage in 1 Peter has sparked through history, it has been the source of tremendous thought and speculation in the Christian tradition. The Nicene Creed states, "he suffered death and was buried," while the Apostles' Creed has the phrase, "he descended into hell," though some versions of the prayer show the phrase removed.

One of the most influential artistic depictions of the Harrowing of Hell, and one of the most beautiful, is found in the apse of the former Chora Church in Constantinople, present-day Istanbul. In that fresco, Christ pulls Adam and Eve and all the saints from the OT out of their graves. Satan cannot do anything about it, for he lies helplessly on his back, crushed like a bug by the gates of hell that Christ is standing on. It is a painting replicated by many artists in various media. In 1491, the Sienese artist Benvenuto di Giovanni painted a five-panel series of Christ's Paschal Triduum, titled *The Agony in the Garden*, *Christ Carrying the Cross*, *The Crucifixion*, *Christ in Limbo*,[4] and *The Resurrection*.[5] In addition, Johann Sebastian Bach's mighty Easter chorale, *Christus lag in Todesbanden*, makes passing reference to the Harrowing of Hell.

The Maronite liturgy for Holy Saturday portrays the Harrowing of Hell in a very dramatic and theological way by weaving lines of a special *troparion* through the first five verses of Psalm 31. The text features a discourse by a personified hell, the symbol of death and human suffering.

> Today Hades tearfully sighs: "Would that I had not received him who was born of Mary, for he came to me and destroyed my power.
> He broke my gates of bronze, and being God delivered the soul I had been holding captive."
> Today, Hades groans, "My power has vanished, I received One who died as mortals die, but I could not hold him.
> With him and through him, I lost those over whom I had ruled. I had held control over the dead since the world began, and behold, he raises them all up with him."
> O God of truth, glory to your cross and to your holy resurrection.[6]

4. "Limbo" is a term used in former times to replace "hell." It describes a situation in which one is not enjoying the full presence of God, yet one is not suffering pain and punishment either. Limbo is no longer the official church teaching; instead, one trusts the boundless mercy of God to resolve such ambiguities, which is exactly what the Harrowing of Hell does. Christ's redemption extends to those who have lived and died before his incarnation in human history.

5. This series by Giovanni is on display as part of the permanent collection of the National Gallery in Washington, DC.

6. As edited by Our Lady of the Genesee Abbey (Piffard, NY: Private Publication, 2012).

The First Letter of Peter 3:18–4:6 also reflects on our earthly lives. We are living for the promise of the future, but in the meantime we have to do the things necessary to live in this world. Death will not be a static existence. After the resurrection, Christ moved around a great deal, appearing everywhere and, as we see here, preaching in the prison of hell. Because he sits at the right hand of God, he is no longer hampered by time and space. So too with us; we will live in the existence to which, through Christ, we are destined by centering our lives on Christ in the daily things of life.

Thus Saint Benedict quotes 1 Peter 4:11 in his rule, and it has become the Benedictine motto, "that God may be glorified in all things" (1 Pet 4:11).

Scriptural Cross-references
Matthew 27:52-53; Romans 14:7-9; 1 Corinthians 15:1-30

LETTERS OF JOHN

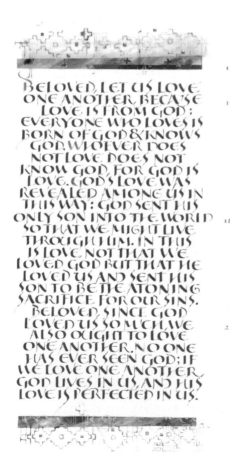

These three letters are considered part of the Johannine corpus, for they are tied geographically, thematically, semantically, and theologically to the Gospel of John. Although not written by the same person who penned the Gospel, the issues addressed in these letters reflect the concerns of the Gospel and the community from which it was produced. As with the Gospel of John, these verses from 1 John express how God is made present when the love of Christ permeates our lives, and they are the only ones given special treatment within the Johannine letters.

Beloved, Let Us Love One Another
1 John 4:7-12; special treatment; Donald Jackson, artist

This beautiful section expresses how the love of God dwells within those who love their neighbors. God is the source of all love. With Christ, the love of God

becomes incarnate; it takes on flesh in this world. The Christian vocation is to take that incarnate love and continue to incarnate it in the world with and through others.

THE BOOK OF REVELATION

For good or ill, little has probably had a more profound effect on the Christian imagination than the book of Revelation. It has not only inspired artists in every age but also given rise to hundreds of visionaries and religious founders even up to the current day. For all its beauty, however, Revelation is also a dangerous book. If read on solely a literal level with a desire to match ancient people and places with the current geopolitical scene, we have reduced Revelation to a fortuneteller's handbook. Such a move draws an impermeable division between good and evil, and when that happens, many people suffer, especially the innocent. On the other hand, if read on a plane that allows the highly visual and symbolic language to breathe in all of its metaphorical glory, Revelation is one of the most hopeful and beautiful books in the Bible.

Although there is no definitive evidence linking it to such, most scholars believe the book was written during the reign of the Roman emperor Domitian (AD 81–96), who led a horrific persecution of Christians. From the first chapter (Rev 1:1, 4, 9) we know that the author calls himself "John," exiled to the isle of Patmos, off the coast of present-day Turkey. This name, and the fact that Patmos is located in the same region as Ephesus, led many early Christian theologians to conclude that the John of Revelation and the John of the Fourth Gospel are one and the same. Such a link, however, was denied by other early theologians and doubted by many contemporary ones; the question is still outstanding.

While there are some theological issues and similarities shared by both the evangelist and the writer of Revelation that suggest the author of Revelation may have been a disciple of John the Evangelist, the two works have diametrically opposed views of the world. The gospel proclaims a realized eschatology—that is, the end-times are now—and Revelation, with its language of impending struggle and judgment, champions a future eschatology.

In addition, two literary genres intermix within Revelation: apocalyptic and eschatological. Apocalyptic literature is noted for its descriptions of violent destruction of life, property, and the whole created order, and sees them as the just results of an irreparably sinful human race. Eschatological literature, on the other hand, may or may not contain apocalyptic imagery, but it moves beyond the doom to a hopeful and even glorious future for those who rely on Christ's mercy and who build their lives on faith, hope, and charity.

Apocalyptic literature surfaces during times of trial and persecution, and a profusion of such writings, many of them noncanonical, arose between 200 BC and AD 200 within Jewish and Christian circles. From the canonical sources, most of the symbolism in Revelation comes from the Old Testament books of Daniel and Ezekiel, along with other imagery rampant in the Mediterranean world of antiquity. Biblical writers use the tools and references at their disposal, which in no way diminishes the sacred character of the Bible, but the fact that they do can make interpreting Revelation exceedingly complex.

Scholars have noted five different accounts or themes involved in the formation of the book of Revelation: (a) contemporaneous, (b) religious, (c) ecclesial, (d) eschatological, and (e) liturgical.[7]

- The *contemporaneous account* relates the situation among Christians at the time of its composition. As such, there was opposition from and persecution by the Roman Empire.
- The *religious account* places the book within the religious movements of the day, including contemporary pagan ones.
- The *ecclesial account* regards Revelation as a prophecy while the early Christian community was in its infancy.
- The *eschatological account* sees the piece as figurative presentation of the ultimate chronological events within the story of salvation.
- The *liturgical account* privileges the Christian liturgy as the locus of interpretation, and, as liturgy, it is an interaction between a reader and a group of listeners.

Numbers are an important part of the symbol system in Revelation, particularly three, four, six, seven, twelve, one thousand, and their multiples. These numbers represent the following:

- three: perfection, and the Trinity of Father, Son, and Holy Spirit
- four: cardinal directions of the compass, and thus the world
- six: imperfection
- seven: totality of perfection
- twelve: the tribes of Israel, or the Twelve Apostles, and therefore the church in its fullness
- one thousand: an immense number, a myriad, countless

7. Ugo Vanni, *Apocalisse: Esegesi dei Brani Scelti*, Fascicolo I (Rome: Editrice Pontificio Istituto Biblico, 1991–92), 7–8.

The liturgical symbolism of Revelation cannot be underestimated.[8] The Eucharist in particular is frequently mentioned in the book, especially represented by the word "lamb." Then, as well as now, the Eucharist melds present reality with the Christian eschatological vision, and the resulting dynamic tension creates highly visual metaphors and graphic imagery.

Frontispiece: Revelation Incipit and Letter to the Seven Churches
Revelation 1:12-20; 2:1–5:14; Donald Jackson, artist

Background
The two depictions, Revelation 1:12-20 and Revelation 2:1–5:14, so close in their theological makeup and physical layout, are treated together here.

Revelation 1:12-20: Revelation Incipit with the Son of Man
The island of Patmos is right off the western coast of present-day Turkey and very near ancient Ephesus and thus close to the churches to which John is writing. Ephesus itself had one of the greatest harbors in the Roman world and was a religious center famous for its great temple to the goddess Artemis.

In the opening verses, John of Patmos describes his vision. Christ speaks directly to him and identifies himself, " 'I am the Alpha and the Omega,' says the Lord God, who is and who was and who is to come, the Almighty" (Rev 1:8). "Alpha" and "Omega" are the first and last letters of the Greek alphabet, two extremes to represent everything in between.

The introduction to the book cites the seven churches to which John must write, referred to here as "seven golden lampstands" (Rev 1:12); Revelation 2 begins the respective messages. The symbolism behind the lampstands is evident. Churches are supposed to be lights in the darkness. The "Son of Man" (Rev 1:13) is a messianic figure and is a reference to Daniel 7:13; the description also parallels the transfiguration scene. Christ uses the title "Son of Man" when referring to himself in the gospels and alludes to this passage from Daniel when standing before Caiaphas and the council after his arrest, causing the authorities to accuse him of blasphemy—a charge that leads to his condemnation.

John of Patmos faints at the sight of the terrifying scene, but the Son of Man speaks words that we have seen elsewhere in the Bible: "Do not be afraid" (Rev 1:17). We hear this phrase at the annunciation of John the Baptist to Zechariah (Luke 1:13), at the annunciation to Mary (Luke 1:30), to the spice-bearing women (Matt 28:10), and with nearly every other point of divine intervention. The Son of Man commands John of Patmos to go to work (Rev 1:19).

8. Ibid., 8. See also Wes Howard-Brook and Anthony Gwyther, *Unveiling Empire: Reading Revelation Then and Now* (Maryknoll, NY: Orbis Books, 1999).

The NRSV, for reasons of gender inclusivity, does not use the phrase "Son of Man" in the OT books (it reads "Mortal" instead), but it does employ the phrase for the NT writings. Consequently, the theological connection between Jesus' references to himself as the "Son of Man" throughout the gospels is not always readily visible with those instances of the "Son of Man" in the OT, but it is there nonetheless.[9]

The fainting ("as though dead," Rev 1:17), the following command not to be afraid, and other similar descriptions are good examples of "liturgical stuttering," found throughout the Bible. In speaking to God, we do not know what to say; who would be so bold to even speak? Consequently, we repeat prayers, actions, and parts of both over and over—liturgical stuttering.[10] The repetitious descriptions are quite in place here since the book is set as a grand

9. See the discussion on pp. 216–217.

10. For example, see the Lord God's commands as well as the reaction of Moses and the people in Exodus 19.

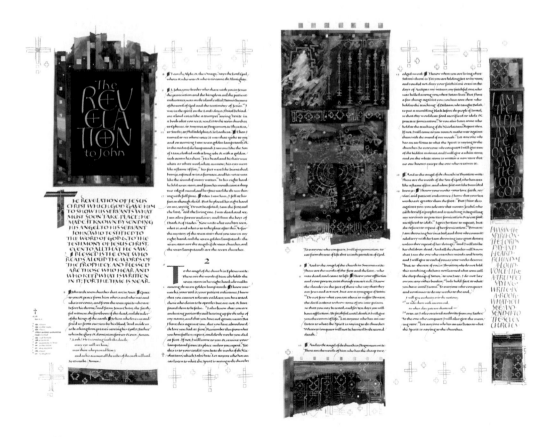

liturgy. Indeed, in Revelation 1:19 past, present, and future are fused, just as time is during a liturgy.

Revelation 2:1–5:14: Letter to the Seven Churches with the Heavenly Choir

This section contains messages to each of the seven churches. The number seven represents perfection and thus gains importance; if there are seven churches, they collectively signify the "One Church," a point reinforced by the repeated phrase, "Let anyone who has an ear listen to what the Spirit is saying to the churches."[11] The churches themselves are situated along the west coast of present-day Turkey, all within the ambit of Ephesus. At the time of the writing, this area was called "Asia Minor." Why these seven are selected is difficult to say outside of the fact that they are located in the same part of the world as the writer.

The core message is the same for all seven churches: they are to be worthy of the vocation to which God has called them. The condemnatory language is unvarnished. The people are not following God's doctrine, most defiantly by their worshiping of false gods. Even in the third letter (Rev 2:12-17), the issue of food offered to idols is really about the worship of idols, and an idol can be anything—food, money, prestige, *anything*—that detracts from the worship of God alone.

An interesting point is that some of these churches were in wealthy harbor cities along rivers. Yet all their harbors silted up because of the great deforestation that took place in ancient times. Some exegetes think that much of the imagery in Revelation is based on the great ecological destruction wrought by the greed of the Roman Empire. The desire for wealth destroyed these cities, and the message to the churches is not to succumb to the idolatrous quest for riches.

Image

Many of the leitmotifs in *The Saint John's Bible* surface here and throughout Revelation. The number seven abounds across both pages in torches, crosses, and decorative squares. The rich and vibrant colors reflect the resplendence of a liturgy with incense, oil lamps, and processional movement.

The left page augments the opening verse (Rev 1:1-3) with a script different and larger from the body of the text; it announces the book to the reader. The right page presents the viewer with a composite image weaving together all the varied strands from the churches. The lampstands are clearly lined up in the upper right register of the left panel. The white figure in the upper left of the same panel is the Son of Man. We see him at Daniel 7, upon which is reflected in the depiction of the transfiguration (Mark 9:2-8).

11. Rev 2:7, 11, 17, 29; 3:6, 13, 22

The right margins reproduce Christ's self-identifying, "'I am the Alpha and the Omega,' says the Lord God" (Rev 1:8), and his words to John, "Write in a book what you see and send it to the seven churches" (Rev 1:11). Together, these verses tie the image on the right page to the beginning of the book of Revelation on the left page.

Visuals for the seven churches continue after the page turn. We can discern seven church buildings recognizable by the different crosses. Each cross is done in a style that reflects the changes in art over two millennia as well as represents the main branches of Christianity: Latin, Greek, Coptic, Ethiopic, and Syrian churches. The seven lampstands appear with fallen, pagan idols in between them. At the hooves of the slaughtered lamb is the scroll with seven seals, and the acclamation, "You are worthy to take the scroll and to open its seals" (Rev 5:9). The song of the four living creatures (4:8) is portrayed on the right page with the "Holy, holy, holy" written on the banners in the three ancient languages of the early church—Syriac, Greek, and Latin.

The bright colors convey the great range of human emotion, from violet blue to bright gold, just as the faith of the church, both personally and communally, has its moments of sorrow, repentance, joy, and deliverance. In the

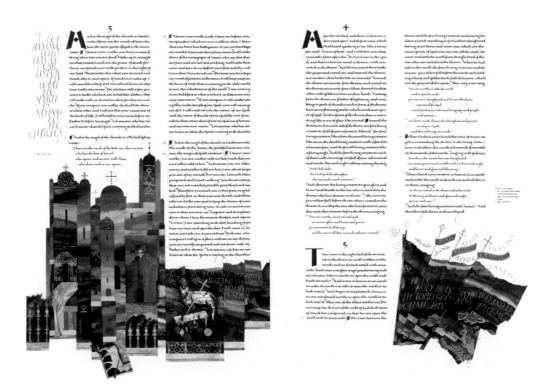

left margin of the left page we can read the refrain that concludes each letter to the seven churches, "Let anyone who has an ear listen to what the Spirit is saying to the churches" (Rev 2:7, 11, 17, 29; 3:6, 13, 22)

Scriptural Cross-references
Isaiah 6:1-13; Ezekiel 1:24; 2; 43:2; Daniel 7:13-14, 27-28; 8:17; Matthew 26:64; 28:10; Mark 14:62; Luke 1:13, 30; 22:69

Four Horsemen of the Apocalypse
Revelation 6:1-8; Donald Jackson, artist

Background

The four horsemen of the Apocalypse have figured in Christian art throughout the centuries, and they have always been symbols of doom, death, and destruction—apocalyptic in the truest sense of the word. The white horse is difficult to specify. Described as going forth, "conquering and to conquer" (Rev 6:2), does it represent a particular people or country? For much of Revelation, Rome incorporates all evil and, historically, it certainly had a policy of conquest, making it logical to link this horse with Rome. On the other hand, Rome's archenemy was Parthia, whose men flanked the eastern frontier of the Roman Empire. Excellent horsemen who could shoot from the bow while riding, the Parthians were the only ones to defeat a Roman legion on the open field. All Romans, soldiers and civilians both, were terrified of a Parthian invasion. Whether the white horse represents the Romans or Parthians, its symbolic value can be broadened to include all greed and the violence that such avarice perpetuates, be that individual or societal. If we interpret the white horse accordingly, the remaining horses follow suit.

Uncontrollable greed spills into war and so arrives the red horse, complemented by a rider and a huge sword. The black horse, with the scale in the rider's hand to measure food rations, is famine, which frequently follows war. The green horse signifies death and decay—the result of people starving to death in the streets.

Each of these horses is unleashed by opening a respective seal on the scroll. The Lamb breaks each seal (5:1-7), but the Lamb is not the agent causing the destruction; rather, it is letting events unfold according to the course that sinful action normally takes. Despite teachings and warnings against chasing wealth and riches, people do so, and when they do, consequences of suffering naturally follow. Nonetheless, the point for the reader is that suffering and death do not have the last word; eternal life does, as the book read in its entirety shows.

Image

The focus is on the four horses with the four riders fused to them in an intense identification. The panel reads from left to right. The lamb, situated in the lower register of the left page, has three broken seals at its feet. The fourth broken seal is in the center at the page break where the last of the four horses, the green one, emerges on the scene. The horses gallop across the top of the written text, each one with a banner marking its action: conquest, war, famine, disease. Most of the details should look familiar, for they first surface in other books of *The Saint John's Bible*. The insects crawling through the piles of rubble are the artist's imaginary constructions. Jackson has used the praying mantis as the basis for his design of insects, finding it a scarier looking insect than a locust.

It is up to the reader to decide whether the bright colors of red and orange depict a firestorm, a sunset, or a sunrise.

Scriptural Cross-references

2 Kings 25:1-11; Jeremiah 21:1-12; Ezekiel 37:1-14; Matthew 24–25; Mark 13; Luke 21:7-38; 23:30-31

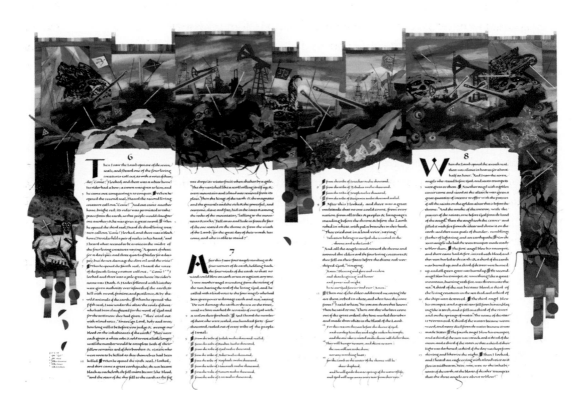

Woman and the Dragon
Revelation 12:1-18; Donald Jackson, artist

Background

The struggle between the woman and the dragon can be interpreted on two levels. The woman has a cosmological significance as evidenced by her position in the sky and her clothing. Reading the story one way, we see the Blessed Mother giving birth to Jesus, who is threatened by Satan (the dragon). God intervenes and saves them both. On another level, the woman is the church, and as the church, she gives birth to Christ inasmuch as the church is the presence of Christ on earth. Here too, Satan threatens her, and once again God intervenes and protects her. Both levels converge, i.e., the Blessed Mother and the church, when the dragon wages war against the rest of her offspring. The offspring are, of course, all the baptized. We do not know exactly what the writer has in mind, but Christians today can hold both interpretations simultaneously.

The war that breaks out in heaven is most dramatic. The battle erupts over the child. Once again, we see Christ as being responsible for the fall and rise of many (Luke 2:34). The presence of Michael the Archangel in this fight has its origin in the Jewish apocalyptic literature, for Michael is the defender of Israel (Dan 10:8-21; 12:1). He and his angels fight, but there is no mention of weapons; truth and goodness in the face of evil are potent enough.

A cosmic war between the forces of heaven and hell is the subject of much noncanonical literature at the time the NT was being compiled, and the imagery here, such as the dragon and the cataclysm in heaven, draws from those works. While it is impossible to peg with any certainty what each reference signifies, it seems that the forces out to destroy the woman and her child would be the enemies of Christianity at the time Revelation was written: the Roman Empire with its allies, or sin and hatred in general.

For our current situation, these enemies are in one sense metaphorical in that they can be anything that hinders or hounds the proclamation of the Gospel and the spreading of Christ's kingdom of God. These enemies are not any person, place, or thing but rather the selfishness and sin we all carry within us, both individually and societally, and it is dangerous and wrong to focus on a particular person or group of persons or nation. In another sense, the enemies can be identified with Satan and demons, who, if not ultimately viable threats to Christ and the church, have long been trying to destroy both. In a sense, the satanic enemy and the metaphorical ones are the same.

There is symbolism in the numbers too. The woman is nourished for 1,260 days. This time frame equals approximately three and one-half years

on the lunar calendar, which is half of seven. The writer is telling the reader, therefore, that this battle is not the full story of God's plan; it is incomplete. We can even say that the story is only half finished. The sense of a redeemed creation, which is so much a part of Pauline theology, functions in Revelation as well by the fact that the earth helps the woman in Revelation 12:16. It seems that this account demonstrates a future eschatology that has already begun, a time of the already and not yet.

Image

The woman is the center of attention. Her pregnancy is indicated by the hand on her womb, inspired by a photograph of Mabel Jackson, Donald Jackson's spouse. Springing from the woman's diadem are the cosmic allusions, which carry over to her blue mantel. The rainbow pattern surfaces here as it does in other illuminations where good and evil are juxtaposed with each other. The woman's face registers concern. The red robes reflect a pattern seen in other images of women in *The Saint John's Bible*, specifically the woman at the house of Simon the Pharisee (Luke 7:36-50) and Mary Magdalene at the resur-

rection (John 20:11-18). Together, the articles of clothing are reminiscent of Our Lady of Guadalupe, patroness of the Americas and defender of the poor.

The lower register shows the dragon, angry at the woman and the church, ready to spring. Persistent evil is confronting eternal good. In this face-off, the text identifies the reality of evil, an evil that never conquers the world but is always out there. Here, the reader gets the sense that when the Messiah comes, he will resolve all the ambiguity associated with evil. For this reason, we are told that this battle is taking place at the halfway mark to perfection, noted by the three and one-half years.

The coral snake reprises from the scene of Adam and Eve in the Garden and functions as the dragon here, underscoring Mary as the new Eve. Its head is a composite of other deadly monsters utilized in other books of this Bible. The cross in the middle is Saint Michael's sword, for it is by the cross of Christ—the passion, death, and resurrection—that we are saved. In the upper register of the left page, above the calligraphic marginalia and functioning as a visual representation of Revelation 12:5, 10, is the Son of Man motif that occurs at various places.

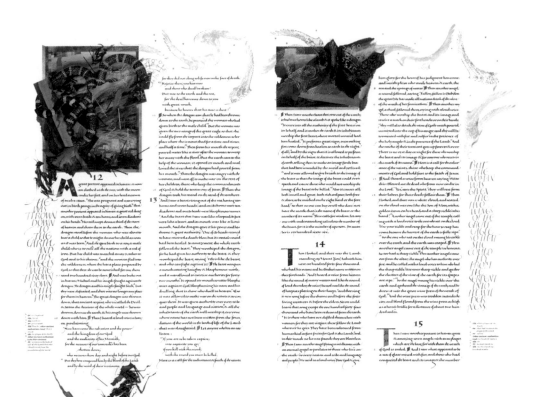

Turning the page brings us to the outcome of the battle. The snake is cut in pieces at several places, as the grotesque insects (its henchmen?) begin to eat the carcass. Parts of Revelation 6 occupy the lower right corner of the image. Drifting upward over the right column and across the page break are the ethereal wings of the seraphic angels, seen in the calm colors at the upper register of the right page, who carry the woman to the wilderness. She will rest there "for a time, and times, and half a time" (Rev 12:14).

The Italian composer Ottorino Respighi (1879–1936) wrote a piece called the "Window of Saint Michael" based on his experience of visiting Chartres Cathedral. Its opening has a dramatic glissando with smashing cymbals and blaring trumpets, a musical version of this scene.

Scriptural Cross-references
Daniel 7:13-14; 10:8-21; 12:1; Luke 1:28-56; 1 Corinthians 15:51-58

Vision of the New Jerusalem
Revelation 21:1–22:5; Donald Jackson, artist

Background
These chapters provide the hopeful, eschatological component to the apocalyptic narrative we have encountered thus far. For a persecuted church, for the Christian community, or for an individual, these words offer tremendous consolation, as Revelation takes a positive turn in portraying the heavenly Jerusalem.

The mention of the Lamb throughout these two chapters connects this scene with the Passover and the Last Supper; this description here in Revelation gives the passion, death, and resurrection of Christ their eschatological focus. The Lamb furnishes all the light that surpasses that of the sun and moon (Rev 21:23). It is the paschal Lamb that was slain, the same one mentioned in Revelation 5:9–6:17, who opens all the seals.

The reference to the Alpha and Omega (Rev 21:6) that echoes their occurrence in Revelation 1. These letters have a special place in the Christian tradition and often appear on icons of Christ. By saying he is the Alpha and Omega, the one seated on the throne is expressing the complete and total perfection of his being.

Revelation describes the heavenly Jerusalem with vocabulary based on Ezekiel's rendition of the Jerusalem temple (Ezek 40–41). Even more so does it reflect Isaiah 60:1-22, and, indeed, this account in Revelation fulfills Isaiah's prophecy; these gates never close, for the heavenly Jerusalem is open to all people of every nation (Rev 21:26). The measurements in Revelation are per-

fect. The jewels, the size, the precious materials, all suggest splendor beyond imagining, but they are metaphors because in this text there is no temple; God and the Lamb (Christ) form the temple. The scene as presented is both a present and future reality, and in this sense, it reflects Pauline theology.

Up until Christ, the understanding of a temple has been the building within which God dwells. Through the blood of Christ's redemption, we have been made one with him; hence, we have all been glorified with him into a new creation. The Lord no longer needs a temple, a dwelling place, because all creation is the Lord's and so are we. A phrase such as, "I saw no temple in the city, for its temple is the Lord God the Almighty and the Lamb" (Rev 21:22), is understandable in this regard.

The text contains a restriction, "But nothing unclean will enter it, nor anyone who practices abomination or falsehood, but only those who are written in the Lamb's book of life" (Rev 21:27). What constitutes abominable practices and falsehood is not defined, and only Christ is the judge. When read within the context of Revelation 21:4-5, it is difficult to conceive of a door being closed to anyone who wants to enter, an understanding in line with gospel teaching and emphasized by the script in the left margin, "After this I looked, and there was a great multitude that no one could count, from every nation, from all tribes and peoples and languages, standing before the throne and before the Lamb" (Rev 7:9).

References to a river and the tree of life (Rev 22:1-2) bring us back thematically to Genesis 1–3, the beginning of creation and creation's fall. Here, in the last book of the Bible, creation has been redeemed and restored, even to the point that darkness has ceased to exist because of the accessibility to the Lord God's eternal brightness (Rev 22:5). The redemption is spiritual and physical.

Image

The marginalia (Rev 21:5) introduces what is about to appear at the page turn. Pearls in the middle of each side mark the four gates as the cardinal points on the compass—an echo of Ezekiel 48:30-34. The Lord God is set in the middle of the uppermost register in the familiar design. The angelic choirs of cherubim and seraphim are recognizable by the light, golden wings swirling about. The tree of life stands in the lower right corner. Swatches of red streaking flames sweep over the temple.

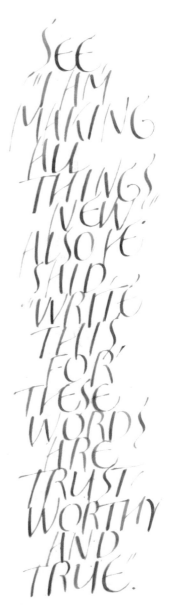

The text describes the heavenly Jerusalem in terms of light and color, yet the light and color do not come from the sun but from the brightness of God's glory. Considering that the compound for the physical temple in ancient Jerusalem encompassed nearly one-fourth of the ancient city, and it dwarfed all other buildings, the people hearing this description in Revelation could have visualized its astounding dimensions and apply them to the glory of the life to come. No longer is there need for the temple of stone. Other buildings are absent as well; the presence of God provides the shelter for his people.

The colors and designs tie into the great illuminations found in other books of *The Saint John's Bible*. The rainbow, a sign of God's loving sustenance from the first pages of Genesis (9:13-16), is reiterated at Revelation 4:3; 10:1. Throughout *The Saint John's Bible*, it has surfaced at times of greatest stress and greatest deliverance, often representing the people as well as their hope. At the close of Revelation, rainbow hues abound. Indeed, the small squares and triangles, in their great diversity of colors scattered below the frame of the lower register, shimmer like fractals of a rainbow. These geometric shapes

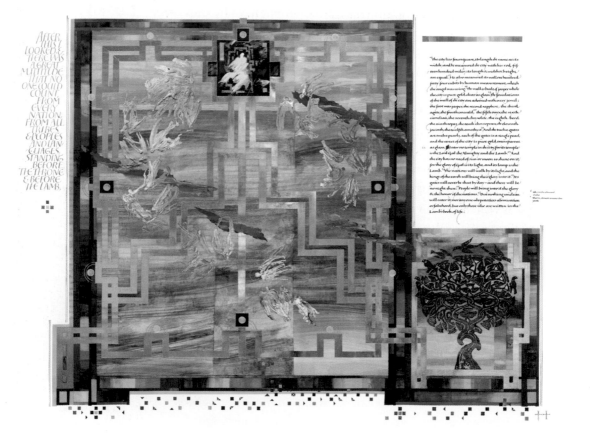

seem to be congregating around the gate, ready to enter the city, and call to mind the multitudes saved by the love and grace of Christ (Rev 7:9); they are entering the heavenly city gloriously.

Scriptural Cross-references

Genesis 4:17; Isaiah 24:23; 60:1-22; Ezekiel 40–41; 47:1-12; 1 Peter 4:5-6

The Great Amen
Revelation 22:20-21; Donald Jackson, artist

Background

The conclusion to the book of Revelation, with its warnings to anyone who would add or subtract from the text, has a sense of finality. No other book in the Bible ends similarly. Yet, the ending does not close any doors; like the gates of the heavenly city of Jerusalem, the conclusion is an open invitation for all eternity.

The imperative, "Come, Lord Jesus!" though originally written in Greek, is an Aramaic phrase (*Maranatha*). It was probably the refrain from an ancient Christian hymn. It closes the book, the New Testament, and for Christians the whole Bible, on a musical note. Instead of looking back, these words peer toward the future. Jesus says, "Surely, I am coming soon," to which the writer says, "Amen! Come, Lord Jesus!" The first words in Genesis, "In the beginning," meet their complement with Revelation's last word, "Amen"—*so be it*.

The Bible begins with creation and ends with creation, a new creation, inhabited by our redeemed humanity in Christ, what Paul calls the New Adam. It is a vision that goes well beyond optimism; it is the guaranteed glory of hope fed by faith and lived in love. With the completion of this new creation as described in Revelation, *The Saint John's Bible* has also been brought to its completion and, in doing so, draws attention to Sacred Scripture's finale—a finale leading into eternal life.

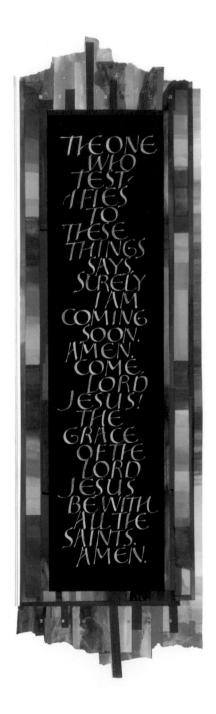

Image

The emphasis of this page is on the text, "The one who testifies to these things says, 'Surely I am coming soon.' Amen. Come, Lord Jesus! The grace of the Lord Jesus be with all the saints. Amen" (Rev 22:20-21). While the highlighted text is on the left page, the image on the right balances the whole depiction. The palette and design features carry over from the preceding illumination (the heavenly Jerusalem); they are the same rainbow motifs and shades that open Revelation.

This visual unity expresses the very construction of Revelation itself. As a narrative, Revelation does not have a linear plot line. Instead, it spirals and loops around and around, gradually making forward progress, and the illuminations, calligraphic treatments, and images do the same thing. The final panel in *The Saint John's Bible* features a thin, golden cross with a dart of flame acting as a hand to hold it. Just below the crossbar are airborne angels. This image contains elements found in Luke's Birth of Jesus and Crucifixion as well as Pentecost in Acts. It is worth contemplating on this Revelation image with those others in mind.

Scriptural Cross-references

Psalms 41:13; 72:19; 89:52; 106:48

On Saturday, June 18, 2011, during Evening Prayer at Saint John's Abbey and University Church, the final mark was placed on *The Saint John's Bible*. Donald and Mabel Jackson processed up the center aisle with Revelation 22 and placed it on the limestone altar. Abbot John Klassen of Saint John's Abbey and Saint John's University president Father Robert Koopmann then took gold leaf and burnished the last "Amen."

CONCLUSION

When Abbot John Klassen and Saint John's University president, Father Robert Koopmann, polished the gold leaf on the final "Amen" in the book of Revelation, it may have seemed as though the twelve years of work on *The Saint John's Bible* had come to an end. In reality, however, the project was just beginning. This seven-volume work comprises one of the greatest artistic and theological projects whose goal is to evangelize the next millennium. What really marks this effort, however, is not so much that Saint John's Abbey and University decided to sponsor such a project but that the whole endeavor unified so many seemingly disparate entities in the act of spreading the good news of salvation.

We speak of the Bible as the Word of God. To be sure, biblical studies amply shows that it is the Word of God in human words, and those words are fraught with inconsistencies, contradictions, and mistakes. Yet the Bible nonetheless remains a book like no other; it has a sacred character in the faith tradition. Simultaneously, the Word of God takes root in any number of us in its own way, and such flowering has become most visible in the coordination between the academics and artists in the project.

We can say that art and theology work symbiotically in their search for truth in that what one discipline misses, the other finds, but such a view does not do justice to their true relationship. More rightly, theology and art both search the divine mystery to gain better understanding; the former uses words, and the latter, color and form. The common pursuit of these two disciplines, however, points to an even greater unity within the whole dimension of divine revelation.

Throughout this study, the interplay between image and text has been discussed by employing *lectio divina* according to the ancient fourfold model of exegesis—literal, allegorical, moral, and anagogical—in which the literal level establishes the normative text and the allegorical opens up to the normative meanings of the text. It is to be understood that the term *allegorical* moves well beyond its original meaning now to include intra- and intertextuality.

A result of our communal and personal encounter with Scripture is moral action. Finally, all three practices lead to the anagogical (i.e., life in Christ).

Scholars in Collegeville and artists in Wales labored jointly on a venture that has done more than open many new doors to biblical and artistic interpretation. The academic and artistic components have also engendered a book with accentuated sacramentality, and sacramentality brings us into contact with the divine. *The Saint John's Bible* is an expression of Scripture's anagogical dimension, and it is here that we can see the project's ongoing purpose.

In the Christian tradition God reveals God's self both in the book of the Bible and in the book of physical creation, and these two tomes, as it were, must be in constant dialogue with each other. Human experience contributes to our understanding of the Word of God, and the Word of God gives sense to our human experience. Art is a means, a formidable means, of communication between human experience and God.

The goals of *The Saint John's Bible* as set out in the "Vision and Values" statement are worth repeating:

- to glorify God's Word
- to give voice to the unprivileged
- to ignite the imagination
- to revive tradition
- to discover history
- to foster the arts

Working with these objectives reveals that none of them is ever capable of being fully realized, but therein lies their strength. The glory of the Word of God has no end, the weak and unprivileged will always need the voice of the strong, an ignited imagination burns as an everlasting flame, new interpretations of ancient practices continue a tradition, every passing day adds to history, and art exists wherever on person's reflection meets another person's talent. Perhaps the Rule of Benedict supplies the best standard with which to measure the success of *The Saint John's Bible*, and indeed all human endeavor: "ut in omnibus glorifcetur Deus" (RSB 57.9), a paraphrase of 1 Peter 4:11, "so that God may be glorified in all things."

GLOSSARY

acrostic. A poetic technique found in the Psalms in which each word or stanza begins with a letter of the Hebrew alphabet, starting with the first letter, *aleph*, and continuing to the last letter, *tau*. E.g., Psalm 119.

allegory. Literally, to say something in other words. An allegory has a narrower interpretation than a metaphor because an allegory directly connects one entity to another. For example, for Christians to say that the crossing of the Red Sea by the Israelites foreshadows baptism is an allegory.

anthology. Literally, a collection poems and verses, it is used in *The Saint John's Bible* to describe an amalgam of biblical texts composing the background for an image or illumination.

apocalypse. Greek for "unveiling" or "revelation," it describes the events leading to and including the end of the world. As a literary genre, apocalyptic texts are recognizable by their fearful descriptions of absolute destruction. Whereas many cultures and civilizations have their own versions of apocalyptic literature, Jewish and Christian apocalypses are recognizable by a showdown between good and evil wherein good ultimately triumphs. Christian versions of the genre use apocalyptic literature as a prelude to Christ's second coming. See *eschaton*.

Apocrypha. A term for scriptural works whose canonicity is doubtful but nonetheless edifying. Confusion enters because most Christian denominations are not in total agreement about what works should be considered apocryphal, canonical, or deuterocanonical. The determination rests upon whether the respective branch of Christianity employs the Hebrew OT or the Greek OT (*Septuagint*). Protestants refer to the Hebrew version, Roman Catholics, Greeks, and the Eastern Churches rely on the Greek version, but even among them, total agreement is lacking. See **deuterocanon**.

Bible. Sacred Scripture for both Christians and Jews. For Christians, the Bible consists of both the OT and NT. For Jews, it is formed by the TaNaK. Throughout this commentary, the term *Bible* always means the Christian Bible, unless otherwise noted. See **Hebrew Bible**, **Old Testament**, and **New Testament**.

canon. From the Greek, meaning "ruler" or "measuring stick," a canon is the collection of written works deemed to be sacred and normative by a faith community for its worship and tradition. The Jewish biblical canon consists of the TaNaK. The Christian biblical canon is comprised of the OT and NT.

carpet page. The light abstract design that fills the open space of a manuscript between different books of an illuminated Bible.

Chalcedonian churches. Consisting of Eastern Orthodox, Roman and Eastern Catholic, and Protestant churches, these Christian bodies accept the teachings of the Council of Chalcedon, the city across the Bosphorus from Constantinople where the council took place in 451. Specifically, the council stated that Christ has both a human and a divine nature and that these separate natures remain unmixed. Because of language and cultural difficulties, the Oriental, Egyptian, Syrian, Armenian, and Assyrian churches do not adhere to the Chalcedonian definition and instead maintain that Christ has one nature that is both fully divine and fully human. Ecumenical dialogue over the years has lessened the misunderstanding and tension between the Chalcedonian and non-Chalcedonian churches.

codex. A book with pages gathered between two covers. The pages can be papyrus, parchment, paper, or any other writing surface.

colophon. What might be called a trademark or signature today was, in medieval times, a scribe's colophon. Placed at the end of the manuscript upon its completion, a colophon often includes some information about the composition or reflection on the labor that went into the piece.

deuterocanon. The name for scriptural works whose canonicity is plausible but not elevated to the degree as regular canonical books. See **Apocrypha**.

diptych. A single work of art composed of two halves that can be folded as a book.

doxology. A short hymn of praise to God usually said at the conclusion of a prayer.

epistle. An essay or treatise sent to a community to be read in front of all its members. Epistles relay a certain theme or themes and, in the case of Saint Paul, they are usually prompted by a particular question or problem.

eschaton. A Greek term meaning "end-times" or "last things" and from which we derive *eschatological* and *eschatology*. While references to the *eschaton* may involve some apocalyptic images and descriptions, the major purpose of eschatological writings is to describe the fulfillment of history. Rather than seeing creation destroyed, eschatological writings depict creation brought to its ultimate purpose in union with Christ. The book of Revelation, while containing apocalyptic passages, is eschatological literature. See **apocalypse**.

etiology. An explanation read back into an event or place to explain a current situation or name.

evangeliar or **evangeliary.** A handwritten manuscript containing the four gospels, it was often illuminated and used in daily eucharistic liturgies of monasteries and major churches.

florilegia. A Latin term meaning "a selection of flowers," *florilegia* describes an early form of scholarship. In the days of handwritten manuscripts, readers would often write in the margins the comments that previous scholars made about the text in question. *Florilegia* became a standard feature of theological writing up through the Middle Ages and beyond. Indeed, one can see in this style of writing the forerunner to footnotes, endnotes, and other forms of documentation.

folio. A large piece of parchment, vellum, or paper used as a writing service. Technically, a folio does not have numbered pages.

fourfold sense of interpretation. An ancient methodology for interpreting Sacred Scripture, it is an approach wherein the completion of one step leads to another. First, the literal sense establishes what the text says, who is speaking, and what the circumstances

of the story are. Second, the reader develops an allegorical one-to-one correspondence between the literal sense and some other biblical or spiritual reality. Third, the biblical or spiritual reality teaches and leads to proper moral and ethical behavior. Finally, the whole endeavor of steps 1 to 3 lead to union with Christ. The hermeneutics of *The Saint John's Bible* reworks and redefines these categories in light of two thousand years of Christian tradition. See chapter 1.

frontispiece. The major illumination opening the individual books of the Bible. See **incipit**.

Hebrew Bible. The Christian name for the Bible used in Judaism. The Jewish term itself is TaNaK, for *Torah* (Law), *Nevi'im* (Prophets), and *Ketuvim* (Writings). See **Old Testament** and **New Testament**.

historiated. A decorative element in medieval Bibles that relates a story or episode found in the accompanying text. Historiated figures usually appear in the decorated, initial capital letters of major books or chapters.

historical criticism. Investigating and researching the history behind a written text. The principles of historical criticism, which take in textual and literary analysis, were first applied to ancient literature. This interpretive system has been used on the Bible to greater and lesser degrees for over two hundred years, and some parts of it go back to ancient times.

homily. An explanation of Scripture and theology preached to a congregation after reading particular biblical passages. Historically, homilies were written down and collected, especially if they were good or were the work of a great speaker or theologian.

illumination. An embellishment of a manuscript through painting or drawing. The term itself describes the gold leaf reflecting the candlelight at the page turn in a dark church.

image. In *The Saint John's Bible*, any abstract or representational illumination. All illuminations are images, but not all images are illuminations.

incipit. A term taken from medieval manuscripts, *incipit* signifies the introductory image or special treatment to one of the biblical books in *The Saint John's Bible*. See **frontispiece**.

intertestamental. Because Christians define their Bible as the Old and New Testaments, this term refers to the age that extends from roughly one hundred years before to one hundred years after the birth of Christ. The same time frame is often called the "Second Temple Period" after King Herod's building project, which took place simultaneously.

intertextuality. A postmodern term for a dialogue between texts, with *text* given the broadest possible interpretation. Hence, tangents of thought within a stream of consciousness that often occur while reading Scripture are not dismissed but rather folded into the interpretation of the biblical passage. Nothing is too profane, for we must reckon that the Holy Spirit is leading the thought somehow and some way back to God.

intratextuality. In biblical research, *intratextuality* defines the relationship between one book of the Bible and another, thereby assuming that the way the canon is assembled from Genesis through Revelation is itself worthy of interpretation.

lectio divina. Also known as sacred reading, *lectio divina* is an ancient monastic discipline in which one reads a biblical passage prayerfully. As a prayer, the Holy Spirit is present and, as with all things under the Holy Spirit, we are expected to use both our mind and our heart in interpreting a biblical passage. Science, literature, history, philology, spirituality, theology, and philosophy (to name a few disciplines) all inform and aid

the process of *lectio divina*. At no point has the Christian tradition viewed *lectio divina* along the lines of biblical fundamentalism. See **visio divina**.

letters. As a biblical term, letters are written to an individual in response to a question or simply as an act of communication. Although they are not meant to be read to the whole community, in the case of the New Testament, that is exactly what happened.

marginalia. Special treatments or decorations written or painted in the margins of a book.

metanarrative. In the Christian sense of the term, the metanarrative is the ongoing story of salvation. It interprets all of life and the existence of creation through the lens of Christ's redemption. Personal trials and joys, failings and successes are viewed as participation in the life of Christ as are the purpose and fulfillment of the whole universe.

metaphor. A literary device in which the description of one reality expresses another. For example, a sunrise can express the beginning of new life without ever stating it. In fact, if something is outlined and defined, the metaphor no longer exists. In Christianity's sacramental system, the understanding is that metaphors are not limited to literature but include all things perceived through the senses.

metonym. A part that represents the whole, as in the phrase "The White House" for the whole executive branch of government.

New Testament. The name given to books of the Christian Bible, written after the birth of Christ and beginning with the Gospel of Matthew and continuing through the book of Revelation, often abbreviated NT. See **Hebrew Bible** and **Old Testament**.

nonrational. Intuitive thinking that transcends logic and empirical data as a way of knowing. Because such thinking can often reference a numinous experience, it is the basis of much spirituality. *Nonrational* is not to be confused with *irrational*, which is thinking that defies logic, reason, experience, and reality. See **rational**.

normative meaning of the text. An interpretation of the normative text that may change over time. For example, whereas Genesis 1–2 were considered for most of history to describe the origins of humankind's physical existence, in light of evolutionary theory, physical descent from Adam and Eve is no longer credible. Consequently, the truth of the creation story lies in its ability to describe the existential reality of human limitation and hope for redemption before a loving God.

normative text. The written, biblical text we have in front of us as defined by the canon of Christian tradition. New research into the text and the findings thereof are considered part of the normative text. It is the foundation for the normative meaning of the text.

Old Testament. The name given to the Hebrew and Greek books of the Christian Bible, which were written before the birth of Christ. The Old Testament, often abbreviated OT, begins with Genesis and continues through Malachi. The Old Testament is not the same as the Hebrew Bible and should not be confused with it. See **Hebrew Bible** and **New Testament**.

palette. A selection of colors. In *The Saint John's Bible* different hues evoke an array of understandings and will sometimes connect themes.

parchment. A collective term for the animal skin used as a writing surface. For *The Saint John's Bible*, the parchment employed is calfskin and often called "vellum."

Psalter. An alternative name for the book of Psalms.

quill. A pen made from the large wing feathers of geese, turkeys, and swans, that are tempered, treated, and cut to function as a writing instrument.

rational. Thinking that utilizes logic, reason, and empirical evidence as a way of knowing. See **nonrational**.

script. A cursive form of writing, usually produced with pen and ink.

scriptorium. In medieval monasteries, this was the room where books were written. In the context of *The Saint John's Bible*, "scriptorium" refers to the workshop in Wales where artistic director Donald Jackson and his team did their calligraphy and illuminations.

scroll. A rolled sheet of parchment containing writing. It predates the codex.

symbol. Something which represents and suggests something else. Symbols connote rather than denote an understanding.

synesthesia. A psychological term used to describe stimulation in one sensory pathway that prompts stimulation in another. Sounds may translate into colors, or touch into flavors, and so on.

theophany. An appearance or manifestation of God to a human being.

triptych. A single work of art composed of three panels that can be folded one upon another. Usually used as an altarpiece.

typology. A study of symbols, how they can be classed, and how they work. In Scripture, typology tells us how certain verses and passages have been interpreted through the ages.

visio divina. Everything said about *lectio divina* is true about *visio divina*. The only difference is that *visio divina* engages art as its point of departure.

BIBLIOGRAPHY

Chapter 1

Auerbach, Erich. *Mimesis: The Representation of Reality in Western Literature*. Princeton: Princeton University Press, 1953.

Baron-Cohen, S., and J. Harrison, eds. *Synaesthesia: Classic and Contemporary Readings*. Oxford: Blackwell Publishers, 1997.

Berdini, Paolo. *The Religious Art of Jacopo Bassano: Painting as Visual Exegesis*. Cambridge: Cambridge University Press, 1997.

Bertens, Hans. *The Idea of the Postmodern: A History*. London: Routledge, 1995.

Bloom, Harold. *An American Religion: The Emergence of the Post-Christian Nation*. New York: Simon and Schuster, 1992.

Bonyton S., and D. J. Reilly, eds. *The Practice of the Bible in the Middle Ages: Production, Reception and Performance in Western Christianity*. New York: Columbia University Press, 2011.

Bosch, P. *The Name of This Book Is Secret*. London: Little, Brown, 2007.

Brevard Childs, *The New Testament as Canon: An Introduction*. Valley Forge, PA: Trinity Press International, 1994; first printing 1984.

Calvino, Italo. *Six Memos for the Next Millennium*. London: Random House, 1996.

Caputo, John D. *Deconstruction in a Nutshell*. New York: Fordham University Press, 1997.

———. *On Religion*. London: Routledge, 2001.

———, Mark Dooley, and Mark J. Scanlon, eds. *Questioning God*. Bloomington: Indiana University Press, 2001.

Chauvet, Louis-Marie. *Symbol and Sacrament: A Sacramental Reinterpretation of Christian Existence*. Translated by Patrick Madigan and Madeleine Beaumont. Collegeville, MN: Liturgical Press, 1995.

Childs, Brevard. *The New Testament as Canon: An Introduction*. Valley Forge, PA: Trinity Press International, 1994.

Cytowic, R. E. *The Man Who Tasted Shapes*. Cambridge: MIT Press, 2003.

———. *Synesthesia: A Union of the Senses*. 2nd ed. Cambridge: MIT Press, 2002.

Cytowic, R. E., and D. M. Eagleman. *Wednesday Is Indigo Blue: Discovering the Brain of Synesthesia*. Cambridge: MIT Press, 2009.

Dann, K. *Bright Colors Falsely Seen*. Cambridge: Harvard University Press, 1998.

De Certeau, Michel. *The Mystic Fable*. Translated by Michael B. Smith. Chicago: The University of Chicago Press, 1992.

De Córdoba, M. J., et al. *Sinestesia: Los fundamentos teóricos, artísticos y científicos*. Granada: Ediciones Fundación Internacional Artecittà, 2012.

De Incarnatione 54, no. 3. In J.-P. Migne. *Patrologiae cursus completus accurante. Series Graeca*. In *Patrologia Graeca* 25:192B. Paris: Frères Garnier, 1912.

Derrida, Jacques. *Given Time: 1. Counterfeit Money*. Translated by Peggy Kamuf. Chicago: University of Chicago Press, 1992.

Duffy, P. L. *Blue Cats and Chartreuse Kittens: How Synesthetes Color Their Worlds*. New York: Henry Holt & Company, 2001.

Dungan, David Laird. *The History of the Synoptic Problem*. New York: Doubleday, 1999.

Florensky, Pavel. *The Pillar and Ground of Truth*. Translated by Boris Jakim. Introduction by Richard F. Gustafson. Princeton: Princeton University Press, 1997.

Gadamer, Hans-Georg. *Truth and Method*. New York: Crossroad, 1975.

Harrison, J. *Synaesthesia: The Strangest Thing*. Oxford: Oxford University Press, 2001.

Hart, Kevin. *The Dark Gaze: Maurice Blanchot and the Sacred*. Chicago: University of Chicago Press, 2004.

Hart, Kevin, and Yvonne Sherwood, eds. *Other Testaments: Derrida and Religion*. London: Routledge, 2004.

Hart, Kevin. *Postmodernism*. Oxford: Oneworld Publications, 2008.

Hartman,Geoffrey. *Scars of the Spirit: The Struggle against Inauthenticity*. New York: Palgrave, 2002.

Holland, Michael, ed. *The Blanchot Reader*. Oxford: Basil Blackwell, 1995.

Horner, Robyn. *Rethinking God as Gift: Marion, Derrida, and the Limits of Phenomenology*. New York: Fordham University Press, 2001.

Illich, Ivan. *In the Vineyard of the Text: A Commentary to Hugh's Didascalicon*. Chicago: University of Chicago Press, 1993.

Janicaud, Dominique, et al. *Phenomenology and the "Theological Turn": The French Debate*. Translated by Bernard G. Prusak, et al. New York: Fordham University Press, 2000.

Jay, C. *Breathing in Colour*. Boston: Little, Brown, 2009.

Jensen, Robin M. *The Substance of Things Seen: Art, Faith, and the Christian Community*. Grand Rapids, MI: Eerdmans, 2004.

Louth, Andrew, trans. *Saint John of Damascus: Three Treatises on the Divine Images*. Crestwood, NY: St. Vladimir's Seminary Press, 2003.

Lévinas, Emmanuel. *Ethics and Infinity: Conversations with Philippe Nemo*. Translated by Richard A. Cohen. Pittsburgh: Duquesne University Press, 1985.

———. *Is It Righteous to Be? Interviews with Emmanuel Lévinas*. Edited by Jill Robbins. Stanford: Stanford University Press, 2001.

Marion, Jean-Luc. *On Descartes' Metaphysical Prism*. Translated by Jeffrey L. Kosky. Chicago: University of Chicago Press, 1999.

Marks, L.E. *The Unity of the Senses: Interrelations among the Modalities*. New York: Academic Press, 1978.

Mass, W. *A Mango-Shaped Space*. Boston: Little, Brown, 2003.

Milbank, John. *Being Reconciled: Ontology and Pardon*. London: Routledge, 2003.

———. *Theology and Social Theory: Beyond Secular Reason*. Oxford: Basil Blackwell, 1990.

Nancy, Jean-Luc. *The Inoperative Community*. Edited by Peter Connor. Translated by Peter Connor, et al. Minneapolis: University of Minnesota Press, 1991.

———. *The Sense of the World*. Translated and foreword by Jeffrey S. Librett. Minneapolis: University of Minnesota Press, 1997.

Norris, Christopher. *Uncritical Theory: Postmodernism, Intellectuals and the Gulf War*. Amherst: University of Massachusetts Press, 1992.

Norwich, John Julius. *Byzantium: The Early Centuries*. New York: Alfred A. Knopf, 1989.

O'Kane, Martin. *Painting the Text: The Artist as Biblical Interpreter*. Sheffield, UK: Phoenix Press, 2007.

Orosz, Magdolna. "Literary Reading(s) of the Bible, Aspects of Semiotic Conception of Intertextuality and Intertextual Analysis of Texts." In *Reading the Bible Intertextually*. Edited by Richard B. Hays, Stefan Alkier, and Leroy A. Huizenga. Waco, Texas: Baylor University Press, 2009.

Ouspensky, Leonid, and Vladimir Lossky. *The Meaning of Icons*. Translated by G.E.H. Palmer and E. Kadloubovsky. Crestwood, NY: St. Vladimir's Seminary Press, 1982.

Riccò, D. *Sinestesie per il design: Le interazioni sensoriali nell'epoca dei multimedia*. Milano: Etas, 1999.

———. *Sentire il design: Sinestesie nel progetto di comunicazione*. Roma: Carocci, 2008.

Robertson, L., and N. Sagiv. *Synesthesia: Perspectives from Cognitive Neuroscience*. Oxford: Oxford University Press, 2005.

Rosenweig, Franz. *The Star of Redemption*. Translated by William W. Hallo. Notre Dame: University of Notre Dame Press, 1985.

Rowedder, Anna K. *Für Dich—For You—Pour Toi*. Luxembourg: Synaisthesis, 2009.

Sinha, Jasmin, ed. *Synästhesie der Gefühle, Emotional Synaesthesia*. Luxembourg: Synaisthesis, 2009.

Tammet, D. *Born on a Blue Day: A Memoir of Aspergers and an Extraordinary Mind*. London: Hodder & Stoughton., 2006.

Taylor, Justin. "The Treatment of Reality in the Gospels: Five Studies." *Cahiers de la Revue Biblique*. Pendé, France: J. Gabalda et Cie, 2011.

Tornitore, T. *Scambi di sensi: Preistoria delle sinestesie*. Torino: Centro Scientifico Torinese, 1988.

———. *Storia delle sinestesie: Le origini dell'audizione colorata*. Genova: Genova, 1986.

Van Campen, Cretien. *The Hidden Sense: Synesthesia in Art and Science*. Cambridge, MA: MIT Press, 2007.

Vattimo, Gianni. *Belief*. Translated by Luca D'Isanto and David Webb. Stanford: Stanford University Press, 1999.

———. *The Transparent Society*. Translated by David Webb. Baltimore: John Hopkins University Press, 1992.

Von Balthasar, Hans Urs. *The Glory of the Lord: A Theological Aesthetics: The Realm of Metaphysics in the Modern Age 5*. Translated by Oliver Davies, et al. Edited by Brian McNeil and John Riches. Edinburgh: T&T Clark, 1991.

Ward, J. *The Frog Who Croaked Blue: Synesthesia and the Mixing of the Senses*. London: Routledge, 2008.

Zygmunt, Bauman, *Postmodernity and Its Discontents*. New York: New York University Press, 1997.

Chapter 2

Aland, Kurt, and Barbara Aland. *The Text of the New Testament: An Introduction to the Critical Editions and to the Theory and Practice of Modern Textual Criticism*. Grand Rapids: Eerdmans, 1989.

Daniell, David. *The Bible in English: Its History and Influence*. New Haven: Yale University Press, 2003.

Dungan, David Laird. *A History of the Synoptic Problem: The Canon, the Text, the Composition, and the Interpretation of the Gospels*. New York: Doubleday, 1999.

The Holy Bible, Containing the Old and New Testaments in the Authorized King James Version. Chicago: Timothy Press, 1959.

The Holy Bible, Containing the Old and New Testaments Translated out of the Original Tongues; Being the Version Set Forth A.D. 1611, Compared with the Most Ancient Authorities and Revised A.D. 1881–1885. Newly edited by the American Revision Committee, 1901. Standard ed. New York: T. Nelson, 1929.

The Holy Bible, Containing the Old and New Testaments. Revised Standard Version. Catholic ed. Translated from the Original Tongues, Being the Version Set Forth A. D. 1611; Old and New Testaments Revised A. D. 1881–1885 and A. D. 1901, Apocrypha Revised A. D. 1894; Compared with the Most Ancient Authorities and Revised A. D. 1952, Apocrypha Revised A. D. 1957. Catholic Biblical Association of Great Britain. Toronto: T. Nelson, 1966.

The Holy Bible: New Revised Standard Version, Catholic Edition. New York: Oxford University Press, 1999.

International ISTC Agency. *The International Standard Text Code 1.2*. April 2010.

Metzger, Bruce M., Robert C. Dentan, and Walter Harrelson. *The Making of the New Revised Standard Version of the Bible*. Grand Rapids: Eerdmans, 1991.

Metzger, Bruce M., and Bart D. Ehrman. *The Text of the New Testament*. 4th ed. New York: Oxford University Press, 2005.

Neuhaus, Richard John. "Bible Babel." In *First Things* (May 2001), http://www.bible-researcher.com/neuhaus1.html.

Parker, D. C. *Codex Sinaiticus: The Story of the World's Oldest Bible*. London: British Library, 2010.

Rule of Saint Benedict in Latin and English with Notes. Edited by Timothy Fry, OSB; Imogene Baker, OSB; Timothy Horner, OSB; Augusta Raabe, OSB; Mark Sheridan, OSB. Collegeville, MN: Liturgical Press, 1981.

Wansbrough, Henry. *The Story of the Bible*. London: Darton, Longman and Todd, 2006.

Chapter 3

Boynton, Susan, and Diane J. Reilly, eds. *The Practice of the Bible in the Middle Ages: Production, Reception, and Performance in Western Christianity*. New York: Columbia University Press, 2011.

Brown, Michelle, ed. *In the Beginning: Bibles before the Year 1000*. Washington, DC: Freer Gallery of Art and Arthur M. Sackler Gallery, Smithsonian Institution, 2006.

Cahn, Walter. *Romanesque Bible Illumination*. Ithaca, NY: Cornell University Press, 1982.

Calkins, Robert G. *Illuminated Books of the Middle Ages*. Ithaca, NY: Cornell University Press, 1983.

Chazelle, Celia. "Ceolfrid's Gift to St. Peter: The First Quire of the *Codex Amiatinus* and the evidence of its Roman Destination." *Early Medieval Europe* 12 (2003): 129–57.

De Hamel, Christopher. *The Book: A History of the Bible*. London: Phaidon, 2004.

———. *A History of Illuminated Manuscripts*. 2nd edition. London: Phaidon, 1994.

Dutton, Paul Edward, and Herbert L. Kessler. *The Poetry and Paintings of the First Bible of Charles the Bald*. Ann Arbor: University of Michigan Press, 1997.

Eusebius of Caesarea. *Life of Constantine*. Translated by Averil Cameron and Stuart G. Hall. Oxford: Clarendon Press, 1999.

Gameson, Richard, ed. *The Early Medieval Bible: Its Production, Decoration, and Use*. Cambridge: Cambridge University Press, 1994.

Kessler, Herbert L. *The Illustrated Bibles from Tours*. Princeton, NJ: Princeton University Press, 1977.

Meyvaert, Paul. "Bede, *Cassiodorus*, and the Codex Amiatinus." *Speculum* 71 (1996): 827–83.

———. "The Date of Bede's In Ezram and His Image of Ezra in the Codex Amiatinus." *Speculum* 80 (2005): 1087–1133.

Parker, D. C. *Codex Sinaiticus: The Story of the World's Oldest Bible*. London: British Library, 2010.

Chapter 4

Rule of Saint Benedict in Latin and English with Notes. Edited by Timothy Fry, OSB; Imogene Baker, OSB; Timothy Horner, OSB; Augusta Raabe, OSB; Mark Sheridan, OSB. Collegeville, MN: Liturgical Press, 1981.

Chapter 5

Rule of Saint Benedict in Latin and English with Notes. Edited by Timothy Fry, OSB; Imogene Baker, OSB; Timothy Horner, OSB; Augusta Raabe, OSB; Mark Sheridan, OSB. Collegeville, MN: Liturgical Press, 1981.

Chapter 6

Schneiders, Sandra M. *The Revelatory Text: Interpreting the New Testament as Sacred Scripture*. San Francisco: HarperSanFranciso, 1991.

Chapter 7

Bernard of Clairvaux. *Talks on the Song of Songs*. Edited by Bernard Bangley. Brewster, MA: Paraclete Press, 2002.

Bulgakov, Sergius. *The Lamb of God*. Grand Rapids: William B. Eerdmans Publishing Company, 2008.

Kornblatt, Judith Deutsch. *Divine Sophia: The Wisdom Writings of Vladimir Solovyov*. Ithaca: Cornell University Press, 2009.

Rule of St. Benedict in Latin and English with Notes. Edited by Timothy Fry, OSB; Imogene Baker, OSB; Timothy Horner, OSB; Augusta Raabe, OSB; Mark Sheridan, OSB. Collegeville, MN: Liturgical Press, 1981.

Thompson, Francis. *The Hound of Heaven*. Mount Vernon, NY: Peter Pauper Press, 1960.

Chapter 10

Dungan, David Laird. *A History of the Synoptic Problem*. New York: Doubleday, 1999.

Morrison, Craig. Personal correspondence (May 2001). Pontifical Biblical Institute.

Porter, Stanley E., ed. *The Pauline Canon*. Boston: Brill, 2004.

The Roman Martyology. Edited by Canon J. B. O'Connell. Westminister: Newman Press, 1962.

Rule of St. Benedict in Latin and English with Notes. Edited by Timothy Fry, OSB; Imogene Baker, OSB; Timothy Horner, OSB; Augusta Raabe, OSB; Mark Sheridan, OSB. Collegeville, MN: Liturgical Press, 1981.

Chapter 11

Di Giovanni, Benvenuto. Five panel series of Christ's Paschal Triduum: *The Agony in the Garden, Christ Carrying the cross, The Crucifixion, Christ in Limbo*, and *The Resurrection*. National Gallery, Permanent collection: Washington, DC.

Howard-Brook, Wes, and Anthony Gwyther. *Unveiling Empire: Reading Revelation Then and Now*. Maryknoll, NY: Orbis Books, 1999.

Murphy-O'Connor, Jerome. *Paul: A Critical Life*. New York: Oxford University Press, 1996.

————. *The Theology of the Second Letter to the Corinthians*. New York: Cambridge University Press, 1991.

Rule of St. Benedict in Latin and English with Notes. Edited by Timothy Fry, OSB; Imogene Baker, OSB; Timothy Horner, OSB; Augusta Raabe, OSB; Mark Sheridan, OSB. Collegeville, MN: Liturgical Press, 1981.

Troparion. The Maronite Liturgy for Holy Saturday. Piffard, NY: Our Lady of the Genesee Abbey Private Publication, 2012.

Vanni, Ugo. *Apocalisse: Esegesi dei Brani Scelti, Fascicolo I*. Rome: Editrice Pontificio Istituto Biblico, 1991–92.

SCRIPTURE INDEX